W9-DAN-260

"How Shall We Tell Each Other of the Poet?"

"How Shall We Tell Each Other of the Poet?"

The Life and Writing of Muriel Rukeyser

Edited by

Anne F. Herzog
and Janet E. Kaufman

St. Martin's Press
New York

ISBN 0-312-21320-4

Library of Congress Cataloging-in-Publication Data
How shall we tell each other of the poet? : the life and writing of
 Muriel Rukeyser / edited by Anne F. Herzog and Janet E. Kaufman.
 p. cm.
 Includes bibliographical references(p.) and index.
 ISBN 0-312-21320-4
 1. Rukeyser, Muriel, 1913– . 2. Women and literature—United
States—History—20th century. 3. Women poets, American—20th
century—Biography. I. Herzog, Anne F., 1959– . II. Kaufman,
Janet E., 1964– .
PS3535.U4Z69 1999
811'.52—dc21
[b] 98-51904
 CIP

Design by Letra Libre, Inc.

First edition: August 1999
10 9 8 7 6 5 4 3 2 1

*For Hollis, Emily, and Lucas Graham
for constancy of love and support*

*For Lynn, Andrew, and Karen Kaufman
for their love, inspiration, and courage*

Contents

Acknowledgments

In composing this book, again and again we have been moved by the generous spirit of many people. When we first began seeking contributors, we were consistently greeted with kind and passionate enthusiasm for this project by people who knew and had worked with Muriel Rukeyser. On the phone, in letter exchanges, and over coffee, her friends, students, and colleagues told us stories about her and the impact she had on their lives. Often, when these individuals were not able to contribute to the book, they put us in touch with others who could. In this way, we have come to sense how far Muriel Rukeyser's reach extended, how broad her influence was, how her presence and poetry transformed peoples' lives.

Jan Levi, Gerald Stern, Galway Kinnell, and Sharon Olds participated in the first Modern Language Association conference panel devoted to Muriel Rukeyser in 1994. From that panel this book evolved, and we are grateful to them for their support of and involvement in the project from the beginning. Jane Cooper has welcomed us into her home on numerous occasions to talk about Rukeyser, giving us a sense of personal connection to the poet. Adrienne Rich, in her correspondence with us, has encouraged and challenged us. All of these writers have deepened our understanding of the centrality of Muriel Rukeyser's work to twentieth-century American literature. Moreover, we are deeply grateful to William L. Rukeyser, Muriel's son, for helping in whatever ways he could throughout this project. Bill's enthusiasm for this book and his openness in sharing personal history invigorated our work. He brought an attentiveness to the details of the poet's life and work that educated us; additionally, he offered crucial critical feedback in the final stages of the book's revision.

We are indebted to Alicia Suskin Ostriker and Adalaide Morris, our dissertation directors, who began encouraging our work on Rukeyser many years ago, when her books were out of print and only one critical work about her existed. These two made it possible for us to take the necessary scholarly and imaginative leaps of faith to progress on our path. Along the way, we

have been honored by the many teachers, colleagues, and friends who have read and guided our work, helping us to complete the book, including Jan Heller Levi, Jacqueline Osherow, Oren Postrel, Jenny Skerl, and Eleanor Wilner. We are also grateful to those named and unnamed who have nurtured the book through their mentoring, friendship, and caring for us. In particular, we thank Jane Bertone, Margaret Brady, Margaret Breen, Suzanne Diamond, Robert and Gladys Herzog, Jane Jeffrey, Susan Miller, Michael Peich, Janet Shepherd, Christopher Teutsch, and Helen Whall.

A grant from West Chester University's CASSDA Fund enabled us to work together in Salt Lake City, speeding and easing our collaboration. Along with the Dorothy and Clarence Snow Scholarship Fund from the University of Utah English Department, it helped us to obtain editorial assistance. We thank the staffs of our respective university libraries for assisting us in obtaining the books and articles that inform this collection. We are indebted to Amy Reading and Rick Delaney at St. Martin's Press for their contributions to this book. Our editor at St. Martin's Press, Maura Burnett, offered sound guidance along the way. Most importantly, she appreciates the importance of creating critical, literary dialogues about women writers, and we are grateful to have had the opportunity to work with her.

Finally, we could not have completed the preparations for this book without the attentive, skillful editing of Brenda Miller, who brought her talents as both writer and editor to this project, and who cared about this book with us.

Foreword

◇◇◇◇◇◇◇◇◇

Alicia Suskin Ostriker

We live, it seems, in a time bereft of vision. Capitalism triumphs globally. Wars break out like fiery blisters nobody knows how to heal. Politicians are assumed to be infinitely corrupt. The idealisms of the past—the battles for integration and civil rights, the peace movement, feminism, the hope of eradicating poverty, the notion (remember?) of loving your neighbor, or of expanding your consciousness—are embarrassing relics to today's young. To read the paper or watch the news is to be filled with sorrow and leaden-eyed despairs, as Keats might say. Postmodernism, explains one witty commentator, is modernism without the hope.

Fifty years ago, the poet Muriel Rukeyser knew all this, and she rejected despair. One of her poems begins, "I lived in the first century of world wars. / Most mornings I would be more or less insane." The poem goes on to evoke how the poet, along with similarly crazed friends, is making her poems "for others unseen and unborn,"

> . . . would try to imagine them, try to find each other.
> To construct peace, to make love, to reconcile
> Waking with sleeping, ourselves with each other,
> Ourselves with ourselves. (*RR* 212)

After a stanza pause, the poem concludes simply, "I lived in the first century of those wars." It is a way of saying that the struggle is neither to be concluded nor abandoned.

Rukeyser (1913 – 1980) was an American-Jewish poet, journalist, biographer, lifelong political activist, and passionate visionary. Dismissed by the

New Critics (she calls them "old") for excessive interest in politics and sexuality, spurned by the Left for excessive interest in formal experiment and an imprudent refusal to toe a correct proletarian line, Rukeyser became a foremother of 1970s feminist poetry. Two anthologies of women's poetry—*No More Masks!* and *The World Split Open*—bear titles taken from her poems. Writers as wildly different as Adrienne Rich and Sharon Olds, Alice Walker and Dorothy Allison, have expressed reverence for her work and life. Anne Sexton called her "Muriel, mother of everyone." More recently she has become exemplary as a writer who was under FBI surveillance for 40 years, who was arrested at the age of 19 at the trial of the Scottsboro Boys, who at 22 was in Barcelona at the start of the Spanish Civil War, and then in Gauley Bridge, West Virginia, where miners were dying of silicosis because of inadequate protection, who went to Hanoi during the Vietnam War, and to Korea to protest the imprisonment of a poet—and who wrote of these things with rage, grief, and intelligence in what we now call the "poetry of witness."

It is appropriate that the present volume combines analytical essays on Rukeyser's writing with personal reminiscences of her as a physically and morally powerful person, that it surveys her omnivorous mind—Rukeyser was fascinated by science, technology, film, economics, politics, history— and her impact and influence as a teacher, and that it mixes prose with poetry. For Rukeyser was in love with mixings, blendings, relationships. Unafraid of chaos, she made a literary method of it in works that defy category, shifting between the oracular and the documentary, the lyric and the epic, strict rationality and digressive flights of imagination. It is appropriate too that Rukeyser, who spent a lifetime giving a voice to society's voiceless ones and remembering history's forgotten ones, is here eloquently remembered and re-voiced. If Rukeyser has been excluded by some of America's cultural gate-keepers, this volume opens gates, making a path to her life and work that will be traveled by many seekers, among them the "unseen and the unborn."

Introduction

An "American genius," our "twentieth-century Whitman." Anne Sexton and Erica Jong both referred to Muriel Rukeyser as "the mother of everyone." To read her collected works is to track American history of the twentieth century and to question with her the particular nature of the American imagination. She began publishing in the 1930s, writing about Sacco and Vanzetti, Sappho, the Scottsboro boys, the Gauley Bridge industrial disaster, and the Popular Front's stand against fascism, insisting always on the link between public subjects and the personal, individual life. Until she died in 1980 at the age of 66, she persisted in bringing the events of the world into poetry, and poetry into the world. At 21, in her first published collection, she wrote: "Breathe-in experience, breathe-out poetry." Her writing stretches the American poetic imagination, indeed the very definitions of American poetry, drawing its strikingly interdisciplinary metaphors from such sources as the physics of Willard Gibbs, the explorations of Elizabethan navigator and naturalist Thomas Hariot, and the Native American rituals described by anthropologist Franz Boas. Rukeyser's sources come, as well, from her wide-ranging life experiences as a pilot, a journalist, a social activist, and a single parent. She was a person who put her body and her writing alike on the line when, for example, as president of PEN American Center, she stood vigil outside the prison cell of South Korean poet Kim Chi Ha, and when she traveled to Hanoi in 1972 to protest the American war against Vietnam.

At her death, she left us 15 volumes of poetry, biographies of the scientist Willard Gibbs and the explorer Thomas Hariot, a biography—in "story and song"—of the politician Wendell Willkie, an astounding treatise of poetics arguing passionately for poetry's vital role in society, translations of the Mexican poet Octavio Paz and the Swedish poet Gunnar Ekelof, six children's books, one novel, and a large body of uncollected journalism, essays, criticism, plays, and film scripts. She published her first book, *Theory of Flight*, in 1935 when she was 21 years old. The Yale Younger Poets Award distinguishing this publication marked the beginning of a lifetime of recognition: the

Harriet Monroe Poetry Award (1941), a Guggenheim Fellowship (1943), the Levinson Prize (1947), election to the National Institute of Arts and Letters (1967), the American Academy of Poets' Copernicus Prize (1977), the Shelley Prize (1977), and grants from the American Academy of Arts and Letters and the National Institute of Arts and Letters. Rukeyser was a poet who broke into new language and new forms because she wanted for poetry what Willard Gibbs found in physics: "a language of transformation . . . a language of changing phase for the poem . . . a language that was not static" (Packard 131). *"How Shall We Tell Each Other of the Poet?"* discusses the many facets of Rukeyser's language of transformation, showing the significance of her place in American poetry in the latter half of the twentieth century.

"Oh, for God's sake / they are connected / underneath," Rukeyser wrote in "Islands," one of a number of her poems that expresses her rejection of the false divisions (such as poetry and politics) and disciplinary splittings (such as literature and science) commonly accepted in her time and ours. Following Rukeyser's lead, this book brings together multiple voices: scholars, both established and new, who have been challenged by the complexity and richness of her poems; friends, colleagues, and students reflecting on their personal knowledge of the poet; and finally, contemporary poets whose work shows Rukeyser's direct influence. Rukeyser emphasized poetry as dynamic, depending upon the "moving relations" within it, and she believed in constellations of readers, writers, and poems—not boundaries set to divide them. Thus, in keeping with this vision, we have not divided the writing collected in this book into sections according to traditional generic distinctions. Rather, *"How Shall We Tell Each Other of the Poet?"* is designed to span the personal, the scholarly, and the creative—resulting, we hope, in greater understanding and scope than one might achieve through less hybrid choices. We see the separate pieces in this collection—prose or poetry, memoir or criticism—as contributing to each other. None stands alone.

To provide some assistance for readers, we have grouped individual pieces according to similarity in approach or concern. The opening section, "Poetics and Vision," considers Muriel Rukeyser, the woman and poet, as a figure in American poetry. The pieces in it offer paradigms for understanding her formal experimentalism, her poetics, the connections between her Jewish identity and her principles of relationship and witnessing, and the consistent ethics undergirding all of her poetry and activism. "Activism and Teaching" shows the import of Rukeyser's political poetry and the tremendous personal impact Rukeyser had on students, colleagues, readers, and activists. Stories of the powerful connections she made with her students as well as the details of her pedagogical practices continue to provide generative models for cre-

ative teaching. "The Body, Feminist Critique, and the Poet as Mother" documents Rukeyser's extraordinary influence on the development of women's poetry in the twentieth century. She was a leader among poets in addressing experiences specific to the female body (menstruation, lactation, childbirth), in challenging sexist and heterosexist assumptions, and in writing erotic love poems—including love poems addressed to women. The section "Poetry of Witness" responds primarily to Rukeyser as a political poet and poet of witness. A number of these essays focus on "The Book of the Dead," Rukeyser's magnificent long poem that has recently drawn new critical attention and readers. Rukeyser's poem and these essays probe one of the most serious industrial disasters in American history, in which untold numbers of migrant workers—most of whom were African American—died of silicosis poisoning because of inadequate precautions taken by Union Carbide and Carbon Corporation in the drilling of the Hawk's Nest Tunnel in West Virginia. The essays in this section explore poetry as witness, the documentary elements of Rukeyser's writing, and her fascination for unexamined and marginalized passages of American historical experience. Finally, this collection concludes with overviews of Rukeyser's life and writing, including an original piece, the first of its kind, by her only child, William L. Rukeyser.

A word about the title of our collection is in order here. The opening question, "How shall we tell each other of the poet?" is taken from *The Gates* (1976), Rukeyser's final book of poetry. We read this question as including an imperative for us and for future readers to respond—not only readers of Rukeyser, but readers of other poets. Since the poet's work has inherent and undeniable value in our lives, since we *must* tell each other of the poet, how shall we do that? Which words and forms will we find and choose? Rukeyser wrote in *The Life of Poetry,* "Art is not a world, but a knowing of the world. . . . Art is practiced by the artist and audience" (26). For Rukeyser, the obligation to respond creatively to the individual life and the world was never limited to the artist or seeker; she saw such responses as a collective responsibility, contributed to and shared by all within any culture of integrity. Thus, our title foregrounds her question, prodding each of us to respond.

Rukeyser once said that she wrote her biography of Willard Gibbs because it was a book she needed to read. We feel similarly about this collection. Having both worked for a significant period on the critical reassessment of Rukeyser's poetry, we know well the difficulties of building the foundation for such scholarship: locating and obtaining published considerations of her work; tracking down poets, colleagues, and friends for informal conversations about their impressions of and knowledge about the poet. It is our greatest hope that this collection will further enhance the

growing interest in the life and writing of Muriel Rukeyser—that it will support new scholarship, new poems, new thinking about her significance within the evolution of American poetry. May the conversation continue.

◆

A note about citations: Page references for books of Rukeyser's poetry and prose have been abbreviated throughout the text. The abbreviations are as follows:

CP: *The Collected Poems*
RR: *A Muriel Rukeyser Reader*
OS: *Out of Silence*
LP: *The Life of Poetry*

Part I

◇◇◇◇◇◇◇◇◇

Poetics and Vision

Jane Cooper

◇◇◇◇◇◇◇◇◇

"And Everything a Witness of the Buried Life"

This essay, in slightly different form, was first presented as a talk before the Poetry Society of America in October 1987. Since at the heart of it lay my frustration at how little of Muriel Rukeyser's work was then available to students and others, I have not attempted to change the paragraph on anthologies. Nor have I wanted to impose a "written" on what was fundamentally a "spoken" tone.

Fortunately for us all, in the intervening years many more anthologies have opened their pages to Rukeyser (including the latest Norton Anthology of Modern Poetry*), and any student now has readily at hand* A Muriel Rukeyser Reader, *selections of both poetry and prose chosen and introduced by Jan Heller Levi;* Out of Silence: Selected Poems, *edited by Kate Daniels; and reissues of* Willard Gibbs, The Life of Poetry, *and* The Orgy. *A new edition of* The Collected Poems *is promised soon.*

My thanks to the Poetry Society for permission to reprint these remarks.

It's very hard for me to begin talking about Muriel Rukeyser, because I never know where to end. First of all she was my friend for over 25 years—a fact that never ceases to amaze me. It amazes me because we were so unlike, and our work is so unlike—but then, after all, the deepest friends are the ones who have the power to change you, and out of our differences, I was certainly changed by Muriel.

Even before I knew her personally, she was a presence in my life; this happened very early. Muriel would often ask, at a reading or the beginning

of a workshop or on some similar occasion, "How old were you when you first knew there were living poets?"—in other words, when you first knew there weren't just printed poems locked up in a book by somebody certifiably dead? I first read some poems by Muriel when I was 13 or 14, and she was no more than 25, and in this way she was one of my first living poets, if not the very first. The thought that there was this young woman alive out there in the world writing poems, and that it was her business, became a very fiery thought for me at that time. Later, I came to believe that hers is one of the truly significant voices of this century in America, one of the significant female voices, right at the heart of various meanings of her, and our, generations.

She is at the same time in many ways still an unknown writer.

A couple of weeks ago I was talking to the writer Esther Broner on the phone and I said, "I have to give this talk on Muriel Rukeyser, what shall I say?" and she said, "Talk about how to make her more accessible," or perhaps it was, "Try to make her work more accessible."

I know from teaching that this is no easy task. First of all, there is so much of it. Muriel wrote some dozen or 15 books of poems—depending on how you count them; she did notable translations of Octavio Paz and others; she wrote children's books, plays, screenplays, a prose journal/fantasia based on Ireland's Puck Fair that has been called a novel, a book of theory and criticism titled *The Life of Poetry;* and then there are the three extraordinary prose "Lives," two of world-class scientists, Willard Gibbs and Thomas Hariot, the third of a political imaginer, Wendell Willkie.

And if you love her work—and have patience—you find that everything is somehow interdependent. In fact, at the beginning, just one poem, or two poems, may not seem so striking as they later turn out to be once the grand outlines of her achievement are revealed. She is both grandly substantial and determinedly—I think I must say determinedly—evasive. Just when you are sure you understand her, she slips away. Certainly she is hard to anthologize—yet it makes me sad to see how many editors have apparently simply written her off. Two of the landmark feminist anthologies of the 70s have titles taken from her work—*No More Masks!* and *The World Split Open*—and the recent *Norton Anthology of Literature by Women* contains an excellent selection of poems. But this year's *Faber Book of 20th Century Women's Poetry* includes only two Rukeyser entries. And when in preparation for this talk the Poetry Society tried to get more copies of her *Collected Poems* to sell, they were told McGraw-Hill had let it go out of print, after only five years in paperback. In several of the big teaching anthologies, notably the *Norton Anthology of Modern Poetry,* she isn't listed at all.

This kind of very spotty recognition was a problem all through her lifetime, and obviously, it still is. Somehow I'm reminded of that fine curse poem of Muriel's called "What Do We See?" which points out all the contradictions around us and includes the line "Cadenza for the reader," where you're allowed to insert your own curse. So I leave a little pause here where we can all register our particular responses concerning blindness and injustice.

To get back to her scope:

Here are some of the things she cared about and was trained in or had read widely in or was experienced in: She cared enormously about history, especially American history. What is the particular nature of the American imagination?—that would always have been one of her questions. Even Thomas Hariot, the English Renaissance navigator, mathematician, and astronomer who had the telescope as early as Galileo and made a credible moon map, was seen as one of us, a forerunner, because in *A Brief and True Report* he wrote sympathetically and accurately of Raleigh's Virginia, its native people and extraordinary flora and fauna.

She was well read in anthropology and had studied with or knew Franz Boas, about whom she always meant to write. She was at the same time deeply versed in Jungian psychology and the study of comparative mythologies.

She used to say she didn't know how she got into Vassar, where she spent two joyous years before her father's bankruptcy (real or faked) forced her to withdraw, because in school she had flunked everything but English and math. I don't honestly believe that, but her emphasis on English and math points to her passionately held conviction that there is no such thing as C. P. Snow's "two cultures." The imagination of the great mathematician or scientist was, for her, no different in kind from the imagination of the great poet. Both had before them the challenge of the unknown, the unknown as a component of experience, and after moving from the purely present to the only dreamed of, both had the challenge of bringing together experience and vision. Science and poetry: two modes of discovering, two ways of coming to speech—that, I take it, would have been her thought. She said in her biography of Willard Gibbs, America's "father of physical chemistry," that the "great wish" of the great is "to discover, to make known, to find a language for discovery." And she loved the story of how Gibbs stood up and said very quietly in a Yale faculty meeting—the only time anyone remembered him *ever* to have spoken in a faculty meeting—"Mathematics *is* a language."

Muriel was not, I suppose, a scholar or historian of science in any of several accepted senses, but anyone who doubts her grasp of such matters should have watched her poring, day after day, over the microfilms of Hariot's manuscripts,

in their Elizabethan script, in which equations jostled charts of the constellations, broken words and phrases, even an occasional poem. This was after her first stroke, which felled her for most of a year when she was only 50, and somehow it seems important to mention that the apartment she lived in then looked over the American Museum of Natural History, from the Planetarium side. Even on days of peak frustration with Hariot, she always seemed perfectly confident of her ability to navigate among those cloudy pages.

Then consider her love of technology. She was crazy about gadgets, about mechanical toys and games. She was also a marvelous driver. I've spoken before of how driving out to Sarah Lawrence with her, in Monica McCall's zippy little Lancia, which I used to call her common-law car, was like driving with a centaur. She really was a part of that machine. And Sharon Olds has described how Muriel said, after a later and truly incapacitating stroke, "I used to dream sex and bread, but now I dream driving." She had learned to pilot a plane quite early, and I wish I could have flown with her. In one of her last summers, she was designing exhibits for the Exploratorium, San Francisco's museum of science and perception, and I hope at least some of those exhibits have been built.

Biography. Autobiography. Both were important to her. She cared very much about what she called "exemplary lives." And lives became exemplary for her not only because of the qualities of discovery and articulation they embodied but because she would feel, in whatever field, that somehow the full meaning of the life was not appreciated; the person, or the achievement, had gotten lost. Besides the three prose biographies, all of lost or partially obscured men, she also wrote a series of longer poems called by her simply "The Lives," which continues through book after book. She used to speak of the wave-motion of an exemplary life, how there would be a shooting forward, then a lull or defeat, then another burst of energy or revelation. Of her own life she would always say, "First a no, then a yes." Pause. Then: "It was all like that." She wanted, always, a graph of transformations, of transformative powers. Speaking of the prose biographies to a *New York Quarterly* interviewer, in the early 70s, she said, "I haven't been particularly interested in doing anything where the work had already been done."

Autobiography. Biography. She wrote a lot about herself, but not exactly as others seem to have done. I would say she used herself as a sort of laboratory, her experience as the field for exploration. In the Preface to *The Collected Poems* she wrote: "Here are . . . two kinds of reaching in poetry, one based on the document, the evidence itself; the other kind informed by the unverifiable fact, as in sex, dream, the parts of life in which we dive deep and sometimes—with strength of expression and skill and luck—reach that place

where things are shared and we all recognize the secrets." She wrote of her own pregnancy in "Nine Poems for the unborn child" at a time when such matters were simply not breathed in poetry. She wrote of accepting her sexuality and the parts of ourselves we ordinarily despise or flush away. For instance, one late poem, called "Despisals," runs in part:

> In the human cities, never again to
> despise the backside of the city, the ghetto,
> .
> In the body's ghetto
> never to go despising the asshole
> nor the useful shit that is our clean clue
> to what we need. Never to despise
> the clitoris in her least speech. (*RR* 246–47)

and ends "Not to despise the *it* . . . to know that I am it," which shocked a lot of readers and hearers. But she used to say that in some cases the poems that had seemed the most private, perhaps too private ever to print, became the ones that people took to heart, that in the long run they told her they shared in most deeply.

"To discover, to make known, to find a language for discovery."
 It wasn't only using the inner self as text that was important to her. Muriel believed in the test of the spirit through action; she was adventurous, risky, passionate, foolhardy. She wanted to be *there*. One way of witnessing was to write. Another was to put her body on the line, literally. She was, almost from the first, deeply committed to the cause of social justice. At 20, she drove to Alabama to be present at the trial of the so-called Scottsboro "boys." Her second book contained a long muckraking series of poems on miners—tunnel-builders, really—who were dying of silicosis in Gauley Bridge, West Virginia, because of appalling working conditions. She came back again and again, in conversation and in her writing, to the experience of leaving Spain, leaving Barcelona, just after the Spanish Civil War broke out in 1936 and it looked, for a moment, as though the Loyalists had won. She wrote always about war and violence, our twentieth-century continuum, and about peace—not as a vacuum, the absence of war, but as a possible city of the future. When she was already seriously ill, after several strokes, lame, with diabetes, her eyes none too good, she went to jail for protesting the Vietnam War—she lay down on the marble floor before the Senate chamber—and in 1975, as president of American PEN, she

stood all day outside the South Korean jail where the poet Kim Chi Ha was kept in solitary and seemed to be dying. Earlier, flying to Hanoi, she had written:

> The conviction that what is meant by the unconscious is the same as what is meant by history. The collective unconscious is the living history brought to the present in consciousness, waking or sleeping. The personal "unconscious" is the personal history. This is an identity.
> We will now explore further ways of reaching our lives, the new world. (*RR* 249–50)

(Somehow this puts, for me, Donne's "O my America, my new-found land" in a startling perspective. Donne, of course, was addressing his mistress.)

As a young woman, she seems to have been a kind of meteor. And she did have some early, genuine recognition. Why not? Think of four books of poems, along with the stunning biography of Gibbs, all written by the time she turned 30. And the climate of opinion—the open if desperate 1930s—was somehow right for her, right for her political sympathies and helping to shape them, right for her long, thrusting, experimental lines. I've spoken before of how, toward the end of World War II or just after, nevertheless her world seemed to close in. Except for her son's birth in 1947, nothing went very well. Jobs were harder to come by; she wrote less. What was that all about? Perhaps the reasons are not so hard to seek. She was a single mother when there were few acknowledged ones around. It was the McCarthy era, and ideologically she was by now extremely suspect. (In the end, her FBI file came to over 100 pages, most of them blacked out.) In poetry the New Critics reigned, so that the model poem held up for us to emulate—those of us who were just beginning to write—was tightly formal, ironic, packed with ambiguities, and too often self-enclosed. *The Green Wave,* published in 1948, which contained the pregnancy poems, met with some searing reviews, notably one by Randall Jarrell. It was only with the publication of *Waterlily Fire,* a selected poems, in 1962 that the critical ethos started to relent. Two years later, with her first stroke, her health began to decline. The irony can't have been lost on her. First a no, then a yes—but then? Still, as the 60s went along, Muriel found herself increasingly a hero to the young, rediscovered by them both politically and as a seminal artist. The civil rights movement and the women's movement both reconfirmed her vision, as did protests against the Vietnam War. And while words probably never again came so easily, she was writing a lot, and the poems have

a new firmness and clarity, a saving humor. She was determined to strip off the masks.

There is no way to write, or talk, about Muriel Rukeyser or her work in any linear way, and this may be, finally, the hardest thing to get our minds around. She herself said (again, this is from *Willard Gibbs*): "For our time depends, not on single points of knowledge, but on clusters and combinations." She even wrote in clusters. Anyone who knew her will remember those tiny notebooks, found at the very bottom of her huge sloppy handbags, where in her precise, elegant handwriting she jotted down ideas, phrases, the right or at least the suggestive word—a kind of shorthand. At the very end of her life, she told those of us who were around that the title of her next book was going to be *Findings* and said, with satisfaction, "Now that's what I call poetry." She saw the writer as one who would always be in readiness to receive, in readiness to respond. Poems, she said, were meeting-places, especially the longer ones. The trick was to be ready for the unknown. This meant loving the unfinished, being willing not to control the poem but respecting its inner life until it could find its own way and time to come into being. I remember that when she taught at Sarah Lawrence she used to ask seniors to start a piece of work they could not possibly finish before graduation. Then they would have to go on writing, because of the nagging magnetism, the fix of the unknown or incomplete.

In the Preface to *The Collected Poems* she said: "Here you have a book that is like a film strip of a life in poetry: like the idea in Asia of the long body. . . ." All the phases of one person, all her transformations. She also said, "It isn't that one brings life together—it's that one will not allow it to be torn apart."

You must be wondering just where this talk is going. I've been trying to show some of the obstacles Muriel herself put in the way of her being easily known or apprehended. The work is all of a piece. There is a lot of it. It occurs in different modes, so you can't just read the poems. And it can't be divided from her life in time. It has that peculiar integrity, that wholeness. For me, hers was, and is, an exemplary life, which like her silence—to use her own phrase—"goes on speaking."

Now, what is the characteristic shape of a Rukeyser poem, if indeed there is any such animal as a "characteristic"? What is that shape? And in what ways are we still unprepared for it?

I used to tell students, when they were starting to read Rukeyser for the first time and feeling bewildered, to think of how films are put together. And I would cite the fact that Muriel was trained as a film editor, and as a young woman worked occasionally as a film cutter, as hav-

ing been useful to her own understanding of poetic form. In film, we all know how there will be a leap of association from one visual image to the next. How the camera will move in close, then appear to swerve away. How an image is rarely finished, but the director and editors organize instead for speed and surprise. I've found that when people first read her work they often think it blurs or is sloppy, because they want the images—specifically, it seems to be the images—to be more complete; they want that speed of imagination to hold still. But if you say "film" to them, it can help. However, the more I've studied the early work, in recent years, the more I've felt that Muriel's method anticipated film, or at least her own experience in film. Here is the beginning of the very first poem in her first book, "Poem out of Childhood." Listen to the frames, as it were—the transformations:

Breathe-in experience, breathe-out poetry :
Not Angles, angels : and the magnificent past
shot deep illuminations into high-school.
I opened the door into the concert-hall
and a rush of triumphant violins answered me
while the syphilitic woman turned her mouldered face
intruding upon Brahms. Suddenly, in an accident
the girl's brother was killed, but her father had just died :
she stood against the wall, leaning her cheek,
dumbly her arms fell, "What will become of me?" and
I went into the corridor for a drink of water. (*RR* 5)

Now think back to the quotation I've already cited from the Gibbs book: "For our time depends, not on single points of knowledge, but on clusters and combinations."

And here is a quotation from the opening pages of *The Life of Poetry*, lectures that grew out of the crisis, for a creative mind, of World War II and that explore poetry's healing nature:

I have attempted to suggest a dynamics of poetry, showing that a poem is not its words or its images, any more than a symphony is its notes or a river its drops of water. Poetry depends on the moving relations within itself. It is an art that lives in time, expressing and evoking the moving relation between the individual consciousness and the world. The work that a poem does is a transfer of human energy, and I think human energy may be defined as consciousness, the capacity to make change in existing conditions. It appears to me that to accept poetry in these meanings would make it possible for people

to use it as an 'exercise,' an enjoyment of the possibility of dealing with the meanings in the world and in their lives. (*LP* xi)

And here, in juxtaposition—over a gap of 20-odd years—is another quotation from the *New York Quarterly* interview: The interviewer, referring to the poem about Akiba, the ancient Jewish hero/martyr from whom Muriel's mother told her they were descended, asks: "Do any of the other poems in your *Lives* have a personal connection? What was the common denominator of the people you have written about? There was a composer, an artist, a painter, a physicist, an anthropologist. Was there anything that drew you to these particular people?" And she answers:

> I think it had something to do with what we were talking about before. The structure of a life being an art form. About the ways of getting past impossibilities by changing phase. The reason I think that I came to do Gibbs was that I needed a language of transformation. I needed a language of a changing phase for the poem. And I needed a language that was not static, that did not see life as a series of points, but more as a language of water, and the things are in all these lives that I try to see in poems. Moving past one phase of one's own life—transformation, and moving past impossibilities. Things seen as impossibilities at the moment . . . It seems to me that the language of poetry is the best way . . . More like transformation than anything that I know. That meaning is a religious meaning. And a very common plain one too. (Packard 130–31)

Finally, here are some lines from the last section of "Käthe Kollwitz," which was one of the last of her "Lives":

> Self-Portrait
>
> Mouth looking directly at you
> eyes in their inwardness looking
> directly at you
> half light half darkness
> woman, strong, German, young artist
> flows into
> wide sensual mouth meditating
> .
> eyes shadowed with brave hand
> looking deep at you
> flows into
> wounded brave mouth
> grieving and hooded eyes

alive, German, in her first War
. .
flows into
"Seedcorn must not be ground"
and the grooved cheek
lips drawn fine
the down-drawn grief
face of our age
flows into
Pieta, mother and
.
one more war
flows into
face almost obliterated
hand over the mouth forever
hand over one eye now
the other great eye
closed (*RR* 218–19)

"I needed a language that was not static, that did not see life as a series of points, but more as a language of water. . . ." Always her method was one of fade and dissolve, repetition, reincarnation. The aim was speed as well as complexity of perception. But since character (or any other "moment of truth") must always be reborn out of the heart of change, the "Lives" are all, of necessity, longer poems.

Which brings me to one last thing I want to say about the work, one last hurdle it presents, perhaps. I've been trying to suggest Muriel's ambitiousness—that quality women are supposed, classically, to be or do without. The breadth of her interests and sources: the physical sciences, history (which in her case included biography), psychology (which included autobiography), anthropology, myth, warfare, peace-fare, poetry. . . . (In a very early poem she wrote, "*think:* poems fixed this landscape: Blake, Donne, Keats," which I find quite delicious.) And then there is the resonance of her life through time, the way it developed vertically, if you can say that, the ribbon of it. She was also magnificently ambitious in that she wasn't content to be a lyric poet. She was a lyric poet, of course, who wrote at all ages beautiful and suggestive and moving and witty short poems and songs. But she also had the sweep of imagination that leads to epic, to the desire to make epic—an epic consciousness. Sometimes I've found people who on first reading her can't stand the fact that she will say "we" instead of "I"—this is particularly true in the early and middle books. Sometimes it feels to them like populist sen-

timentality. And sometimes I agree. But at best it seems to me that the urge to write the long poem or sequence, which she always had, is the urge not only to construct a system (again, the word is Gibbs's, but I use it here in a simplified way to distinguish a field poem from a more linear or logically reasoned one) but to speak for one's community, to say "we." An epic, to my way of thinking, is not just a poem including history, as Pound called it, but an effort to put a community on paper. Since Americans traditionally have had a hard time with community, this is a large challenge for an American poet. But one can never understand Muriel's work fully unless one deals head-on with the fact that in every major book there is at least one major, large-scale, longer poem, usually a poem in parts, and quite often there is more than one. And if anyone should ask me which of these to read—since they are meeting-places where the Rukeyser method is most clear—I'd suggest, besides "Käthe Kollwitz," "The Book of the Dead," "Ajanta," "Waterlily Fire," and at least one of the title poems from the last three books, "The Speed of Darkness," "Breaking Open," or "The Gates," preferably all three.

Before ending, since I'm speaking as a friend, and not just a critic, or a teacher, or even a poet speaking about another poet whose words she loves and has learned from, I would like to tell you a couple of stories. Because what worries me is that I may have woven this quite complicated web and yet left you without a sense of Muriel's real power and mystery, her enormous, fitful charm, her angers, her generosity, and her humor. I could tell some funny stories; she was a very funny woman. But instead I've decided that I'd like to tell two stories that, if they were poems, would be poems of unverifiable fact. Both concern Muriel's death, but they are not sad. Strange, rather. And the intimacy of them seems to me what I finally owe her. To speak out of an unexpected intimacy.

In the second week of February, 1980, I was at the University of Cincinnati giving a reading and a workshop for the graduate students there. And after my reading a young man came forward, a composer, who told me he wanted to write an antiwar cantata and asked if I could suggest any poems for him to set. So I suggested poems by various people, and then I said, "Of course there are marvelous poems by Muriel Rukeyser." "Rukeyser?" he said, and it turned out he had never heard of her. So I told him to find me after the workshop next day and I'd give him some titles.

Fortunately, the workshop was scheduled for the Elliston Poetry Room of the University Library, where they try to collect all the significant books of poems that come out in any year; the room is open for students to browse

in, and many of the volumes are signed. After class the young man reappeared, saying more urgently, "Now, Rukeyser?" and together we went to the shelves marked "R." There were all Muriel's books of poems, all the separate books, shining in their different colored jackets, and I took down the whole row of them, leaving only the black *Collected Poems,* because she didn't care for that one very much; she always said it was so big it was good for nothing but a doorstop. And together we began to read. And as we read I thought, "As soon as I get home I'm going to call Muriel to tell her about this." And I kept thinking how instead of "teaching" she used to like the phrase "reading poems with people." She was, however, very ill at the time, and as I walked through the door of my New York apartment the phone was ringing, and it was Liz Rukeyser, Muriel's cousin, to tell me of her death. Afterward I found out that she had died at 3:15 on February 12, which was exactly when that unknown young man and I were opening her books to look at all the peace poems.

I told you these are stories of unverifiable fact.

The second dates from a few weeks later. Not long after Muriel's death, Bill Rukeyser, her son, who was in New York going through her things, brought me an incomparable present. Some of you, I'm sure, will remember how, after Muriel went to South Korea in 1975 and stood outside the prison where Kim Chi Ha was locked in solitary, Kim Chi Ha's mother and wife gave her a rich red quilt embroidered all over with brightly colored flowers. It was this quilt that Bill brought me, and I burst into tears "and other things," as Muriel would have said. That same night I slept under the quilt, and I dreamed Muriel had come to stay with me. She had a different though still familiar face, but I knew it was Muriel because she was smiling her great smile and standing with her shoulders thrown back, in magnificent carriage, just as Muriel used to stand in health. And with her was a serious young girl of 11 or 13, just on the edge of puberty. Apparently they had just waked up, and I felt very happy, very honored, to have them in my house. But then I grew anxious, the way we do in dreams as in wakeful life. Had I remembered to clean? And sure enough, there on the floor between us lay a little pile of dust or shit or sweepings, and my friend who was Muriel smiled her great smile, as if she had found me out, but benevolently, and said, "You see, there is still a bit of work for me to do."

Jane Cooper

◇◇◇◇◇◇◇◇◇

The Calling

All the voices of the sea called *Muriel!*
Muriel from the Irish *Muirgheal,* meaning
muir, sea, plus *gel,* bright, or in Old English
pure, clean, from the Greek for eyeball

> You who equated *women, ships, lost voices,*
> who lost your speech, then your clear vision,
> who loved flying, sailing, drove a fast car
> with the calm of a centaur, lost your gangrenous toe

from *mori,* body of water, root of Old English *mere,*
a pond or possibly mermaid

> You whose erect carriage was like a figurehead's,
> who lay down outside the Senate, stood by the Korean jail,
> dropped once at a reading of Smart's "Rejoice in the Lamb"
> like a tree felled in the church

whence our cognates *cormorant,*

ultramarine
> Now I perceive what the calling is
> here by this estuary,
> I a year younger than you were when you died

> Body of brightness! I trace your undulant tones
> tossed on a clearing wind

whose last, next book was to be FINDINGS
whose magnified eye stares out past Hariot's trail,
who crossed out *to,* wrote *from*

I a lost voice
moving, calling you
on the edge of the moment that is now the center.
~~To~~ From the open sea

Meg Schoerke

"Forever Broken and Made": *Muriel Rukeyser's Theory of Form*

In a literary climate characterized across much of the twentieth century by division over the question of poetic form, with poets segregating themselves into opposing camps to advocate either traditional form or free verse, Muriel Rukeyser distinguished herself, in both her writings on poetry and her practice, by countering such entrenchment. Equally comfortable writing in free verse or in forms such as the sonnet, the ballad, and blank verse, Rukeyser sought a poetics of relationship and process, "a poetry of meeting-places, where the false barriers go down" (*LP* 20). Throughout her career, she unflinchingly exposed power imbalances that establish and perpetuate barriers; she also envisioned the possibilities of "breaking open" the barriers through concerted movement and forging "relating forces[,] . . . [t]he forces, that is, that love to make and perceive relationships and cause them to grow" (*LP* 20). For Rukeyser, formal poetry offered a dynamic means of connecting diverse emotions and ideas through images and sound patterns into an organic unity that resists static closure: a "gathering-together of elements so that they move together" (*LP* 19); free verse gave her an equally fertile ground for developing connections. But above all, Rukeyser's impulse toward breaking barriers led her to gather together poems in traditional forms *and* free verse in all of her collections, so that her books not only thematically explore but technically embody the unity in multiplicity that, in her view, constitutes freedom.

Rukeyser's poetics was so deeply embedded in her visionary politics that her meditations on politics not only reveal her unsentimental assessment of

American social realities, but also define her aesthetic. Thus, when in *The Life of Poetry* she emphasizes the potential power of social tensions, she implies as well that formal tensions—and tensions between various forms of poetry—connote health and, if allowed to move rather than to stagnate in fixed opposition, give rise to fluid, complex, plural freedoms:

> We need a background that will let us find ourselves and our poems, let us move in discovery. The tension between the parts of such a society is health; the tension here between the individual and the whole society is health. This state arrives when freedom is a moving goal, when we go beyond the forms to an organic structure which we can in conscience claim and use. Then the multiplicities sing, each in his own voice. Then we understand that there is not meaning, but meanings; not liberty, but liberties. And multiplicity is available to all. (211)

While, on the one hand, Rukeyser describes the volatile nature of American society and optimistically suggests that its parts can cohere yet still maintain integrity and vital difference, on the other hand, she also sums up her concept of poetry. For Rukeyser, "going beyond the forms" means not abandoning traditional forms, but creating "organic structures" such as sequences of poems, books of poetry, and even a radical confluence of different genres as in *One Life,* her book about Wendell Willkie, the 1940 Republican presidential candidate; the traditional forms, through the tensions and contradictions of their placement in a sequence, sing "each in [its] own voice," yet they also contribute to the multiplicity and motion of the work as a whole. In fact, Rukeyser's aesthetic is so unified that the same principle can be applied to her use of any "form," such as free verse or documentary prose. The "organic structure" of the whole depends upon the active tensions between different forms juxtaposed against each other and—to invoke an analogy between poetry and film that Rukeyser often adopted—from the jump-cuts she makes from form to form. Equally, in her late books Rukeyser not only moves between poems in different forms, as she does in her previous books, but she also develops a free verse that in many poems gains equilibrium through retaining a residual iambic pentameter norm: by quite literally "breaking open" the blank verse line into two or three lines that, taken together, scan as loose pentameter, she achieves a unity forged from contraries. Rukeyser's adaptations of both free verse and traditional forms, like the expansive "organic structures" of her poetry collections, gain energy through process, contradiction, and freedom of choice; she simultaneously breaks and makes forms. As she writes in "Hero Speech":

But the seeds of all things are the ways of choice, of the forms
Declaring the energy we breathe and man,
Breaking. Changing. Forever broken and made. (*CP* 409)

Louise Kertesz argues that Rukeyser's emphasis on a dialectical process
in which contrary forces gain power through tension and kinetic interac-
tion "is associated with Hegelian theory," an affinity that, she notes, crit-
ics such as M. L. Rosenthal trace to Rukeyser's reading of Marx (6–7).
Rukeyser's interest in the power of volatile contraries also developed from
her lifelong engagement with Blake's work. But her own dialectic, which
she succinctly articulated as a refrain line, "breaking and making," re-
peated throughout many of her books, derives most immediately from
Samuel Taylor Coleridge's definition of the secondary imagination that
"dissolves, diffuses, dissipates, in order to re-create; or where this process
is rendered impossible, yet still at all events it struggles to idealize and to
unify. It is essentially *vital,* even as all objects (*as* objects) are essentially
fixed and dead" (*Biographia Literaria,* 7, I: 304). Rukeyser's concern, not
only in her writings on poetry, but in her unconventional biographies,
Willard Gibbs, One Life, and *The Traces of Thomas Hariot,* with "the the-
ory of change and transformation, and the function of opposites in mak-
ing a new unity" (*Traces of Thomas Hariot* 74), and her stress on motion
and on the combining powers as the defining feature of the creative mind
(whether of poet, scientist, historian, or politician), all find their precedent
in Coleridge's work.

She acknowledges her debt to Coleridge through the titles of two books,
explicitly in *One Life* and implicitly in *The Life of Poetry,* and, in *The Traces
of Thomas Hariot,* she reveals her source as Coleridge's "crucial letter to
Sotheby" (228), in which he argues:

At best, [Greek poetry displays] but Fancy, or the aggregating Faculty of the
mind—not *Imagination,* or the *modifying,* and *co-adunating* Faculty. This the
Hebrew Poets appear to me to have possessed beyond all others—& next to
them the English. In the Hebrew Poets each Thing has a Life of it's [sic] own,
& yet they are all one Life. In God they move & live, & *have* their Being—
not *had,* as the cold System of Newtonian Theology represents / but *have.* (*Se-
lected Letters* 115)

Although in *The Traces of Thomas Hariot* Rukeyser quotes only the last three
sentences of this passage, she accords with Coleridge's concept of the imag-
ination, for the dynamic tension between the differentiated "life of its own"

and the shared "one life" illuminates her vision of a unity sustained by diversity. In particular, Coleridge's transposition of the biblical phrase from "live and move" to "move and live" in order to emphasize that the vitality of the imagination derives from its activity reflects an attitude Rukeyser shared. At the conclusion of Chapter 14 of *Biographia Literaria*, Coleridge stresses that "motion [is] its [poetic genius'] life" (7, II: 18), and in Chapter 18, in his discussion of meter, he alludes to Ezekiel's vision of the wheels to describe how emotion impels poetry: "the wheels take fire from the mere rapidity of their motion" (7, II: 72). Rukeyser, in her poetry and prose, again and again makes the same connections. She offers her tersest equation in her brief poem "The Sixth Night: Waking": "That first green night of their dreaming, asleep beneath the Tree, / God said, 'Let meanings move,' and there was poetry" (*CP* 416). Here, working from "move," Rukeyser emphasizes process, multiplicity of meanings, poetry's capacity to inspire change, and poetry's emotional force, a crucial element of her—and Coleridge's— notion of poetic form. Since for her, as for Coleridge, motion is the life of poetry, the titles to many of her poetry collections invoke motion: *Theory of Flight, U.S. 1, A Turning Wind, The Green Wave, The Speed of Darkness,* and *Breaking Open.*

When adopting Coleridge's "one life" as the title to her book on Wendell Willkie, however, she chooses as her epigraph not the sentences she quotes in *The Traces of Thomas Hariot,* but an earlier passage from the same letter to Sotheby: "everything has a life of its own . . . we are all one life." Her preference here for "we" over "they" suits her democratic goal of recognizing and healing the split between false oppositions and her portrayal of Willkie as an agent of change: "Power, ideas of power, and human gifts, our deep energies. The hero of this movement in our lives being process itself; in his own terms, Willkie becoming a hero of this process" (xii). A lawyer and power company executive who came to believe that business should not exploit communities, but develop responsible relationships with them, and who, after his defeat by Roosevelt in the 1940 presidential race, served as Roosevelt's emissary abroad and helped persuade the American people to abandon isolationism and come to the aid of the world community, Willkie became, in Rukeyser's view, a hero of process because of his ability to change. Throughout her career, Rukeyser consistently equates process with both power and freedom, and for her the "one life" of a community does not diminish individual identity as long as members of the community leave themselves open to transformation. She quotes a speech by Willkie: "Freedom is not just a set of laws. It is the ability of men to make these infinite combinations between one another, and be-

tween the communities in which they live. . . . And so we say to you: Bring us together" (136).

Rukeyser's faith in the power of process, moreover, shapes not only her politics but the "infinite combinations" of the forms she includes in her books. Thus the experimental form of *One Life* substantiates her ideal of a unified yet deeply pluralistic society, for the diverse forms—quotations from Willkie's speeches, fictionalized narratives of his life, dialogues between children and teachers, quotations from newspapers, transcriptions of Congressional hearings, and, of course, poetry in free verse and in traditional forms—retain their individuality but also cohere into the "one life," the community of the book as a whole. Although she depends upon the precedent set by John Dos Passos for her documentary techniques, by applying them to biography Rukeyser fuses the factual life with what she calls "the inward man" and reconfigures the genre entirely. She seeks movement, in other words, through infinite combinations and recombinations in which "form . . . is meaning and motion" (*One Life* 237).

Rukeyser's debt to Coleridge's ideals of "organic form" and "reconciliation of opposites" allies her with the New Critics, who developed their systems of "practical criticism" from Coleridgean principles. But Rukeyser staunchly opposed the New Critics, for she believed that they reduced a poem to a "Still Life," a static "object" divorced from emotion, history, politics, and the life of the poet (*LP* 174). The New Critics, in her view, rather than seeing the unifying commonalties between poetry and science, compete with scientists by differentiating and compartmentalizing the two, yet also reductively imitate the applied mathematical precision of scientific method in their analyses of poems:

> I have a high regard for some of the poets who are setting up these structures: dissecting poetry into ideas and things, and letting the life escape; or counting words as they might count the cells of a body; or setting the "impression" against the "scientific truth" in order to dismiss them both. But I cannot accept what they say[, for] . . . they are thinking in terms of static mechanics. . . .
>
> When Emerson said that language was fossil poetry, he was leading up to some of these contemporary verdicts. If we can think of language as it is, as we use it—as a process, in which motion and relationship are always present—as a river in whose watercourse the old poetry and old science are both continually as countless pebbles and stones and boulders rolled, recognized in their effect on the color and the currents of the stream—we will be closer. To think of language as earth containing fossils immediately sets the mind, directs it to rigid consequences. The critics of the "New" group, going on from there, see poetry itself as fossil poetry. (*LP* 166–67)

Characteristically, Rukeyser counters the New Critics' "static mechanics" with a metaphor for process: language as a river whose motion shapes both poetry and science and brings them together into one stream. Her analogy, moreover, is essentially Romantic, for it recalls Coleridge's sacred river Alph, Shelley's River Arve, and the rivers that wind through Wordsworth's *The Prelude*—all symbols for process, power, thought, and poetry. Rukeyser therefore implies that, through their obsession with analytical dissection, their severing of poetry from process and relationship, the New Critics calcify their Romantic models in favor of a superficial, and reductively formulaic, application of scientific method.

Rather than dryly appropriate scientific analysis, Rukeyser favored the discovery of correspondences between poetry and science to combat the rigidifying tendency toward specialization that, she believed, raises false barriers between disciplines and impedes liberty. In *Willard Gibbs,* her biography of the nineteenth-century American physical chemist, she celebrates

> . . . the need for new unities! When one perceives that the liberty of the human being extends in all directions, and on every side discovers laws that define that liberty, one discloses only a margin of the possibilities. The freezing of the forms is unworthy of science, as the imaginary forms that fail to project life are unworthy of art. The schools are adept at fostering both of these; each has its jealousies, and makes them vocal. But there are relationships, and the point at which they are found is the dignity of the human spirit. (81)

Rukeyser understood "form"—whether in the sciences or the arts—primarily as a means of fostering relationships that gain power through growth and movement. In her view, "the forms of imagination" are neither separate nor exclusive (*LP* 160), and she therefore opposes dualistic thinking and champions "pilgrim[s] of the joined life" (*TTH* 268)—such as Gibbs and Willkie—who broke through barriers between disciplines or within their own disciplines and made transformation possible through envisioning new combinations. Equally, the methods Rukeyser borrows from science are conceptual, rather than formulaic; she cultivates "new arrangement[s]" that lead to "new perception[s]" (*TTH* 229), and she stresses that in both poetry and science "the arrangement is the life" (*LP* 167).

In articulating her concept of "organic form," she therefore looks not only to Coleridge, but also to the biologist D'Arcy Wentworth Thompson, who, in his *On Growth and Form,* analyzes "form in its dynamical relations: we rise from the conception of form to an understanding of the forces which

give rise to it" (1027). Thompson argues that, however much organic forms develop through growth and movement, they are nonetheless variations of their earliest configurations; despite the asymmetries they may have acquired during the growth process, all organic forms can still be classified as one or a combination of prototypical forms such as the sphere, parabola, and ellipse. Thompson, like Rukeyser, sees form as a process, "a function of time" (*LP* 171). The "organic forms" of Rukeyser's poetry, therefore, can be thought of in terms of process—as a means of growth and movement, both in the development of a particular poem over time and in the development of her career—but are always variations on traditional elements of poetry such as meter and rhyme. Rukeyser, in other words, aims not to abandon tradition, but to break *and* make it: to reconfigure tradition so that elements of a poem are the same as the elements of past poems (whether her own poems, or poems by predecessor poets), and yet not the same.

Of course, most poets share this objective. In his discussion of meter in *Biographia*, for example, Coleridge notes, "the composition of a poem is among the *imitative* arts; and that imitation, as opposed to copying, consists either in the interfusion of the SAME throughout the radically DIFFERENT, or of the different throughout a base radically the same" (7, II: 72). Although twentieth-century American poets have experimented widely with form, Rukeyser's experiments are notable for their interfusion of radical sameness with radical difference—and for her radical independence. She favored a very loose iambic pentameter line and took great liberties with traditional forms such as the sonnet and particularly with rhyme. As Kate Daniels remarks, "throughout her career, she drove critics wild with her eclectic revisions of received forms" (*Out of Silence* xiv); critics on both the left and right found fault with her forms and often suggested that her politics were to blame. During the 1930s, her adaptations of traditional forms, along with her deployment of Modernist collage and rapid juxtapositions, led some leftist critics to declare that Rukeyser's poetry was both politically and prosodically flawed. Reviewing *U.S. 1* for the *Partisan Review,* John Wheelwright insists that she had "assimilated [bourgeois] prosodic taste and social philosophy" and concludes that "revolutionary writing in the snob style does not reach a proper audience" (54, 56). She was also faulted for "obscurity" (Rolfe 39), "formlessness" (Burnshaw 49), and "harshness" and lack of melody (Hicks 386). Seconding Hicks's criticism in a *New Masses* forum on Horace Gregory's 1937 anthology, *New Letters in America,* Rolfe Humphries implicitly indicts Rukeyser as one of "too many revolutionary poets [who] are politically sound in their politics, but politically unsound in their poetry; that is to say, they are still Bohemians, or, at best, anarchists, who consider themselves superior to prosodic

discipline" (Humphries 405). Similar complaints were voiced during the heyday of the New Criticism: Rukeyser was accused of having "no restraint" (Bishop 56); her verse was called "haphazard" and her technique "faulty" (Millspaugh 360), her form too "elastic" (Salomon 54), and "her metres . . . substantially amorphous: they are either inadvertent or an afterthought" (Blackmur 346). Like her leftist opponents, such critics often attributed her "deviant" form to her "deviant" politics: specifically, to her vision of a socially responsive poetry. Surveying her career in 1942, John Malcolm Brinnin argues that her development reveals what he considers the essential dilemma of political poetry, an impasse arising from irreconcilable contraries: "Here [in "A Flashing Cliff" from *U.S. 1]* Miss Rukeyser comes to the crux of the problem of the social poet: whether to insist on first premises, even though that means a static repetition of familiar ideology, or to exercise full imagination and the resources of language in an endeavor to contribute a new dimension to poetry, though that attempt, in its inevitable intellectual concentration, must deny the social audience" (567–68). Rukeyser, in effect, was suspect among the leftist literati of the 1930s for her radical sameness—what they termed her bourgeois prosody and Modernist obscurity; yet she was equally suspect among the New Critics because her formal poetry was too experimental—for her radical difference.

Now certainly, not all of Rukeyser's experiments were successful. Her *Collected Poems* displays great unevenness; as Suzanne Gardinier notes, "some [of her poetry] is bad (she is not afraid of that)" (30). Rukeyser's devotion to process led her to publish gropings alongside achieved poems, because for her the search itself, as a means of resisting stasis, was as important as the result. In the biographies, she meditates frequently on her subjects' mistakes and associates defeat with renewal; her obsession with unsung innovators who strove to realize their visions in the face of opposition, misunderstanding, and their own crucial swervings reflects her own situation. Describing the young Willkie's parachute jump, for example, she champions the need to fall: "Begun again, I praise / The fall for being sure, / May I fall whole and perceiving / On the arisen shore" (*One Life* 31). Rather than rest easy in a secure position, Willkie risks taking the plunge—and hopes to fall into knowledge. In *Willard Gibbs,* she offers a description of the creative process that helps to account for her falls—her fluctuations and intermittent diffuseness—as well as her attitude toward form:

> Creation is a delicate and experimental thing. The process of combining depends on experimentation. Knowledge and effective action here become one gesture; the gesture of understanding the world and changing it.

This combined power does not call for a knowledge of types alone, but for a search among deviations. The expression of turning-points, of new groupings and rhythms observed for the first time, leads to new analogies, new holy families. (82)

Rukeyser was constantly seeking "turning-points . . . new groupings and rhythms," and her experiments—being experiments—did not always work, yet, as provisional "gestures of understanding," they paved the way for her successes, the suddenness and freshness she achieves when the poems *do* cohere. The liberties she takes with form are her means of searching "among deviations" for "new groupings and rhythms."

For Rukeyser, form was always in flux, a resource she explored not only to reconceive traditional literary associations, as in her sonnet sequence "Nine Poems for the unborn child," but to remake, clarify, and question her own assumptions. Thus each new sonnet in the series reconfigures elements of the preceding sonnets, a practice that certainly derives from the traditional development of sonnet sequences, yet one that Rukeyser also contests through her tense balance between unpredictable rhyme schemes and a staving off of rhyme altogether. As she stresses in *The Traces of Thomas Hariot,* "the facts of history are the facts of the present, with the past acknowledged and alive" (62). "Nine Poems for the unborn child" acknowledges a fact of literary history: sonnet sequences, as love poems, were a means of charting the complexities of a relationship. But Rukeyser vitalizes the tradition not only through her formal deviations, but also through her radically different premise: an unmarried mother writes a sequence of love sonnets to her unborn child. As Gardinier remarks, "the sonnets . . . are not graceful" (43). Their roughness and provisionality approximate the difficult territory Rukeyser explores, one that is both the same and yet not the same as that of traditional sonnet sequences.

Whereas in her poems in traditional forms Rukeyser interfuses "the different through a base radically the same," in her free verse she sometimes does the reverse, by maintaining a residual, though characteristically loose, iambic pentameter norm to which she returns at intervals as the poem develops.[1] In the following lines from "Käthe Kollwitz," she both describes and enacts the process:

"The process is after all like music, 30
like the development of a piece of music.
The fugues come back and
 again and again

interweave.
A theme may seem to have been put aside, 35
but it keeps returning—
the same thing modulated,
somewhat changed in form.
Usually richer.
And it is very good that this is so." (*RR* 215) 40

Initially, Rukeyser seems to anchor the passage with two solid lines of iambic pentameter (lines 35 and 40), which serve as a ground bass for the freer modulations of the other lines. Yet those modulations, on close inspection, aren't as free as they at first appear, for the whole passage could easily fall into a liberal, often anapestic, pentameter:

> The process is after all like music,
> like the development of a piece of music.
> The fugues come back and again and again interweave.
> A theme may seem to have been put aside,
> but it keeps returning—the same thing modulated,
> somewhat changed in form. Usually richer.
> And it is very good that this is so.

Yet in the actual poem, through breaking up her lines, Rukeyser reconfigures her customary loose blank verse so that it is, quite literally, "the same thing modulated," yet only "*somewhat* changed in form," like a fugal inversion that is the same and not the same as the main theme. A strict prosodist would insist that the lines, because they scan as iambic pentameter, are not free verse. Other readers, particularly those who came of age during the shift to open forms in the 1960s and 70s, might attend only to Rukeyser's lineation, overlook the iambic pentameter norm, and therefore call the lines free verse.[2] Twentieth-century poets and critics have, in other words, tended to view traditional form and free verse as contraries. But Rukeyser, who believed that "it is the power to hold the contraries together that is the actual power, that will give us *magisterium*" (*TTH* 74), set out to write poetry that both is and is not in traditional form, and also is and is not in free verse. Thus, during the last phase of her career, "breaking open" traditional verse did not mean "breaking from" it, abandoning it entirely as many of her contemporaries did. Instead, alongside poems in free verse, she continued to include traditional verse in her books. She also developed forms that, while not entirely free, are also not entirely traditional, such as the last section of "Breaking Open," in which she

creates parallelism through maintaining three stresses in lines 1 and 3 and two stresses in lines 2 and 4, and also binds the quatrain through vowel rhymes between "moment" and "open" and the exact, though unconventionally positioned, rhyme between "waking" and "breaking":

> Then came I entire to this moment
> process and light
> to discover the country of our waking
> breaking open (*OS* 150)

As she emphasizes in the preceding section of the poem, "It [the process of transformation] is something like the breaking open of my youth / but unlike too" (*CP* 535)—the same and not the same.

The ability to explore such a paradox fuels Rukeyser's theory and practice of poetic form and also serves, for her, as the habit of mind that defines and links the innovators she admired most, who were capable, because of their flexibility, of making new discoveries. Committed to "end[ing] the oppositions" (*TTH* 248), she praises the Renaissance mathematician, philosopher, and cartographer Thomas Hariot for seeking "the place where the country of Est and the country of Non Est are seen to meet and be alive, as a door to a continually opening new world" (299). And she extols Gibbs for his ability to envision how components interrelate: because he derived laws such as the Phase Rule that predict the behavior of a system, he made new combinations possible. Like many of Hariot's experiments in mathematics, Gibbs's Phase Rule also depends upon the conjunction of "est" and "non est." In *Willard Gibbs,* she quotes his definition:

> In considering the different homogeneous bodies which can be formed out of any set of component substances, it will be convenient to have a term which shall refer solely to the composition and thermodynamic state of any such body without regard to its quantity or form. We may call such bodies as differ in composition or state different *phases* of the matter considered, regarding all bodies which differ only in quantity and form as different examples of the same phase. Phases which can exist together, the dividing surfaces being plane, in an equilibrium which does not depend upon passive resistances to change, we shall call *coexistent.* (237–38)

She then offers a simple analogy: "The most familiar example of a system containing several phases is ice water, which includes ice, water, and vapor—each with its bounding surface, and contained in a glass," and

concludes that the Phase Rule speaks not "of the processes by which equilibrium is created, but of the state itself, and the relationships within it. It is an instrument whose parts are relationships" (238). For Rukeyser, as for Gibbs, the relationships between the parts establish the integrity of the whole. The ice, water, and vapor are the same substance, yet are also not the same, since they have taken on different phases; those phases, however, compose a unified system, a whole that depends upon the relationships between the components and that, when not in a state of equilibrium, is active, for the ice melts into water and the water turns into vapor. Rukeyser saw in Gibbs's Phase Rule an analogy for poetry, for she emphasized that poetry also depends upon the relationships—the delicate equilibrium—between its parts; equally, she could envision the parts as changing phase. Rhyme, for example, could shift from a traditional pattern of perfect rhymes located at line ends to new groupings of interrelated sounds, as she suggests in a 1964 interview:

> People have asked me why I've rhymed so little and I think they've done this with poet after poet who rhymes very much and uses rhymes within the line and who works with the sounds as they climb. I work in a form which I call held rhyme, in which all the rhymes are modulations of one central sound and move toward a tonic, if you like, which is the last word of the poem. (134–35)

Here, "held rhyme" both is and is not rhyme, for it breaks away from perfect rhyme and predetermined patterns, yet, through "modulations," it reconfigures perfect rhyme; it is the same "substance" but has taken on a different "phase." Nevertheless, it achieves equilibrium through interacting with other components of a poem. Like the system of ice, water, and vapor in a glass, the poem is, for Rukeyser, a system in which energy is exchanged between the components, and that exchange also makes possible shifts of phase—transformations—of the components.

But Rukeyser, unlike the New Critics, does not see a poem as a closed system, for she also includes both poet and reader in her equation. And the transformations, or changes of phase, that she envisions may inspire the reader to change both herself and "existing conditions": "Exchange is creation. In poetry, the exchange is one of energy. Human energy is transferred, and from the poem it reaches the reader. Human energy, which is consciousness, the capacity to produce change in existing conditions" (*LP* 173). The poet transfers her energy to the poem, and the poem's energy may spark individual and social change. Moreover, because she views the Phase Rule as a metaphor for transformation, Rukeyser calls "the structure of a life" "an art

form" and connects "changing phase" with both the processes of poetry and of human life:

> The reason I think that I came to do Gibbs was that I needed a language of transformation. I needed a language of a changing phase for the poem. And I needed a language that was not static, that did not see life as a series of points, but more as a language of water, and the things are in all these lives [i.e., those of her "Lives" series, from *A Turning Wind*] that I try to see in poems. Moving past one phase of one's own life—transformation, and moving past impossibilities. (Packard 131)

The Phase Rule, her language of transformation, can be applied to poetry, to individual lives, and, more broadly, to the life of a society, for each must "move past impossibilities" and change phase. Rukeyser's wish for "a language of water" recalls her depiction in *The Life of Poetry* of language as a river and her discussion in *Willard Gibbs* of the action of water, ice, and vapor in a glass, for both examples resist stasis. Ultimately, Rukeyser's deployments of Gibbs's Phase Rule as a metaphor for poetic form, an individual life, or a society elaborate processes that are, to her imagination, similar, interrelated, and yet also different because the very substances of each system differ. Poetry, individual poets and readers, and society, in other words, can be seen as closed systems capable, in and of themselves, of changing phase; yet Rukeyser also, particularly in *The Life of Poetry*, traces the interconnections between these systems and suggests that a change of phase, or energy exchange, in one system, such as a poem, generates transformation in the other systems. Like water, each system flows into the other and, also like the fugue form, modulates through motion and relationship.

Thus in Rukeyser's poems, sequences of poems, and books of poetry, the contraries she sets in motion—between forms, as well as between seemingly irreconcilable assertions she may make as a poem develops—enact the difficult, and sometimes balked, process of growth through energy exchange that, she insisted, characterizes both the individual and society. She therefore refused to develop a system in which the components—the various forms—carry fixed, predetermined values. Her unorthodox punctuation and spacing, for example, defy easy categorization. Her colons sometimes suggest balance between lines or parts of lines, yet they also sometimes indicate division: the colons can serve as open gates, but also as barriers. Nor does she rest upon static, simplistic associations of traditional form with patriarchal power, but revels in contradiction. Accordingly, her descriptions of the dam and the river in "The Book of the Dead" both evoke and undermine the Romantic Sublime. And, although

she adopts Miltonic blank verse in "Power" to indict the destructive, "terminal power" of the electric company, she also depends upon blank verse to describe the contrasting, changeful, fluid power of the river itself in "The Dam." Yet "The Dam" encompasses not blank verse alone, but "contrary" forms: she also includes free verse, some of which, like her late free verse, is composed of broken lines of iambic pentameter; Congressional subcommittee testimony about the Gauley Bridge tragedy; and Union Carbide stock quotations. Rukeyser, in other words, achieves a confluence of forms in "The Dam," and therefore the poem, like "The Book of the Dead" as a whole, and also like the river she describes (and the workers she associates with the river), gains power because it moves through diverse phases: "It will rise. These are the phases of its face. / . . . It changes. It does not die" (*CP* 98). Integrating several forms, the poem enacts Gibbs's concept that "the whole is simpler than its parts," a definition Rukeyser quoted often, but in *Willard Gibbs* amplifies through a by now familiar metaphor: "Truth is, according to him, not a stream that flows from a source, but an agreement of components, an accord that actually makes the whole 'simpler than its parts[.]' . . . It is truth flowing through the world, depending on an accord in great complexity" (339).

Ultimately, her faith in the transformative, life-giving power of "accord in great complexity" is deeply political, for she believed that the paradoxical conjunction of unity and diversity gained through tense, shifting interrelationships is a particularly American, and democratic, concern. Therefore she looked, among poets, above all to Walt Whitman, who also celebrated the conceptual links between poetry and science, as an exemplar whose search for a poetic equilibrium that does not diminish tension, contradiction, and multiplicity inspired her own search. She stresses that Whitman's

> fight for reconciliation was of profound value as a symbol. The fight was the essential process of democracy: to remake and acknowledge the relationships, to find the truth and power in diversity, among antagonists; and a poet of that democracy would have to acknowledge and make that truth emerge from the widest humanity in himself, among the horizons of his contradicted days and nights. The reconciliation was not a passive one; the unity was not an identification in which the range was lost. (*LP* 78)

While for Whitman inclusion meant gathering up all things American into his poetry, Rukeyser understood inclusion to embrace variety of form as well as of subject matter. Rukeyser's own range, her capacity to include so many forms in her books, can be seen not only as an active—and activist—struggle

for reconciliation, "to find the truth and power in diversity," but as one means by which she envisioned the inclusive process of democracy.

Notes

1. See Annie Finch, *The Ghost of Meter: Culture and Prosody in American Free Verse* (Ann Arbor: U of Michigan P, 1993), in which Finch, through her metrical code theory, explores the significance of the metrical patterns, particularly iambic pentameter and anapestic or dactylic triple rhythms, that arise in many American free verse poems. She argues that, more often than not, poets who write in free verse adopt meter, consciously or unconsciously, when evoking (and opposing) elements of culture that they find oppressive. However, she notes that contemporary poets such as Audre Lorde and Charles Wright, having come of age in an era when free verse was the norm, embed in their free verse "iambic pentameter and dactylic rhythms [that] carry more uniformly positive connotations than these meters did for earlier generations" (132). In contrast, Rukeyser's own canny employment of the ghost of meter in her free verse is distinctive not only because she buttresses it with her theory of form, but because it cannot be so easily associated with positive or negative connotations.

2. Louise Kertesz, for example, searching only for radical difference, misses Rukeyser's "radical sameness" and repeatedly defines her prosody as "adaptations of the free verse line of Whitman" (80).

Anne Herzog

◇◇◇◇◇◇◇◇◇

"Anything Away from Anything": Muriel Rukeyser's Relational Poetics

In a 1974 interview, Muriel Rukeyser recalled a question asked of her by the young Alice Walker,[1] then a Sarah Lawrence undergraduate: "'I thought poets were all universal people. Who is the universal poet?'" (Packard 123). Rukeyser's succinct answer, "That's an unborn poet, of course," expresses her disaffection for universality as a category of aesthetic value. Her answer to Walker must be heard within the context of her lifelong commitment to a poetry thoroughly grounded in historical particularity. She once defined the goal of art as follows: "to show continually the lives of our own people under the times they carry" (*Land of the Free* 28). Rukeyser's eschewal of the universal is only one of a number of her stances that anticipates by several decades postmodern theoretical developments. Her passion for historical narratives, her challenges of high and low art distinctions, and her radically inclusive, genre-questioning beliefs about what actually constitutes poetry also mark her as a poet with strong affinities for postmodernism in ways singular for her generation. These same theoretical developments may, at long last, provide the missing paradigm for a substantive reassessment of Rukeyser's place within twentieth-century poetry in the United States.

In her foreword to Lenore Marshall's *Invented a Person* (1979), Rukeyser addresses the author's effort to combine a life of political activism with writing. She sympathizes with Marshall's desire to bring the "inner" and "outer," the activist and writer, together, and to work against "the split between the two." Rukeyser writes, "Deep in our century, we suffer from that split" (8). Her response to Marshall's "split" was an assertion of relationship as the uni-

fying principle undergirding all of life and art so that activism and poetry merge into one creative activity. At the conclusion of her 1974 Barcelona memoir, "We Came for the Games," in which she reflects on her presence in Barcelona for the Anti-fascist Olympics at the inception of the Spanish Civil War she wrote: " . . . the acts of this century . . . have said in tragic clarity that our lives would not be shredded, not as athletes nor women nor as poets, not as travelers, tourists, refugees." She continues, "Not to let our lives be shredded, sports away from politics, poetry away from anything. Anything away from anything" (370). When questioned in 1974 about the fusion of "autobiographical, political, philosophical, and religious" interests in her poetry, Rukeyser answered: "'I don't work with unrelated elements'" (Packard 134). "Anything away from anything," a deceptively simple phrase, is the cornerstone to understanding Rukeyser's complex and original relational poetics as well as an appreciative reading of her life's poetry.

In his introduction to *Poetry and Politics* (1985), Richard Jones traces the historic splitting of literature and politics to an "unresolved tension between contemplation and action, between the articulation of an ideal in a work of art and its realization in the polis" (9). Critical responses to Rukeyser replicate this process. In their collective inability to imagine literature and politics in relation, numerous reviewers have misconstrued the importance and power of Rukeyser's poetry. The result has been a history of critical assessment that is painfully myopic.

Supporters of her work have attempted to circumvent the negative fallout from the uneasy relations between literature and politics during this century by accentuating her "purely" literary work, her "personal" as opposed to her "public" voice,[2] yet consequently they have devalued the complex interrelations between aesthetics and politics within both her poetics and her poetry. Assessing her life's work, one must probe the close relations between these two powerfully divisive forces, literature and politics, tracing her efforts to mediate between the two, in order to construct a more accurate, revisionary critical assessment.

In response to critical misreadings of her writing, Rukeyser began publishing from the earliest moments of her career what Kate Daniels reads correctly, I think, as "an explanation and defense of her approach to poetry . . ." ("Muriel Rukeyser" 248). This body of prose reviews and essays, originating in 1932 and continuing right up until her death in 1980, is a collection of writing in which Rukeyser insists, over and over again, on *relationship*—between literature and politics, between literature and everything—as the central figure guiding her poetics and poetry. She wrote dozens of reviews, essays, and book prefaces and forewords. Publishing in a large variety of

journals of greater and lesser literary import, she assessed the work of such writers as Sherwood Anderson, Robert Duncan, William Faulkner, Robert Frost, Robinson Jeffers, Franz Kafka, Marianne Moore, Kenneth Rexroth, Rainer Maria Rilke, and Anne Sexton. She responded to novels, documentary films, film theory, philosophy, biography, autobiography, photography, children's books, war posters, and such newsworthy figures and events as the Spanish Civil War, the Scottsboro Nine trial, Sacco and Vanzetti, and Julius and Ethel Rosenberg. Given her postmodernist belief that nothing should be excluded from the auspices of the literary/poetic imagination, it is not surprising to find that she wrote on such an extraordinary range of topics, many of which are noticeably extradisciplinary to poetry.

Yet one cannot fully apprehend the originality of Rukeyser's critical vision without turning to her most extensive formulation of her poetics, *The Life of Poetry*, published initially in 1949 and reissued in both 1974 and 1996. Exceeding 200 pages, this book virtually resists summary, so wide-ranging is Rukeyser's conception of poetry's presence in the world. Popular arts, nursery rhymes, Native American chants, the Blues, theater, architecture, painting, photography, film, science, and more—each of these arenas for creative expression is shown by Rukeyser to exist in vital relationship to poetry. James Caldwell's statement in the *Saturday Review* (March 1950) that Rukeyser's "idea is, of course, far too big for the book, and strains at the bindings" reflects the vastness of her poetic project, as does Charles Rolo's 1950 *Atlantic Monthly* review describing *The Life of Poetry* as "ambitious," "profound," and "demanding." Rukeyser's book is simply unlike any other argument for the vital "life" of poetry written during the twentieth century. While it does indeed resist summary, one can point to a number of its recurring points as well as its defining characteristics to talk about the premises underlying Rukeyser's work as critic, poet, and activist.

The Life of Poetry is divided into four sections: "The Resistances," "Backgrounds and Sources," "The 'Uses' of Poetry," and "The Life of Poetry." Its Introduction includes the first of many passages that reveal Rukeyser's understanding of the powerful relationships that exist between history, consciousness, and creativity. Here, she specifically and historically locates the text within what she calls a "time of crisis" and reflects back in some detail on her experience of being present in Barcelona at the outbreak of the Spanish Civil War:[3] "In time of crisis, we summon up our strength" (1). For Rukeyser, poetry was one of this country's natural resources. Different in kind but not in potential usage from unmined mineral resources, poetry was an untapped source of "strength" that could be summoned up to meet the many crises faced by the United States during the twentieth century. Specif-

ically, she believed in the transformative potential of poetry to "further humanity" (41). Advocating poetry, she writes: "In a time of suffering, long war, and the opening of horizon, there is no resource which we can afford to overlook or to misunderstand" (8).

The particular memory from her days in Barcelona that she chooses for her initial framing of *The Life of Poetry* is the moment when all foreigners were being asked to leave the embattled city. She recalls a group address in which she and others were told: "'Now you have your responsibility,' the voice said, deep, prophetic, direct, 'go home: tell your peoples what you have seen'" (2). Several aspects of this historical framing are significant in understanding Rukeyser's poetics. First is the extent to which it springs from a conception of poetry that is profoundly ethical, imbued with a sense of responsibility barely distinguishable from that which one might associate with a religious vocation. Indeed, her recounting of the Barcelona address echoes the language of biblical accounts depicting the endowment of a prophetic vocation. The charge that is given here to Rukeyser (and her companions) is one of witnessing: "'tell your peoples what you have seen.'" "Witnessing," a word heavy with spiritual and legal tones of obligation, is the vocation that Rukeyser accepts when she concludes the Introduction with this profession of faith: "Then I began to say what I believe" (3).

Poetry as witness forms the foundation of Rukeyser's poetics and recurs throughout *The Life of Poetry*. Unlike many of the "pure" aesthetes of her generation whose notion of responsibility was limited to the continued development of their particular art form, Rukeyser believed that the "primary responsibility of the poet is to the human consciousness" (52). In her discussion of the role of the audience in the reception of poetry she proposed a substitution of the word 'witness' in place of the words of common literary currency ('audience,' 'reader,' or 'listener') because she found them "inadequate." She preferred "witness" for its "overtone of responsibility" (175). At a later point in *The Life of Poetry*, Rukeyser writes: "the reality of the artist is the reality of the witnesses" (187). Thus, we can see that the responsibility she associated with an art obligated to witness was not limited to the artist alone but also extended in a much larger circle to include the witnessing audience.[4]

Perhaps the most radical implication of the seriousness with which Rukeyser considered the shared consciousness of both author and audience can be seen in her critique of what she called the "charge of obscurity" (54) in poetry. Given her belief that both writer and audience cocreate art, she addresses allegations of her own poetry's obscurity, as well as modernist poetry in general:

It is one of the major charges brought against contemporary poetry, and it must always be taken as a declaration by the audience, which . . . tells us, at first, very much about the audience and nothing about the poem. . . . *Nothing has yet been said about the poem*. . . . If you are going to follow up this challenge, you must then inquire into the consciousness of the challenger. Is the challenger prepared to receive the poem? Or is this merely another way of disowning imaginative experience? (54)

While a more conventional reader may be tempted to dismiss this passage as the author's own defensive refusal to accept what are, perhaps, valid charges of obscurity in language or conception within a poem, Rukeyser's definition of the artistic act as radically cocreative and relational turns the table on these charges and argues that they originate, in fact, in a reductive and falsifying perception of poetic exchange.

James McCorkle's 1992 review discussing the relations between poetry, politics, and history posits a social and ethical conception of poetry very near to that of Rukeyser's:

The space of writing is a shared, social space, yet it does not deny the individual act of creating that space. Such an act is profoundly difficult and one that requires an ethical responsibility or responsiveness, if it is to be authentic in its space and its outward *regard*. To not view poetry as an ethical process, is to initiate a disturbing leveling that extinguishes the very possibility of a responsive writing. The poem is always in the realm of betweenness or dialogue, neither wholly internal nor external; its space is autonomous yet can only be existent as a shared space. (172)

If poetry's "space" is inherently "shared" and "social," it is also, by its very nature, a space within which relationship takes place. The "disturbing leveling" that McCorkle describes here is exactly what must occur, according to Rukeyser's schema, if one assesses a criticism of obscurity only in relation to the written text, ignoring the multiple levels of the triadic relationship that surround a given poem. Thus, when Rukeyser addresses what she sees as the "failures" of modern poetry she locates its limitations in a place of "betweenness": "There has been a failure *between* poetry and its people—its writers and audience" (emphasis mine) (23). Conceptions of poetry as high literature that exists in an aesthetic universe set apart from the prosaic world of its readers dissolve in the nexus of relationship joining "poetry and its people" within Rukeyser's poetics.

Yet the primacy of relationship plays a much larger role within Rukeyser's poetics than her specific understanding of its impact on the reception of a

particular poem. Assessing societal attitudes toward "the atom bomb, the Negroes, the Reds, the Jews, the 'place' of science, the 'place' of labor, the 'place' of women, and poetry," she writes: "There are relationships which include so much that we can bring to them our own wishes and hostilities, our value judgments and our moralities; they will serve to illuminate all our other relationships" (9). Her conceptualization of what might otherwise be discussed as contested "issues" or "populations" within society as "relationships" reveals the consistency (and originality) of her relational vision. For Rukeyser, relationship is a kind of archetypal philosophical principle that can be used to explain the mysterious workings of life and the universe. And because poetry is not separate from either life or the universe, relationship is instrumental to the workings of any poem. Intellectually spanning a wide variety of disciplines including science, psychology, art, literature, political science, and economics, Rukeyser points to such figures as Karen Horney, Willard Gibbs,[5] Freud, Picasso, Einstein, Joyce, and Marx to demonstrate the extent to which the principle of relationship was central to innovations each achieved within his/her particular field. For example, Rukeyser discusses how Horney's theorizing within the field of psychology contributed to a shift in viewing the "disturbed" individual in isolation to a consideration of this individual in relationship: "a person moving toward other persons, or a person moving away from other persons, or a person moving against other persons" (12). For Rukeyser, all of the most important twentieth-century thinkers were involved in what she called "masterworks" in "relative values," shifting the philosophical terms of discussion from the isolated analysis of finite facts that typified earlier centuries of analysis to a radically different focus on "process and relationship" (12).

There are numerous moments in *The Life of Poetry* where one can observe Rukeyser actively foregrounding her relationship to her readers through variations on direct personal address. She frequently includes her readers in explicit communal relationship through her pronoun usage: "us," "our," or "we." She refers to "our people" (15); and, when speaking of the difficulties of an inadequate critical vocabulary, she counters: "That obstacle is nothing. We are poets; we can make the words" (13). Significantly, Rukeyser's use of the "we" in such passages functions in marked contradistinction to the royal, exclusive "we" commonly invoked within conventional academic discourse. Her audience is included in the identification "we poets." Additionally, there are passages in her discussion in which she directly addresses her readers with such intimacy that it is almost as if the text is transformed into a personal conversation. The intensity of Rukeyser's focus on the reader is, at times, strangely startling, almost disconcerting in

its unconventionally insistent assertion of connection. For example, in Chapter Eight, addressing poetry's impact on drama, she creates the theater scene she wishes to discuss in the following: "How is it with you, sitting beside me? Our coats are thrown back over the chairs, the little books of the program are on our laps, we almost touch each other's arms . . ." (119). She continues: "You sit beside me in the house-dark, with the light thrown from the stage on your face, and shadows at your back. When you laugh, I feel it, . . . We sit here, very different each from the other, until the passion arrives to give us our equality, and to make us part of the play, to make the play part of us. An exchange is being effected" (120). Rukeyser highlights the theater as a location of tremendous physical intimacy between strangers, an intimacy that is so radical that it can be viscerally awkward: our arms "almost touch," I can feel "you laugh." She posits the play as a powerful mediating force between the otherwise disconnected members of the audience. Significantly, estrangement dissolves in the witnessing power of artistic "exchange."

Similarly, she opens her autobiographical twelfth chapter as follows: "My one reader, you reading this book, who are you? what is your face like, your hands holding the pages, the child forsaken in you, who now looks through your eyes at mine?" (189). Here she moves even closer to the reader, not only addressing the adult persona but casting back to each reader's childhood memories in a rhetorical move that implicitly pulls her audience along on an introspective exercise paralleling the autobiographical analysis that follows. Each of these examples demonstrates the extent to which Rukeyser constantly practices a poetics of heightened relationship that accentuates the active writer-reader connection within the rhetoric of her text.

Because she believed that science and poetry in particular were profoundly related disciplines, Rukeyser looked extensively to science as a model for the kinds of reconstructive thinking she was trying to achieve with poetry.[6] She defined science as "a system of relations" (165) and cited Poincaré to support her definition: "'It is before all a classification, a manner of bringing together facts which appearances separate, though they are bound together by some natural and hidden kinship. . . . It is in the relations alone that objectivity must be sought; it would be vain to seek it in beings considered as isolated from one another . . .'" (165). Here we see again her attraction for theorists who foreground relationship as a way of complicating the unidimensional quality of traditional analytical approaches. Thus, Poincaré's interest in the "kinship" between ostensibly "separate" facts appeals to Rukeyser. Additionally, she was influenced by the physicist Willard Gibbs's relational construction of truth as "not a stream that flows from a source, but

an agreement of components" (167). She viewed science and poetry as existing on one end of a spectrum of belief whose contrasting pole was characterized by "dogma and shrinking from the external world" (162). These two characteristics are particularly resonant when one considers Rukeyser's collected poetry. While she consistently resists simplistic, partisan allegiances and dogmatic tendencies, her writing is indeed dense with images and details that evidence a powerful attraction for the "external world." Science's prototypical antidogmatic, questioning stance, along with its unwavering focus on the material world, offered her the perfect impetus for the revisionary thinking she was striving to effect within her field.

Rukeyser's thinking about science-poetry relations led her to formulate an interpretive approach that has serious ramifications for traditional critical discourse on poetry. In language heavily influenced by scientific theory, she proposed that a "poem, like anything separable and existing in time, may be considered as a system, and the changes taking place in the system may be investigated" (186). Challenging the interpretive vocabulary commonly applied to the reading of poems, she insisted that a poem was "not the words and images, but the relations between the words and images" (167). Ultimately, she was struggling to articulate a poetics that would genuinely convey the dynamism of language, the ways in which the movement and life of language in poetry eludes the confining grasp of traditional approaches attempting its explication: "Grammar and criticism need not destroy; but they will, if words are raised above language. . . ." (16).

During a period when most literary critics were firmly under the sway of New Critical tenets, Rukeyser's thinking, to a startling degree, sounds strikingly postmodern. Addressing the making of meaning in poetry, she writes: "In poetry, the relations are not formed like crystals on a lattice of words, although the old criticism (which at the moment is being called, of course, the New Criticism) would have us believe it so. Poetry is to be regarded according to a very different set of laws" (166). And again, "I have a high regard for some of the poets who are setting up these structures: dissecting poetry into ideas and things, and letting the life escape; or counting words as they might count the cells of a body. . . . But I cannot accept what they say. . . . [I]n all of their statements, one evidence after another shows that they are thinking in terms of static mechanics" (166). Ironically, the New Critics were also interested in the wedding of scientific and poetic approaches, but it is clear that the model of science they preferred held little in common with the model adopted by Rukeyser. In contrast, Rukeyser proposed a dynamic vision of language in which "motion and relationship are always present" (167) as the potential starting point for a genuinely "new" criticism. Given

this vision, one could not approach the poem as an "object"; Rukeyser insists that "the poem is a process" (174). Finally, Rukeyser issued what came to be the guiding caveat emptor behind her poetic thinking: "dismiss every static pronouncement and every verdict which treats poetry as static" (167).

One of Rukeyser's favorite analogies for tracking the movement of language in modern poetry was drawn from her experiences in filmmaking. As early as 1935, the year that marks the beginning of her career as a poet with the publication of her first book, *Theory of Flight*, she was training as a film editor as well as writing "titles and commentaries for foreign films" produced by Garrison Films (Kertesz 391). These experiences impressed upon her the extent to which movement and the passage of time were both openly acknowledged elements of film production that were virtually ignored in the commentary surrounding poetic texts. Articulating the "meeting-place"[7] between film and poetry, she wrote: "The continuity of film, in which the writer deals with a track of images moving at a given rate of speed, and a separate soundtrack which is joined arbitrarily to the imagetrack, is closer to the continuity of poetry than anything else in art" (141). Thus, she discussed the "quick, rhythmic juxtapositions" typical of her poetry, in particular, and of modern poetry, in general, with film terminology: "Now films and visual sequences may be put together smoothly with all the links filled in, or according to other rhythms, in which one sequence will approach a main meaning, to be cut off by another sequence . . . so that the third sequence will be reinforced, made to change and grow because of what has gone before" (18–19). Rukeyser extracts from film theory its ability to account for movement and the passage of time within a particular artistic text, regardless of the historical period of that text's creation. She came to view film editing as "a parable in the motion of any art that lives in time . . ." (142). And, as she would repeat throughout *The Life of Poetry*, like "music, theatre, film, writing," poetry was one of the "arts that *live in time*" (emphasis mine) (10).

Poetry's close relationship to time irrevocably binds it to history and historical processes within Rukeyser's poetics. Throughout her poetry and prose, her fascination with history's past and present unfolding is evident. Yet, consistent with her insistence on a poetics that expresses the dynamism and richness of language in poetry by resisting the static mechanical approach of the New Critics, Rukeyser adopted a suspicious stance toward the totalizing, inevitably limiting narratives promulgated within traditional historical discourse. Her probing of history's unlit corners and unmarked passages, along with her insistence on poetry's engagement with history, resulted in both a poetics and a body of poetry profoundly marked by historical reconsideration. She wrote: "There is . . . in any history, the buried, the wasted, and the

lost". Her conviction of what she called the "great submergence" (85) within American history, the repression of all that has been forced to the margins of our culture, along with her vision of poetry's vital relationship to *all* of history, propelled her to challenge the poetic canon to an extent that anticipates by several decades the substantive debates on canon reconstruction that originated in the political ferment of the sixties. In her declaration of canon independence, she wrote: "If we are a free people, we are also in a sense free to choose our past, at every moment to choose the tradition we will bring to the future" (21).

In many ways, *The Life of Poetry* is a "breaking open" of the canon, as Rukeyser surveys an amazing range of poetry's forgotten texts: tribal songs, Native American chants and dream-singing, African American poems, children's songs, and what she refers to, in general, as the poetry of the "public domain" (97): all of the unpublished folksongs, chanteys, cowboy songs, work gang songs, mining songs, strike songs, the blues. She devotes two full chapters (6 & 7) to what she calls (following her naming of poetry as an untapped natural resource) this country's "[d]ead power . . . everywhere among us" (86). Rukeyser's thinking, here, is noticeably more expansive and much less marked by any one group's partisan concerns than the most recent efforts to theorize canon revision have achieved (e.g., feminist or African American critics who limit their focus to the recuperation of women or black writers). In fact, more than 40 years after *The Life of Poetry* was published, discussions of canon reform are only now approaching the breadth of inclusivity modeled by Rukeyser in this remarkable text.

Two canonical figures singled out by Rukeyser for retention within her project of revising poetry's history are Melville and Whitman. Melville, whom she called the "poet of outrage" (83), influenced her poetics in his ability as a poet to transform what she called the "oppositions" into "music." Melville's ability to deconstruct in poetry what might first appear to be binary oppositions—specifically, surrounding the "problem of evil"—drew her greatest respect (67). She quotes from two different drafts of Melville's "Art" in which he addresses this transformative process. First: *"In him who would evoke—create, / Contraries must meet and mate"* (67). And, from a later draft:

> *Instinct and study; love and hate;*
> *Audacity—reverence. These must mate,*
> *And fuse with Jacob's mystic heart,*
> *To wrestle with the angel—Art.* (72)

Through her relational vision, Rukeyser, like Melville, worked to "fuse" the "contraries," forcing those that appeared to be separate and discrete "to meet and mate." One need only contemplate the extent to which she integrated high modernist aesthetic principles with the concerns of left-wing political activism throughout her poetry, "mating" two apparently irreconcilable forces, to appreciate the importance of Melville's modeling of a reconciling poetics.

Whitman, on the other hand, is Rukeyser's "poet of possibility" (83). In contrast to Melville (and yet parallel to Melville), she admired Whitman for facing the "problem of good" in a world that was clearly both good and evil. According to Rukeyser, Whitman's question, "How was it possible to search for the good, find it, and use it?" (72), was answered in his method of identification: identifying with America, "multitudinous and full of contradictions" (73). She identified Whitman's aesthetic and philosophical struggles with "the essential process of democracy," thus highlighting what were for her politically relevant choices made by both poet and human being. In Rukeyser's words, the "essential democratic process" evident in Whitman consists of a two-tiered approach: "to remake and acknowledge the relationships" and "to find the truth and power in diversity, among antagonists" (78). Reading these lines today, it is hard not to notice their prefiguring of the language of current debates on cultural pluralism and diversity in the United States.

Clearly Muriel Rukeyser synthesized both poetic stances, Melville's "outrage" and Whitman's "possibility," within her poetic vision. And yet, as is evident in her readings, to her way of thinking both poets were ultimately committed to one approach, guided by common ideals of relationship and inclusivity, attempting to face and describe the world, good and evil, in all its complexity. In perhaps one of the most gorgeous prose-poetry passages from *The Life of Poetry*, Rukeyser demonstrates the extent to which she has learned well the lessons of both poets:

> I see the truths of conflict and power over the land, and the truths of possibility. I think of the concrete landscapes of airfields, where every line prolongs itself straight to the horizon, and the small cabin in the Appalachians under the steep trail streaming its water down; of the dam at Shasta, that deep cleft in the hills filled with white concrete, an inverted white peak with the blue lake of held water over it, and over that, Shasta the holy mountain with its snows; New York at night when the city seems asleep and even asleep full of its storm and songs; the house in the desert and the pool wooden-lidded against the sand, where poems are being read to the gold miners by the woman who came there to die of tuberculosis twenty-three years ago. I think

of the lines of marchers before the fascist meeting, and the brown breasts of the policemen's horses, the feeling of being pushed back against the buildings of your streets; of the joyful dawn over the rivermouth, a boat riding down in slimness and white, and seeing three feet beyond the bow, a boy leaning like an angel on the air, for a moment there until I saw the harpooner's nest of the seagoing fisherman. . . . (64–5)

Whitman's America, "multitudinous and full of contradiction," as well as the "meeting and mating" of Melville's "contraries" are fully embodied in this passage.

Along with her conception of poetic responsibility and poetry as witness, Rukeyser's eschewal of binary oppositions, affirmation of relationship, and fascination for poetry's "timed" nature form the cornerstones of her poetic practice. The second conversation highlighted by Rukeyser in her introductory framing of *The Life of Poetry* takes place on the deck of her ship departing Barcelona. She describes the scene in which "a man—a printer, several times a refugee—asked, 'And poetry—among all this—where is there a place for poetry?'" (3). The "this" of the printer's question is civil war; in essence, he is forcing the question of what, if any, is the actual relationship between poetry and the world. In Rukeyser's words, "in time of crisis," is there any place for poetry? Does poetry exist as a viable art form in relationship with the historical, material world, or is poetry, as it has been popularly and stereotypically conceived, the stuff of ivory towers and sentimental chapbooks, existing only in the most marginal of relationships to surrounding world events? *The Life of Poetry,* Rukeyser's poetic opus, acclaims the legitimate place of poetry across a vast range of cultural arenas and is Rukeyser's ultimate answer to the printer's provocative question.

Notes

1. While Rukeyser does not specifically identify Walker as the "black woman student" questioner within this interview with *The New York Quarterly,* her uncollected poem "An Unborn Poet," dedicated to and largely about the young Alice Walker, makes clear the connection between the two.
2. See, for example, Virginia Terris's "Muriel Rukeyser: A Retrospective" (1974).
3. Not only did Rukeyser publish three journalistic accounts of her experience as a reporter at the People's Olympiad, but also references to Barcelona's importance resonate throughout her life's work of poetry and prose writing.
4. In *The Life of Poetry,* Rukeyser diagrams the artist/audience/artwork relationship as geometric shapes with an overlapping, common area, signifying

the "consciousness" shared by artist and audience (51). This textual attempt to give the author-audience relationship visual, material reality testifies to the extent to which Rukeyser believed others to be blinded to the actuality of this relationship, and also reflects the intensity of her own desire to convince her readers of the importance of acknowledging the author-audience relationship within the discourse of poetry.

5. See Rukeyser's biography *Willard Gibbs* (1942) for a fuller understanding of the poet's assessment of Gibbs's significance.

6. See Grace Schulman's "Song of Our Cells," *Hudson Review* 29.1 (Spring 1976): 130–38, for a review essay that discusses remarkable philosophical connections between *The Life of Poetry* and Lewis Thomas's *The Lives of a Cell.*

7. See page 139 of *The Life of Poetry* for Rukeyser's affirmation of a "literature of meeting-places."

Janet Kaufman

◇◇◇◇◇◇◇◇◇

"But not the study":
Writing as a Jew

*My themes and the use I have made of them have depended on my life as
a poet, as a woman, as an American and as a Jew. I do not know what
part of that is Jewish; I know I have tried to integrate these four aspects,
and to solve my work and my personality in terms of all four. . . . To live
as poet, woman, American, and Jew—this chalks in my position. If the
four come together in one person, each strengthens the others.*

—Muriel Rukeyser, "Under Forty"

Not many of Muriel Rukeyser's poems are explicitly Jewish. That is, few
specifically address Jewish history, politics, or culture. However, in two
poems coinciding with monumental moments in American Jewish history,
Rukeyser expressly asks what it means to be Jewish in the twentieth-cen-
tury, what it means to find one's sources for poetry in the Hebrew Bible
and the rabbinic tradition. The first of the two poems I will discuss, a son-
net from her poem sequence "Letter to the Front," published in 1944, as-
serts and claims the theological idea of Judaism as a gift; 16 years later—in
1960—Rukeyser's poem "Akiba," a poetic exegesis of the great rabbi
Akiba, brings to full light the sources for her insistence on "witnessing": a
political, ethical, and theological approach to reading and writing poetry
that she began to set forth in *The Life of Poetry* (1949).[1] These two poems
make direct statements and claims about the aesthetic and moral central-
ity of Rukeyser's Jewishness to her work. Even though, during the inter-
vening years of 1945 to 1960, she did not devote whole poems to overtly

Jewish subjects, the poems of those years suggest both that her heritage was a profound source for her poetry and that her own relationship to Judaism in some ways paralleled the uncertain and evolving identity of American Jews. The Jewish part of herself, as she had claimed, strengthened the other parts, creating a poetry with an aesthetic of making, building, and creating relationship and transformation.

Rukeyser's first published poetic lines reflecting on the meaning of being Jewish emerge in a Petrarchan sonnet in her ten-poem sequence "Letter to the Front" (1944), which confronts the horrors of the Spanish Civil War and World War II. Searching for a way to respond to these wars specifically as a woman and a poet, the sequence opens with a visionary declaration: "Women and poets see the truth arrive" (*OS* 61). Progressing through the sequence, Rukeyser imagines the influence women could have by responding to war and beckons for their "Involvement in the world." Finally, she concludes by imagining the heroic efforts of resistance fighters that began with "signs of belief" and offered hope; her poem, a letter to the front, becomes an effort to return the favor of those signs: "As I now send you, for a beginning, praise" (*OS* 68).

Giving no hint of itself earlier in the sequence, the seventh poem of the sequence, a sonnet, announces itself with a proclamation: "To be a Jew in the twentieth century / Is to be offered a gift." (*OS* 65). Imagine writing these lines at the apex of the Nazi genocide. In a poem-letter addressing women in general and herself as a poet—and indirectly addressing her lover, Otto Boch, who had died fighting in the Spanish resistance—why did she abruptly insert this declaration? What could she have meant by it, and why would she write it as a Petrarchan sonnet, the ultimate form for the love poem? The octet continues:

> If you refuse,
> Wishing to be invisible, you choose
> Death of the spirit, the stone insanity.
> Accepting, take full life. Full agonies:
> Your evening deep in labyrinthine blood
> Of those who resist, fail, and resist; and God
> Reduced to a hostage among hostages. (*OS* 65)

The "gift," these lines make clear, is not offered unconditionally; the price of refusing it is "death of the spirit." Accepting it, however, means knowingly accepting "full agonies," willingly stepping into "labyrinthine blood." She invokes centuries of persecution against Jews with these words, as well as the

courage and persistence of Jews who resisted persecution throughout history. Her words also disturbingly echo the appellation of God in Jewish liturgy— "King of Kings" or "Host of Hosts"—when they claim that accepting "full agonies" also means facing a history with God fallen, reduced to "hostage among hostages." This was 1944.

The sestet of the poem rescues, offers hope, even while it equates the gift with torment:

> The gift is torment. Not alone the still
> Torture, isolation; or torture of the flesh.
> That may come also. But the accepting wish,
> The whole and fertile spirit as guarantee
> For every human freedom, suffering to be free,
> Daring to live for the impossible.

The "torment" evokes not only the physical suffering inflicted by a history of oppression, but the mental torture of hoping for freedom and peace that, in the midst of the Spanish Civil War and World War II described in "Letter to the Front," seems impossible. The "accepting wish" torments because it dares and tethers one to a life of resistance and risk-taking. Rukeyser's language evokes the covenant between God and the Israelites at Sinai, contingent upon the Israelites, and all succeeding generations, accepting it. When Moses says to the people, "Not with our fathers did the Lord make this covenant, but with us, even us, who are all here alive today" (Deut. 5:3), the people respond: "We will hear it and do it" (5:24). To accept the gift is to accept a binding responsibility, but a responsibility that liberates, making the impossible possible. Many have argued that the notion of the covenant distinguishes the Jewish people and Jewish history; Rukeyser seizes on this idea in her sonnet: the gift of Judaism is a binding relation to God, history, and the future. With the seed of this idea in an essay earlier in her career, Rukeyser had written, "To me, the value of my Jewish heritage, in life and in writing, is its value as a guarantee" ("Under Forty" 9).

Although, ostensibly, one can accept or deny the contract posited in the sonnet, choice does not seem viable. As the octet declares, not to accept the gift, if one is born a Jew, is to be invisible, to blind one perhaps even to oneself. Rukeyser published these lines in a time not only when Jews were being annihilated in Europe but when, in America, Jews were striving to assimilate rapidly into mainstream American society.[2] Given that, in childhood, Rukeyser found her parents' temple bereft of meaning and that she remained distant from organized Judaism, the fact that both the American Reform and

Reconstructionist movements adopted "To Be a Jew" into their prayer books "astonished" her. "One feels that one has been absorbed into the line and it's very good" (Packard 122). Much of Rukeyser's poetry displays these conventional qualities of prayer: praise, supplication, argument, dialogue, and risk. We see this, for instance, at the end of "Nine Poems for the unborn child" (1948): "praise / To the grace of the world and time that I may hope / To live, to write, to see my human child" (*OS* 78), or in "The Poem as Mask" (1968): "Now, for the first time, the god lifts his hand, / the fragments join in me with their own music" (*RR* 213). Prayer entails a spiritual risk of participating in a conversation that offers no certainty of response; writing to and trusting so emphatically in poetic language, Rukeyser creates a listener, drawing upon poetry as prayer as a way to "live for the impossible." When she asserts in "Notes for a Poem," early on in her first volume, *Theory of Flight,* that the poem offers "a plough of thought to break this stubborn ground" (*CP* 11), she harkens back to Isaiah's injunction: "They shall beat their swords into plowshares and their spears into pruninghooks" (2:4). While Rukeyser's sonnet in "Letter to the Front" emphasizes the liturgical qualities of her poetry, it also defines Judaism as a source of courage to break through the silences that perpetuate injustice.

Rukeyser reinforces this idea in an essay published the same year as the sonnet "To be a Jew," in a collection entitled "Under Forty: A Symposium on American Literature and the Younger Generation of American Jews" in the *Contemporary Jewish Record.*[3] The editors of this symposium wanted to know whether the writer's position as artist and citizen had been "modified . . . by the revival of anti-Semitism as a powerful force in the political history of our time." Among the essays, Rukeyser's was the only one insisting on the interwovenness and interdependence of her various identities.[4] Elaborating on her theme of Judaism as a gift, Rukeyser wrote about her sense of her Jewish heritage as a guarantee: "Once one's responsibility as a Jew is really assumed, one is guaranteed, not only against fascism, but against many kinds of temptation to close the spirit" (9).

Given that Rukeyser expressed these ideas so forthrightly in 1944, that she understood the Jewish aspect of her identity as a guarantee against the "closing of the spirit," how do we understand the fact that her poems between 1944 and 1960 engage Judaism so much more subtly? The glimpses that Rukeyser gives into her life and the times in which she grew up help to answer this question. In the "Under Forty" essay, Rukeyser writes that her parents were both born in the United States—one of German-Jewish and the other of Romanian-Jewish descent. Her father, from a large family in Wis-

consin, was brought up "among the Western Stories" and rebelled early against religion for reasons Rukeyser did not articulate. Her mother came from Yonkers and went through an "anti-religious reaction against [her] studious and improvident father." Rukeyser described her extended family as "'second-generation'—split with the parent culture, leaning over backward to be 'American' at its most acceptable." Ostensibly the only "marks" of Judaism in her childhood home were a "silver ceremonial goblet, handed down from a great-grandfather who had been a cantor, and a legend that [her] mother's family was directly descended from [the second century scholar and poet in Palestine] Akiba" (5). However, William L. Rukeyser, Muriel's son, commented that her parents spoke Yiddish to each other; Judaism marked the language, the air, in their home.[5]

Though, as a child, Rukeyser may not have perceived Jewish culture as something distinct in the world outside her home, the fact that she attended religious school and services, that she heard Yiddish at home, and that she was told Jewish family stories attests to her immersion in it. Indeed, thinking back to her childhood, she wrote, "I had no idea of what a Christian was. . . . I did not know what a Jew was, nor that the term could be used in contempt" ("Under Forty" 5). Her description of her parents' resistance to Judaism is not surprising in light of both the anti-Semitism of their times and the zealous assimilationist efforts of German Jews. In contrast to a rise in Orthodoxy in the late eighteenth and early nineteenth centuries, the early and mid-nineteenth centuries saw German Jewish reformers trying to assimilate by redefining Jewish practice according to Protestantism. As Charles Silberman describes this phenomenon, these reformers

> expurgated the national and ethnic aspects of Judaism, dropped Hebrew as the language of prayer, prayed with uncovered heads, and introduced sermons, organ, choir, and other changes designed to make worship in the synagogue resemble a Protestant service as much as possible. . . . It was not just that reformers dropped any part of Jewish tradition that seemed out of keeping with the spirit of the age. They went further, putting the burden of proof, so to speak, on the tradition: rituals and practices were to be dropped unless one could demonstrate their contemporary relevance. (38)

Confirming these conditions, Rukeyser recalls that the people in her parents' Reform congregation wanted "a religion of reassurance; they listened to the muted organ, and refused to be involved in suffering that demanded resistance. . . . If they had a mission as a responsible and inspired people, they did not want it" ("Under Forty" 6).

Rukeyser reacted against this attitude when she was sent to religious school "automatically" though she "did not know what a Jew was" and when, as a young girl, she began accompanying her mother to temple every Saturday for seven years when her mother "suddenly" turned to religion "out of a need or sadness of her own." She discovered the poetry of the Bible during religious services, finding it far more entertaining and compelling than the services; it was far "closer to the city"—to the realities of the "street-gangs" she played with and the "prostitutes on the Drive"—than anything could possibly be in temple. People brought up in this "reformed" Judaism, she imagined, "must go starving for two phases of religion: poetry and politics" ("Under Forty" 6).[6]

Rukeyser was not particularly observant as a Jew throughout her life, though her Confirmation class claimed her as its prize student, and for 20 or 30 years she corresponded periodically with her rabbi. When her son, Bill, was in fifth or sixth grade, the poet reenacted the Exodus story on Passover by painting the doorframes with ketchup.[7] She went to synagogue on Yom Kippur about every other year. And her friend and poet-colleague Jane Cooper remembers that near the end of Rukeyser's life, when she was very ill, Rukeyser fasted on Yom Kippur.[8] However, William Rukeyser remembers that she "flirted with Episcopalianism" and that part of her always wanted to be "thin, blond, and drive a Mercedes." She liked to be called "Mrs. Rukeyser" even though she was not married. These desires, Cinderella-esque fantasies, are not surprising given the desire among American Jews in the first decades of this century to assimilate. In fact, Rukeyser's son initially went to a predominantly Jewish elementary school, but she managed, even in her poverty, to gain his admission to an Episcopalian boys' prep school.[9] This kind of action points to tensions she easily could have felt in a world in which it was so important to "pass." Yet, while Rukeyser resisted formal identification with organized religion, her poetry nevertheless reiterated the theme from "Letter to the Front": refusing the gift of being Jewish means turning away from one's heritage and one's own self, denying one's spirit. In "Bubble of Air," also published in 1944, Rukeyser's persona, fighting "a bubble of air stand[ing] in [her] throat," declares:

The angel of the century
.
turned to my dream of tears and sang:
Woman, American, and Jew,
three guardians watch over you,
three lions of heritage

resist the evil of your age:
life, freedom, and memory. *(OS* 61)

Here we see again, as she asserted, that her identities cannot be separated from each other and that, with them, her Jewishness serves in the role of guardian, propelling her beyond resistance to response. "Speak!" the poem commands at its conclusion.

In some respects Rukeyser is like the "non-Jewish Jew" Isaac Deutscher describes when reflecting on the lives of great Jewish modern revolutionaries such as Heine, Marx, Luxemburg, and Trotsky. Deutscher sees these figures as Jewish precisely in the way they transcended the boundaries of Judaism, living their Judaism in a universal arena: all believed in human solidarity, and all saw solidarity as extending beyond Jewish borders. Jewry was "too narrow, too archaic, and too constricting" for them (26); however, as the contemporary feminist theologian Judith Plaskow observes, these revolutionaries "betrayed a passion for justice and action that is rooted in the tradition they wanted to leave behind" (218). Reflecting on nineteenth-century Jewish radicals, Plaskow asserts that they reworked, albeit unintentionally, Isaac Luria's sixteenth-century, Kabbalistic notion of *tikkun olam*—the repair of evil released in the world by God's withdrawal from it—such that the task of repairing the broken world was entirely in human hands. As Plaskow asserts, action for them came to mean social action; evil was injustice; and revolution was the solution to repairing the material world, the only world (219).

In both her political action and writing, Rukeyser was clearly a descendant of these radicals. In his book *Assimilation and its Discontents*, Barry Rubin proposes some explanations for the assimilationist tendencies so prevalent among nineteenth- and early twentieth-century politically radical Jews, arguing that they believed in integration as a way to precipitate utopia, the arrival of the secular Messiah (133). Rubin argues that, for these figures, the escape from oneself as a Jew became a flight from self; Rukeyser differed insofar as she *did* return to the tradition rather than leave it behind. We can see her path of faith developing in her writing as early as 1949 in *The Life of Poetry:* "the sources of poetry are in the spirit seeking completeness" and "peace is completeness" (209). For Rukeyser, making peace meant fighting for justice, repairing brokenness, and thereby creating wholeness in one's self and in the world. Perhaps she did not know the connection between the Hebrew word *shalom*—peace—and the word *shalem*—complete or whole—but it seems to have gotten through to her by the zeitgeist.

Sociologists and political scientists have documented the insecurity and strong assimilationist tendencies of American Jews between 1945—the end

of World War II, their grief and shame from the Holocaust emerging—and 1968, when Jewish pride swelled, political activism increased, and identification with Israel intensified after Israelis won the Six-Day War in 1967. Charles Silberman describes the war as a watershed between two eras: "one in which American Jews had tried to persuade themselves, as well as Gentiles, that they were just like everybody else, only more so, and a period in which they acknowledged, even celebrated, their distinctiveness" (201). Concurrent in the decade of the Six-Day War was the rise, in the United States, of the civil rights and women's movements, both dramatically contributing to increased awareness of the significance of and strength in racial, ethnic, and gender identity.

Rukeyser's relative quietness as a specifically Jewish poet during the years between 1944 and 1968 certainly seems to parallel the path of American Jews as Silberman describes it, insofar as her poems continue to manifest a Jewish presence but do not speak as Jewish manifestos. In "This Place in the Ways," from her 1948 volume *The Green Wave*, the persona at an intersection "set[s] out once again . . . / from where I began: belief in the love of the world"; further down she precisely echoes the rage of the biblical prophets, finding "Rage for the world as it is / but for what it may be / more love now than last year" (*RR* 113). Here we see the faith in the possibility for transformation integral to Biblical stories. In a poem from the same volume, "Then I Saw What the Calling Was," Rukeyser hears "the voices of the wood" calling "Muriel!" Here she echoes the voice of God calling out to Adam in the Garden of Eden: "Where are you?" Adam offers excuses to God for not responding: "I heard your voice in the garden, and I was afraid" (Gen. 3:9–10). But in Rukeyser's poem, the calling was "the road I traveled," and she responds: "I came into my clear being; uncalled, alive, and sure. / . . . I offered and all was well" (*RR* 112). The impulse and necessity of response drives Rukeyser's poetry: the response of the poet to the world, and of the reader to the poem, are central to the process of poetry. In the last of her series of ten elegies, entitled "Elegy in Joy" and published in 1948, Rukeyser writes:

> Nourish beginnings, let us nourish beginnings.
> Not all things are blest, but the
> seed of all things are blest.
> The blessing is in the seed. (*OS* 105)

Her words seem to draw directly from God's speech to Abraham, echoing the beginnings, the seed, the blessing implied by the promise of the covenant: "I

will establish my covenant between me and you and your seed after you in their generations for an everlasting covenant, to be a God to you, and to your seed after you" (Gen 17:7). And the poem "The Place at Alert Bay," in formal verse, from her 1958 volume *Body of Waking*, affirms "Creation" as "A music to be resumed in God. / . . . / All forms to be . . . / Identified. Resumed in God" (*CP* 418). In this poem she invokes a "Tree of meanings" that resonates with the identification of the Torah as a "tree of life," and a "ladder of lives / Reaching to time" that evokes the image of Jacob's ladder. The Jewishness of Rukeyser's poems during these years is more subtle but marked, as all these passages show, by a language and ethic that are inseparable, rooted in the Hebrew Bible.

In 1960, Rukeyser's "Akiba"—commissioned by the Union of American Hebrew Congregations—began appearing serially in *American Judaism*. The timing is significant: the 1956 Suez Crisis assured Jews that Israel had the military strength to defend itself against combined Arab armies, and thus to become more than an eight-year experiment in statehood; the 1960 capture and extradition of Eichmann from Argentina, followed by his 1961 trial in Jerusalem, became a pivotal event that gave Israeli, American, and European Jews confidence to begin directly facing the horrors of the Holocaust in legal contexts, literature, and scholarship. By the time "Akiba" had become available to a broader American audience through Rukeyser's volume *The Speed of Darkness* in 1968, a dramatic shift had occurred in American Jewry, from shame born of the European genocide to pride in identification with the young, strong state of Israel that had survived the Suez Crisis and the Six-Day War. In *The Speed of Darkness*, Rukeyser marked "Akiba" as one of her "Lives" poems; a biographical, long sequence poem, it wrestles with themes urgent in her poetry from the beginning: risk and possibility, political and family history, the place of love and desire in social and political change, and witnessing the personal and historical moment. In "Akiba," though, these themes find roots in the ancient stories of the Israelites and Jewish tradition. Rukeyser includes a footnote to this poem, worth citing for what it reveals about the significance of Akiba's story to Rukeyser's own life:

Akiba is the Jewish shepherd-scholar of the first and second century, identified with the Song of Songs and with the insurrection against Hadrian's Rome, led in A.D. 132 by Bar Cochba (Son of the Star). After this lightning war, Jerusalem captured . . . Akiba was tortured to death at the command of his friend, the Roman Rufus. . . . The story in my mother's family is that we are descended from Akiba—unverifiable, but a great gift to a child. (*CP* 473)

Here Rukeyser, who began writing about the significance of "the unverifiable fact" in the early part of her career, honors it with faith in this biological, familial connection. Her Jewishness, this footnote claims, is not only a theology or history or culture, but it is in her blood.

For his writings and rabbinic teachings as well as for his activism, Akiba stands in tradition as a compassionate and wise leader and also as the rabbi who insisted upon the Biblical canonization of The Song of Songs. He is highly regarded as both a great advocate of the poor and a promoter of freedom of interpretation of *halacha*—rabbinic Jewish law. As one who gave legal authority to interpreters and students of Torah, his Talmudic decisions are still privileged above those of other teachers from his own time and beyond.

Rukeyser's poem about Akiba is composed in five sections: the first, *"The Way Out,"* recounts the story of the Exodus; the second, *"for The Song of Songs,"* celebrates not only the Biblical poem but also, implicitly, Akiba as the Jewish upholder of poetry for its own sake; the third, *"The Bonds,"* traces Akiba's biography, his path from a shepherd "who rages at learning" to his discovery of "the burning Word"; the fourth, *"Akiba Martyr,"* imagines the moment of Akiba's execution and its significance for Rukeyser; finally, the fifth, *"The Witness,"* brings the story of Exodus full circle, asserting Rukeyser's own accountability to both history and the future. Equally important in this last section is her invitation to us, her readers, to witness history with her and use it to transform the present.

With the first line of this poem, Rukeyser immediately alerts us that we are on Biblical terrain:

> The night is covered with signs. The body and face of man,
> with signs, and his journeys. Where the rock is split
> and speaks to the water; the flame speaks to the cloud;
> the red splatter, abstraction, on the door
> speaks to the angel and the constellations.
> .
> we hear the hoofs over the seethe of the sea. (*CP* 473–74)

By the end of the first stanza, she has invoked the blood the Israelites splattered on their doorposts to trick the angel of death, the Israelites' escape from Egypt, God's pillars of cloud and fire that guide the people in Sinai, and Moses drawing water from the rock. The details of the Exodus story suffuse this first section of the poem, including Miriam's singing and dancing after the Israelites' crossing of the Red Sea—"Music of those who have

walked out of slavery."[10] The language from "Letter to the Front" appears again: in that poem, Rukeyser warns, "If you refuse [the gift] . . . you choose / Death of the spirit"; in "Akiba" she imagines those who have "walked out of slavery. . . . refusing to accept the curse, and taking / for signs the signs of all things." The word "signs" harkens directly back to the signs God gave the Israelites in the Exodus story; in Deuteronomy, the Israelites are warned not to follow the "signs and wonders" of false gods (13:2). As Rukeyser's poem invokes the language of the Bible, so too does it interpret theology. "These dancers are discoverers of God," Rukeyser writes and, in the "slaves refusing slavery, escaping into faith," she recognizes those "who walked through the opposites, from I to opened Thou" (*CP* 474). In the Israelites' escape from slavery "into faith," they encounter what Martin Buber, in *I and Thou,* terms "full and complete relation"; that is to say, rather than separating "the world" from "God," they "include the whole world in *Thou*" (79).

In a short essay following the last serial publication of "Akiba," Rukeyser acknowledges the contribution of Buber's philosophy to the poem.[11] By the time Rukeyser came into knowledge of Buber's writing, she had been writing for nearly 25 years about the importance, to both poetry and politics, of relationship and dialogue. It is not surprising that, when Rukeyser did begin reading Buber, he seemed familiar to her. Like him, she worked to find a way of describing the unity she discovered among otherwise disparate arenas such as politics and spirituality. Religion for Buber carried no overtones of exaltation or ecstasy but referred to "all that is lived in its possibility of dialogue" (*Between Man and Man* 14). Buber wrote extensively of the *meeting* that occurred *between* "I" and "Thou," and some of his primary terminology recurs throughout Rukeyser's poetry: meeting, meeting-place, I, Thou, It, between, binding, signs, change. *Meeting,* for Buber and Rukeyser, does not remain stable over time but occurs in process, in the *between,* in the effort to go out toward an Other and recognize its full presence. Rukeyser fulfills that intention in "Akiba" by standing witness to the integrated political and spiritual life of the rabbi, being changed by it and, in turn, asking her readers to witness and be changed by her own poetry.

The second section of "Akiba" celebrates The Song of Songs, the great erotic love poem of the Bible that is also the only one not to mention the name of God. Akiba is known for having proclaimed, "All the Writings are holy, but The Song of Songs is the Holy of Holies." His argument for canonizing the poem prevailed over the rabbinic voices of his generation that found the poem's silence about God in face of the celebration of sexuality untenable and, therefore, determined that the relationship between the lovers must be an allegory for the relationship between God and Israel. Here,

Rukeyser recognizes Akiba's greatness for upholding the sacredness of poetry on its own terms, for its own sensuality, for recognizing the poem as The Song of Songs. Rukeyser affirms Akiba's vision:

> However the voices rise
> They are the shepherd, the king,
> The woman; dreams,
> Holy desire. (*CP* 475)

Desire is holy, and poetry affirming eros is holy enough to be canonized. As Akiba defended the Biblical book, so Rukeyser writes, "I defend the desire / Lightning and poetry." She proclaims, as strongly as he must have, that the poem is creation itself:

> This song
> Is the creation
> The day of this song
> The day of the birth of the world. (*CP* 476)

The desire of the lovers from The Song of Songs becomes the desire in this poem to "make / A way through the wilderness." In the song of desire, she seems to announce, God is rescued from being "hostage of hostages" and rises to the "Holy of Holies."

In section three, *"The Bonds,"* Rukeyser traces Akiba's life journey from shepherd to scholar and returns to her recurrent theme of the gift, acknowledging both the giver and the receiver:

> In giving, praising, we move beneath clouds of honor,
> In giving, in praise, we take gifts that are given
> The spark from one to the other leaping, a bond
> Of light, and we come to recognize the rock;
>
> We are the rock acknowledging water . . . (*CP* 477)

With the image from *kabbalah*—Jewish mysticism—of holy sparks emanating from vessels of creation, Rukeyser creates a bond between Akiba and herself, and later herself and her readers. She again places herself on Biblical terrain, in the moment when Moses draws water from the rock. She acknowledges not only the power of God to bring forth water from rock and, implicitly, God's bond with Moses and the wandering Israelites, but also the "rock *acknowledging* water, and water / Fire, and woman man, all brought

through wilderness" (*CP* 477, my emphasis). Thinking through Akiba's life with Biblical images leads her to elemental connections, the kind she recognizes in her poem "Islands," when she writes "O for God's sake / they are connected / underneath" (*RR* 256). In this biographical section of "Akiba," Rukeyser points to the signs of the Exodus story as a source for her refusal to separate "anything away from anything"—the giver from the receiver, the scholar from the poet, the sparks from each other. Relationship, as Anne Herzog argues, is central as a principle, a figure, throughout Rukeyser's poetry; here Rukeyser further elevates the significance of relationship with the word *bonds,* bringing to it the weight of the covenant, sacredness.[12]

Akiba was tortured and executed for practicing and teaching Judaism against the edict of the Roman emperor Hadrian and, in the fourth section of her poem, *"Akiba Martyr,"* Rukeyser imagines this event. Invoking the Jews' revolt against Hadrian, Rukeyser arrives at the essence of Akiba's legacy. He was willing to compromise

> In all but the last things. Not in the study itself.
> For this religion is a system of knowledge;
> Points may be abandoned one by one, but not the study. (*CP* 478)

She could well be speaking for herself with these words, for over and over she insists on study in an array of forms: by questioning, documenting, "searching," "breaking open," "pouring poems." The study for her never ended; even the last line of her last book of poems, *The Gates,* ends with questions:

> How shall we tell each other of the poet?
> How can we meet the judgment on the poet,
> or his execution? How shall we free him?
> How shall we speak to the infant beginning to run?
> All those beginning to run? (*RR* 266)

These lines could as well be about Akiba as about the imprisoned poet Kim Chi Ha. We see in them that, for Rukeyser, poetry is a way of inquiring, a way of learning and seeking answers—but not necessarily finding them, or finding final answers—that manifests her passion for the world. *The Gates*—book and poem both—ends with the previously quoted question about children, about the beloved and the future. When Rukeyser describes Akiba's resistance, she links his refusal to revoke studying directly to love and faith. In the poem, Rufus, the Roman general, asks Akiba if he feels pain from the

"iron rakes / Tearing through to the bone." Akiba replies, recalling the ancient words from Deuteronomy:

> "No. But there is a commandment
> saying
> Thou shalt love the Lord thy God with all thy heart, with all
> thy soul and with all thy might.

These words are central to Jewish liturgy, words that Rukeyser would have known since childhood. She goes on to assert Akiba's response to this commandment:

> I knew that I loved him with all my heart and might.
> Now I know that I love him with all my life."

Akiba answers the commandment and then takes it further, moving directly from the Biblical to the wholly personal, linking one to the other. And from this dialogue between God and Akiba, Rukeyser then makes a direct link between herself "in the time of confrontation" and Akiba in his moment of martyrdom:

> My hope, my life, my burst of consciousness:
> to confirm my life in the time of confrontation.
>
> The old man saying Shema
> The death of Akiba. (*CP* 478)

As she imaginatively remembers the death of Akiba, witnessing his life and death, she has her own "burst of consciousness" and moment of "confirming" her life, a term laden with religious overtones. The *Shema*, from Deuteronomy 6:4, commands the people to listen: "Hear, O Israel," it directs, and then it affirms: "God is our God, God is One." A Hebrew hermeneutic takes the last letter of the word "shema" (hear) and the last letter of the word "echad" (one) and spells the word "witness." For Akiba, being a witness to the love of God and to the religion meant becoming a martyr; indeed, the word "martyr" comes from the Greek for "witness."

It seems no mere chance, then, that Rukeyser titles the final section of this poem *"The Witness."* It opens with a series of questions: "Who is the witness? What voice moves across time . . . ?" and then makes a connection of immediacy between Akiba and herself: "Tonight the life as legend / Goes building a meeting for me. . . ." The poem itself serves as the "between," the

place where Rukeyser can *meet* Akiba and where he, in turn, can become present to her. However, as the poem draws to its conclusion, the "you" of the poem—initially the poet's address to Akiba—transforms to address Rukeyser herself and then broadens to include us, her readers. Suddenly *we* become the witness with her:

> You are the meeting.
> You are made of signs, your eyes and your song.
> Your dance the dance, the walk into the present. (*CP* 479)

Then Rukeyser seems to speak on behalf of us, as she circles the poem back to the language of its first two lines:

> All this we are and accept, being made of signs, speaking
> To you, in time not yet born.
> The witness is myself.
> And you,
> The signs, the journeys of the night, survive. (*CP* 479)

As in "The Gates," Rukeyser speaks here to the generations to come, invoking the mandate to witness history and heritage. In *The Life of Poetry*, Rukeyser writes of art: "It will apply to your life; and it is more than likely to lead you to thought or action, that is, you are likely to want to go further into the world, further into yourself, toward further experience" (26).

To witness God as Akiba does is to seek Akiba's response to life, to go both into oneself and toward further experience, to legitimize the power of poetry and, by grounding oneself in the particulars of faith, to become "total and unified." Drawing us in at the end of "Akiba," Rukeyser vows to accept Akiba's legacy and therefore to accept Judaism as a gift that, by insisting on and loving study, brings together "All the opposites, all in the dialogue."

In the 1944 sonnet "To Be a Jew," when Rukeyser writes of the gift as "[t]he whole and fertile spirit as guarantee," she invokes the spirit of Judaism itself, a path of searching and study that guarantees, or at least makes possible, freedom of the spirit. She understands the torment of the gift—whether it is "torture of the flesh," as Akiba suffered, or the inner torment of searching and desiring in a world devastated by wars—but also understands that refusing that gift is to invite inner devastation. If this sonnet leans toward being a love poem, as its Petrarchan form suggests, it is because the poem declares the potential for freeing the hostaged human spirit and the hostaged God: "Daring

to live for the impossible." It opens the way for the expression of faith Rukeyser discovers in writing the story of Akiba, faith that declares the "love of the world" suffusing her poetry (*CP* 264). While many poems in Rukeyser's oeuvre include and rely on Biblical and Jewish imagery, history, and tradition, "Akiba" appears as a response from a later period of Rukeyser's life and career to an earlier one, the developed exploration of the proposition that being Jewish is a gift. In Akiba she finds a Jew who loved God "with all the heart, all passion;" Akiba embodied the possibility not only of evolving from one who "rages at learning" to one who upholds the virtue of learning, but also the possibility of witnessing. At the end of "Akiba," Rukeyser echoes her ending of "Letter to the Front," in which she writes about "Beginning with signs of belief." In "Akiba," she addresses "You," and it is hard to discern whether she is writing in the voice of Akiba addressing his followers, or in her own voice addressing us, her readers—likely both:[13]

> You who come after me far from tonight finding
> These lives that ask you always Who is the witness—
>
> Take from us acts of encounter we at night
> Wake to attempt, as signs, seeds of beginning (*CP* 479)

As an American, as a woman, and as a poet, Rukeyser knew that her Jewish heritage did not provide the only path on which to find a spiritual guarantee. But she felt the imperative to search for religious ancestors. She felt, "if one is free, freedom can extend to a certain degree into the past, and one may choose one's ancestors, to go with their wishes and their fight" ("Under Forty" 8). Indeed, witnessing, as she articulated it in the story of Akiba's life, was a driving and crucial force throughout her life and her poetry. To be a Jew, Rukeyser understood, is to be history's tragic survivor. Yet it is also to act and write from the hope and faith that human beings can be "seeds of beginning" who, as she writes about the prophet Miriam, "dance the dance, the walk into the present" (*CP* 479).

Notes

1. Rukeyser initially published "Akiba" serially in *American Judaism* magazine from April 1960-April 1961. The full poem later appeared in her 1968 volume *The Speed of Darkness*.
2. For American Jews, as Charles Silberman describes in his sociological study of contemporary American Jewry, *A Certain People*, the 1930s offered a world with informal but firm quotas and restricted opportunities: "Jews saw themselves (and were seen by others) as outsiders. Where we lived, where we

worked and at what occupation or profession, even where we played (for the ball fields in New York City's Central Park were divided into Jewish and non-Jewish turf) were affected, and often determined, by what 'they' (non-Jews) would allow" (22).

3. In addition to Rukeyser, the writers included were Alfred Kazin, Delmore Schwartz, Lionel Trilling, Ben Field, Louis Kronenberger, Albert Halper, Howard Fast, David Daiches, Clement Greenberg, and Isaac Rosenfeld.

4. Ben Field declared, similarly to Rukeyser: "The keystone of my ideology, which is a devotion to the cause of the common man, is in the spirit of true Americanism and Judaism." Field attempted to link similar aspects of the two: the Declaration of Independence and the "prayer of the Jew who asks the Lord to raise the needy from the dunghill"; and Lincoln and Hillel, "both of whom labored with their hands in their youth and were woodcutters" (20).

5. William Rukeyser, personal interview, 30 December 1991.

6. Is it, perhaps, part of her commentary to have called the Reform Movement "reform*ed*"?

7. William Rukeyser, personal interview, 30 December 1991.

8. Jane Cooper, personal interview, 10 June 1991.

9. William Rukeyser, personal interview, 30 December 1991.

10. In her sequence "Searching / Not Searching" (*CP* 498), Rukeyser devotes the second poem, "Miriam : The Red Sea," to the prophet Miriam. Speaking in her voice, the poem remembers the Israelites' crossing of the Red Sea and the drowning of the Egyptians. Miriam, the one who in the exodus led the singing and dancing after the escape from Egypt, here speaks in a somber, solitary, and determined voice: "I alone stand here / ankle-deep / and I sing, I sing, / until the lands / sing to each other.

11. Rukeyser cites "the works of Martin Buber, particularly Faith and Judaism, and Teaching and Deed, in *The Writings of Martin Buber*, edited by Will Herber, Meridian Books, New York, 1956; and Buber's *Moses*, Harper Torchbook edition, 1958; Maurice S. Friedman's *Martin Buber: The Life of Dialogue*, University of Chicago, 1955; articles in the Encyclopaedia Britannica (especially the 11th edition) and the Jewish Encyclopaedia . . ." She also notes, "The first poem, 'The Way Out,' takes its material from stories of the Exodus and the desert, of American history and our own times" (*American Judaism* April 1961:13).

12. See Herzog's essay "'Anything Away from Anything'" in this volume. The phrase "Anything Away from Anything" comes from the conclusion of Rukeyser's 1974 Barcelona memoir, "We Came for the Games."

13. In her 1961 note on "Akiba," Rukeyser writes, "In 'The Witness,' we come again from these scenes to our own lives, with the knowledge of the past—of this one life, with its development and transformation, its teaching, the belief in Bar Kochba, the death; and then oneself as the one witness to what has been given to us" (13).

Adrienne Rich

Beginners

The two best-known poets of the nineteenth-century United States were a strange uncoupled couple, moving together in a dialectic that the twentieth century has only begun to decipher. Walt Whitman (1819–1892) and Emily Dickinson (1830–1886) were both "beginners" in the sense of Whitman's poem:

> How they are provided for upon the earth (appearing at intervals)
> How dear and dreadful they are to the earth,
> How they inure to themselves as much as to any—what a paradox appears their age,
> How people respond to them, yet know them not,
> How there is something relentless in their fate, all times,
> How all times mischoose the objects of their adulation and reward,
> And how the same inexorable price must still be paid for the same great purchase.

Whitman's "beginners" aren't starters-out on a path others have traveled. They are openers of new paths, those who take the first steps, who therefore can seem strange and "dreadful" to their place and time ("dear" can mean "beloved" but also "costly," a sense echoed in the final line above). To "inure" means to "accustom yourself to something difficult and painful." Whitman also uses "inure" in the sense of "inhere" or "belong," as in:

> All this is thenceforth to be thought or done by you whoever you are, or by anyone,

These inure, have inured, shall inure, to the identities from which they
sprang, or shall spring.

These "beginners" cost difficulty and pain to themselves as well as to oth-
ers, in whom they arouse strong feelings yet by whom they remain un-
known—their age feels paradoxical because of their presence in it. The
appearance of the beginner is a necessary, even a "relentless," event in human
history, yet these persons appear as misfits, are not what "the times" adulate
and reward. Both the person and the times pay a price for this, yet the be-
ginner is "provided for"—part of the longer scheme of things.

Whitman and Dickinson shared this problematic status as white poets in
a century of slavery, wars against the Indians, westward expansion, the Civil
War, and the creation of the United States as an imperial power. In terms of
their social origins and their places in the social order, the two shared little
beyond white skin. The woman—daughter of a lawyer, legislator, and trea-
surer of Amherst College, raised in a home with Puritan roots and Irish ser-
vants, briefly attending a female seminary, dropping out to keep house for
an ill mother, rarely leaving the village of her birth or even her father's
house—might seem the very type and product of the mid-nineteenth-
century's diagram for patriarchally protected middle-class femininity, mar-
ried or not. The man—son of a Puritan farmer-carpenter and a
Dutch-Welsh mother, educated in the Brooklyn public schools, turned trav-
eling journalist, journeyman printer, war correspondent, and field nurse,
rambler from Niagara to New Orleans—might seem one paradigm of "New
World" masculinity, the stock of explorers, pioneers, frontiersmen, allowed,
as a male of northern European/Anglo origins, the free expression of his per-
sonality in an expansive era.

And so they have come down to us, as reclusive, compressed Emily and
all-hailing, instinctual Walt, white dress and neck-ribbon, shaggy beard and
wide-brimmed hat. For Dickinson, the private life, intense, domestic, mi-
crocosmic; for Whitman, the "kosmos," the "democratic vistas" of the urban
panorama, the open road, *the middle range of the Nineteenth century in the
New World; a strange, unloosen'd, wondrous time.* For Dickinson, a father's li-
brary, letters as link to the world, poem itself as "letter," books as metaphors
for and lines into experience, life itself as "Primer" to the "Book" of eternity:

He ate and drank the precious Words—
His Spirit grew robust
.
And this Bequest of Wings

Was but a book—What Liberty
A loosened Spirit brings—

For Whitman, a world of newspapers and printshops, city wanderings, casual sexual encounters, Civil War hospitals, and always his suspicion of printed texts, of the failure of the dictionary, the published history or biography. *I cannot divest my appetite of literature, yet I find myself trying it all by Nature; The real war will never get in the books; What is it that you express in your eyes? It seems to me more than all the print I have read in my life.* The poem as *national* product, engendering the heroic identities of a democracy: *Without yielding an inch the working-man and working-woman were to be in my pages from first to last.* For Dickinson, several anonymously anthologized poems, the rest enclosed in letters, stitched into sequences stored in a bedroom chest. For Whitman, the 1855 edition of *Leaves of Grass*, no name on the title page, the poet's open-shirted likeness as frontispiece, his authorship revealed in the text of the poems. Dickinson: *Renunciation is a piercing virtue; No is the wildest word we consign to language.* Whitman: *I celebrate myself . . . one of the roughs, a kosmos / Disorderly fleshly and sensual, eating drinking and breeding.*
For Dickinson:

On my volcano grows the Grass
A meditative spot—
An acre for a Bird to choose
Would be the General thought—

How red the Fire rocks below—
How insecure the sod
Did I disclose
Would populate with awe my solitude.

For Whitman:

Through me forbidden voices,
Voices of sexes and lusts, voices veil'd, and I remove the veil,
Voices indecent by me clarified and transfigur'd.

Didn't they seem to fit their age, though, these "beginners"? Didn't they seem to act out precisely the charted roles, the constructions of white, middle-class masculinity and femininity that suited the times? Were they really "beginners," then, or just polar incarnations of a nineteenth-century sexual dualism?

Both took on North America as extremists. She from her vantage point: female, New England, eccentric within her world, not the spinster servicing the community, but a violently ambitious spirit married to the privacy of her art. He from his vantage point: male within a spectrum that required some males to be, like Dickinson's father, stiff-collared wardens of society, while allowing others to hanker, ramble on open roads. Both showed masks to the world: behind her acceptable persona of gingerbread-baking self-effacement, a woman artist remaking poetic language; the metaphysical and sensual adventures of her poems; and what Muriel Rukeyser called "her unappeasable thirst for fame."

I tie my Hat—I crease my shawl—
Life's little duties do—precisely
As the very least
Were infinite—to me— . . .

To simulate—is stinging work—
To cover what we are
From Science—and from Surgery—
Too Telescopic Eyes
To bear on us unshaded—
For their—sake—not for Ours—
'Twould start them—
We—could tremble—
But since we got a Bomb—
And held it in our Bosom—
Nay—Hold it—it is calm

He, behind the persona of shape-changing omnipresence and "personal force," socially vulnerable as a poet breaking with Puritanism in a mercantile, materialistic nation less than a century old, sexually vulnerable as a frankly desirous man attracted to men.

At the end of the twentieth century these two poets are still hardly known beyond the masks they created for themselves and those clapped on them by the times and customs. Our categories have compressed the poetic energies of the white nineteenth-century United States into a gendered opposition: a sensual, free-ranging, boastful father and a reluctant, elusive, emotionally closeted mother—poetic progenitors neither of whom had children of the flesh. (Whitman boasted of his but clearly never knew who or if they were; Dickinson remains an ostensible daughter to the end.)

Yet that woman and that man *were* beginners *(we know them not):* the woman choosing her inner life and language over inconvenient domestic,

social, and literary claims; the man overriding Puritan strictures against desire and insisting that democracy is of the body, by the body, and for the body, that the body is multiple, diverse, untypic. .

They were a wild woman and a wild man, writing their wild carnal and ecstatic thoughts, self-censoring and censored, as the empire of the United States pushed into the Far West, Mexico, the Caribbean. He cannot possibly have heard of her unless he chanced to meet one of her rare sponsors (like the novelist Helen Hunt Jackson, hater of the Empire, who wrote *A Century of Dishonor* about the white destruction of Indian cultures and, in a letter, told Dickinson: "You are a great poet"). *She* allowed only that she'd heard his poems were "immoral." In the United States, on this enormous continent, poetry has been a strange crossroads, where poets often pass each other by dawn or twilight and do not know who they are passing.

But the wild woman and the wild man are Americana now: folded into textbooks, glossed in exhaustive scholarly editions. And the protagonist of Maxine Hong Kingston's extraordinary novel *Tripmaster Monkey* is a young Chinese-American poet named Wittman Ah Sing, who reads poetry aloud to the passengers in the buses of San Francisco.

Twenty-one years after the death of Whitman, twenty-seven years after the death of Dickinson, another poet is born. Her name is Muriel Rukeyser.

———

What happens when, the year before the outbreak of World War I, a girl is born into an urban, tempestuous, upwardly mobile, contradiction-ridden, Jewish family? What happens when, at twenty-one, her first book of poems is published, the year is 1934 around the world, and the title of the book (derived from a piloting manual) is *Theory of Flight?* When the first poem of that book is already big, assured, panoramic, accomplished, drawing on techniques of film, yet unflinchingly personal? What happens when that young woman pushes off the class ambitions she was raised in (*I was expected to grow up and become a golfer*), breaks with her family, to move deeper into her country, her world, her century? When, neither asexual nor self-diminutizing, she affirms herself as large in body and desire, ambitious, innovative; travels to crucial political scenes, in Spain and the United States, as working journalist and poet; learns to pilot a plane; works in film; feels in her imagination the excitement of the lost connections between science and poetry? When her work as a poet continuously addresses the largest questions of her time—questions of power, technology, gender—in many forms: elegies, odes, lyrics, documentary poems, epigrams, ballads,

dramatic monologues, biographical narratives? What happens when a woman, drawing on every political and social breakthrough gained by women since Dickinson's death in 1886, assumes the scope of her own living to be at least as large as Whitman's?

Add to this that she writes three major biographies—a life of the "father of American physics," Willard Gibbs; another of the English Renaissance naturalist, mathematician, navigator, astronomer Thomas Hariot; a book about the 1940 U.S. presidential candidate and compromised visionary Wendell Willkie—screenplays, essays, translations of poetry; a haunting documentary novel about sexuality and ritual, *The Orgy;* and a study of our national imagination, *The Life of Poetry.*

She is our twentieth-century Coleridge, our Neruda, and more.

What happens? She falls between the cracks. Her books do not have to be burnt.

In *The Traces of Thomas Hariot* she wrote of her subject as *a lost man who was great. And if he is great, what is his greatness? If he is great, why is he lost?* She describes Hariot as *caught . . . in all the heresies of his time, scientific, political, philosophical, sexual . . . a rebel who appears to fail at every climax of his life. He can be seen to go deeper at these times.* She was also touching a finger to the pulse of her own reputation, her own development.

In an interview late in her life, Rukeyser said:

One of the attacks on me for writing that Hariot book spoke of me as a she-poet—that I had no business to be doing this, and I was broken for a while and looked out the window for awhile. And then I thought, yes, I am a she-poet. Anything I bring to this is because I am a woman. And this is the thing that was left out of the Elizabethan world, the element that did not exist. Maybe, maybe, maybe that is what one can bring to life.

————

It is by a long road of presumption that I come to Willard Gibbs. When one is a woman, when one is writing poems, when one is drawn through a passion to know people today and the web in which they, suffering, find themselves, to learn the people, to dissect the web, one deals with the processes themselves. To know the processes and the machines of process: plane and dynamo, gun and dam. To see and declare the full disaster that the people have brought on themselves by letting these processes slip out of the control of the people. To look for the sources of energy, sources that will enable us to find the strength for the leaps that must be made. To find sources, in our own people, in the living people. And to be able to trace the gifts made to us to two roots:

the infinite anonymous bodies of the dead, and the unique few who, out of
great wealth of spirit, were able to make their own gifts. Of these few, some
have been lost through waste and its carelessness. This carelessness is compli-
cated and specialized. It is a main symptom of the disease of our schools,
which let the *kinds* of knowledge fall away from each other, and waste knowl-
edge, and time, and people. All our training plays into this; our arts do; and
our government. It is a disease of organization, it makes more waste and war.

Presumption it is to call it a disease, to say that it is one of the reasons
Gibbs was lost, and the main reason he has not been found.

Lost, I say, and *found;* but he was never lost. It was that he has not reached
far enough to meet him.

Rukeyser herself was never literally lost. In her lifetime, she was some-
times the target of extraordinary hostility and ridicule, based on a critic's fail-
ure to read her well or even try to understand her methods: often, during the
1940s and 1950s especially, because she was too complicated and indepen-
dent to follow any political "line" or because she would not trim her sails to
a vogue of poetic irony and wit, an aesthetics of the private middle-class life,
an idea of what a woman's poetry should look like.

Rukeyser lived and worked through a period of general political discon-
tent in the 1940s and 1950s—disillusionment with Stalinism leading to a
blind hatred of Marxism for some ex-Communists, compounded by FBI
and McCarthy Committee persecution of suspected Communists and "fel-
low travelers." At the same time, white and male middle-class poets, espe-
cially in the northeastern United States, were being hired into the
universities as writing teachers, while university-trained scholar-critics were
replacing poets as the interpreters of poetry. Rukeyser's books were praised
by a range of her peers. Through her mature life she was recognized with
those grants and honors that she called "the toys of fame." But in the history
of poetry and ideas in the United States—always difficult to grasp because
of narrow definitions, cultural ghettos, the politics of canon makers—she
has not been seriously considered in the way that, say, the group of politi-
cally conservative white southern poets known as the Fugitives or the gener-
ation of men thought to have shaped "modern poetry"—Ezra Pound, T. S.
Eliot, William Carlos Williams, Wallace Stevens—have been considered.
Her thought remains unintegrated into our understanding of the poetic cur-
rents, the architectonic shifts of the twentieth century. Her poetry not only
didn't fit the critical labels, she actually defied the going classifications, de-
claring them part of the "disease of our schools."

She was a woman who wrote—as a sexual woman and as a Jew—un-
apologetically. The chartings of modern poetry were the work not just of

men, but of Anglo-Saxons and Christians. She never thought of herself as making an academic career, with its fragmentation into periods or "fields" of all she sought to connect. So those who think in such patterns may have had difficulty reading her. She was never literally lost, but we have still to reach her.

———

How do we reach her? Most of her work is out of print. Poets speak of her, but she is otherwise barely known—least of all for her biographies, which in their visionary scholarship put to shame the genre as it's generally practiced today. Included in a major current college anthology, her poems are preceded by patronizing and ignorant commentary: "To be absolutely contemporaneous was the aim of Muriel Rukeyser. . . . Her first volume, *Theory of Flight* (1935), displayed her knowledge of aviation. . . . Her poems seem to arise from her like natural growths." Well, Whitman and Dickinson have suffered like silliness and cluelessness in popular anthologies, both in terms of commentary and of selection.

Rukeyser was immersed in history, science, art, and the Western poetic tradition. She revised her poems furiously, was a memorable teacher of poets. How should it be necessary to say this here? Had a man of her class and background put forth this kind of lifework in scholarship and theory along with poetry, would it be so difficult to embrace his achievement, to reach him?

We reach her, of course, as we reach all poetic resources blocked from us by mindless packaging and spiritless scholarship. We reach her by recognizing our need for her, by going to libraries and taking out volume after volume, by going, finally, to the crossroads—of poetry, politics, science, sexuality—and meeting her there, where she waits, reaching toward us.

Richard Howard

A Sibyl of 1979

The river lay white that afternoon, the highway too—
 apparently frozen to a standstill.
Muriel Rukeyser hobbled to her high window,
 standing beside me, both of us looking
down at the big meat-trucks parked on West Street, empty now
 but not as they would be after dark, men
furtively climbing in and out, walking away fast.

"Do you ever go to the trucks, Richard—go inside?"
 her voice close to my ear, low, determined.
The question, its very tone took me by surprise: so
 she knew what that meant, *going to the trucks*—
even in the dead of winter, the cherished, feckless
 secret of many who still persisted . . .
And even if she did know, the question surprising:

were we on those terms? What terms? "Dangerous, isn't it—"
 the voice persistent as she took my arm
"doing . . . what you do, inside there?" Staring down at them,
 I told her I never went to the trucks.
"I'm glad. That's not a judgment, only relief. Only
 my own cowardice, really . . . Dear Richard,
I asked you here because I want to give you something

you may be able to use. I can't. When they sent me
 home from the hospital, after my stroke,
it was right here, this computer-thing: supposed to be
 helpful because it changes what you write
so easily, so easily restores what you change . . .
 I tried it a while, but it doesn't work
for me: I don't need to change things so much any more,

not the way you do, my cautious friend. I'm past changing."
 About the trucks nothing more was said, and
I took the virtually virgin computer home
 and plugged it in. Nothing occurred, until
a few days later, my fingers "wandering idly"
 (just as in Sir Arthur's *Lost Chord*!) over
the unresponsive keys, these sentences appeared, words

she had abandoned, "past changing" now: *No thought wakens
 without waking others . . . There is one proof
of ability, only one: doing it! . . . The more
 you love yourself, the more you are your own
worst enemy . . . Seers don't need to be observers . . . We keep
 learning—involuntarily, even—
and finally we learn to die.* Muriel learned, and died,

but reading her words the screen retained—sortilege? poems?—
 I faltered: time was, if you lost even
a tenth part of the Sibyl's leaves, you too would be lost . . .
 Was now the time when if you kept even
a tenth part you were saved, as a frightened man is saved
 by words? *You will not be deprived because
your dreams did not come true, but because you never dreamed.*

The Sibyl, Petronius reports, could not die, only
 wither away until she was so small
she survived in a leather bottle, pleading for death.
 Muriel's bottle was her own body;
I bring her words up on that pale, superseded screen
 where they glow like omens, benefactions:
Everything you really possess was given to you.

*

A post-script, seventeen years afterwards. The gift
 I bring would be quite as bewildering
to you as that computer: what would you make, Muriel,
 of a CD claiming to reproduce
(on the right contraption) *The song of the Sibyl*—words
 the very ones Aeneas might have heard,
music from as late as the Tenth Century? . . . My offering.

Part II

◆◇◆◇◆◇◆◇◆

Activism and Teaching

Elaine Edelman

"Were we all brave, but at different times?": A Student Remembers Muriel Rukeyser

I can still see Muriel Rukeyser as she was in 1959, the year I took her English Literature seminar at Sarah Lawrence College. She was a large, handsome woman in her mid-forties, superbly calm—though if you'd read her poems, you knew it had cost her. She would cruise down the campus's curving paths between dogwood trees and red-brick Tudor-style buildings with the ease of a great ship, her large head set slightly forward of her bulky body, seeming to part students and faculty, air and weather smoothly to either side. Her face open and eager as she came toward you, wanting to know who you were. And a sense of gaiety, often, and of physical exuberance barely restrained that made you half expect this imposing figure in her blue or black all-season dress to break out in a quick, syncopated dance step for a moment. But there could be heavy weather, too, in the dark eyes under flame-shaped, black brows that looked out so intently—at you, at anything. (*The hawk's fierce alone look,* she wrote in a poem not directly about herself.)

And around her the swarm of identities and mythologies: she was the famous poet, a diva on the all-star faculty; she was the left-wing radical, a veteran of the major social and political wars of her time, who'd walked through fire during the McCarthy period; and she was—not least—the unwed (outlaw) mother who'd disobeyed a basic rule and was raising her son on her own, taking her lumps.

I signed up for her course wanting to work on my poems. But I'd never met anyone like Muriel before. She had real beliefs, real principles. *The work that a poem does,* she'd written, *is a transfer of energy, and I think human energy may be defined as consciousness, the capacity to make change in existing conditions.* It was a clear voice, sure of itself and its values in a time when various "official" languages seemed to muffle or dismiss most real issues. As for making a poem—that "transfer of energy"—Muriel hardly thought it a "ladylike" business. *Work on the poem is work on the self of the poet,* she'd said, setting a huge moral task, far beyond aesthetics.

It was the kind of task I was looking for, evidently. This was my senior year; come summer, I'd have to go into the real world, and I was nervous as hell about it. The traps, especially for women, seemed everywhere. But Muriel—this woman-rebel-poet who took herself and her work as seriously as any man I knew of—appeared to have sprung a lot of them. She was not my mother nor the mother of any of my friends. She seemed brave, and I wanted to learn how to be brave. I probably studied Muriel that year as much as I studied with her. After I graduated, we stayed in touch—in and out of touch—until her death in 1980. And if in those 20 years we were sometimes almost friends, I was never not her pupil.

There were 13 students—mostly seniors—in her idiosyncratic "Orlando" seminar, meeting once a week in a second-floor classroom above the sculpture and painting studios. We were young and fairly raw, sporadically brilliant but essentially tame teenagers sitting around an oblong wooden table with this impressive "she-poet" who'd had her first inside view of jail nearly 25 years earlier (when she was about our age) at the Scottsboro Nine trial. She'd continued to live in the large world of issues and action, witnessing the start of the Spanish Civil War and reporting on West Virginia miners suffering from silicosis. She had taken enormous personal risks when that was unthinkable for most women—was, in fact, punishable. (She told us none of this; it was in her poems and in her prose work *The Life of Poetry.*) In all, Muriel was heady stuff, certainly for me, age 19, from suburban Dallas.

Muriel took up a lot of space in our classroom—not because of her size, but her force. Leaning forward over the conference table, her small, thick hands opening and closing against each other, she would alternately coax and command us to meet her head-on concerning Spenser or Hardy. Energy poured from her, smoky and warm. It moved in waves across the face that came forward out of wiry, black hair casually swept aside. It broke open in the delight that would suddenly take her over and could escalate at the slightest excuse into head-back, sometimes bawdy, laughter—or slide into something quite different, a grin, canny and troubling in its ambiguity, as though she were tuned to some cosmic joke that she generously (but often wrongly) assumed the rest of us also caught. When she spoke, her voice

poured a rich, thick crooning. And when she stood back from the table to read aloud (as she liked to do), her voice would go deeper and darker, toward chanting and keening. She listened with the same intensity. When one of us students struggled with something elusive or found words that flashed an insight, Muriel's whole being seemed to stop and listen. Words, her attention to them said, were precious. So were we. She made clear early on that she expected a lot from our sessions.

Nevertheless, there would be flashes of something else—a storm, fairly quickly eclipsed; and her face, afterward, open in a different way, with a look of complicity and warmth that said, Yes, that was real, I also struggle with demons.

I saw those demons outright only a couple of times. Once, near the start of that first semester. It was early November, as I recall; a dull, gray day, the sky hanging down in thin strips. From where I sat at the table, all that was visible outside the windows were the empty twig-tops of three dogwood trees on a nearby hill.

By this time we'd read some early English lyrics and a few of the songs of Campion and Waller, and probably had skipped forward into nineteenth-century poems. The course, heavy on poetry, consisted of Muriel's personal pickings from English literature, using Virginia Woolf's novel *Orlando* as the frame for and bridge to the past. Though we touched many of the bases of any English Literature survey, mostly we followed themes and images, ignoring predictable "meanings" to watch figures of voyage and search, pilgrim and seeker persist through their changes from period to period, author to author. Images out of Beowulf, for instance, transformed in Raleigh or Wordsworth. Ideas from a mystical text such as "The Cloud of Unknowing" echoed in Blake or Hopkins.

Our classes were mostly free-wheeling talk—that was the college's style then. Though other teachers sometimes sneaked in a lecture, Muriel never did. Nor did she take texts apart or teach anything like conventional literary criticism. *All the answers come as new questions,* she'd written; her teaching believed that. She might point out things to look for in a work, but she offered few judgments. She asked a thousand questions.

Still, she set the terms more powerfully for being indirect and allusive, using the Zen-like stories and paradoxical anecdotes that she loved to convey what was most important. One thing was clear: this course wasn't about something fancy or distant or containable under the narrow rubric of "literature." It was about survival—each poem and play and novel was a personal, urgent matter, revealing an imagination's transactions with its era, using the past or taking a stand against it, either breaking through the dead conventions to make new life, or failing and dying out. "What is the world like with this work in it?" was her basic lit-crit question. Along with its corollaries:

What does this work make happen in you, and what can you make happen from it?

In the session I'm remembering here, we were getting into a poem in a new way: simply reading it aloud, again and again, each girl taking a turn around the table. A sonnet by Keats—or was it Shelley? But something wasn't working, and Muriel soon stopped whoever was reading, asking another student to go to the window, describe this living day. I can't remember who the girl was who slouched out of her hard-backed chair to the window side of the room, only the look on her face—vague and terrified.

She stood looking out. "I see dead trees," she started, hopelessly. Abruptly, Muriel scraped her own chair back from the table and walked heavily toward the windows. She looked out for a second, then squared off toward us, blocking a chunk of the light. "The trees are not dead," she announced, laying each word out, separately, precisely, on the table between us. Her face was dark, her voice barely contained its anger, almost rage. She turned toward the unlucky girl. "Look again," she commanded quietly.

It was an awful moment. I'm still ashamed at how relieved I felt to be hidden back at the table as the room suddenly constricted around the poet's demand, "Look again." Let the girl at the window swim, swim for her life, I thought. I'm not sure how we got through the rest of the session. Muriel probably told us to go outside after class and get to know a tree or two for ourselves, then shifted the mood without undercutting the importance of what had happened.

Were we all brave, but at different times?—her line, one of the many I'd memorized by now. I didn't know how to protest directly, so I wrote a letter. It took me two days. I told Muriel any one of us could have answered as badly as that girl, including me, and I felt she'd been unfair and harsh. Protesting didn't come naturally to me; now I wonder if Muriel, herself, who generally showed so much care for fairness, had brought me to it. I slipped the letter under her office door. A few days later, she phoned my dorm, asking me to come to see her.

Her door stood open when I got there. Her narrow office was dim, the overhead light turned off. I arrived armed with a dozen retractions and apologies, but the shadowy figure who swiveled away from her desk and motioned me to the chair beside it held up her hand against that. She leaned forward to look into my face for a moment. Her own face looked tired, dark pouches under her eyes. But she didn't seem angry at me (as I'd expected). She talked. She talked in a general way about reading and writing, the worlds outside and the worlds inside our heads. I was too nervous to take much in, and our meeting didn't last long. She handed back my letter—refolded in thirds—saying, "Yes." Then her head and shoulders drooped for-

ward slightly, but when she stood up to let me leave, her smile was clear again. She laid her hand on my arm and thanked me.

I saw that generosity in Muriel many times over the years. *Whatever can come to a woman can come to me,* she wrote in "Waterlily Fire," acknowledging that she too was subject to the natural cataclysms and, more importantly, to every emotional and spiritual failure. She acted this out most courageously in the exposed, public place of her poems, saying "we" whenever she wrote of weakness. Years later, for instance, her poems against America's part in the Vietnam War stood out for her ability to identify with those she opposed. *We did not know we were insane / We do not know we are insane.* She included herself as usual among the sick and wounded who turn our inner wars into outward violence. *Waking this morning / a violent woman in the violent day / . . . today once more / I will try to be non-violent.*

Look again. For all her permissive teaching style Muriel insisted on certain facts: the facts of trees and seasons, the factual aspects of a work of art, the facts of dreams and fantasies. All are true, but make distinctions. That's one way of describing her politics, I think: Know the different kinds of real. In class, it translated as: look, listen, feel for the differences, and let yourself respond—honestly, free from a priori notions. And with a work of the imagination, dive in and bring it back alive, into yourself and your own time, to see if it makes the world different. There were no right or wrong answers, but she wouldn't abide the careless ones, born of habit or laziness or routine. And when these, inevitably, came, she demanded that we look again.

It took me a while to catch on to the fact that Muriel wasn't "teaching books." She was trying to shake us loose from sloppy reading and sloppy seeing, and teaching us to teach ourselves. One of her favorite devices was the surprise paper, written during class. She'd toss out a subject—always an odd take on what we'd read—grinning, curious to see what we'd do with it, letting us know that *she* knew we felt on the spot, was having some fun putting us there, and that the matter wasn't earthshaking.

I particularly remember one sequence of two papers. We'd just finished reading the story of Peredur (Percival) in *The Mabinogion,* a gathering of Celtic, pre-Arthurian tales, and had gone on to study how T. H. White handled the same figures and images in his modern novel *The Once and Future King.* Muriel started class that day by asking us to jot down all the items crowding Merlin the magician's laboratory as White had described it. When we went around the table comparing notes and she discovered I'd written only two or three things, she laughed and said how "typical" that was of me, but in such an affectionate tone that I couldn't feel bad. In the next session, she asked us to explore Merlin's theory of education, according to White (in brief: to study a fish, become a fish; to learn a flower, become one). This was more my meat, and I wrote nonstop until quitting

time (and got good reviews for my effort). Such papers weren't about grades; they were meant to show us ourselves. These two, for instance, made a clear point, if a different one for each of us. I'd seen a strength, but also a crucial weakness in the way I read and knew what I needed to do. A useful lesson. Or, as Muriel put it another time in a totally different context (and perhaps making up her own Zen koan): "After ecstasy, the dishes."

Two years after college, I moved to New York City and stayed in touch with Muriel from then until her death. "Come to me," she'd say on the phone, her voice focused and meaning it. But she was busy: her daily writing, her teaching and public readings, and, as the 1960s and the Vietnam War ground on, the meetings, marches and frightening acts of civil disobedience, while her draft-age son went into exile in Canada. She put off our meetings again and again. Finally, I'd go to see her in one of her ever-changing apartments, to drink white wine while Muriel had a glass or two of her "Irish." I remember a faded green couch, rubbed gray along its back and arms, and comfortable, nondescript chairs and a dining table. But mostly books—in double rows in the ceiling-high bookcases, stacked on tables, on the floor, at the sides of the couch: fat, nonfiction hardcovers about psychology and history and thin volumes of poetry. And piles of manila folders: research for the biography she was working on, pages of her own poems, and the poems of the young and older poets who asked—and usually got—her response. She seemed to change apartments every few years, and as the green couch and chairs were fit into ever smaller and less comfortable spaces, or into apartments in less convenient (i.e., cheaper) parts of town, I imagined poverty chasing her. Maids and chauffeurs had appeared in a rare note about her childhood in *The Life of Poetry*, but she spoke, vaguely, of "disinheritance." She was still getting grants and winning poetry prizes, but she had no ongoing job, no "safe place" in academia (nor, I think, did she want one). Her books kept coming out, but the reviews were mixed and some were nasty, attacking her for writing poems that were too "personal" (though they were rarely literally autobiographical). Only with the women's movement of the late 1960s and the 1970s did critics catch on to and value the rebellious and "female-centeredness" of her work, and this brought her her best readers in decades. Erica Jong called her "the mother of us all" (though when Muriel quoted this to me she seemed less than comfortable with it).

We'd meet in the late afternoons, after I got off from work and Muriel had finished her writing day. I'd try to make my glass of wine last, to keep clearheaded, as I looked through the xeroxed sheaves of her new poetry and Muriel settled into the couch. Our glasses shone in the light, the cheese and crackers came on a pretty plate with a handsome serving knife—she liked her few pretty things. I wanted to hear about *her*, how she handled some of the practics of life; I needed some wise guidance on the minor and absolute

problems of being in a city like New York, earning a living and making a writing life. Instead, she usually focused on me: my various jobs in documentary film-making and public affairs TV, my men friends, my intermittent crises. Then she'd lay my new poems across the valley her skirt made between her spread knees and make pencil marks ("nice") or circles ("diction?") on the pages, occasionally writing in her bold looping hand across the top of one, "superb."

And sometimes she let me glimpse the private woman inside the public poet and activist. She rarely talked about personal problems—she hated what she called "self-pity" and wanted always to focus on moving ahead: " . . . *how to go on / from the moment that / changed our life / . . . proceeding from the crisis / and not from the moment / of sleep before it?* she wrote sometime after her first or second stroke. She needed to speak of recovery, not the pain and terror that went with it. How she'd taught herself how to walk again, trained her mind to find and sort the words. She acted as though the work of survival, each step taken back toward health, was a fresh act of creation. Only in her poems did she lay out the demons and furies. There, she engaged them as few American poets had at that time, transforming torment and fear, shame and humiliation into new sources of energy. This honesty was a powerful gift to readers who could accept it, returning the daily, non-heroic feelings that most of us evade to their natural place as part of our human equipment—and fit subjects for poetry. Recognizing that feeling, itself, is the central life, *all* feelings being respectable, useable. *Our material,* she'd written years earlier, *is the way we feel and the way we remember.*

Still, I wanted to know Muriel more directly, not only in her writings. I wanted somehow to be useful to her—my notion, I suppose, of breaking out of the student role. I felt honored the few times she let me see something raw in herself. The first time had been during college. In 1959, the American Legion attacked Sarah Lawrence in the local, Bronxville newspaper for "hiring the famous radical, Muriel Rukeyser." Harold Taylor, president of the college, answered the press. But a week later, when I had my private, bi-weekly conference with Muriel, she was still stewing over the attack. Why had those old charges been resurrected? "I agitated for peace," she said, "and they keep calling me a Communist." Worse, the college had asked her not to reply publicly. She felt muzzled. Answering her attackers had always been her way, she said; she had always spoken for herself: she was a writer, an answerer! I left our conference thinking how strangely innocent she seemed, to be caught by surprise and be so thrown after all she'd apparently been through during the earlier, Red-baiting period. Under all her savvy and worldliness, how could she still be so vulnerable?

That year, too, after one of the two or three dinners I had at her New York City apartment, she aired another worry. Her other guests had gone;

she and I were clearing the dishes before I'd leave to go back to school. Suddenly, she spoke of her son, Bill, who was 11 then. "He needs a man, a male image here," she said. "I don't know what to do about it." She seemed to be asking my advice but I was over my head. (She soon solved the problem by hiring male college students to baby-sit.) I did better years later, I think, when she was having problems with her biography of Thomas Hariot, the "first New World scientist," as she called him.

By now she'd moved into the artists' building at Westbeth in Greenwich Village; it would be her last apartment on her own, merely a large, L-shaped room. The first thing she did when I got there was make me look out her window: there was the Hudson River, moving fast, pink in the afternoon sun—Muriel's river, which had run through her life and poetry since her childhood on Riverside Drive. Still, she couldn't suppress her worries about the Hariot book. She'd been through most biographers' frustrations—the closed doors and dead ends—in writing her earlier "lives." But this time seemed worse. She'd been chasing Hariot clues for several years and had just returned from another research trip to England and Ireland. "But there are all these gaps," she said. She sat wedged into a corner of the couch. "The trail starts up and then it keeps petering out." Her voice was small, almost girlish. She looked unsure in a way I'd not seen before. I was suddenly inspired. "Keep the blur," I said. "The petering out is apparently part of your story." It was a good answer; she might have given it, herself, to someone else in need. And did the smile that took over her face then reflect the answer's usefulness, or that it had let her know what a good teacher she'd been?

We had our hard times, too. Confusions, misconnections. At times her allusive, abstracted responses to my practical worries felt evasive, even dismissive. A lost copy of a book manuscript (mine). A half-hour TV show I created around her that hadn't come off as well as I'd hoped, and I felt I'd let her down. *Needing makes clumsy*—another of her lines; I could chant it in my sleep. But there was also her own backing and forthing, what Louise Bernikow called in a *Ms.* magazine profile the "winds of 'Yes' and 'No'" in her.

I saw Muriel for what turned out to be the last time in October 1979. Though we'd talked on the phone, I hadn't actually visited her in several years. She had come back from her strokes with three more books of poems, plus *The Traces of Thomas Hariot,* then her *Collected Poems* in 1978. In 1972, frail, she and the poet Denise Levertov had flown to Saigon to "see for themselves," "to witness." Back in Washington, Muriel had lain down on the floor of Congress with a handful of other protesters and been hauled off to jail. American PEN recruited her for its president in 1975. But, wanting to protest the imprisonment of a South Korean poet, and impatient with writing letters and organizational bureaucracy, Muriel had flown to Seoul alone,

to stand in the rain and mud outside the poet's prison—not allowed to speak to the man inside.

Three years before our last meeting, Muriel had called me at the publishing house where I was now an editor. Her son's second child was due soon; she could use some money; she'd written a new children's book. I'd lost track by now of how many strokes had slammed through my teacher; I said "yes" immediately, without seeing the manuscript. Later, I let Muriel bewitch me into commissioning full-color art from a painter friend of hers, though I knew his work might make the book prohibitively expensive and hard to sell. Muriel insisted. And how could I talk manufacturing costs and sales projections with Muriel Rukeyser?

The apartment door on this October afternoon in 1979 was opened by a nurse in white—something new. Muriel had moved in with her agent now; she needed taking care of. From the hallway I could see her in the living room, a large-framed but painfully thin body, inert inside a shiny metal wheelchair. When I came over to her, her lips tried for a smile. She uttered a barely audible, "Hello, Lanie." But her face was so still, one side of it "fallen" and completely frozen, as though it had separated from the other side. Her eye on the frozen side looked tilted inside layers of displaced skin. I wasn't sure what she could see.

I wasn't ready for it—the nurse, the wheelchair, the landslide face. Or the right hand—her "writing hand"—lying weakly in her lap. "It doesn't work anymore," she whispered. She'd said in the past that the act of moving her pen across the page was central to her writing process—meaning, crucial to a life centered on writing. Now the power hand lay helpless on her skirt, unable to tighten around a pen. "And this is the worst," she said in the low, hoarse, one-slow-word-at-a-time that was all that was left of her beautiful voice. I looked at what had been done to the demanding, consoling poet and teacher I loved. I felt helpless, furious. And what do you say to someone whose demand has never been for pity?

We went to work. The illustrator of her children's story had finished his painting, and I'd come this afternoon (unhappily) to get Muriel to cut the manuscript—it was much too long and repetitive. She couldn't see to read, so I read her pages out loud to her, going slowly, line by line. The writing was dense, like poetry, so a cut or a change in one place affected everything else. I backed up and read the lines again and again. I could feel Muriel's attention, but she hardly responded to my questions and suggestions, and when she did, her voice was either so low I couldn't hear it or the words came out garbled. I wasn't sure what she wanted. I read some of the lines again, watched for her head to change angle or her face to move even slightly, if only toward or away from the sound of my voice. Only occasionally did she say a word I couldn't mistake—"No!"

We spent almost two hours at it. As I listened and watched for her signals, I thought how little I'd been around for her in recent years, how little I knew her anymore, except in her poems, especially in the enormous lines of forgiveness that mark so many. . . . *We are bound by the deepest feuds to unity. . . . Were we all brave, but at different times? . . . Needing makes clumsy. . . .* And, most radical (in a different way): *One writes in order to feel.* (A friend of mine, a psychotherapist, tried to correct this one: "No," he said, "You feel in order to write." And he was wrong.)

Muriel's hair, thin and colorless now, barely covered the back of her head. Her expressive face was still, the smile gone, along with the easy laugh. I sensed her concentrating; she was working hard this afternoon. But when I left I wasn't sure of what she had wanted or agreed to. Only the "No!" had been clear. Almost her one clear word. That "No!" sounding again and again, until in this room where changing or cutting her words was the subject, it overcame everything else. "No, No!" Slow, arduous, toneless—but the old ferocity was there! And I was so relieved and grateful, I didn't give a damn about anything else. She was wrong about the manuscript—it needed work. So what? We'd publish it as is.

When I finally kissed her goodbye and put my hand to the side of her face, I was sure I felt something alive under its surface: the writing hand may not work, but there's writing—this new book—coming.

Muriel didn't live to see the publication of *More Night.* But I'd like to think our talk that afternoon about changing and cutting her words had given her a place to stand, a chance to slow what she'd called *the speed of darkness* and to answer it back in one powerful, radiant, disobedient "No!"

Chris Llewellyn

Summoning the Shade:
Poetry as Vocation,
Advocation, and Evocation

Just over a decade ago, I couldn't shake the feeling that I was getting older and yet not getting any closer to being a real poet. I was considering revisiting Rilke's *Letters to a Young Poet* when I returned to the "R"s of the public library shelves and instead picked up *The Life of Poetry.* This was to be my relief and recognition. Relief because my poetry journey was affirmed, and recognition because my poetry process and politics were compatible with Rukeyser's. Always forceful and never forcing, her words continue to clarify my poetry.

Vocation

While I look at Rukeyser's poetry as vocation, I take the term from the Latin *vocare,* which is a call or summons to a state of action or to the religious life or to regular employment.

I'm remembering how the artist-heroine of Chekhov's "The Seagull" passionately proclaims, "When I think of my vocation I am no longer afraid of life." When I think of Rukeyser's vocation, I am less afraid of my life.

My earliest poems depict the workplaces and workers of childhood memories. In my hometown of Fostoria, Ohio, our livelihoods were dependent on the Union Carbide and auto-parts plants. The regularly employed and not-so-regular workers were my poetic subjects (to this day I know my subjects pick me and not the reverse), but it wasn't until after that first decade of poems that I learned that a poetry of tools, tasks, job

conditions, and relationships has a name: labor poetry. After a poetry reading (from my first book, *Fragments from the Fire: The Triangle Shirtwaist Company Fire of March 26, 1911*), I was approached by Donald Spatz, an AFL-CIO union official representing cement workers, who asked if I would write poems about the Hawk's Nest Tunnel tragedy. Exploring his idea, I discovered Rukeyser' s outstanding labor-poetry sequence, "The Book of the Dead," researched the history of the tunnel, and studied the poems.

Not only the poems about Triangle Shirtwaist, but most of my work I call political, although I use the term close to its origin, i.e., the *polis* or city-state. Poems that are political address those social and economic concerns and conditions that affect groups of the populace. So I was particularly affirmed and instructed by "The Book of the Dead," the first sequence of political poems with personal content in *U. S. 1* ("Night Music" and "Two Voyages," the second and third sequences, are largely personal poems with social content).

In Rukeyser, I see personal and political intersections in the way events initially external to the poet's personal life (the Hawk's Nest Tunnel and other subjects) became absorbed and then expressed by her reportage (social data in dramatic design) and by her poetic-dialectic (my term). As a political science student, I had read the work of Marx and Engels and was influenced by feminist writings such as Shulamith Firestone's *The Dialectic of Sex* (1970). "The Book of the Dead" and others of Rukeyser's poems display a scaffolding of the stages of dialectical materialism: thesis, antithesis, and synthesis. Rukeyser demonstrates and promotes an imagination that sees the unity within opposites and the solutions within contradictions.

Because it investigates relationships in terms of the powerful (again Union Carbide), the powerless, and the empowerment of the powerless, I find "The Book of the Dead" in particular to be a program for social reform. Her voice as poet-narrator, reporter, and witness in this sequence also best represents the state and action of her *vocare*.

Yet Rukeyser's importance to our culture is not due to her skills as dialectician, historian, journalist, etc. Rather, her contribution is due to the qualities of her poetic language and to the accessible *vocare* in her poems. She credits her free-verse voice to her apprenticeships with Walt Whitman, John Milton, and writers of the holy scriptures. Here is her *vocare* as a call to the religious life. After all, the Bible does take us back over a thousand years and is a source for ideas of how the world (or *cosmos*) and how the word (or *logos*) were expressed and understood. Logos was Reason, which for the ancient Greeks was the controlling factor in the universe and according to the dictionary, "the divine wisdom manifest in the creation, government, and redemption of the world and often identified with the second person of the Trinity."

Logos was the subject of poet St. Francis of Assisi when he wrote: "If thy heart were right, then every creature would be to thee a mirror of life and a book of holy doctrine." In Logos each creature is a book or voice: "The heavens declare the glory of God and the firmament showeth his handiwork. Day unto day uttereth speech, and night unto night showeth knowledge. There is no speech nor language where their voice is not heard" (Psalm 19). Rukeyser acknowledged the scriptures in her *vocare* when she stated, "We are talking about the endless quarrel between the establishment and the prophets, and I hope to be forever on the side of the prophets."

William Blake, George Eliot, Hart Crane, and Jean Toomer come to mind as other poet-prophets who have explored and explained ways the machine age has affected poetic subjects and language. When the Industrial Revolution began in England (c. 1760), machines began replacing hand tools, and huge industrial and social changes arose in the places Blake would describe as "dark satanic mills." Now, as the twentieth century winds down, instead of a respect for Logos, instead of serving humankind, our machine age has high-tech and consumer language that is not held accountable. While Logos was revealing, this language is concealing. "Artificial coloring and flavoring" are listed as food ingredients, and nuclear-warhead missiles are named Peacemaker. Rukeyser's "Poem White Page White Page Poem" summarizes how we poets predate and postdate the Industrial Revolution. With its breaking waves and standing light, the poem exemplifies Logos:

> Poem white page white page poem
> something is streaming out of a body in waves
> something is beginning from the fingertips (*RR* 268)

And this is one of several of Rukeyser's poems that affirm the Poet as embodiment of the raw materials, labor, tools, and tasks, as well as the finished article of poetry.

Advocation

Advocacy (from the Latin *advocare*) is the practice of those who summon and plead the cause of another, and who defend or maintain a cause. Among my pending poetry projects are two biography-based manuscripts, book reviews, and critical papers. Yet I must confess to completing too few poems in the last year. While I long for the space and silence, I don't claim to have writer's block or a literary "silence." What I have written is dozens of articles, letters, and testimony for public hearings as part of my advocacy work for special-education students. Each evening I spend three hours helping my daughter who has special needs with school work. I am involved in the care

of my mother and two siblings, and I am a partner to my husband who is blind. And then there is preparation for the classes I teach. Yet I can turn to Rukeyser as my advocate, teacher, and caretaker. Just as she promises in "Then," she does speak "out of silence" and to my poetic silence.

While I'm surprised to be writing here about my family, advocacy, and poetry work, I am not surprised that it's Rukeyser who provides us with this very forum to talk about the mixedness of our lives. If I can't break through the fear of rejection (among the "resistances" to poetry described in *The Life of Poetry*) to write on this white page and in her presence, then can there be any place to tell my story? Here in my home in Washington, D.C., I am uplifted by her poem "The City of Monuments," in which the "marble men" and buildings are "Split by a tendril of revolt" (*CP* 51).

I am writing this on my daughter's eleventh birthday. I am proud of the ways she educates our community about her wholeness. The slogan "it takes a whole village to educate a child" takes on new meaning when reclaimed as "it takes a whole child to educate a village." I find Rukeyser supports such reclamations throughout *The Life of Poetry* and specifically with the adage "All the forms wait for their full language" (155). Despite my advocacy efforts, I have not been able to keep a neighborhood school from being closed or to find an appropriate school placement for my daughter. Last night I stood before the Congressionally appointed Emergency Transitional Board of Education Trustees and asked the CEO, a retired army general, if he believes veterans have upheld democracy. Did he know students with disabilities are veterans—and we, their advocates, are veterans—in a battle against discrimination? Were the trustees aware of how they and their families are, by birth or injury, only an accident away from a disability?

Nowadays I see parallels between my advocacy for the inclusion of persons with disabilities and Rukeyser's advocacy for the placement of poetry: "In speaking about poetry, I must say at the beginning that the subject has no acknowledged place in American life today" (*LP* 5). I am well aware of the resistances, fears, and oversights that work to exclude persons with disabilities from the "mainstream" of life. I remember Rukeyser advocated to provide a place in poetry for "the lives of Americans who are unpraised and vivid and indicative in my own documents" (*LP* 6). I remember how she alone kept vigil in the cold and rain outside the prison gates in Seoul, how with her physical presence, disabled from stroke, she advocated for the release of Korean poet Kim Chi Ha.

But today, in Washington, D.C., my daughter has been reading about another civil-rights advocate. *The Story of Ruby Bridges* by Robert Coles is the story of the first and lone student to racially integrate Frantz Elementary School in New Orleans. Ruby's mother believed her daughter was strong

enough to pioneer integration, and Ruby truly was strong to walk to school through the taunting and threatening crowds. I must inform our school board general about a true veteran and hero in six-year-old Ruby. The story says she had what she needed to succeed in school: the love of her family, the prayers of her church, a devoted teacher, and federal marshal escorts and protectors. She had the backing of a sympathetic press, President Eisenhower, and the U.S. Constitution.

I must convince the general that my daughter and other special-education students are also pioneers of integration and are equally as heroic. Though they too are taunted and threatened, the vast majority have no protectors or advocates when, as young as four, they integrate the local schools. All too often their educational needs go neglected and federal laws protecting their civil rights to an appropriate education are flaunted with impunity. Each year far too many special-education students are placed in a new school and must spend hundreds of hours being bussed only to haphazardly receive educational services. Their placement and location are of little concern. "General, my daughter and her schoolmates were fortunate enough to attend their neighborhood school—one of the decent few left—yet you and the trustees voted to shut it down."

I am writing this on my daughter's eleventh birthday, recalling Rukeyser's influences, fishing directives from *The Life of Poetry* to meet my major challenges. I can rely on Rukeyser's *advocare,* the defense of my cause, for she calls out: "you entire / alive among the anti-touch people" (*RR* 251). Now I'm recalling the birth day. After 30 hours of back labor and within 5 minutes of a prideful Lamaze delivery, the doctor told us ours is a baby with Down syndrome. Weeks later my husband confessed how he wept that day on his long subway ride home, knowing first-hand the resistances our daughter must encounter from those who would judge her based on appearances.

My husband continues to get aggravated with us "sighted folks" who too often don't or won't see. I'm reminded of Rukeyser's refrain, "What do we see? What do we not see?" Stated or implied, it's an ever-present question that summons the reader and listener to a life of advocacy. There's another thing I see in Muriel Rukeyser: where there is no resolution at closure, there is symbolic and often literal transformation or transcendence. When I look at all her advocations and avocations (peace-activist, pilot, photographer, reporter, poet, teacher, biographer, playwright, single parent, etc.), I wonder at her accomplishments. How did she do and be all these?

One thing I do know. She practiced her conviction that truth must be known by the body as well as the intellect. More experiential than empirical, I am reassured when I find her physical presence in her poems and essays.

The Book of Proverbs asks, "A woman of valor who can find?" The great labor organizer Mother Mary Jones used to proclaim, "You can agonize or you can organize." Mother, I want to organize.

For starters, I want *The Life of Poetry* to accompany, if not replace, Rilke's *Letters to a Young Poet* as a standard reference for poetry. It should be on every Introduction to Literature syllabus for students and new poets. First, because unlike Rilke's speaking from Paris prior to two world wars, Rukeyser is speaking from mid-twentieth-century North America about those and subsequent wars, about economic depression, about racial struggles, and about their effects on her life and creativity. Second, because to promote Rilke's standard of solitude yet neglect Rukeyser's head-on-body confrontations does a disservice to those seeking their places in poetry.

Evocation

Evocation, derived from *evocare,* contains a call or summons to re-create imaginatively. I am always riveted by the *ars poetica* of Whitman, Keats, Shakespeare, and others that directly and presently address the reader. Poems telling us that our eyes and hands, now touching this poem and page, touch live human flesh and not dead paper.

Not just in "Then," but in many of her poems and essays, Rukeyser gives us that *ars poetica* degree of inclusiveness, intimacy, urgency, and presence. Still with us as a presence, she's like a "Shade." (Remember that Dante's shade was Virgil, who acted as spirit-guide to the underworld.) Even today, the Shade approaches. . . .

What do we see? Can we agree that to be a poet is to promote others to use their imagination? To see things in many different ways? To find the common ground? To seek new solutions and resolutions? If so, then through our poems and through our teachings of poetry we will empower others to imagine. Alongside she who is caretaker, teacher, and Shade, we will prevail as poets of vocation, advocation, avocation, and evocation.

Michael True

The Authentic Voice:
On Rukeyser's "Poem"

The long defeat that brings us what we know

—Muriel Rukeyser, "Neruda, the Wine"

Rereading Muriel Rukeyser's "Poem"—beginning, "I lived in the first century of world wars" (*RR* 211)—I inevitably wonder why anyone speaking American English *wouldn't* regard it as one of the most remarkable poems in contemporary American literature. Where else, in 20 lines, do we have such an accurate rendering of what it feels like to live at this moment in history? Who else provided such a precise, simple statement of our "nuclear" dilemma? Which other writer managed not only to identify the terror that dominates the landscape, but also to suggest a strategy for moving through its insanity toward a safer place?

Such a judgment obviously reflects an attitude toward poetry and what one regards as its purpose and function in the larger culture. It is an aesthetic judgment, implying a preference for simple, direct language accessible to the general reader when one is speaking about elemental truths. That judgment reflects, also, my assumption that poetry must be about the most basic, haunting questions facing people at a particular moment in history. Not all poetry must be "serious," but certainly writing that provides a sense of how it *feels* to live in America can be expected to reflect the terror of the bomb as well as the legacy of its use and deployment over the past half-century.

When I say that "Poem" belongs among the great poems of this period, I have in mind major achievements in verse such as Roethke's "In a Dark Time," Ginsberg's *Howl*, Kunitz's "The Testing-Tree," and Levertov's "Life at

War," among others. These are the poems that best represent American language during a painful period of history; such poems help me to understand and to survive the psychological assaults associated with living in an imperial culture. They convey and, in a remarkable way, help to "contain" the harsher truths that lesser writers and artists either have not or cannot confront in their work. The particular genius of Rukeyser was her ability to move beyond lamentation and confrontation, and to offer the promise of a different social order. She imagined alternatives to the conventional manner of living during "the first century of world wars," as she named it in "Poem."

Coming of age in the 1930s and writing with insight about the Depression, "the invisible scar," she endured and understood the full implications of major events that shaped American life and culture and framed the period during and since World War II. Reading her poems, one participates in these events and comes to understand their consequences. Anyone wishing to know the story of our time may experience it by reading a Rukeyser poem for each decade. For the 1930s, for example, there is "The Disease" from "The Book of the Dead," a series of poems about an industrial tragedy among West Virginia miners, who "died like ants in a flour bin" (qtd. in Kertesz 99). The poem consists of a dialogue between a doctor/interviewer and a miner suffering from silicosis, a disease with effects like suffocation and strangulation.

> That is what happens, isn't it?
> A choking-off in the air cells?
>
> Yes.
>
> There is difficulty in breathing.
>
> Yes.
>
> And a painful cough?
>
> Yes.
>
> Does silicosis cause death?
>
> Yes, sir. (*OS* 21)

For the 1940s, there is "Letter to the Front," including the remarkable lyric beginning, "To be born a Jew in the twentieth century / Is to be offered a gift" (*OS* 65). For the 1950s, "F. O. M.," on the death of F. O. Matthiessen, a victim of the Cold War; for the 1960s, the poem discussed in this essay; and for the 1970s, "Waking This Morning," about her personal commitment to nonviolence, or "The Gates," set in South Korea. Nothing of consequence during her adult life appears to have been lost on Rukeyser, and to the very end, she remained attentive to and often engaged in significant issues defining her era. Going to Seoul in 1975, as president of PEN America, she stood outside

the prison on behalf of Kim Chi Ha, a young Korean poet sentenced to death for speaking out against a repressive regime supported by U.S. policy. This resistance to injustice, even after Rukeyser had suffered two strokes, is altogether representative of her vocation as a writer.

A particular genius of her work is her ability, again and again, to convey the full implications of public matters in a private voice. Although sometimes rhetorical, she seldom lectured her readers. She spoke in her own voice or the voice of a person we can identify with, not out of some impulse to preach to or to teach the reader, but out of her commitment to bring those voices to full resonance and authenticity.

Rukeyser's poems, in other words, reflect an amazing understanding of the political, economic, and religious implications of life over half a century. In the midst of prosperity and power, wars and rumors of wars continued to lay waste the intellectual and material riches of the United States. This took place amid the turmoil and achievements of civil rights struggle, the corrosive effects of the Vietnam War, and the ultimate decline during the imperial presidencies of Johnson and Nixon.

In my experience, Rukeyser, more than almost any other contemporary author, communicates the particular tensions of personal and public life since World War II. I say this after reading her poems with thousands of undergraduate, graduate, and adult-education students, in this country and abroad, in courses in modern literature and introduction to peace studies. Young women, particularly, are amazed and delighted with Rukeyser's powerful evocation of her (and their) experience in poems such as "Effort at Speech Between Two People" and "Long Enough.'"

For activists and ordinary citizens working to halt the proliferation of nuclear weapons and the attendant violence associated with them, her poems are a source of historical insight and encouragement. Over the past 20 years, I have given some 400 presentations of a slide/lecture on "The American Tradition of Nonviolence," which includes a recitation of "Poem" (see below), and members of the audience, often unfamiliar with her life and writings, inevitably request copies of her poems.

A typical response to Rukeyser is that she makes concrete issues that young readers, particularly, may have regarded as "merely political" or as somewhat distanced from their own experience. They speak of how Rukeyser helps to clarify their own struggles to make meaning of their lives and to understand the frantic and conflicting nature of American culture. Her poems take to heart humanity's discovery, in Orwell's words, that "our souls had been cut away," as well as the panic associated with that discovery. What higher compliment can I pay to Rukeyser's poems than to say that they are useful to one's struggle to "survive" in a mad, mad, mad world? For as Robert Francis once said of the art, "it is not our business to defend poetry but the business of poetry to defend us."

Rukeyser's work has, in fact, become so much a part of my life and my impulse to resist the violence of the status quo that I find it difficult to write about it "objectively," that is, to communicate my reasons for admiring her work. I hope to make those reasons explicit by focusing on a single poem. A close reading of "Poem" provides an opportunity to focus on Rukeyser at the height of her powers in language and form, while remembering a woman whose life adds up to something very special. The poem, only 20 lines long, appeared in the volume *The Speed of Darkness* (1968) in her 55th year. Although she had already suffered one stroke, she was in the midst of a productive period as a writer and teacher, having recently published translations of Octavio Paz, been elected to the National Institute of Arts and Letters, and been engaged in writing *The Traces of Thomas Hariot*. Several poems in *The Speed of Darkness* were written during the darkest years of the Vietnam War, and one of the impulses of "Poem" seems to have been to remind her readers, and perhaps herself, in the words of the concluding lines of the poem, of "the regenerative powers of poetry."

That quotation is from a lecture she gave, also in 1968, at Scripps College on "Poetry and the Unverifiable Fact." There, she talked about the power of poetry to evoke people's sense of "the resonance in the world," a power "more living than the dead enormous powers that keep the war going" (Kertesz 308). "Poem" is, among other things, a journey through discouragement, even despair, to a renewed acquaintance with the restorative powers of history and biography, represented by the "men and women / Brave, setting up signals across vast distances" (*RR* 212).

I lived in the first century of world wars.

The opening line, an assertion, places the speaker in time, in an era unlike any other, scourged by modern warfare. In the 1970s, Rukeyser, as with any person her age, rightfully felt that the world had been at war continually throughout her lifetime. "Käthe Kollwitz," written about the same time as "Poem," mentions the special bond Rukeyser feels with an artist enduring the same fate:

Held between wars
my lifetime
among wars, the big hand of the world of death (*RR* 214)

Although the movement against the war in Vietnam, to which Rukeyser contributed, had gathered strength by the late 1960s, it had provoked no change in policy in Washington, and the war would drag on for another five years.

The simplicity of the opening statement in "Poem" gives it a particular weight and authority. It is a pronouncement, but also a lament, whose simple language keeps it from sounding pompous or pretentious. It's as if the speaker were beginning a casual autobiography—"I was born in Philadelphia in 1913." The mood, approaching depression, is quickly established, so that we are prepared for the ironic statements, bordering on anger, that follow. Both the depression and the anger are reasonable responses to the situation in which the speaker finds herself. That first line sets up expectations that are fulfilled and at the same time challenged by the second line:

Most mornings I would be more or less insane, (*RR* 211)

The word "insane" in the second line is surprising in the way that Joseph Brodsky said is characteristic of American poems (he had in mind Auden's "September 1, 1929"): "it violates the preconceived music of the meter with its linguistic content" (Brodksy 308).

Although wars are obviously horrible and impinge on the lives of everyone, including people far from the battlefield, Rukeyser's rather bald statement, nonetheless, draws the reader up short. Is she being funny—or serious? The following lines not only answer that question but also describe how the peculiar insanity of the Vietnam period was accomplished:

The newspapers would arrive with their careless stories,
The news would pour out of various devices
Interrupted by attempts to sell products to the unseen.

The war in Vietnam was a TV war fought in living rooms and barrooms across America. It was an undeclared war initiated by "careless" people who felt no responsibility to tell the truth. Communication, based upon trust, was systematically subverted by bureaucrats merely doing a job, assisted by journalists whose reports were little more than press releases from the White House. Stories of the war omitted or suppressed important details. "Careless stories" repeated lies of American foreign policy, as it was being conducted from Washington (a fact substantiated only later by the Pentagon Papers). Also, contrary to a popular impression, TV coverage of the war probably lengthened rather than shortened it. Domesticated by TV, it became mere background among advertisements in the media.

The word "devices," suggesting something devious or malign, is particularly appropriate here. Although the Pentagon did not exploit TV for propaganda purposes as fully and obviously during the Vietnam War as it did during the Gulf War, people sensed that information was being withheld.

Only later did the public learn that the body counts, evidence that "we were winning," were phony.

> I would call my friends on other devices;
> They would be more or less mad for similar reasons.

In the search for reassurance, the speaker in the poem telephones a friend, only to find that person similarly undone by a century of wars. Even after the guns are silent and the treaties are signed, the destruction goes on and on, in the suicides and the innocent victims of landmines that seldom appear among the casualty lists, as well in nightmares, evidence of scars and trauma among those who survive.

The theme of war's insanity is given further weight by the word "mad." Although this is a lyric poem, anger, even fury, over circumstances responsible for "a century of world wars" are central to the argument of the poem. ("Mad," by the way, was used with similar effect in the Auden lyric mentioned earlier: "the world offence . . . / That has driven a culture mad.")

Little by little, however, the speaker moves through the negative energy associated with this state of being toward a positive state. The transformation occurs when she offers to others a simple gift:

> Slowly I would get to pen and paper,
> Make my poems for others unseen and unborn.

The generous impulse to make a poem is life-giving for the person offering the gift, as well as for the one receiving it. And in the act of writing, changes take place that ultimately move the speaker toward a new insight. This change is accomplished with the aid of memory, as the speaker reclaims the lives and values of those who represent positive alternatives to the present:

> In the day I would be reminded of those men and women
> Brave, setting up signals across vast distances,
> Considering a nameless way of living, of almost unimagined
> values.

Although the speaker does not mention specific people, the list undoubtedly includes people such as Käthe Kollwitz and Pablo Neruda, who told the truth about war and, against all odds, resisted injustice, and whom Rukeyser wrote about elsewhere in *The Speed of Darkness*.

Remembering their legacy, the speaker moves through the day toward evening, her mind filled with precise memories of what they achieved and how they went about it:

As the lights darkened, as the lights of night brightened,
We would try to imagine them, try to find each other.

It is the concluding lines of Poem," it seems to me, that dramatize the speaker's authority and authenticity in speaking about her subject. Historically, poems on the subject of peacemaking are often predictable, even shallow in content, and anthologies about "peace" are inordinately dull. The sentiments may be admirable, but the images, sounds, and arguments are either predictable or slack. Conventional verses on the topic tell the reader what peace looks like, but not about how it is made. In poetry, as well as in public policy, peace is too often understood as merely the absence of war. An obvious exception to this rule is "Making Peace" by Denise Levertov (with whom Rukeyser traveled to Vietnam about the time "Poem" was written).

In the concluding lines of "Poem," Rukeyser gives us not only a vision of peace, but also specific guidelines for the resolution of conflict and the transformation of power associated with it. Peace is not a happening, but a construct.[1] It is built through the systematic arrangement of ideas and concepts, including love and reconciliation; it is a design that meets specific requirements, a shelter assembled according to plan:

To construct peace, to make love, to reconcile
Waking with sleeping, ourselves with each other,
Ourselves with ourselves. We would try by any means
To reach the limits of ourselves, to reach beyond ourselves,
To let go the means, to wake.

The requirements for peace involve transforming ourselves as well as the world around us. They include integrating our conscious and unconscious "selves," our dreams and our actions, in the long struggle to "wake up." Accomplishing peace "within" and "without" resembles a Buddhist enlightenment, which enables us to become less egocentric and to be fully present to others. Perhaps we may even begin to trust the rhythm of experience that Rukeyser refers to in a number of her major poems.

I lived in the first century of these wars.

The final line, a refrain echoing the opening line, makes an association between violence within and without: peacemaking in the individual and peacemaking in the social order. It is a theme that Rukeyser returned to in several later poems, including "Waking This Morning," about "a violent woman in a violent world." Moving among the "anti-touch people," she pledges, at the end of the reflection, that once more,

I will try to be non-violent
one more day
this morning, waking the world away
in the violent day. (*RR* 251)[2]

My admiration for Rukeyser's poems on peace and reconciliation is related
to Rukeyser's understanding of how violent constructs—those associated, for
example, with the military/industrial/university complex—permeate per-
sonal as well as social relationships. Nothing is left unscathed. That was as
true of the Vietnam period, when the poem was written, as it is of the pre-
sent moment. The annual Pentagon budget ($250 billion), even with recent
minor tinkerings, continues to exceed the expenditures of all other global
military giants combined. The United States, even as it agrees to a nuclear
nonproliferation treaty, initiates a whole new generation of nuclear arms,
while four times as many Americans die by violence as in the next most vio-
lent industrial country. In schools, much of the history we learn is a chroni-
cle of battles, interventions, wars; since 1914, "the same war / continues"
(Levertov, "Life at War" 229–30).

How often I have returned to "Poem" to regain some sense of sanity in
this peculiar period of history. And how often, amid the jangle of slogans
and languages bidding for our attention, I am surprised by Rukeyser's au-
thenticity and simplicity in rendering the tenor of our lives. In poems such
as those mentioned above, she constructs through image and song a recog-
nizable pattern of the way the world strikes me at this moment in history.
Somewhat in the manner of Wallace Stevens, a very different writer, she
seizes control of events, discovering or imposing a pattern on experience that
helps one "see" what is there. As combinations of thought and feeling, idea
and image, her best poems reveal nature or reality for what it is, in space and
time.

I have often puzzled, also, over how she "acquired" that authentic voice.
How was it, among a group of talented poets, that she heard and gave voice
to what was deepest and most formative in the experience of her generation?
It's the kind of question one might ponder when reading Arnold's "Dover
Beach" or Stevens's "Sunday Morning" or Eliot's *The Waste Land* or
Roethke's "In a Dark Time," in their attentiveness to the best and worst in
their times.

I associate Rukeyser's special contribution to American poetry with her
adventuresomeness in striking out continually for new territory, her insis-
tence upon being "promiscuous," as she said in the preface to her *Collected
Poems,* her trust in "the rhythms of experience," and her confidence that her
approach would lead her to a significant place, as indeed it did. Like Whit-
man, she took enormous risks as a person and as a writer, and like him, she

failed, on occasion. Reading through *The Collected Poems,* one is likely to conclude, nonetheless, that her achievement as a poet was intimately connected with risk-taking, which included a dedication to a set of values and strategies for living and writing, and which refused to ignore the dichotomies and contradictions of experience. Values such as these are evident throughout her work, as in "Ballad of Orange and Grape" and these lines from "The Six Canons":

> Go toward the essence, the impulse of creation,
> .
> where sex and spirit are one self
> passing among
> and acting on all things
> and their relationships,
> moving the constellations of all things. (*CP* 439)

What interests me is Rukeyser's ability to find a language for complex ideas, to learn it and to employ it successfully in speaking early and late on a variety of subjects. I say this after knowing and returning to particular poems over the past 25 years and "hearing" a distinctive poetic language that seems exactly appropriate to the postmodern period.

Notes

1. The differences between a peace culture and a war culture are ably described by Elise Boulding, "Peace Culture," in a forthcoming volume, *Encyclopedia of Violence, Peace and Conflict* (New York: Academic Press, 1998); see also her *Building a Global Civil Culture: Education for an Interdependent World* (Syracuse University Press, 1986).
2. This poem is one of many reflecting on the history of nonviolence in the United States, as suggested in my *An Energy Field More Intense Than War: The Nonviolent Tradition and American Literature* (Syracuse University Press, 1995). The standard anthology of writings in that tradition is Staughton Lynd and Alice Lynd, *Nonviolence in America: A Documentary History,* rev. ed. (Maryknoll, NY: Orbis Books, 1995).

John Bradley

◇◇◇◇◇◇◇◇◇

The Uses of Poetry

for Muriel Rukeyser

1.
Their granary
bucking back and forth
on the clothesline,

sparrows, made
reckless by the wind,
dodge and spin.

2.
Break it, break the snow's
cold curve smothering
the seed, and the seed

will one day melt
back into song, song back
into birds, birds back into seed.

3.
This morning, Muriel,
after writing these words,
I threw myself into the embrace

of subzero winds once more,
breaking free the seed
a poem broke loose in me.

Reginald Gibbons

Fullness, Not War:
On Muriel Rukeyser

Born in 1913, Rukeyser wrote very early, in "Poem Out of Childhood" (published in her first book, *Theory of Flight*, 1935):

> we were a generation of grim children
> leaning over the bedroom sills, watching
> the music and the shoulders and how the war was over,
> laughing until the blow on the mouth broke night
> wide out from cover. (*RR* 7)

Rukeyser told of how her father was a successful businessman of some wealth, and how her childhood was well provided for materially yet lacking emotionally. She was from an early age one of those children who look upon the adult world and notice. This is apparent not only from her prose work *The Life of Poetry* (1949) but also from another early poem, "Sand-Quarry With Moving Figures" (also in *Theory of Flight*) in which the father promises, "We'll own the countryside" (*RR* 4), and the child is ashamed to be such an owner. I think Rukeyser's poetic portrayal in the lines above of a child's covert spying on the adult celebration of the end of World War I, and of corporal parental punishment for that spying, also implies a social moment in which "the music and the shoulders" prefigure the nonchalance of the wealthy, regarding the far more numerous, suffering, poor; it implies also that there is a punishment for noticing this nonchalance. In any case, the celebration of the adults did not truly mark a cessation of war, which continued in other forms.

Rukeyser wrote in "Ajanta" (originally published in *Beast in View*, 1944), "Wanting my fullness and not a field of war" (*OS* 52) and thus defined the

terms of her life-long artistic project. When we read the body of her work, we see this opposition brought to the page again and again. These terms seem to have been given to Rukeyser early in life, and the decades through which she lived only brought her more instances, ever larger, of every kind of warring against fullness and wholeness of life, of feeling, of possibility. The decades also provided her with instances of courage and love.

Rukeyser saw, in addition to war against foreign states as military enemies, the home-front peacetime war against those who deserved justice and possibilities of life, but who experienced instead the crushing exclusions and relegations of a business world oriented toward the gains of owners. After World War II, and during the war in Vietnam, Rukeyser was still considering how being threatened and contaminated by the insane destructiveness of war is to be driven into a kind of insanity also; *insane,* one is *unseen,* thus in a way one remains *unborn*—these are her great rhymes, creating their own secondary meaning and phantom syntax that hovers over the explicit syntax of her "Poem" (from which I quote below), in which these same words have a prior, primary, meaning. Rukeyser felt the pain of being merely an individual, and thus relegated to small-scale action, unable single-handedly to change the course of the juggernauts of governments and media and corporations in their warring. For their destructiveness lies not only in what armies do, but also in what media do by crowding out the truth, by contaminating it with false ideals and images, by excluding the testimony that might be given from a path that *goes* somewhere. It is testimony that all too often cannot be heard above the din of advertisements and sitcoms and press releases roaring around a closed track that goes nowhere. (What corporations effect in their damage to the "civilian" life of workers and to the environment is also a form of war; bombed forests 25 years ago in Vietnam and Cambodia or 80 years ago in France are no less destroyed than today's burned forests in Brazil or clear-cut forests in Oregon.)

And yet there are the small things that one can do, that bring the "insane" and "unseen" and "unborn" together to accomplish the work of feeling and of reason, of "imagination and knowledge," as Rukeyser herself put it. "I lived in the first century of world wars," she wrote in "Poem," and continued:

> Most mornings I would be more or less insane,
> The newspapers would arrive with their careless stories,
> The news would pour out of various devices
> Interrupted by attempts to sell products to the unseen.
> I would call my friends on other devices;
> They would be more or less mad for similar reasons.
> Slowly I would get to pen and paper,
> Make my poem for others unseen and unborn. (*RR* 211–12)

Making her poem for others, Rukeyser sees poetry as a gift, in itself, that opposes all the warring for nation or advantage or power or sheer love of destruction. In her mind, poetry is a gift similar to example and testimony. In *The Life of Poetry* she writes of "those who risked themselves and died in the Resistance movements of many lands; little children, who in a far-reaching moment of consciousness, made their gifts; miners, anonymous women, those suffering and poor, and the privileged of all functions in life, those gifted with insight so that they understand the beauty of unconditional love, and live and make their gifts" (*LP* 37). She was one of the first of our age to see the value of thinking of art as still being, even now, a gift-economy that honors both imagination and love, and that pushes back against utilitarian reason, which arms nations for profit simply because it profits by selling anything and everything. She writes, "The one difference between the artist and the audience is that the artist has performed upon his experiences that work of acknowledging, shaping and *offering* which is the creative process" [my italics]. And she reiterates her point: "Writing is only another way of giving—a courtesy, if you will, and a form of love. But does one write in order to give? One writes in order to feel: that is the fundamental mover" (*RR* 131, 134, 135). These sentences echo another poem:

> I came into my clear being; uncalled, alive and sure.
> Nothing was speaking to me, but I *offered* and all was well. (my italics;
> *RR* 112)

Having sought my own teachers, among the living and the dead, in the continuing process of coming to understand what it is that I want to learn, I have found myself returning repeatedly to an imagined colonnade of poetry—a place of shaped space and admitted light, open to the weather of events like an ancient Greek stoa. Among the columns of my stoa—each one different from all the others—are two of special beauty and reassuring solidity: Muriel Rukeyser and Thomas McGrath.

What have I sought in that stoa, and what do these two columns represent? These columns—forming a space in which people and the imagination may freely move, as they cannot inside the barriers and walls and barbed wire of the institutions based on war and profit—sustain a different institution: they sustain the truth of experience and the possibilities of truth in language.

Rukeyser and McGrath are two of the pillars of poetry as a free imagining of our being-in-language in relation to others. All of us are so shaped by the momentum and power of the dominating forces of nation and corporation—with their agile and volatile minion, capital—that we are kept small and are all too often ineffective at resisting. The language, poem-shapes, and

imagination in the work of Rukeyser and McGrath revolutionize not only our individual powers of perception—as we expect almost all poetry to do, since the Modernists—but also the terms in which we conceive the political and social structures that shape, in turn, what and how we perceive. In McGrath's and Rukeyser's poetry, we find models of imagination that challenge those attitudes of entitled privilege that make patriarchy so slow to change, those attitudes of entitled power that give wealth its self-justification, those attitudes of elite execution of decisions that give mainstream and reactionary political positions their excited blindness to reality, that success of established wealthy power in maintaining and aggrandizing its position. But in Rukeyser, more than in McGrath, we find challenges to what is oppressive not only in large-scale institutions such as the U.S. Congress (which she illuminates starkly in her documentary poem "The Book of the Dead") but also in small-scale ones, such as a father's attempt to control the lives of his wife and children—as in "Sand-Quarry with Moving Figures," quoted above, or in "Paper Anniversary" (from *A Turning Wind,* 1939), in which she describes an orchestral concert on "the night of the Crash" of 1929. There, the fathers obsessed with money, who patronize the concert but experience no joy in the music, and who effectively own the "ostrich-feather wife / lying alone" and the children who "go home again to the insane governess," become "a rout of men / stampeded in a flaming circle" (*CP* 179) by the stock-market crash, which Rukeyser suggests is a kind of justice.

I regret that I never met Rukeyser. In 1987, with Terrence Des Pres, I interviewed McGrath. Des Pres and I, with the simplifying and unmasking drive of those who want to hear a revelation, pressed the canny poet, who had lived a complicated history, had made difficult and artistically heroic choices, and had created a complex aesthetic stance. We wanted to know what he believed was possible for poetry, in light of both the world as it is and his long-standing radical political commitment. Because McGrath, unlike Rukeyser, joined the Communist Party, organized workers in the shipyards, and intervened in other organized ways in social and political life, he—like Rukeyser—had been attacked not only by the right but also by the left, for not having been radical *enough* in his poetry. I asked him about "programmatic" poetry, wanting to get him to clarify a famous distinction he had once made, with rueful wit in military terms, between "tactical" poetry, meant to mobilize people toward a goal, and "strategic" poetry, meant to raise consciousness. Like Rukeyser, McGrath has seen poetry as a realm of possibility, not a kind of artifact. Like Rukeyser, when criticized by the literary establishment for his political engagement, McGrath, undiscouraged and even fierce, would counter with intransigently engaged work. But if pressed to write something "political," he would go the opposite way and,

like Rukeyser, write a poem of delicacy focused on the moment of consciousness or perception. One moment in our exchange seems to me to express terms that are very helpful to our understanding of Rukeyser's great capaciousness, as a poet, as well as McGrath's:

MCGRATH: . . . One of the things that *anybody* should do—it seems to me so obvious—is that we ought to honor ourselves and the natural world and our fellows in every goddamn way we can! . . .

GIBBONS: That means you don't entirely accept the Brechtian dictum about the raindrops being an unsuitable subject [in a time of great social injustice].

MCGRATH: No, I don't, I don't, I don't. Even when writing a poem about a flower seems almost treason or almost a crime. Well, I'll tell you, given certain situations and times, I would believe that. And of course Brecht was coming out of a fascist state, and I understand that perfectly. And I honor him for it. But maybe what I'm feeling is different— . . . In a way, my imagination is like a meadow. If you don't let the meadow go its own way, you know, if you start plowing up bits and pieces of it, or restricting yourself to the use of only a part of it, the other part will suffer, too. Not enough room for pollination, or whatever. So, while I have this theory about revolutionary poetry, the revolution—*except* at the place where you're at the barricades, and it's a matter of total life and death, and maybe only right at your death—cannot *assume everything,* take everything. Because at times other than that, no matter how much of a revolutionary, you're also a human being! (Gibbons 99–100)

Rukeyser also seems to me a superb example of the poet whose work is "strategic" in that it changes the terms by which we understand the truth of our experience. From what I know of her, her political commitment seems not to have been organized similar to McGrath's. And while there is sheer love of life in the poetry of both poets—a great essential of their work— Rukeyser experienced and understood gender politics in a way that McGrath didn't. Why would she *exclude* from her poetry an attempt to engage her energies, and ours, against what is oppressive and inhumane and exploitative, especially of women? While the established poets and reviewers, with the power to address a reading audience, routinely condemned both Rukeyser and McGrath, saying that their leftist politics deformed their poetry, it was perhaps never said, in those same quarters, and is rarely said today, that those poets whose poetry is socially complacent, narcissistic, small or narrow have turned away from the wholeness of life, from a fullness of being. The issue isn't politics at all, but wholeness of being and of imagination, and the fullness with which one can inhabit the language and the possibilities of poetry—formal and thematic.

Rukeyser was born in 1913, McGrath in 1916. The culturally dominant poetic genealogy of America, though, includes in its family tree Robert Lowell, born in 1917, and Randall Jarrell, born in 1914. Older, and most influential, were Allen Tate, Robert Penn Warren, and the critic Cleanth Brooks, born in 1899, 1905, and 1906, respectively. (To other coeval American poetic genealogies belong, for comparison, Charles Olson, 1910; Gwendolyn Brooks, 1917; important also has been that figure who combined in his poetry a deep sense of civic commonality and empathy with the polished poetic manners of the established figures, William Meredith, born in 1919. In any case, Rukeyser and her readers have mostly belonged to the camp of *other* genealogies of American poetry, not the dominant one.) The established figures set the tone of the reading and appreciation, and to a large extent the writing, of American poetry; their particular knowledge of poetry militated strongly against any sense of the poem except as an object that might hold one's attention tightly but that was not necessarily to serve the purpose of revealing, unmasking, finding meaning in, or changing the world outside itself. While Rukeyser was exploring, for decades, new possibilities of poetry in theme and form, the poem of the established taste was mostly expected to be an instance of graceful tension in which paradox was set in amber, so to speak, rather than lived. Rukeyser aimed not at grace but at inquiry and witness and re-imagining. However well-made her poems—and many are very beautifully made in traditional ways—they do not try to occupy some realm beyond an explicit discourse regarding values. The belief of those who were culturally dominant, that the poem was an object, apart from lived experience, did not remove poetry from the contest of values outside it but only brought forth various poetic strategies that disguised or hid the presence of value in such poems. We must preserve a place for the poem that is not required to "take a position"—as even McGrath insists—but equally we must see clearly that the attack on Rukeyser for writing poems that present the reader with passionate argument was an attempt to require that poems never "take a position" that is in conflict with more or less accepted ways of understanding what poetry is, and what the world might be, instead of what the world is. Those attacks have been not just a critique of Rukeyser's poems but also a way of excluding certain values from the conversation about literature.

The established taste so obscured Rukeyser's accomplishment, when it did not actively attack it, that even today almost any discussion of Rukeyser's work still seems to be in part a necessary recuperation. Those who admire her work are still trying to show how the artistic values by which it was criticized were not, and are not, in themselves fixed, nor able to account for art that, like hers, arose from a broader understanding of the possibilities of poetry, from broader poetic principles and artistic goals. If there is no reasonable argument to be made against art as, in part, an ornament to the hours

of leisure, as invitation to reflection, as amelioration of the hardships of living, of thinking and feeling—this, we all need from art—nor is there any reasonable argument, nor even any historical evidence for such an argument, that this is all art is, or has been, or should be.

It was certainly not Rukeyser's way to separate poetry from the conflict of human values that drives forward the unfolding of human life as social experience. In her biography of an American scientist, *Willard Gibbs* (published in 1942), Rukeyser included an extraordinary account of the Amistad mutiny, in which in 1839 African slaves rose against the captain of the slave ship on which they were being transported and against the two Spaniards who claimed to own them. (Already in 1942 Rukeyser understood this event as a powerful emblematic narrative within American history, while very recent popular treatments of it, in film and fiction, more than 50 years later, are still unfortunately nearly barren of such understanding.) The Africans were arrested off the coast of the United States and were confined to prison until the Spaniards' "ownership" and the Africans' "mutiny" could be heard in court in 1840 in the free state of Connecticut. Although those who had at this point survived their various ordeals were acquitted, they then had to be defended—while remaining in prison—on appeal, against unprincipled greed and accommodation on the part of U.S. military authorities and the then president of the United States, Martin Van Buren. Rukeyser includes this narrative in her book because the father of Willard Gibbs, Josiah Willard Gibbs, a professor of theology and a linguist, took it upon himself to provide a translator for the Africans so that they might tell their own story in court. Their enemies were suppressing the truth by narrating the actions of the Africans in a way that would conveniently categorize them as property rather than as human beings. (This powerful confluence of immersion in language and preoccupation with human freedom and social justice is part of Rukeyser's temperament, too, of course.)

Rukeyser thus contextualizes the birth of her subject, Willard Gibbs, not only in a certain year but also in the light of the infant's father's dedication to the cause of individual freedom and to the particular needs of the imprisoned Africans; she situates Gibbs's birth not only in a time and place but also in a scene of moral, ethical, and political conflict. This will not surprise anyone who has read Rukeyser's poetry, which from the beginning contextualizes the psychological interiority that is the source of poetry within the social and political moment that partly shapes and constrains individual thought and action. The remarkable newness and courage of her work, in its own time and now, as well, lies not only in her language and the shapes of her poems, but also in her insistence on the value of poetry as the way to unearth the truth of feeling in everyday life, in shared life and hope, and to

resist, with that truth, the untruth and violent warring of patriarchal myths and of greedy or morally corrupted persons in control of destructive systems. If, as Rukeyser wrote in "Wreath of Women" (originally published in *Beast in View*, 1944), that we "are in that war defiled," she also added that we are "obsessive to be freed" (*OS* 59).

Rukeyser's formative experience during the Depression—the experience of anyone who was not protecting private wealth—was of social disruption, the inequities and injustices of wealth and poverty, and the hypocrisy that from so many mouths and publications justified or excused social and individual suffering as a part of some supposedly given or inevitable order of things. Then came the Spanish Civil War—to which she went as a journalist—and the military and civilian horrors of World War II, especially the Holocaust. Yet she insisted that "To be a Jew in the twentieth century / Is to be offered a gift" (*OS* 65). Again, her sense was that feeling and art are gifts that transcend the constraining and even annihilating circumstances of life. A sensitive child and a youth with a passion for causes, a young woman with a commitment to social change and a pained inability to tolerate injustice and suffering, she was *given* to see, by her time, more than enough to know that much suffering is simply imposed by those with financial and political power—if not by decree, then by convenient legislation and convenient elimination of alternative possibilities of life. Having arrived again and again at places of darkness and despair—the Scottsboro trials, the Depression, the silicosis epidemic among miners, the military wars, the cold war—she also saw in and among the instances of what was wrong the signs of what was right. With the gift of poetry she replenished and restored herself, and us:

> Having come to this place
> I set out once again
> on the dark and marvelous way
> from where I began:
> belief in the love of the world,
> woman, spirit, and man. (*RR* 113)

In *Willard Gibbs*, Rukeyser briefly portrays the aged John Adams, who reluctantly agreed to argue the case of the Africans before the Supreme Court. She wrote that his infirmity and fatigue—both physical and political—nearly prevented him from agreeing to the desperate request for help from the friends of the Africans. She characterizes his motives as follows:

> He was concerned with the future—a future living in one's own time, whose origins are to be seen in the flowing present, a future that must daily be found

and helped clear. . . . Repudiated by his country, conscious of failure at every step of his effort toward the country's enlightenment, he knew the depth of the contemporary antagonism—the cleft in the republic, the great split in which he acted a firm and frightful role, prophetic, integrated, and hostile to a planted majority. (*RR* 91–92)

To Rukeyser, two powerful enemies of poetry, and of fullness of life, were death-dealing war in all its forms—military and commercial; international, civil, and domestic; material and psychological—and a fear of feeling, both in individuals and in the "planted majority," the hostile audience. To the latter—but also *for* them, as an offering—she wrote the great late poems "Käthe Kollwitz," "The Speed of Darkness" (both from *The Speed of Darkness*, 1968), "Despisals" (from *Breaking Open*, 1973), "St. Roach," and "The Gates" (both from *The Gates*, 1978). Opening up the shape of the poem again, as she had done daringly in that first great American documentary poem, "The Book of the Dead" (1938), she makes the poem something like an energy field or force field, a magnetic field—not of inhuman forces but of vital life. In her field of poetic possibility, sometimes lines are spread out and oddly spaced and punctuated, marking a visual field, in this sense, on the page as much as a realm of sound in the ear. And in her poem-field of vital possibility, the poem-sections stand like flowering plants and paused creatures in a meadow—defining a space, marking it, ornamenting it, and constituting the meaning of it.

To return, then, to her poetry, is to find that meadow of which McGrath speaks, a meadow of the imagination, where stands Rukeyser's beautiful "Tree." In that tree, fullness triumphs for a time over destructiveness, life grows out of death, and energy rises out of defeat, to encourage us all:

It stood blasted open,
Its trunk black with tar on its unsealed destruction.
You could see blue through that window, endless sky in the wound
Bright blue past the shining of black harm. And sound
Fresh wood supported branches like judge's arms,
. .
And the crown? World-full, beneficent, round,
Many-branching; and red, apple-red, full of juices and color-ripe,
The great crown spread on the hollow bark and lived.
Lavish and fertile, stood on her death and thrived. (*RR* 196)

Aaron Kramer

Elegy for Muriel Rukeyser

1. Meeting Her Train

He was afraid her train would be late,
afraid she would not be on it;
what he wasn't afraid of
was that
moving toward his upraised arms would be
not Hippolyta
with massive stride and head
but thin legs bayoneted,
thin hairs strafed.

Forgetting she is a touch poet,
he does not meet her mouth . . . mumbles instead
something about a toothache;
but her bag, deep armory of books, he takes.
Already they are touching,
though he is slow to feel it.
She, hesitant at the stairs,
talks of an eye operation
and thanks him for holding her elbow.
In fact, again and again,
as if he has touched her in places of craving,
she thanks him: for fetching coffee,
guiding her to the washroom,
cheering her battle plans.

But when she aims square in the face
that level voice: "What would you like?"
he recoils, as if from a touch,
and lies that he really wants for little . . .
compared to others, is doing much as he likes . . .
and turns from his scar tissue, from an interesting
shell that seems to have landed in his chest,
back to her battered walls, back to the list
of their mutual dead and dying:
a long, golden list
which they quietly keen.

2. Tidings

It had nothing to do with lack of breeding.
The barest lowering of his head.
Then he went on kneading, kneading.
The oven roared for bread.

Then dinner. Then required reading.
Then the Olympics—who was ahead?
Four years he'd waited for those speeding
demons of skate, ski, sled.

Day. The pangs of emptying, feeding.
A chill has boldly climbed into bed.
The radio woos him: warm, misleading.
Not now. Muriel's dead.

3. She Marches Past

May placarded her eyes, bannered her hair;
the teeth in her smile sixteen abreast
from curb to curb; her fist
roaring into the Square
 FREE TOM MOONEY AND THE SCOTTSBORO BOYS

rank on rank
bloomed or haggard
straight or bent
they seized the city—
Dashiell Hammett, Lola Ridge, Arturo Giovannitti

DOWN WITH THE BOOKBURNERS OF BERLIN
Alfred Kreymborg, Waldo Frank,
Langston Hughes, Genevieve Taggard,
Rockwell Kent

in the wake of furriers ten thousand strong—
leftright leftright
 HOLD THE FORT
behind them the dressmakers' fiery song
 REINFORCEMENTS NOW APPEARING
Maxwell Bodenheim, Scott Nearing,
Kenneth Fearing

leftright leftright
never till nor ever since that day
such a mix
of age, voice, sex, race, politics—
the Robesons, Soyers,
Untermeyers
 COMING, COMING
John Dos Passos, Steve Benét,
Clifford Odets, Edna Millay,
Granville Hicks
 MANCHURIA HOLD THE FORT
 ETHIOPIA WE ARE COMING

and she, just grown herself,
smiled
at the wild
cheering of a child of twelve
who already knew
what her marching meant
 WORK BREAD
who leant
forward, far forward, almost grew
feathers, almost flew
into her lyric tread,
dreamt
the Square would someday feel him too
fisting through . . .

May will not meet the regiment
she led
this year
so early; no May crowd
will cheer;
May will not praise her lion head
under the shroud;
a surly cloud
placards her eyes—

and behind her they are coming, coming—
Robert Hayden, posture once so proud,
Melville Cane, at last struck witless with surprise,
Millen Brand,
who used to set the pace with his heart's drumming
—dead, four weeks, four poets dead—
nor will James Wright
wake this time to tell us of his dreaming;

once more leaning
forward, I already understand
the meaning
of the square toward which they flow
left right left right
five mouths, so variously bright,
to form so hushed a band—
no one on the sidewalks cheering
left right
till they're out of hearing
out of sight—
forward, far forward leaning—
 HOLD THE FORT, FOR
one inch further and I go

Christopher Cokinos

Rereading Muriel Rukeyser's "The Speed of Darkness" After Tracking Votes on Amendments to the Interior Appropriations Bill

> . . . *thinking of the poet*
> *yet unborn in this dark*
> *who will be the throat of these hours.*
> *No. Of those hours.*
> *Who will speak these days,*
> *if not I,*
> *if not you?*

I have stepped too
desperate again
out on my stoop
to face winter's southern

sky, so I name what I see
to be who I am
Orion, Canis Major, faint
Eridanus *the river*

the water's light,
star breath I give back
lung to luminous core
to deep, reactive centers,

till exhalations are all
fallen finally someday
to mutative singularity—
I could leave

all the amber ciphers
of my screen lit forever
in a room I'd never enter.
I could say nothing

but these breathings,
legs folded on a stone floor,
wearing stillness
like a robe.

Then to sink in silence,
a chair beneath
an icy marsh,
spending only myself.

My neck and brow
tighten with chill.
For now, I'll say
nothing. I'll cry

instead or sing or
swallow the hours
and be the nothing
I am, the always-

doing-that-is-
never-enough: the worded
necessities I am, we are.
And threatened

with dreams like entrails
dropped from palms. Once
the final memo's read
at the long teak table,

someone, silent,
tingling, stands too fast

ready to say
to say

but only brushes
the front of his suit,
sits again, feeling
the thick *thump*

of his pulse, someone
he was is throwing
books inside his skin.
The others, waiting, stare.

 Last night
I saw the condor
(gray not black)
decapitated, wings

chopped clean from the body
a trunk mounted
on a plaque, displayed
like the curved green

ocean fishes that decorate barrooms
that arc of leaping clear
from what they live in
in order, frantic, to return

(a barb stings the mouth, hooked
flame, yanked
 and working deeper)—

Sharon Olds

Solitary

for Muriel Rukeyser

I keep thinking of you standing in Korea, in the courtyard
of the prison where the poet is in solitary.
Someone asked you why not in the street
where you could be seen. You said you wanted
to be as close to him as you could.
You stood in the empty courtyard. You thought
it was probably doing no good. You have written
a poem about it. This is not that poem.
This is another—there may be details
wrong, the way variations come in
when you pass on a story. This is a poem
about a woman, a poet, standing in a courtyard,
feeling she is probably doing no good.
Pass it on: a poet, a woman,
a witness, standing
alone
in a prison
courtyard
in Korea.

Lyn Lifshin

Muriel Rukeyser Accepting an Honorary Degree

with the night smelling of
rain that hasn't started.
Damp leaves a mist where
there will be roses. Muriel.
with her hair sleeked black
like someone trying never
to hide anything a figure
head on a ship hair blown
away from the sea wind.
The room is hot rustle
of programs. Black robes
black skirts and white
blouses. Bright red silk
rings beneath her robe
like a smile or a wave.
Her face uplifted near
the podium is that of
a woman looking up at a
lover, open feeling
sun warm on her skin
and the air all lilacs
who feels July stretch
ahead like route 107
in Kansas knows this
minute is everything

Part III

◇◇◇◇◇◇◇◇◇◇

*The Body, Feminist Critique,
and the Poet as Mother*

Lorrie Goldensohn

Our Mother Muriel

I might as well say at the outset that I was someone who was brought to Muriel Rukeyser's poetry. I didn't stumble on it, love it, collect it, and then press it on all others around me with that proprietary enthusiasm that some of us love and some of us dread in our friends. My first acquaintance with more than the odd anthology piece was in the empty dining room of an arts colony; I was seated with a composer, looking at what had intrigued him, and working to find an arc of image and event that could carry a song cycle. But sitting there at a table covered with poems and fragments of poems, something with power and beauty like a scent was given off, for instance, in this two-line poem, "Darkness Music," from 1944:

> The days grow and the stars cross over
> And my wild bed turns slowly among the stars. (*RR* 106)

What is so darkly mysterious and effective here? Something that one points to confidently as true lyric? It's probably done by first hooking the large, slow, and distant rhythms of days and then stars in motion together, then further joining them to that incongruous but marvelous piece of erotic furniture, the bed, turning on its axis like the earth itself. The whole assembly leaping into austere and magical flight, a flight sensuous, noble, and funny.

In the company of this two-liner, the more familiar "The Poem as Mask"—the poem that became a feminist manifesto—gained another kind of intensity. It is subtitled "Orpheus":

> When I wrote of the women in their dances and wildness, it
> was a mask,

on their mountain, gold-hunting, singing, in orgy,
it was a mask; when I wrote of the god,
fragmented, exiled from himself, his life, the love gone down
　　with song,
it was myself, split open, unable to speak, in exile from myself.

There is no mountain, there is no god, there is memory
of my torn life, myself split open in sleep, the rescued child
beside me among the doctors, and a word
of rescue from the great eyes.

No more masks! No more mythologies!

Now, for the first time, the god lifts his hand,
the fragments join in me with their own music. (*RR* 213)

Even without the simple biographical facts to shoehorn into a reading—of
the poet's own charged experience of waking out of anesthesia after a ce-
sarean birth and being told of the hysterectomy also performed on her, with-
out her consent, at the same time—the poem reads explosively, with the
famous masks and mythologies still flashing their exclamation points like
stoplights. Through memory, the mortally wounded psyche is healed and
rescued with the child, and the god lifts his hand as if Stravinsky himself had
orchestrated it, in a new and even stronger and more disturbing mythic rite,
this time from the deliberately female vantage point of that cleft speaker, re-
gathered as Orpheus, maenad, and mother.

The poem is embedded in my own twentieth-century history as well as
Rukeyser's, part of a seventies movement primed for sisterhood, but not
quite ready for mothers, especially if they were ours. Reprinted in 1993,
first released in 1973, Florence Howe's anthology of feminist poetry, *No
More Masks!* chooses Rukeyser's negation of the practice of masking for its
blazon. "The Poem as Mask," however, performs a series of much more
complicated maneuvers of recognition and retrieval, maneuvers that hardly
dismiss the adoption of masks or personae. And the famous exclamations
seem more a question of which persona, rather than a dismissal of all per-
sonas: "No more masks! No more mythologies!" is one moment in
Rukeyser's poem.

In an interview published in 1972 by William Packard, when asked
specifically about this line, Rukeyser agrees that when it is spoken, "the myth
begins again." The lifted hand becomes an acceptance of myth both para-
doxical and necessary that occurs "[a]s soon as the refusal is made" (129). By
the time actual memory confronts myth through the reality of the birthing
female, exile from the self is undone, and under the baton of the god's lifted

hand, the shattered fragments of the self enact a literal movement of recollection and raise "their own music." And their own new mythology.

For Rukeyser, the duo of Orpheus and Eurydice dance their steps through several decades of work until Eurydice sinks down out of sight, leaving Orpheus eclipsed as husband, but coruscating as poet-singer. In 1938, the potencies of Orpheus's insight are tested and the unhappy gender relations this myth of conjugal liaison reveals are enacted in a poem called "In Hades, Orpheus." In this poem, Eurydice is central: a diluted Orpheus's declaration to Eurydice is heavily ironized—"He faced her full for the first time, speaking, / turned with his hand her face to meet his mouth / 'but that death's over'" (*OS* 41). He ends the clear fool of his insight, and the final view is of Eurydice's collapse:

> he sees the sharp fear pass
> verdict upon her, pitching and frothing toward the
> mechanical white walls. (*OS* 42)

Neither his nor Eurydice's death or life are at his bidding, or controlled within his song. By contrast, in the 1943 review, "Nearer to the Well-Spring," of M. D. Herter Norton's translation of Rilke's *Sonnets to Orpheus,* Rukeyser closes in on a grander tradition at a higher elevation, both psychologically and aesthetically. Readying us for later engagements with the myth, she repositions Orpheus and Eurydice: "For Eurydice, pure and unconscious, is human to the end, even in after-life. But the poet, the wound, Rilke-Orpheus, rent and scattered, cannot be destroyed; in the end, he can only be heard, heard everywhere." If on the way to Parnassus Rukeyser wants to jump the mortality/immortality gap, the only passage opens through the wound of a Christ-resembling Orpheus, and not a speechless Eurydice. Like Adrienne Rich in "I Dream I'm the Death of Orpheus," Rukeyser chucks Eurydice and keeps Orpheus in his death throes as the salient part of the legend for women.

It's important to understand the ramifications of Rukeyser's preoccupation with Orpheus, because it is through her unique transformation of this myth that she designs a new place within a lyric tradition as well as a feminist one. In a *New Yorker* review, Louise Bogan once issued this job description for the woman poet:

> The chief virtue of woman's poetry is its power to pin down, with uncanny accuracy, moments of actual experience. From the beginning of the record, female lyricism has concerned itself with minute particulars, and at its best seems less a work of art than a miracle of nature—a flawless distillation, a pure crystallization of thought, circumstance and emotion.

A Miltonic Shakespeare warbling her native woodnotes wild. Or worse yet, an Emily Dickinson dressed up as a fey Julie Harris, babbling about recipes for chocolate cake. If ever women poets were to imprison themselves within a tiny domesticity or a narrow range of intellect, here was the urging for it, and from as sharp and brilliant a woman poet as the era would produce. Bogan scolds Rukeyser for her verbal manners, for using "a deflated Whitmanian rhetoric," and then lights into her clothes: "Muriel Rukeyser is the one woman poet of her generation to put on sibyl's robes, nowadays truly threadbare." But even if Rukeyser never succeeded in retrofitting the sibyl's gown to meet Bogan's exacting standards, Rukeyser's insistence on the vatic potential within "female lyricism" should interest us. Her makeover of the Orpheus legend clearly had two aims: one, to reconnect poetry to its older roots in prophecy and wisdom literature, crippling discourse in favor of image; two, to provide a poetics that would acknowledge the full range of female experience as not incidental to poetry, but essential to it. Over many years, Rukeyser strove to take a male myth of the genesis of poetry and recover it for women, thereby to ground herself both theoretically and practically as woman *and* poet, with neither category ever to subtract energy from the other.

The poet-protagonist of the 1949 "Orpheus," written when Rukeyser was in her thirties, and to which she will refer nearly 20 years later in "The Poem as Mask," is consistently male. But even in 1949 it appeared her intention to rework "Orpheus" as the psychobiography of a woman poet: finally, Eurydice's descent to hell and Orpheus's loyalty as husband fades into the story of the poet whose sufferings led to the Orphic mysteries. (We might hypothesize that another source of Rukeyser's continuing interest in the Orphic mysteries lay in their relation to Christianity. Another polar reality of Rukeyser's was the experience of being Jewish in a Christian culture: in Orpheus she altered a male myth of creativity for her own womanly purpose; a not incidental side effect of this mythwork, perhaps, was her assimilation of a proto-Christian myth to a self not only female but profoundly Jewish.)

It took quite a while for all the terms to assert themselves. As in "The Poem as Mask," the poet's masculinity is questioned suggestively when Rukeyser opens "Orpheus" with his murder and its consequences. "Orpheus" begins as a poem of aftermath:

> The mountaintop stands in silence a minute after the murder.
>> The women are furies racing down the slope; far down,
>> copper and black of hair, the white heel running, escaped line
>> of skirt and foot,
> among the leaves and needles of the witness trees. (*OS* 106)

There is no escaping the rather firm opposition of the women in this poem to the poet. They are not patrons of the arts. Nor is there any safe place within them where the woman poet can stow her problematic gift. No wonder Rukeyser sends Eurydice to the outskirts of the poem and disowns the women as a false mask when she gets around again to Orpheus in 1968. It is not until Orpheus has been torn to pieces (or, as in the later poem, "split open") that the moon of the poem "cleared range and rose, female and male" (*OS* 106), and women achieve presence, and the possibility of benevolence supplants their suffocating and destructive rage. In successive engineerings it is made clear that Orpheus's symbolic murder necessarily brings about his recognition of Eurydice, of love, and that through the assaults of love, he will go from weapon to wound to song, to transcend the gendered and separated body.

But there is limited comfort in that transcendence for women. The women of this poem are suspended in fragmentation: "now they need be whole. / And the pieces of the body cannot be. / They do not even know they need be whole" (*OS* 110). And the focus shifts decisively back to Orpheus's wounding, to the problem of his becoming whole, and away from any transmutation of female rage. The wounds of Orpheus take the place of the complaints of the furies. Throughout section II, like neglected wives, the wounds stand around and beg Orpheus repeatedly, "Touch me! Speak to me! Love Me!" (*OS* 108). It is certainly the wounds of Orpheus's body that one by one wake him up and get him into a singing frame of mind; through the unexplained intervention of a Pentecostal-looking "breath of fire," they even become responsible for his literal transfiguration through song. Orpheus's wounds, stripping his body of phallic potency, ultimately resemble nothing so much as the female reduced or distilled to stark sexual opening, openings that then transform to the mouths of creation:

Cyclic dependence the god and the miracle
needing each other, and all the wounds are mouths,
weapon to song transfigured. (*OS* 112)

The displaced women of the poem, both Eurydice and the furies, are conveniently if uneasily subsumed within the vague generality of that "all." In 1968 it is this complicated dance of body parts and uncertain gender assignation that "The Poem as Mask" decisively rejects. In 1949, Rukeyser's attention drops away from women's bodies to heal the split between male and female, by tucking the female nicely without quarrel inside the apparently accommodating male. Before death and wounds transfigure him, Rukeyser observes:

> Scattered. The fool of things. For here is Orpheus,
> without his origin : the body, mother of self,
> the earliest self, the mother of permanence. (*OS* 107)

At this moment, Orpheus, flashing briefly as phallic mother, is seen as "sideshow," as "body as circus," but in this early sequence it is still through the male body of Orpheus that the woman writer must find her route to song. A woman cannot become a poet except as a kind of enlightened man, wearing her prophylactic Orpheus mask. Even in 1949 Rukeyser points to the inadequacies of this myth, in the "Song" section ending "Orpheus," whose lines plead, "Days and voices, sing / creation not yet come" (*OS* 113). But in 1968 it is the gendering of all this mythic superstructure that "The Poem as Mask" challenges.

In stages, deep within the work another creation myth is germinating inside the story of the origins of the female poetic voice. It is a myth that may worry the anti-essentialist feminist. In "The Poem as Mask" Rukeyser proposes the founding moment of a female self-recognition, and her simultaneous rejection of Orpheus and acquisition of her own voice, as the moment of a violated childbed, when her fertility is attacked in the instance of its expression. And yet, the female splits; gives birth; and suffering, acquires voice. In a split that also heals the gap between writing and living—between poetry and life—the poem couples or splices an "actual" autobiographical memory with a fictive or mythic recognition. But Rukeyser bears down on female memory or authentic experience as that which gives rise to the new myth, in which a newer god lifts his—and it is still *his*—enabling hand. In "The Poem as Mask" Orpheus may be a woman finally with the right mask on, clutching the right mythology, but the deity hasn't changed *his* pronoun.

I can imagine critical responses rejecting the implied pronatalism of this Orpheus myth, its potentially coercive suggestion that the catalyst of female creativity be childbirth, in a remake of Freud's movie Anatomy as Destiny, this time as produced and directed by a feminist. Yet Rukeyser's imagery can also be read nonprescriptively, and as generated from the context of a particular life and history that may not be pared away from a reading of the poems. Rukeyser in the postwar years is not just scorched, but fired by the experience of birthing and raising a son in the teeth of convention and through ambiguous paternity; fighting for her right even to have this child, she rewrites her creation myth: in "The Poem as Mask" both mask and mythology are cast aside, only to be retrieved and re-shaped.

But the recuperative role that motherhood plays is clear: the self split open in self-mothering is the cloven female body, despite the male's appropriation of midwifing and control over procreation, and despite the wound to her fertility that the poet undergoes in her hysterectomy, on the way to a

deliverance both psychic and actual. The new myth is this female body whose wounds produce the Orphic song, its emblem the poet-mother and child. Against the surgical knife of male cancellation, body and family become female: first mother, then tentatively, then more and more strongly, bisexual or lesbian. And perhaps a shouldering aside of the male, except as son, becomes a necessity for a strong woman poet who has just undergone four years of a global conflagration in which militarism sidelined or dismissed or victimized women.

Rukeyser early began pairing the uterus with the lyre and the arts of peace: in her poetry both during and immediately after World War II, she sustains as reference point the classic binary in which men carry weapons and women carry babies. In section IX of "Letter to the Front" she cries:

> You little children, come down out of your mothers
> And tell us about peace.
>
> I hear the singing of the lives of women,
> The clear mystery, the offering and pride. (*OS* 67)

In *A Gulf So Deeply Cut*, Susan Schweik argues that the unique accomplishment of this sequence becomes Rukeyser's articulation of an alternative and nonmilitarist ideology that subverts the materialist terms of warrior thinking that can only counter fascism by piling up the dead bodies of soldierly sacrifice and relegating female flesh to mute and passive compliance. Schweik sees "Letter to the Front" as a poem that "consistently substitutes spiritual and mental contest for physical engagement. It insists, repeatedly, on a conceptual fight which precedes, and takes precedence over, armed struggle" (*Gulf* 165–66). And here, for Rukeyser and other believers in the innate superiority of women's talents for peace, among whom I am never quite able to count myself, women's bodies are vessels rededicated not to the breeding of future armies, but to the containment of militarist ravage. By focusing on this period of Rukeyser's career, Schweik can enlist Rukeyser as an antimaterialist "upholding . . . the primacy of negotiable belief over the felt experience of the body" (*Gulf* 167); in this reading, "Letter to the Front" becomes "unapologetically rhetorical and resolutely antimimetic" (*Gulf* 167). And, we might add, unashamedly sibylline.

Yet Schweik cannot take the body out of Rukeyser's poetics, or transform her complicated feminist materialism. For Schweik, Rukeyser in closing "Letter to the Front" ends "with a voice resonantly Orphic," a voice in which "the female Orpheus unifies front and home, far countries and familiar cliffs, and transforms all with a power of voice and insight derived not from the maenads but from Demeter" (*Gulf* 164). What Schweik recognizes here is

Rukeyser's originality in grafting the functions of Demeter onto the figure of Orpheus. Schweik quotes Rukeyser earlier from "A Letter to the Front,": "Women and poets see the truth arrive." In her late reworking of the Orpheus myth Rukeyser takes away that "and"; seeing that women can only become poets if they move into Orpheus's territory directly, she dares to insist upon foisting motherhood onto Orpheus not in place of, but in alliance with, song.

Rukeyser's insistence upon an embodied woman's poetics didn't stop with the war years. Two years after the birth of her own son, in a review of Charlotte Marletto's *Jewel of Our Longing,* she says in a clearly rectifying mood: "There is no poetry of birth in the literature that reaches us." Further, "This is an entire area of experience which has not reached poetry." And then again, "In the books about the artist . . . , there is absolutely no allowance made for the possibility of the woman artist." When women did appear, as we see from Louise Bogan, they accepted limits on how womanliness was to be packaged. No womb-waving. But Rukeyser continues:

> Now birth as trauma has an important repressive role in our art—our literature in particular. Few of the women writing poetry have made more than a beginning in writing about birth. There is exceptional difficulty in giving form to so crucial a group of meanings and experiences. And the young men in poetry seem, for the great part, to suffer so from the fear of birth that we have a tabu deep enough in our culture to keep us even from speaking of it as a tabu.

Rukeyser's choice to spend part of her next decades in poetry fitting childbirth into some related and enabling pattern, however, did not always mean unadulterated celebration of either maternity or maternal capacity. In "Cloud, Airs, Carried Me Away," gender itself, neither essentially enabling nor inevitably hurtful, appears in another look at Orpheus, Rukeyser's symbol of the fecund singer, and the self-motherer:

> Orpheus in hell remembered rivers
> .
> One piece in tatters sang among its blood:
> man is a weapon, woman's a trap;
> and so is the hand with the map, my dear,
> so is the hand with the colored map.
> And I to myself the tightest trap. (*OS* 70)

Yet even if the female body begins as entrapment, nevertheless a "shining is born;" "Cloud, Airs, Carried Me Away" points to all the triumphant birth poems and images that wind up this period of Rukeyser's life—including

"Nine Poems for the unborn child"—declaring: "I am born; / you bring shining, and births." As elsewhere, for Rukeyser childbirth marks the crossover into true song.

In 1971 Rukeyser's alignment of childbirth and poetic expressivity can be read alongside Adrienne Rich's "The Mirror in Which Two Are Seen as One." Here the woman poet is simultaneously poet and midwife, in a hospital in which these lines show an alternate birth-myth:

> the hospital
> where all the powerful ones are masked
> the graveyard where you sit on the graves
> of women who died in childbirth
> and women who died at birth
> Dreams of your sister's birth
> your mother dying in childbirth over and over
> not knowing how to stop
> bearing you over and over
>
> your mother dead and you unborn
> your two hands grasping your head
> drawing it down against the blade of life
> your nerves the nerves of a midwife
> learning her trade

No less powerfully than Rukeyser, Rich offers an embodiment of a feminist poetic; perhaps the difference is in that line of women birthing themselves and each other. Rukeyser concentrates on the split self bearing, but there is no future tradition of difference sketched in which male and female poet inevitably serve in separatist camps. Rukeyser's handling of difference is always inclusive rather than exclusive.

Again and again, Rukeyser affirms the importance of sexual difference as she reworks classical myths. In "Myth" in 1973, she rewrites Oedipus's encounter with the Sphinx:

> Oedipus said, "I want to ask one question.
> Why didn't I recognize my mother?" "You gave the
> wrong answer," said the Sphinx. "But that was what
> made everything possible," said Oedipus. "No," she said.
> "When I asked, What walks on four legs in the morning,
> two at noon, and three in the evening, you answered,
> Man. You didn't say anything about woman."
> "When you say Man," said Oedipus, "you include women
> too. Everyone knows that." She said, "That's what
> you think." (*RR* 252)

And in her introduction to *Out of Silence: Selected Poems,* Kate Daniels notes Rukeyser saying trenchantly to Cynthia Ozick: "I write from the body, a female body."

It should be said of Rukeyser that her politics always function in a world of generous promise for both male and female. By the time she publishes *The Gates,* in 1976, a mask makes another kind of appearance in "Burnishing, Oakland," as near the waterfront, in the wide mouth of a shed, the poet sees "One man masked / holding a heavy weight / on the end of a weighted boom / . . . / I see him draw / his burnisher":

> Statement of light
> I see as we drive past
>
> Behind my head
> the shoulders of hills
> and the dark houses.
> Here the shine, the singing cry
> near the extreme
> of the range of knowing
> one masked man
> working alone
> burnishing (*CP* 560–61)

A mask in this poem is not something to throw away, but a protective and enabling instrument, allowing its human user to come close to and master a great and potentially damaging force of light. The mask image of this poem becomes a silent admonition not to let the devices of earlier poems become simple slogans. Once again, although her poetry has often been taken to stand for the apotheosis of the personal because of its emphasis on body poetics, Rukeyser's particular genius was always to insist on the idea of body with the widest resonance—*body politic* or *body electric*—it's all on her turf.

Even first acquaintance with her poems should establish the desire not to read Rukeyser serially, poem by poem, but to read her in the cross-lacing of her work, including the prose, both fiction and nonfiction. The same stubbornness that leads her to fight conventional dichotomies in a poetics or a politics leads her to variety in formal practice. Both Jan Heller Levi and Kate Daniels, in their recent collections, demonstrate Rukeyser's inventiveness, presenting us with work that switches easily from tight, rhymed stanzas to collage and typographical experimentation. Rukeyser has moved authoritatively through as wide a range of forms as any twentieth century poet. Emphasizing the bodily wholeness of her work, with its dynamically branching parts, as well as its scale, is especially crucial. This is a poet who staked much on the breakage and redefinition of links of all sorts, on systems of relation-

ship both within and without the formal cage of the poem, and on a cross-genre fertilization as well. Both *Theory of Flight* and *U.S. 1* combine prose and poetry skillfully, and *One Life,* her book on Wendell Willkie, openly mixes both lyric poem and lyric prose for a kind of biography no one has written before or since.

The biography of Willard Gibbs, the inventor of the field of statistical mechanics and a mathematician who pioneered in equilibrium studies and vector analysis, illuminates the complicated nature of Rukeyser's fusions of art and science. Gibbs hardly seems the obvious choice for a book by a poet, but some 70 pages into her 1942 biography, Rukeyser paraphrases John Quincy Adams in the following: "The republic we have here founded . . . rests on natural faculties, and on the multiplying and sharpening of those faculties by education, which thrives on liberty. And its hope—its existence, indeed—rests on the fact that man is a curious and inquisitive human being" (73). No description could be more serviceably applied to Rukeyser herself, tackling her improbable subject: "one of the reasons that I wrote this book," she says, "was that I needed to read it" (*Gibbs* 443).

In her 1972 interview with William Packard, Rukeyser says about the book merely, "Prose is really a footnote to the poems." But given the sketchy, notational form of the poems directly stemming from prose work, such as "Gibbs" and *The Outer Banks,* her out-take from her book on the Elizabethan scientist, *The Traces of Thomas Hariot*—I'd reverse the comment, and say the poems are properly footnotes on some original and compelling prose, hardly concealing the very substantial part that prose played in developing her thought, particularly on materialism. The writing of *Willard Gibbs,* a key chapter of which is included in Levi's reader, provided her with several paradigms for the creative life across intellectual disciplines.

Part of developing an embodied poetics means that, like Emerson, she saw history as biography, not as mere data retrieval. History is primarily a mental occupation shaped by its visions of human life, and she assumed its underlying aesthetic form. She muses about the thoughts generating her book:

> The structure of a life being an art form. About the ways of getting past impossibilities by changing phase. The reason that I came to do Gibbs was that I needed a language of transformation. I needed a language of a changing phase for the poem. And I needed a language that was not static, that did not see life as a series of points, but more as a language of water, and the things are in all these lives that I try to see in poems. Moving past one phase of one's own life—transformation, and moving past impossibilities. (Packard 130–31)

She presses this concept of life as an art form, and of biography as the fluent tracing of that art form, further in *Willard Gibbs.* But her ideas go beyond the

aesthetics of biography into a vision of both individual and collective motions of creativity as well, in which transformation, or an explosive and vital change, also becomes an inevitable part of the linked flow of human event. It may be puzzling to imagine why this book occupied her when it did, at the height of the wartime years. Something in her irrepressible optimism must have been rallying her to put both connectedness and social cohesion alongside the processes that were intrusively ripping a stable society apart, and goading her to find in volcanic intrusion itself some benefit.

Like her assault on the gender separatism of the Orpheus myth of creativity, her interest in Gibbs once again involved impulses of inclusion and integration. Her mind moved against acceptance of science and technology as a largely male intellectual realm, and no doubt she saw herself making an incursion into her subject's blueblood Yankee world as well.

As she describes Gibbs, part of his importance belongs to his position within a family with an historically recognizable mission. In italics, she notes as central this conclusion for Gibbs's father, Josiah Gibbs: "*Language is a cast of the human mind*" (*Gibbs* 52). It is the younger Gibbs's recognition and development of mathematics as both a pure and particular language that burns through her account of his achievement. But her relation of family and creativity takes on another cast, as "family" becomes a metaphor charged with multiple meanings. In her chapter "Science and the Imagination," with an ecumenical delicacy and subtlety, she describes science's quest for knowledge as one transcending specialization and dedicated to "combining":

> This combined power does not call for a knowledge of types alone, but for a search among deviations. The expression of turning-points, of new groupings and rhythms observed for the first time, leads to new analogies, new holy families. (*Gibbs* 82)

Further:

> The imaginative act, in all its delicacy, in all its explosiveness, realizes these energies [of revolutionary change] . . . and the continuity behind them—the continuity of force, and of the human spirit alive in many lives. The realization is expressed in the interruptions, however, at those dramatic points which disturb all balance, which flash and are gone as balance is made again. And in the flash we see the equilibrium, as in the work of a great artist we see his age. (*Gibbs* 82–83)

Willard Gibbs, whose isolation was part of his fascinating originality, enacts Rukeyser's idea of balancing, as his work is finally absorbed into American intellectual and scientific history. There is also a certain irony in her insistence on seeing these relations between creativity, change, and collective

effort within the metaphor of "family" advance, through the lives and work of Willard Gibbs and his father, the linguist Josiah Gibbs. At the start of Rukeyser's research, Gibbs's heirs and a former student made strong objection to her as Gibbs's biographer because of her inappropriate "ancestry," meaning her Jewishness. Rukeyser traveled past irony, however, as she sought to understand both Gibbses within the context of two other American families, James and Adams. Just as she sought to convert the Orpheus myth by transforming its gendered roots, so she sought to transform the vicious snobbery of Gibbs's descendents and his influential student, E. B. Wilson, into a more generous vision, to make "a final translation in a series of translated statements. . . . Generation after generation seeks expression for one truth in modality after modality, as if a small race had an utterance to make, and tried to make it until it found its form."

In similar fashion, one of the first and most memorable of her poems, "Sand-Quarry with Moving Figures," is about her father and his construction company. From the beginning of her work to its end she makes an effort to understand her human position as a point moving within a series of interconnecting, also moving and historically phase-linked, points. The long, wartime preparation for the Gibbs's biography and her immersion in the complexities of the phase rule, for which Gibbs was best noted, were likely part of what brought her in 1949 in *The Life of Poetry* to describe the strength of Whitman. Hinting at her own work, she writes that Whitman's poetry is "not beginning nor ending, but endlessly drawing in, making forever its forms of massing and falling among the breakers, seething in the white recessions of its surf, never finishing, always making a meeting-place" (78). Crucially, Whitman's is "a language of water."

Rukeyser focuses again on flux and relationality in passages from *The Life of Poetry* as she cites Peirce as her model for a triad of interactive response—poem, poet, audience—with huge consequences for her idea of lyric form. Rukeyser says: "A poem is not its images any more than a symphony is its themes." Then, more provocatively: "A poem is not its words any more than a symphony is its notes." She shows how she *means* this in Chapter Eleven of Part Four, thoroughly shaking up our belief in the object status of the sacred, canonical text, by telling about a class exercise she uses:

> I have called for a volunteer in workshop, and asked the intrepid one whether he could make a poem—quality set aside for the moment—on the spot. After his moment of blankness, we could see his face change, and soon he said he had something. I asked him whether he could remember it; and he said Yes, he could. Then I asked him to leave the room, to wait in the hall and after a while, to write the poem down; I would come out for him a little while later. (179)

The class is asked whether there was a poem. One person holds out for the poem only if it exists on paper. Others concede its existence even if only in the mind. The nature of poems is discussed. The volunteer is asked to return, recite, and then tear up the poem. Oh, fatal act! Rukeyser continues:

> The poem exists in the imagination of the poet and the group; but are there as many poems as there are witnesses? What is the role of the words on the paper? Even . . . what would have happened if the volunteer had died in the hall—would there have been a poem? (180)

The concentration on poetry as living impulse that transcends even the physicality of the language on the page, that moves with intensity to melt the moment of writing into the moment of thinking, the moment of speaking with the moment of writing, is a curious one to savor for generations of readers brought up on the material purity of texts. But Rukeyser, that paradoxical poet of the body, preserves something beyond materialism for poetry, and beyond any messing around with gendered deity, in this sentence from *The Life of Poetry:*

> Art and nature are imitations, not of each other, but of the same third thing— both images of the real, the spectral and vivid reality that employs all means. (*LP* 26)

It is her fidelity to the search for this presence, beyond any doctrine of the image or adhesion to a particular rhetoric, that keeps her poems momentous, our view of the work always a little off-balance, craning our necks to see its flashing manyheadedness.

Almitra Marino David

For Muriel Rukeyser

*the power of eyesight is very slowly arriving
in this late impossible daybreak
all the blue flowers open*

—Muriel Rukeyser

three flights you
climb to this room
where windows don't
shut out October wind you
stand defying
the doctor who said
stay home in this room
women come together to write

and again you have
come to the gates
this time you say to a
new power of women to
the woman as writer
you have
survived wars to say this

outside no
fireworks open the sky
this celebration is quiet as
our breath you say listen

to each pause to
every drawing in and
letting go

when the rhythm of your breath was
broken your voice
your balance
shattered as though
someone (perhaps from a
battlefield you crossed) shot at
your right side
you called it
lightning from behind the eyes

your eyes this morning
see us see
the structure of
this room of
the trees nearly bare in
the wind you
gesture as you speak
poems you say
roll down my right arm

Jan Johnson Drantell

◇◇◇◇◇◇◇◇◇

Or What's a Mother For?:
Muriel Rukeyser as Mother/Poet

If I could I would claim Muriel Rukeyser for my mother. What do I mean by *if I could?* What do I mean by *claim?* What do I mean by *mother?* Questions to begin, and more questions. At my age, what do I want a mother for? Why don't I simply claim my own? My mother and Muriel Rukeyser are both dead, as are many of the mothers of their generation, mothers to the women of mine. Muriel Rukeyser was born in 1913 and died in 1980. My mother was born in 1918 and died in 1958, less than two months past her fortieth birthday.

Phyllis Johnson, my mother, left behind three living children and the graves of several more. Muriel Rukeyser left behind one adult son, some 570-plus printed pages crammed with poems, 200-odd pages of prose about poetry, two biographies, a novel, six children's books, and assorted articles and translations. Many of these are out of print, difficult to find, and that figures into it.

Words are the heart of the matter. Mothers' silences/words/poems/actions allow/encourage/force us to move from silence, to speech, to silence again, to listening, so we can speak—always in and from a present moment—and from our speaking to act. *The Life of Poetry,* Muriel Rukeyser's manifesto of poetry and life in process, helps teach me to write a sentence like that.

In Chapter Twelve, Rukeyser introduces her readers to her own childhood. About her mother, she writes:

No reading, in these houses, or in yours, until, at a stroke, your mother begins to read Emerson and the Bible, to revive a lost interest in her religion,

and slowly to move, without direction, and years later, after the family breaks, to move forward in her development, as so many of these women move, at their first chance, in their fifties or their sixties. (*LP* 197)

The chapter begins: "My one reader, you reading this book, who are you? what is your face like, your hands holding the pages, the child forsaken in you, who now looks through your eyes at mine?" (189). An invitation, an admonition: see, speak.

My mother never lost interest in her religion. Nor did she, as far as I know, read Emerson or the Bible, a practice strongly discouraged by the pre-Vatican II Catholic Church. One way to say it: my mother died of her religion. She died in childbirth in her twelfth pregnancy, three days before my eleventh birthday, after a priest had laid out her options: practice celibacy or take the children God gave her.

No, my mother did not read much—a few magazines, maybe a novel once a year, and Bishop Fulton J. Sheen's inspirational tracts. She herself never had her first chance "to move forward in her own development." Yet she procured a library card for me as soon as I could read, enrolled me in a Lives of the Saints book club, and scrimped on grocery money to buy me a set of cheap encyclopedias. I have spent years trying to invent a mother who would rejoice in my chances to move forward. I think/suspect/hope and try to convince myself that she had a pre-verbal inkling that my life could—and would—be different from hers.

As a child of the 1950s, this is what I thought women did: they graduated from high school, took jobs as typists or waitresses. They contributed to the war effort by assembling bombers. After VJ Day they exchanged their welding arcs for brooms, their typewriters for mangles. They got (or stayed) married. They kept house for their husbands, who worked hard. They bore children, to whom they dedicated their lives.

As far as I knew, women did not attend International Writers Congresses sponsored by the Communist Party. They did not sail to Spain as working journalists. They were not investigated by the FBI. They did not have sex outside of marriage with men or, God forbid, with women. They most assuredly did not have babies out of wedlock and keep them. They did not write poems. Nor did they tell their children that these things—and more—were possible.

In 1947, my mother and Muriel Rukeyser both gave birth. I was my mother's second child. My brother Stephen died a week after he was born in 1942. Then my father went off to war. In my baby book my mother recorded on the allotted line her first words after I was born: "She's not a boy." Relief? I was not a boy like the one who had died. Or disappointment? Didn't all mothers want to give their husbands a son? These are questions, among many others, I wish for a mother to answer.

I imagine it is 1956. I find it difficult to envision my mother sitting with Muriel Rukeyser over a cup of afternoon tea. What on earth would they talk about? My mother hated Communists and prayed every day to the Blessed Virgin for the conversion of Russia. She also hated war—I think because it took my father away from her—not from any conviction, reasoned or intuited, that war was wrong and might be, if not avoided, at least protested. Her solution to the problems of starving, fatherless children was more prayer. Nightly we prayed for the starving children in Communist Czechoslovakia.

A quarter of a century ago, we who came of age near the beginning of the second wave of feminism (women's liberation as we called it) claimed Virginia Woolf, Gertrude Stein, Sylvia Plath, H.D., Anaïs Nin, Adrienne Rich, Muriel Rukeyser, and a raft of others as foremothers. No matter what they wrote, they were political writers by simple virtue of the fact that they were women. None of these women, and few others, formed part of my college education. But we were sure once we pointed out this small lack, politely and reasonably, or, if need be, with our fists and voices raised, that women writers—beyond the "safe" Emily Dickinson, Jane Austen, Flannery O'Connor—would take their rightful place in the choir of the canon. These were heady days in which the personal—that is, the stuff of women's lives—became the political.

I imagine my younger self, say in 1970, sitting with Rukeyser and my mother over tea. I tell them how women can, or will soon be able to, have it all: children and career, full and equal participation in the public world. My generation will end the war in Vietnam, abolish the military-industrial complex. We will throw off the yoke of our fathers, turn our energies to creating a country in which people can live together in harmony and prosperity. Women are no longer shackled, I say, by archaic church laws that forbid birth control. Should they find themselves pregnant, for the twelfth time in sixteen years or out of wedlock, they have choices. Certainly my mother would begin on the spot to pray for my immortal soul, which she would consider to be in mortal danger.

Perhaps Rukeyser would arch one of her thick black eyebrows, the left one that looks in photographs as if it's permanently arched. Perhaps she would tell me what her life was like in the year of my birth, that she could have chosen an abortion, albeit an illegal one. Perhaps she would tell me what it was like to have the lover of her youth killed in a war or to become a single mother in the era of June Cleaver. Perhaps she would tell me that the world does not change overnight, that those who have power over others do not easily relinquish it.

She might even see in me an echo of her younger self who wrote "Child and Mother" (from *Theory of Flight*, 1935), in which the mother appears as a revolutionary hero, standing at the water's edge "with child braced in the

hip's firm socket / fronting the torrents." This mother "will tell / clews to the young eyes' candor, fertile thoughts / will be asserted." It's the middle of the Great Depression. Communism is not yet the enemy, may be the savior. Mothers are in the vanguard: "we and our children meet these tides / prows of revolt launched among barbarous seas" (*CP* 52–3). The role of the mother is beginning to be articulated: to tell the truth to her child. The world is "barbarous," but if "fertile thoughts" are clearly spoken, change cannot be far behind. Rukeyser, too, had her own heady days of youth. In these early poems it is a simple equation: speak and the world will change.

I recently read Kenneth Rexroth's foreword to Louise Kertesz's *The Poetic Vision of Muriel Rukeyser,* published in 1980. "She is a poet of liberty, civil liberty, woman's liberty, and all the other liberties that so many people think they themselves just invented in the last ten years" (xii). I cringed. Yes, I am of the generation who had little knowledge of the Old Left, despite working diligently to invent the new one. Scottsboro? Was that somewhere near Selma? Well, actually, as it turns out, yes—in time and space. Conscientious objection to World War II? Never heard of it. Poets against the war meant against the war in Vietnam, as far as we knew the only protested war this country ever engaged in. The history we learned in school was one-dimensional. For nuance—how things had been, were now, and might be—we needed, and still need, mothers and poets like Muriel Rukeyser.

Time seems to accelerate as we grow older. I am mother to a child who is now nearly an adult herself. I have grieved personal losses. I have cowritten a book about children whose parents die (*A Music I No Longer Heard: The Early Death of a Parent,* 1998), in large part as a search for my own mother and what she could or would tell me about the world now. I have watched as this country dismantles the small gains of the last 60 years: as we abolish the safety nets we began to weave in the thirties for mothers and children (among others); as we gloat over "winning" the war against Communism; as we spend more money to incarcerate more people and less money to educate fewer children; as we vote to end affirmative action and agree to pretend that women and members of ethnic and class minorities have an equal chance to make their way up a social or economic ladder, while we blithely ignore the rotten rungs on that ladder that are liable to break under the weight of the rampant consumerism, pollution, and racism we think we can pretend is someone else's problem. If there is a better time for the postwar child to go in search of a mother whose lifetime was "Held between wars," ("Käthe Kollwitz," *RR* 214), I can't imagine it. If I do not listen, I will not speak. If I do not speak, I will not survive.

Now, if I could, I would sit over afternoon tea with my mother and Rukeyser. I would listen, because I have learned something of what Rukeyser learned, and teaches, about speech and about mothers. In the second poem

in the sequence "The Speed of Darkness" (from the 1968 volume of the same name), Rukeyser wrote:

> No longer speaking
> Listening with the whole body
> And with every drop of blood
> Overtaken by silence
>
> But this same silence is become speech
> With the speed of darkness. (*RR* 229)

The poet recasts speech/silence and light/dark outside (contrary to) a traditional dualistic symbolism in which speech and light are good; silence and darkness are bad. They are, instead, cyclic and interdependent.

"The Speed of Darkness" uses explicitly sexual and erotic language. In the seventh poem the poet addresses the reader directly: "I bastard mother / promise you / there are many ways to be born." Poem 8 names "these sons" who "fall burning into Asia" (*RR* 230). The "Big-boned man young and of my dreams" in poem twelve could be a lover. Or perhaps he is a grown-up child, old enough to go to war, who "Struggles to get the live bird out of his throat." Or perhaps she (the mother/narrator) is he:

> I am he am I? Dreaming?
> I am the bird am I? I am the throat?
>
> A bird with a curved beak.
> It could slit anything, the throat-bird.
>
> Drawn up slowly. The curved blades, not large.
> Bird emerges wet being born.
> Begins to sing. (*RR* 231)

Is it a dream that in giving birth we find our voices? Is it a dream that by being born we begin to sing? Am "I"/are we dreaming? Yes, and no. The poem images of child/bird/ birth (and by implication the mother who may be her own child) may arise from a dream. But, in being born, perhaps a reference to Rukeyser's own cesarean—i.e., with "blade"—the mother and the child, both newborn birds, emerge and begin to sing, or speak. With the curved beak it can sing and "slit anything." One way to read that is to split it open, expose it, or give birth to it. The throat-bird is *both* the mother and the one being born, the truth-teller and the giver of voice.

I have passed the age my mother was when she died. I have passed the age Rukeyser was when she became a mother, and the age she was when she

wrote about her own mother in "Mother's Garden Round" (published in *Body of Waking*, 1958): "The suffering of your absence flies around me now, / No house can keep out this flying of small birds. / . . . / Touching my face when, almost, touch means kindness." A decade before the bird was the image/instrument of birth, it was the image of the pain of death: "The little fresh pain flutters." (*CP* 400).

I think of birds as traditional images of death and decay, the carrion crow. Or as traditional images of freedom and flight, the soaring eagle. Or as God; the Spirit is dove. The carrier pigeon delivers the message; the canary sings/speaks the truth, sometimes in the mine shaft. Rukeyser's "throat-bird" gives birth. I wish for a concordance for Rukeyser's large body of work. I can only say: Look for birds. Birds abound as images of birth and death, mothers and children, who break the shell of silence, who speak, who listen, and who speak again.

A mother is a foremother, a woman who counteracts history the way it's usually told by forefathers; a person who physically gives birth to us; a social construction of the patriarchy under re-construction. In *The Poetic Vision of Muriel Rukeyser*, Louise Kertesz offers a brief overview of postmodernism when "the poet, aware of and often detailing the insanities of a superabundant yet repressive society, became again the person with a special vision into the wholeness, joy and potential of life." She continues in a discursive footnote: "Among the characteristics critics note as postmodern, of course, are the raw directness and personalism Rukeyser was castigated for in the Forties and Fifties" (365). Kertesz writes: "Rukeyser writes several times of the priestly, tribal function of poetry, saying she makes her work for the 'unborn'" (388). I consider the deliberate blurring of who is being born (and is therefore unborn) in "The Speed of Darkness," as the idea that the mother gives birth to child *and* self. Kertesz ends her book with an excerpt of an unpublished letter from Anne Sexton, addressed to Rukeyser—"beautiful Muriel, mother of everyone" (389). Rukeyser's "unborn" are all of us, including the poet herself.

One of the earliest contemporary feminist explorations of motherhood is Adrienne Rich's *Of Woman Born*, published in 1976. Yet, here, 30 years after her foremother Rukeyser has plowed this ground, Rich demonstrates how her mother-life was split from her "real" life, in a way that society seems to demand: "For me, poetry was where I lived as no-one's mother, where I existed as myself" (12). The book, in large part, opposes the myth that only the subject of idealized motherhood, written primarily by men, is a suitable subject for literature, but Rich's separation of the personal territory of poetry from her life as a mother seems, in a curious way, to buy into it.

The theoretical Rich tells a different story. She recounts the enactment of Eleusinian rituals in honor of Demeter and Persephone as "a final resurgence

of the multiple aspects of the Great Goddess in the classical-patriarchal world." She speculates how these myths affected real women of the time, how daughters "must have longed for a mother whose love for her and whose power were so great as to undo rape and bring her back from death. And every mother must have longed for the power of Demeter, the efficacy of her anger, the reconciliation with her lost self" (240). Rich brings it all back home: "Few women growing up in patriarchal society can feel mothered enough; the power of our mothers, whatever their love for us . . . is too restricted" (243). Then she posits a definition of a mother who could change things:

> What is it we wish we had, or could have, as daughters; could give as mothers? . . . we need trust and tenderness . . . a very profound kind of loving in order to learn to love ourselves . . . we want courageous mothering. . . . The most important thing one woman can do for another is to illuminate and expand her sense of actual possibilities. . . . For a mother, this means . . . that the mother herself is trying to expand the limits of her life. *To refuse to be a victim:* and then to go on from there. (246)

Muriel Rukeyser was a mother; Muriel Rukeyser was a poet. As mother and poet, she surely offers her putative daughters/readers an expansion and illumination of "actual possibilities." She applied both her intellect and her capacity to experience and articulate emotion to make sense of the world. The Great Depression, the war in Spain, World War II, technological advances, science, mythology, psychoanalysis, motherhood—all were fodder for her creative drawing together. As mother and poet, she refused to be a victim.

From the first book, *Theory of Flight,* mothers, mother images, birth images, and images of speaking and silence in relationship to mothers appear in Rukeyser's poetry. Over the years and within the poems, the Demeter-mother as prototype emerges. No Hallmark card sentiment or super-hero archetype for the ages here.

A mother may be a poet and a teacher who says, as does Rukeyser in an interview in *The Craft of Poetry:*

> I care very much about working with young poets. . . . I would very often say "NO." I would say "No" always when a poet says, "Should I go on writing poetry?" I would say, "No" and then I would say, "If they can't go on writing poems in the face of that No which they will get from everybody, they are not going to go on writing poems." If they would bring the poems back to me then, I would do whatever I could. (Packard 126)

I think of a mother cat, feral, who teaches her kittens to kill mice, then sends them out on their own to hunt. Life is hard and you have to learn to speak

your piece in the face of resounding silence. The stance resonates in Rukeyser's poems and in her life.

In "Six Days: Some Rememberings," Grace Paley recalls being arrested with Muriel Rukeyser and others at an anti-Vietnam War action. Paley wore her hair long and in a bun, but the police took away her hairpins. (Presumably they were a weapon?) Rukeyser comforted her, said her hair looked fine. "You really ought to always wear it this way" (448). A mother can also be tender when she needs to be.

But before a mother speaks, there is silence. Early in Rukeyser's own speech the mother is silent, even absent. In *Theory of Flight*, in "Poem out of Childhood," the narrator speaks primarily of the public events from her childhood that influenced her. Significantly, her mother does not appear. Women (mothers) do not go out into the world.

> We grew older quickly, watching the father shave
> and the splatter of lather hardening on the glass,
> playing in sandboxes to escape paralysis,
> being victimized by fataller sly things.
> "Oh, and you," he said, scraping his jaw, "what will you be?"
> "Maybe : something : like : Joan : of : Arc..." (*RR* 6)

In Chapter 12 of *The Life of Poetry*, Rukeyser wrote: "The heroes are the Yankee baseball team, the Republican party, and the men who build New York City. And Joan of Arc. In Domremy, as a little girl, she began to know what she had to do" (195). The daughter who is interested in making her mark in the public sphere turns to the father or other role models, in this case to a woman/girl who so notoriously departed from her expected role that she died for it. In the fixed fifties world of Dick and Jane, I shared this aspiration. Raised among stories of women saints who were obedient, self-sacrificing simps, I too wanted to be Joan of Arc.

"Playing in sandboxes" is arguably more of a boy's activity than a girl's. One builds things in sandboxes—roads, castles. There is an ominous tone. What "fataller sly things" might the girl child be victimized by? The silent mother? The father she cannot grow up to be? The world that would un-horse her?

When the persona/poet's mother does appear in two early poems in *Theory of Flight*, "Four in a Family" and "This House, This Country," she exists only as someone to be left behind. Neither the mother nor the daughter is yet speaking. (The early speaking mothers in *Theory of Flight*, including the one from "Child and Mother" mentioned above and one in "Tunnel," who promises "'It will be a brave child, / ... We will show planes to it, and the bums in the street'" (*CP* 35), remind me somehow of my younger self—the woman who thinks we have only to speak up and injustice will somehow change.

In *U.S. 1* (1938), in the poem "Absalom" (*OS* 18–20), from the sequence "The Book of the Dead," a deceased miner's mother speaks before the Congressional committee convened, ostensibly, to get to the root of the Gauley silicon mine disaster. In straightforward language she begins, "I first discovered what was killing these men." The language is flat, factual: "I had three sons who worked with their father in the tunnel." She tells how they came to get the job, how they came to be sick. She recounts begging a doctor to take X-rays, even though she could pay him only if she received compensation from the corporation, an unlikely prospect in the 1930s. The poem works up to a potency, a Demeter kind of mother who speaks in the last two lines of and for her dying son: "He shall not be diminished, never; / I shall give a mouth to my son." (*OS* 20).

These are the "facts," the external documents Rukeyser works so much with. Interspersed between these stanzas are lines in italics. The first two appear after "Shirley was my youngest son; the boy. / He went into the tunnel." In part, they read as follows:

> *My heart my mother my heart my mother*
> *My heart my coming into being.*
> .
> *I come forth by day, I am born a second time,*
> *I force a way through, and I know the gate*
> *I shall journey over the earth among the living.* (*OS* 19–20)

Who is the speaking "I" in these passages? Is this the mother giving witness of a different sort? Or is it Shirley giving his own witness, either as he lies dying or from beyond the second birth of dying? Look again at "The Speed of Darkness," in which the poet deliberately blurs the mother and the child. It's also happening here. These are the words of the son *and* the mother. To die is to come into being. One way to come into being is to live to testify before the committee, even after the child of one's heart has died, even when doing so offers little real possibility—for the poet, the mother, or the readers—for change, even 30 years later when the mother/son face a war, even now, when homelessness is again rampant and the safety net is frayed. A mother has some hard truths to tell. Demeter is emerging.

In "Käthe Kollowitz" (from *The Speed of Darkness,* 1968), Rukeyser becomes the daughter, telling the mother's story (and in some sections of the poem giving the mother/artist voice):

> the confession of great weakness, war,
> all streaming to one son killed, Peter;
> even the son left living; repeated,

the father, the mother; the grandson
another Peter killed in another war; firestorm;
dark, light, as two hands,
this pole and that pole as the gates.

What would happen if one woman told the truth about her life?
The world would split open (*RR* 217)

In earlier and later poems, Rukeyser repeats the "split open" image, in reference to the world and the "self." The seed splitting open, the body splitting open, giving birth to a child, one's own truth, one's own true life. The most personal and passionate way a woman must grapple with war is as a mother, at risk of losing a son, a bigger outrage even than losing a husband/lover. But, the split open world demands that we live in its present moment and keep formulating the truth. It is about process, not goal. Prototype, not archetype. Truths, not Truth.

Käthe Kollowitz is a foremother of the Demeter sort. The world splits open and women of a younger generation, daughters, learn from their mothers:

Held between wars
my lifetime
 among wars, the big hands of the world of death
my lifetime
listens to yours. (*RR* 214)

Again there is listening.

A mother is also a daughter. When my daughter was little, I invented a *Mother's Book:* "I'm cold; go put on a sweater." Or: "I'm tired; it's time for your nap." When I was driving car pools, I quoted from it: "The car won't start until you've all fastened your seat belts." My daughter later told me she puzzled over this. How did the car "know"? She maintains, however, that she never believed in the existence of an actual, physical book. Yet she participated. Sometimes she'd ask me what it said in the book. These days, my daughter and I talk about deadlines for papers and visas for Italy instead of seat belts and naps. Now I tell her, "it says in the *Mother's Book:* 'Do one thing at a time. Remember to eat, and remember to breathe.'"

Trying to claim Muriel Rukeyser as mother seems a bit like looking for an actual *Mother's Book.* The concept (and the joke) was that the book had *all* the answers, would make everything okay—from a scraped knee to a broken heart. I think of my own, mostly silent mother. Not only did she not live long enough to move forward in her own development, she did not live long enough to tell me the stories of her life. For years after she died, my

mother was rarely mentioned within my family. In *A Music I No Longer Heard,* I write about breaking the conspiracy of silence. As I interviewed subjects for the book and heard their stories, memories of my mother and stories she told came back to me, bit by bit.

My father and stepmother both died the year I began the book, and my brother and I cleaned out their house. I found pictures of my mother I'd never seen, condolence cards from her funeral, and her high school yearbooks. There I met a version of the teenage Phyllis, and she was not exactly who I'd imagined her to be. She barely participated in extracurricular activities. She was not an honor roll student. What? I remember being told how smart I was, just like my mother. I also remember she told me she wanted to go to college, but her family laughed at her. She seems to have been relegated to the secretarial track. Maybe she wasn't an honor student because she was bored. Yet it was my version of her as thwarted college student that made me determined to buck the working class tradition in my family and go to college. In a conversation with my niece, whose mother died when she was 16, I said, "You have to tell the stories with what you have. Piece together the facts, and what you don't know, make up."

Mothers do not live forever, and they do. They live in their daughters who live to tell their stories. In "On the Death of Her Mother" from *Body of Waking* (1968), here again are the birth within death images. And here is the absent mother:

> All those years, Mother, your arms were full of absence
> And all the running of arrows could never not once find
> Anything but your panic among all that substance,

And here is the present mother:

> Watchmen of birth; I see. You are here, Mother, and you are
> Dead, and here is your gift: my life which is my home. (*CP* 407)

In many ways Muriel Rukeyser was, and is, silenced. *The Life of Poetry* came back into print in 1996, after a hiatus of nearly 20 years. After a brief renaissance in the seventies when she was "in," she dropped out of the canon, although it seems she is now being read and taught again. Only one critical book is devoted solely to her work, and few chapters in others (nothing approaching the amount written on Sylvia Plath or Adrienne Rich). There are essays in selected collections of her poems—*Out of Silence* edited by Kate Daniels and *A Muriel Rukeyser Reader* edited by Jan Levi. There is still no completed biography. Her *Collected Poems* is not in print. As I finish this essay, I look longingly at the library copy of this fat, juicy book. I regret

I did not buy it when I had the chance. I glance at the due date: December 1, the anniversary of my mother's death.

I need a mother now to show me the way to speech and action. I needed that mother when I was younger; I will need her as long as I live. To look at mothering through the lens of Rukeyser's poetry is to look at my own life, to listen to a foremother who speaks the truth from her historical moment to mine. What's left is living in the moment: silent, speaking, listening, speaking. I find hints of that mother, and the search for her, in the early poems, written I imagine by a poet/woman in search of a mother herself, a search she continued through her later poems/life. In the blurring of mother/child in the poems, I come to find the mother I am looking for. I find the voice to speak for her, for me, the voice that can say, for today, "I am home."

Susan Ayres

Outlaw Against the Thinking Fathers

> ... literature can play the law, repeating it while diverting or circum-
> venting it.
>
> —Derrida

> Phallocentrism is the enemy. Of everyone.
>
> —Cixous

> My contradictions set me tasks, errands.
>
> —Rukeyser

In a 1974 interview, Muriel Rukeyser explains that, when a reviewer at-
tacked her as a "she-poet"[1] who had "no business" writing the 1971 biogra-
phy of Thomas Hariot, she responded: "I was broken for a while and looked
out the window for a while. And then I thought, yes, I am a she-poet. Any-
thing I bring to this is because I am a woman" (Packard 136). Rukeyser's
awareness of herself as a "she-poet," her awareness of her location as a
woman writer, leads her to resist what she calls the "thinking fathers" ("Se-
crets of American Civilization," *RR* 245). She stands outside the law in many
ways and shows an interest in outlaws such as John Brown, the Scottsboro
boys, Sacco and Vanzetti, and Dred Scott. In her analysis, American history
depends primarily on outlaws: "Tabu-breakers [sic] who fought together for
protections [sic], who settled together and bred another generation of tabu-
breakers to streak through a green wilderness, and other generations to break
their tabus" (*Willard Gibbs* 9). She sees taboo breaking as a characteristic of
her generation: "We focus on our times, destroying you, fathers / in the long
ground" ("The Blood Is Justified," *CP* 67).

Rukeyser emphasizes women's status outside the law in "The Lynchings of Jesus," which locates women and children outside the power of men who "vote":

> death to Sacco a man's name
> and Vanzetti a blood-brother; death
> to Tom Mooney, or a wall, no matter;
> poverty to Piers Plowman, shrieking anger
> to Shelley, a cough and Fanny to Keats;
> thus to Blake in a garden; thus to Whitman;
> thus to D. H. Lawrence.
> And to all you women,
> dead and unspoken-for, what sentences,
> to you dead children, little in the ground
> : all you sweet generous rebels, what sentences (*RR* 14–15)

The keepers of the law have the power to impose "sentences" on political figures (Sacco, Vanzetti, Mooney) and literary figures (Shelley, Keats, Blake, Whitman, Lawrence). But what sentences does the law impose on women? I believe the answer for Rukeyser is that men control sentences for women—both political/legal judgments and literary ones. To subvert this control, Rukeyser attempts to write her own sentences in a woman's voice.

Like Monique Wittig and Hélène Cixous, Rukeyser criticizes not men in general (on the contrary, all three of Rukeyser's biographies and many biographical poems are about and in praise of individual men), but a certain straight/male way of thinking. According to Wittig, the straight mind is the heterosexual construct that regulates sexuality. The discourses of the straight mind "are those which take for granted that what founds society, any society, is heterosexuality" (24). This essay examines three of Rukeyser's attacks against the "thinking fathers": her criticism of binary oppositions, of what she calls "despisals" of the other, and of patriarchal gender expectations. These three criticisms are interrelated, for the thinking of the "fathers"—what Wittig calls the "straight mind"—depends on binary oppositions that make moral judgments.

I. Against Binary Thought: "the penalties of division"

One way Rukeyser challenges the thinking fathers is by opposing binary hierarchized oppositions created by logocentrism/phallocentrism.[2] Cixous, who makes a similar challenge, states, "Logocentrism subjects thought—all concepts, codes, values—to a binary system, related to 'the' couple man/woman" ("Sorties" 64). Like Cixous, Luce Irigaray and Wittig also argue that binary thinking reduces to the male/female binary; Irigary calls

the "division between the two sides of sexual difference" an "injustice" (*An Ethics of Sexual Difference* 126), and Wittig describes the binary in similar terms as a binary of the One/many (51).

Rukeyser likewise observes that Western thinking is essentially binary. In her biography of the Renaissance explorer and mathematician-scientist Thomas Hariot, Rukeyser comments, "this age [the Elizabethan] thought in terms of opposites—as did the ancients, as do we. The banner of this thought was 'To be or not to be'" (*The Traces of Thomas Hariot* 237). A similar criticism appears in *One Life,* her biography of Wendell Willkie. She comments that Willkie was "[b]rought up in the tradition we know—a double tradition . . . body and soul, two political parties, and these are the very least of it . . ." (xiv). Rukeyser rejects binaries by openly questioning them as well as by disrupting them in her poems. Her attack combines the overt—pointing out and questioning the existence of binary thinking—and subversive—playing with binaries in her writing, for instance, by conjoining opposites.

Rukeyser's critique carries ethical and political overtones. In language paralleling Cixous's claim that "the movement whereby each opposition is set up to make sense is the movement through which the couple is destroyed. A universal battlefield. Each time, a war is let loose" ("Sorties" 64), Rukeyser points out the dangers of binary thinking: "in our culture . . . we see a complicated danger . . . caused by . . . a balance of perpetuated conflict, in which everything and every quality is set *against* another thing or another quality" (*The Life of Poetry* 64). In her works, Rukeyser interrogates the "balance of perpetual conflict" and problematizes the binary system to "blow up the law" (Cixous, "The Laugh of the Medusa" 258). The effect of such problematizing—a deconstructive move—"is not to negate or do away with the usefulness of the term . . . rather, it is to free it from its metaphysical lodgings in order to understand what political interests were secured in and by the metaphysical placing, and thereby to permit the term to occupy and to serve very different political aims" (Butler, *Bodies That Matter* 30).

For instance, in the poem "Ballad of Orange and Grape" (*RR* 243), the speaker passes a hot dog stand where a man pours orange drink into a container marked "GRAPE" and grape drink into a container marked "ORANGE" (510). The speaker asks the hot dog man:

> How can we go on reading
> and make sense out of what we read? —
> How can they write and believe what they're writing,
> the young ones across the street (*RR* 244)

In response, the man "shrugs and smiles and pours again." Reading this poem by itself, we might believe Rukeyser endorses binary thinking because

the speaker's questions suggest she disapproves of the man's actions. However, if we consider Rukeyser's work as a whole, she clearly sees the larger problem as teaching children binary systems in the first place. "Ballad of Orange and Grape" raises the practical problem of the confusion that would ensue were we to reject binaries and to label things with their opposites: children would no longer be able to "make sense out of what [they] read" and write.

Thus, in this poem, the grape and orange become a ballad of binary thinking:

> It could be violence and nonviolence
> it could be white and black women and men
> it could be war and peace or any
> binary system, love and hate, enemy, friend.
> Yes and no, be and not-be, what we do and what we don't do. (*RR* 244)

Grape and orange represent many possible binary systems such as wealth/poverty, white/black, or men/women. The hot dog man's mistake of pouring grape and orange into the wrong containers becomes a symbol for "any / binary system." The poem does not directly critique binary thinking, however. Instead, the poem's last lines suggest the inevitability of binary thinking: "a man keeps pouring grape into ORANGE / and orange into the one marked GRAPE, / pouring orange into GRAPE and grape into ORANGE forever" (244). Binary systems, as Wittig and others argue, are inherent to logocentrism. Simply reversing the binary terms will not solve the problem.

In poems such as "Willkie—Stopless Falling Through Air," Rukeyser continues to question binary thinking. Originally published in her 1957 biography of Wendell Willkie, this poem includes a questionnaire satirizing what "they" teach. Willkie, who remarks, "They have threatened us with the penalties of division," rejects their teaching (*One Life* 31). While never explicitly named, "they" presumably means the perpetuators of straight/male logocentrism—in Willkie's case, "they" include his legal training and political affiliations in the 1920s.

> Questionnaire. Write on two sides of the paper only.
> Do you believe in your body? Answer yes or no.
> Do you acknowledge your soul? You know they are separate:
> How long have you known?
>
> When you say Peace, do you think War? Two seconds.
> When they say Female, do you think Male? Two seconds.
> When they say Good, do you think Evil? Two seconds.
> We have given you, always the opposites. Submit. (*CP* 319)

The poem satirizes binary thinking by foregrounding binaries such as "two sides of the paper," two possible answers, and "[t]wo seconds." The terms of the questionnaire present opposites such as body/soul, war/peace, and male/female which the respondent must quickly and automatically answer based on "the opposites" that "[w]e have given you, always." The proper response is to "Submit." Thus, the questionnaire reinscribes the privileged terms of logocentrism, that is, the "One voice" of active (male, good, war) over passive (female, evil, peace). In the lines following the questionnaire, the speaker realizes, however, that he does not have to "accept their ideas," he does not have to "submit." Thus, the "One voice" of logocentrism can be rejected, though not without penalty: "One voice will say in the sounds of penalties / War and No-War, Good and No-Good, Male and No-Male" (*CP* 319).

In addition to demonstrating the prevalence of binary thinking, Rukeyser subverts our expectations of phallocentric binaries and gender references. For instance, she rejects the traditional sun/moon binary that associates sun with male, moon with female. In "Orpheus" the moon contains "female and male" (*OS* 106), and in "Suite for Lord Timothy Dexter," Dexter says, "sun all male and female through me poured" (*CP* 423). In these examples, Rukeyser does not make the opposite association (female sun, male moon) but joins the binary oppositions with "and." Her refusal to reverse the terms suggests that she seeks to problematize the terms in order to undermine their significance. By joining the binaries with "and," Rukeyser allows for inconsistencies and contradictions, as the quote at the beginning of this essay suggests: "My contradictions set me tasks, errands" ("Breaking Open," *OS* 148).

By embracing opposites Rukeyser hopes we can overcome "the penalties of division" ("Willkie," *CP* 319) and become like Orpheus, who in Rukeyser's poem claims, "I will know more and again, / woman and man" ("Orpheus," *OS* 109).

II. Against Despisals

Phallocentric binary thinking suppresses the other: "[S]traight society is based on the necessity of the different/other at every level" (Wittig 28). To counteract this binary thinking, Rukeyser privileges the other and condemns "different/other" thinking, as the last stanza of "Despisals" argues:

Never to despise in myself what I have been taught
to despise. Nor to despise the other.
Not to despise the *it*. To make this relation
with the it : to know that I am it. (*RR* 247)

The statement "to know that I am it" counteracts different/other thinking, a project Rukeyser carries out in many poems about despisals.

Her personal experience informs her thinking and writing about despisals such as the despisal of poetry, illegitimate children, race, sexual preference/homosexuality, and the other. Regarding the despisal of poetry, she comments: "There is a general sneer, not so much at the individual poet, as at the archetype. You will be able to trace its result in any poet you know. You will see the defenses against it take countless forms . . ." (*LP* 52). The general sneer at poetry has existed at least since the romantics; Rukeyser realizes it did not arise as a modern phenomenon. The poem "Reading Time : 1 Minute 26 Seconds" emphasizes that although listening to many lyric poems requires less than a minute and a half, people still fear poetry: "They fear it. They turn away, hand up palm out / fending off moment of proof, the straight look, poem" (*RR* 57). People fear poetry because they fear disclosure and the imagination (*LP* 11, 44). They fear the poem's power to awaken their imagination and senses, what Rukeyser calls poetry's "Moment of proof": "That climax when the brain acknowledges the world, / all values extended into the blood awake" ("Reading Time," *RR* 57).

Rukeyser's description of the fear of poetry in "Reading Time" serves as a premise for "The Flying Red Horse," published almost 30 years later. "The Flying Red Horse" playfully acknowledges that although society may ignore poetry, poetry's symbol—Pegasus—has a pervasive presence "On all the street corners" thanks to advertising (*CP* 467–68). The playful tone in this poem, combined with the *abcb* rhyme scheme and short second and fourth lines, force a rapid reading that reinforces its playfulness. When children ask, "What can it mean? / The grownups answer A flying red horse / Signifies gasoline" (*CP* 467). When adults—"Even the Pentagon, even the senators, / Even the President sitting on his arse"—"swear they do not know," Rukeyser dismisses the ignorance as immaterial: "Never mind—over all cities / The flying red horse" (*CP* 468).

In addition to defending poetry as other, Rukeyser defends illegitimacy and other forms of "despisal" based on her own experience as a "bastard mother" who gave birth, as a single mother, to a son in 1947:

> Life the announcer.
> I assure you
> there are many ways to have a child.
> I bastard mother
> promise you
> there are many ways to be born.
> They all come forth
> in their own grace ("The Speed of Darkness," *RR* 230)

In this poem and other writings, she speaks out for despised children—children the law labels illegitimate or otherwise mistreats, such as Elizabeth I, whom Rukeyser describes as "a young princess declared a bastard and that word having nothing to do with birth and love, but a yellow star of disgrace to be worn not by adults but by their young children" (*Traces* 66). "The Gates" describes the "torture" of Kim Chi Ha's infant, who like her own son was "cut off from his own father" when the South Korean poet was sentenced to execution. Rukeyser sees injustice in both Kim's imprisonment and his son's separation from his father. She asks, "Crucified child—is he crucified? he is tortured, / kept away from his father, spiked on time" (*RR* 264).

Rukeyser's personal awareness of "disacknowledgments" includes the attack made against her Jewish ancestry—another "yellow star of disgrace"—when she wrote the biography of Willard Gibbs. As she explains in *The Life of Poetry,* one of Gibbs's students, E. B. Wilson, wrote to another scientist "to say that he . . . had looked into my origins, and that for me to be writing about Gibbs, my ancestry being what it is, was as bad as for a Negro to be writing about a Southern gentleman" (95). Because she "know[s] what the / disacknowledgment does" ("Desdichada," *RR* 249), Rukeyser traces the history of racial and sexual disacknowledgment. For instance, her novel, *The Orgy,* compares the Irish despisal of gypsies to the American despisal of various races: "We have gypsies in America. We have Negroes, brave, long-suffering beyond belief, controlled somehow in an insane situation. And the tribes, tribes of Indians cut off from the ways and still aware of tribe" (113).

The despisal of one race by another forms part of a larger picture of exclusion and disacknowledgment, as she argues in "Despisals." This poem expands her list of grievances to include despisal of "the other," "the *it*"—the city ghetto, Jews, blacks, homosexuals, and "the body's ghetto":

> never to go despising the asshole
> nor the useful shit that is our clean clue
> to what we need. Never to despise
> the clitoris in her least speech. (*RR* 247)

"The Speed of Darkness" also argues against despising the "body's ghetto": "Whoever despises the clitoris despises the penis / Whoever despises the penis despises the cunt / Whoever despises the cunt despises the life of the child" (*RR* 228). Rukeyser's effort to redeem the "body's ghetto" springs from her childhood, in which her parents taught her that "[t]he two sacred things, tabu, never to be discussed, are money and sex" (*LP* 199), and they "bound up" her hands at night so that she wouldn't explore her own body ("Education," *RR* 280). In the string of associations in "Despisals" and "The Speed of Darkness,"

Rukeyser attacks the despisal, or repression, of biological and sexual functions of the "body's ghetto," arguing for the naturalness and beauty of the "ass-hole['s] / . . . useful shit that is our clean clue" as well as the clitoris's "speech," and the cunt's role in the production of the child (*RR* 247).[3]

Yet another metaphor for despisal appears in a late poem, "St. Roach." Addressed to a roach, this poem confesses despisal for the roach and the years of conditioning in which "[t]hey showed me by every action to despise your kind" (*RR* 255). The roach becomes a metaphor for any despised and oppressed group. Based on her own experience of despisal, Rukeyser counts herself among those "outside" who refuse to respect the law regarding despisals. She speaks for the despised and carries out her critique of the self/other distinction by privileging the other and arguing that we should "make this relation / with the it : to know that I am it": the city, Jews, blacks, homosexuals, the other ("Despisals," *RR* 246–47).

III. Challenging the Role of Women

Rukeyser's opposition to society's gender expectations and traditional roles for women correlates with her challenge of phallocentrism's binary systems and despisals. In her writings and in her life she rejects limited roles for women: "Women in drudgery knew / They must be one of four: / Whores, artists, saints, and wives" ("Wreath of Women," *OS* 58). Not surprisingly, her poems show little tolerance for those who perpetuate the thinking fathers' gender expectations. In "Citation for Horace Gregory" she refers to "a billboard world of Chesterfields, / Mae West hip-wriggles, Tarzan prowess, the little / nibbling and despicable minds" (*OS* 8). Like Wittig, Rukeyser sees billboards and films as "a discourse [that] has a meaning: it signifies that women are dominated" (Wittig 25).[4] This discourse taught adolescent girls in the thirties "to cultivate, perhaps have: / flippant defeat, good sportsmanship, / the miracle figure of the football-player: / a perfect husband, a promised income" ("Eel," *CP* 108). Rukeyser condemns these expectations in a poem describing the women with whom she went to Vassar as "the dull girls with the educated minds and technical passions," who grew into bored, wealthy women ("More of a Corpse than a Woman," *RR* 49). Although Rukeyser is writing about her own time and socioeconomic group, the gender expectations she describes still exist today, giving her poetry's contemporary relevance.

Rukeyser calls for a "new race" of women ("More of a Corpse than a Woman" 50) and argues that if women are to have a "free" life, to reject the compulsory gender expectations and roles imposed by heterosexual society, they must "Choose the myth they obey" ("Wreath of Women," *OS* 58). Her statements here and elsewhere suggest, first, that she believes gender identity

is constructed, and, second, that re-visioning myths provides a way to reconstruct identity. Diana Fuss defines constructivism as the belief "that essence is itself a historical construction," "the effect[] of complicated discursive practices" (2). Opposed to constructivism, essentialism consists of "a belief in true essence—that which is most irreducible, unchanging, and therefore constitutive of a given person or thing" (2).

Many of Rukeyser's poems support a constructivist view by suggesting that gender is performative, "constituting the identity it is purported to be" (Butler, *Gender Trouble* 25). In "The Victims, A Play for the Home" Rukeyser writes: "This is a theatre and many masks have played / the part; female or male : it will not matter here" (*CP* 181). She uses theater metaphors in *The Orgy* also: "I fade out on the talk. Something is happening to me; as if I were at a play that I fully accept. I do not identify with the heroine. I do not identify with the hero, or the murdered father, or the lustful mother who marries the new king. I identify with the whole play" (130–31). These passages suggest that gender identity—"play[ing] / the part"—is performative rather than fixed.[5] However, other poems and writings indicate Rukeyser also holds an essentialist belief in the "female." For example, she argues in "Letter to the Front" that women are better at keeping peace than are men (*RR* 102–3). And she refers to an essential female principle in *Willard Gibbs* (172–73) and in poems praising female sexuality.

This unresolved tension between a constructivist and essentialist view in Rukeyser's work arguably has the same political and strategic effect as problematizing binary systems. In both instances she refuses an either/or solution and instead allows both possibilities. Although contradiction may be difficult to accept logically, it has strategic value because it critiques the essentialist view, displaces gender norms (Butler, *Gender Trouble* 148), and, at the same time, allows "'a sense of identity, even though it would be fictitious'" (Elaine Marks, qtd. in Fuss 104).

Rukeyser further develops her belief that we construct gender identity in revisionist poems that create new myths and reappropriate old ones. This project, similar to Elaine Showalter's "gynocriticism,"[6] can also be considered "revisionist mythmaking," which has the potential to "correct . . . gender stereotypes embodied in myth" (Ostriker, "Thieves" 318). Rich's specialized sense of the word "re-vision" as "the act of looking back, of seeing with fresh eyes, of entering an old text from a new critical direction" ("When We Dead Awaken" 35) provides another way to define Rukeyser's revisionist project. By emphasizing personal and particularly feminine experience, by revising patriarchal gender stereotypes for women, and by "reinvigorat[ing] mythologies of female culture" (Showalter 135), Rukeyser's revisionary poems challenge patriarchal cultural ideology and assumptions.

For instance, Rukeyser rewrites Greek myths about the sphinx in "Private Life of the Sphinx" and "Myth," poems that critique patriarchal stereotypes of women in configuring the universal as male. "Private Life of the Sphinx," a five-part, first person poem, revisions the sphinx as a woman who is not a "Strangler and bitch" (*CP* 279) as she's been called, but a woman who luxuriates in her body and in the pleasures of dailiness. The poem questions sexual stereotypes and provides a sexual identity based on "secrets of milk and dinner and daylight" (280). The first lines reveal the sphinx's impatience with the role that man has thrust upon her: "Simply because of a question, my life is implicated: / my flesh and answer fly between chaos and their need" (278). Because she asked Orpheus the fated question, "they bring their riddles and rhyme / to my door" (278), and "They bring me their need for answers in their hands and / eyes (279). The sphinx resents "their cries . . . / crying the selfsame need"—"all suffer from their weaknesses— / they lack some gut, they are ill, they have womb-envy" (279). As opposed to the "Babble of demand"(278), she "know[s] a garden beyond questioning" (280)—this is her private life. In this place, the importance of answers is displaced and questions are primary: "The shining of questions which cannot be concealed / lies in that mirror" (280). This place is the mystery of dailiness: "secrets of milk and dinner and daylight, / enigmas of gardens, the kitchen and the bed" (280).

Those who call her "strangler and bitch" are wrong; she says, "I set my life among the questioning" (280); "My body is set against disorder"; "My questions are my body. And among this glowing, this sure, / this fact, this mooncolored breast, I make memorial" (279). Rather than a monster woman with "torse [sic] of a woman and quarters of a lion" (278), the sphinx considers herself "the root who embraces and the source" (279). She says in the last part of the poem, "They think I answer and strangle. They are wrong" (280). Instead of death, her questions bring life: the "sacred open mystery" of herself. "I touch you, life reaches me. / You touch me, I am able to give my gifts" (280). Her gifts of "love" and "hope" are "stronger than kill, / stronger almost than question, almost than song" (280). In this revisioning, Rukeyser not only emphasizes feminine experience by giving voice to the sphinx, but also rejects the names men have given the sphinx.

Rukeyser acts as a gynocritic by challenging cultural assumptions about women and by creating an alternative mythology of female identity. She also challenges man's right to occupy the universal position. The first stanza of "Private Life of the Sphinx" alludes to the riddle the Sphinx asks Oedipus: "Simply because I asked one / question, / 'What is this, What?' so that the answer must be 'Man'" (278). That the answer "must be 'Man'" is emblematic of a feminist critique of patriarchy wherein Man occupies the universal

position. In other words, "there are not two genders. There is only one: the feminine, the 'masculine' not being a gender. For the masculine is not the masculine but the general" (Wittig 60). In patriarchy, woman is necessarily other.

"Private Life of the Sphinx" alludes to this argument and "Myth" develops it. Unlike "Private Life of the Sphinx," the 12-line "Myth" reads more like prose, consisting almost entirely of dialogue between Oedipus and the Sphinx. The first several lines establish the setting: years after the first encounter with the Sphinx, when Oedipus, "old and blinded," wandering the roads, "smelled a familiar smell. It was / the Sphinx" (*RR* 252). He asks the Sphinx why he didn't recognize his mother, and the Sphinx answers:

> "When I asked, What walks on four legs in the morning,
> two at noon, and three in the evening, you answered,
> Man. You didn't say anything about woman."
> "When you say Man," said Oedipus, "you include women
> too. Everyone knows that." She said, "That's what
> you think." (252)

The Sphinx objects to woman's traditional exclusion from the world of Man, a point Rukeyser emphasizes in *The Traces of Thomas Hariot* when she quips, "mankind, that's womankind, too" (314).

Rukeyser subversively revises the Snow White fable and the painting of Botticelli's Venus in two poems that critique cultural assumptions about women's desire and about death. In the 20-line "Fable," even though the first line reads "Yes it was the prince's kiss" (*CP* 553), it is *not* the kiss of the prince that revives Snow White, but an "'accident' they hardly noticed":

> When the attendants carrying the woman
> —dead they thought her lying on the litter—
> stumbled over the root of a tree
> the bit of deathly apple in her throat
> jolted free. (554)

"Fable," containing a tone both ordinary and urgent, subverts the myth of romantic love and the myth of heroic actions of men. Rukeyser matter-of-factly informs us of her version of the fable—what "had to be" (553). It wasn't the prince who revived Snow White, but an accident, a stumble. Her tone becomes urgent when she comments on what she considers "Essential": "Not strangled, not poisoned!" (554). She urges us to "notice" the stumble, although she dismisses "their" failure to notice: "better if we notice, / However, their noticing is not / Essential to the story" (554). The joke is on "them," as Cixous argues about the "Beauties [who] slept in their woods,

waiting for princes to come and wake them up": "This dream is so satisfying! Whose is it? What desire gets something out of it?" ("Sorties" 66). To revise this story allows the possibility of women's desire and permits the "miracle" in Rukeyser's last stanza: "Something like error, some profound defeat. / Stumbled-over, the startle, the arousal, / Something never perceived till now, the taproot" (554). The "taproot," while literally a root, metaphorically suggests unconscious desire rising to the surface, not because of the prince, but despite him.

Rukeyser rewrites another myth in "The Birth of Venus," which shows the condition of the goddess before her graceful arrival "on / the crisp delightful Botticellian wave" (*CP* 418). In the first brief stanza in a poem of six irregular stanzas, Rukeyser alludes to the legend of Venus's birth: "Risen in a / welter of waters" (417). The second stanza contradicts the part of the legend Botticelli depicts: "Not as he saw her / . . . Not yet" (417). "He" remains unnamed, but the title, "The Birth of Venus," and the last line ("Botticellian wave") allude to the Renaissance painter. The next two stanzas develop Venus's birth before "he saw her": "born in a / tidal wave of the father's overthrow, / the old rule killed and its mutilated sex" (417). Using repetition, dense imagery, and diction, Rukeyser suggests the destructive turmoil of the sea in the fourth stanza:

> The testicles of the father-god, father of fathers,
> sickled off by his son, the next god Time.
> Sickled off. Hurled into the ocean.
> In all that blood and foam,
> among raving and generation,
> of semen and the sea born, the
> great goddess rises. (417)

In these lines Rukeyser re-visions our image of Venus's birth—rather than the "frayed and lovely surf" that Botticelli imagines, Rukeyser give us the "blood and foam" of Chronos's (Time's) overthrow of his father, Uranus. She associates Venus's birth with death, suggesting what Botticelli marginalizes: the association of death with woman, in which "woman *represents* death or the unthinkable for/by men" (Whitford 115).[7] In the final two stanzas of "The Birth of Venus," Rukeyser comes to an ironic appreciation of Botticelli's vision—"possibly," she writes, the "horror" of Venus's birth "is translated far at the margin into / our rose and saving image, curling toward a shore / early and April, with certainly shells, certainly blossoms" (417–18). Botticelli's Venus appears to have sprung from an easier birth, "wellborn . . . / young-known, new-knowing, mouth flickering, sure eyes" (418). Rukeyser does not dispute that his image appears "delightful," but in the poem's mid-

dle stanzas, she revisions "The Birth of Venus" by creating an image of Venus's journey *before* "he saw her." She presents death as the thinkable, as in "Desdichada": "Death flowing down past me, past me, death / marvelous, filthy, gold, / in my spine in my sex upon my broken mouth" (*RR* 249).

By rejecting patriarchal assumptions about gender expectations and stereotyped roles for woman as "not / Essential to the story" (*CP* 554), Rukeyser further challenges the "thinking fathers." Her attack on phallo-centrism demonstrates the assertion that "the strongest women poets tend to oppose hierarchy; they like boundary-breaking, duality-dissolving, and au-thority-needling" (Ostriker, "Dancing" 215). Rukeyser attacks the "thinking fathers" by dissolving dualities of binary oppositions, by breaking bound-aries between the self and despised other, and by needling authoritative gen-der stereotypes. Ever an outlaw, Rukeyser finds a way for "literature [to] play the law" (Derrida, "Before the Law" 216), thus subverting and transforming "the very conditions of law's production and enforcement" (Schor 73).

Notes

1. The 1973 poem "Breaking Open" also incorporates this identity in the line "Some rare battered she-poet, old girl in the Village" (*OS* 148).
2. Elizabeth Grosz defines "phallocentrism" as "a form of Logocentrism in which the phallus takes the form of the *logos*. The term refers to ways in which patriarchal systems of representation always submit women to mod-els and images defined by and for men" (*Sexual Subversions* xx). Logocen-trism, whose logic depends "on the exclusion and binary polarisation of difference," forms the dominant Western metaphysics and "seeks, beyond signs and representation, the real and the true, the presence of being, of knowing and reality, to the mind—an access to concepts and things in their pure, unmediated form" (*Sexual Subversions* xix).
3. DuPlessis argues that one effect of "[t]he explicit naming of sexual organs and bodily functions . . . [is] . . . an attempt to reappropriate so-called 'dirty' or 'clinical' words, and by so doing, to construct a critique of the cultural values regarding women that have kept these words taboo and unspeakable" (283).
4. Laura Mulvey makes a similar point about women and cinema, arguing that "traditional narrative" cinema represents woman as passive object and "builds the way she is to be looked at into the spectacle itself" ("Visual Plea-sure" 25; see also Mulvey's discussion of the representation of women in mass media and in Allen Jones's sculptures ("Fears, Fantasies and the Male Unconscious" 6–8).
5. Rukeyser's plays—*The Middle of the Air* was produced in 1945, *The Colors of the Day* in 1961, and *Houdini* in 1973—may have contributed to her con-structivist position and certainly influenced many other poems containing theater imagery and allusions.

6. Showalter's definition of "gynocritic" is "woman as the producer of textual meaning, with the history, themes, genres, and structures of literature by women" (128); it includes "reinvigorated mythologies of female culture" (135).

7. Cixous also makes this argument: "Men say that there are two unrepresentable things: death and the feminine sex. That's because they need femininity to be associated with death; it's the jitters that give them a hard-on! for themselves!" ("Laugh" 255).

Ruth Porritt

"Unforgetting Eyes":
Rukeyser Portraying
Kollwitz's Truth

Muriel Rukeyser's poem "Käthe Kollwitz," about the German artist, raises questions about artistic truth and how writers represent the complicated lives of the women they honor. Composed with materials from Kollwitz's writing and art, the poem reveals the kinds of language formation and image-making Rukeyser esteems. Within her response to Kollwitz's work, Rukeyser offers one of her most famous couplets, a searching question and stunning answer that mark the charged intersection of the poem's aesthetic, psychological, and political concerns:

> What would happen if one woman told the truth about her life?
> The world would split open (*RR* 217)

"These immortal lines" Martha Kearns calls them, and indeed their challenging power has informed many women's writing projects.[1] The poem motivated Kearns to write Kollwitz's biography, for "Rukeyser's elegiac portrait demonstrated the usefulness of approaching the artist and her work from a woman's point of view" (Kearns, *Voices of Women* 9). If art is successful to the degree it can transform awareness and promote constructive change, then Rukeyser's poem has been remarkably effective. Published in 1968, her epiphanic lines inspired women living during the second wave of the women's movement: rather than appearing to be strong by enduring pain in silence, women have come to recognize that their most powerful strength can be found in the subversive action of telling their previously unspoken truths.

Balancing social responsibility with creative freedom is a project Kollwitz and Rukeyser share. Both women pursue their art to create a "counterpoise," as Kollwitz would say, to the conditions they must endure in life. For those of us who read and view their work, we sense a correspondence between the artistic processes of poetry and painting and the spiritual processes of the women artists' persistent truth-seeking.[2] At the level of visual impact, the Kollwitz poem moves from the image of a specific woman held by the ubiquitous male embrace of God/War/Death [Fig. 1] to the image of a lone woman who holds her aggrieved face in her own hands [Fig. 2]. The arc of that movement, and the deferrals in between, track the reach of two women's truth-telling imaginations within their dominant cultures and historical times. At the level of language use, the poem moves through different voices to propose that the woman poet should not speak *at* others, nor *for* others, but *with* others to cocreate new truths.

Rukeyser's interest in Kollwitz is similar to her interest in Willard Gibbs, the innovative physical chemist. Rukeyser studies people whose imaginative lives are not curtailed by other people's rejection and the hatred, distrust, fear, intolerance, and violence around them. "The story of Gibbs is that of the pure imagination in a wartime period," she writes, referring to the Civil War. "War and after-war are filled with hatred, and this hatred turns against imagination, against poetry, against structure of any kind" (*Gibbs* 7). Gibbs and Kollwitz develop a resistance to the oppressive emotional conditions of war by forging a willful dedication to the truth of their own work. Although Gibbs and Kollwitz are surrounded by potentially debilitating truths, they pursue within their work a generative truth of invention or expression that anticipates a better future.

Telling the truth in a difficult world is a primary artistic motivation for both Kollwitz and Rukeyser. "The Kollwitz of the unforgetting eyes," Rukeyser says, praising Kollwitz's courageous observations (*LP* 136). Rukeyser admires Kollwitz's attempts to tell the truth in image and language, a project she pursues in a war-torn world. Through the process of becoming familiar with Kollwitz's abridged diaries, letters, and selected artworks, Rukeyser sees how Kollwitz builds resilience to counteract the strain of bearing witness at her level of self-disclosure. Kollwitz's honest engagement with life, her straightforward and unapologetic tone, and her commitment to pursuing the truth in her art and her life reaffirms Rukeyser's own choices. In his testimony to Rukeyser's awareness of the constructive possibilities of truth, William Meredith reports to the *Paris Review* that she "was a very amazing human being and any traces of honesty in my life come from having seen how beautifully honest she was in administering her life and her poetry without any separation—you couldn't get a knife between the two things with her" (Meredith xiv).

In "Käthe Kollwitz," Rukeyser honestly portrays the aesthetic, psychological, and political value of a woman artist's committed engagement with image and language. Her portrait of Kollwitz is compositely contextual: Kollwitz's life is represented in relationship to Rukeyser's life, in terms of its historical period, by Kollwitz's personal writing, by her visual art, and by her own self-portraits. Using these five contributing sectors of signification, Rukeyser tries to express what it is like to arrive at three entwined meanings: (1) the meaning of Kollwitz as she is expressed through her images and language, and (2) the meaning of woman-as-artist in a difficult world. The third meaning conveyed by the poem is Rukeyser's self-understanding as she undergoes the experience of preparing the reader for the arrival of (1) and (2) through finding a poetic form for her own experience of Kollwitz's creative work. These arrivals are themselves a culmination of the poem's dynamic system.

Rukeyser begins her poem by articulating the affinity she feels with Kollwitz: "Held between wars . . . my lifetime / listens to yours" (*RR* 214).[3] War has an impact on both women's lives. Kollwitz loses her second-born son, Peter, in World War I; Kollwitz's grandson Peter is killed in World War II. Rukeyser witnesses the initial days of the Spanish Civil War, which claims the life of her German lover, Otto Boch. To protest American involvement in Vietnam, she travels to Hanoi during the bombings.[4] In response to the pressures war exerts on art, Rukeyser frames her *Life of Poetry* (1949) as an answer to a refugee's question about the value of poetry in times of crisis. Likewise, many of Kollwitz's images respond to the horrors of war, both to protest its sufferings and to support those who suffer. Kollwitz's striking antiwar pieces indicate she would agree with Rukeyser's claim, "I will not protest without making something" (Packard 132).

It seems likely that Rukeyser discovered these biographical correspondences in a collection of Kollwitz's diary entries, letters, and print plates originally published in 1955, ten years after Kollwitz's death.[5] While reading these materials, Rukeyser found another thoughtful woman's attempt to understand "truth" and its relationship to her art. In her diary Kollwitz asserts emphatically, "Only one's inner feelings represent the truth" (K 70). To protect her connection to the truth, Kollwitz vows to herself that she must be "wholly genuine and sincere" in her life and work (K 69). She cautions herself that "in groping for the precious truth one falls easily into artistic over-subtleties and ingenuities—into precocity," a debilitating distraction she wants to avoid (K 69). Although Kollwitz's intuitive sense of truth may seem to be completely subjectivist, she does not locate the "source" of truth *in* the individual per se. For Kollwitz, truth as human feeling has a transcendent dimension, a link with "ultimates" (K 86) and with the "*impression* of divine inspiration and revelation" (K 153), a kind of "soul truth" that is individual

even as it is also profoundly communal. One's true inner feeling can transcend one's own subjectivity through the medium of artful language, music, or imagery because these forms make the individual's feelings accessible to people who can recognize and share them, different as those other people may be. In keeping with her intuition of truth, Kollwitz wants to "write" from "things seen and experienced from the soul."[6] Although she is often depressed by the dominant culture and imagery she experiences around her, Kollwitz does assume that despite it all she can speak herself and draw herself, for she persists in her unembellished writing and, in her art, Kollwitz develops a distinctive integrity of line that manifests a confident belief that she can make the meaningful mark decisively.

In thinking about truth Rukeyser is as influenced by scientific method as Kollwitz is influenced by an expressive idealism. Rukeyser observes, "the search for truth in experience is regarded as something characteristic of the artist as well as the scientist" (*LP* 146). She is impressed by Willard Gibbs, who thinks of truth "not as a stream that flows from a source, but as an agreement of components" (*LP* 167). Gibbs promotes his version of the coherence theory of truth, which holds that the primary criterion of evaluation is whether or not something is "fitting" in its relationship to other parts of the whole. When Rukeyser applies this notion of truth to poetry, she describes "the agreement of components" as "the relations between the word and images" (*LP* 167). Once the agreement is reached, the sense of truth comes from the agreement itself such that "[t]ruth is an accord that actually makes the whole *'simpler than its parts'*" (*LP* 167). A poem is not a static collection of elements that makes step-by-step inferences toward an inevitable conclusion, but a flowing, interactive whole that "arrives" at its meaning. This is particularly apparent when a resonant image is activating a poem, for "[t]he single image, which arrives with its own speed, takes its place in a sequence which reinforces that image" (*LP* 143). The poet's task is to select components so that she can best express "what it feels like to arrive at [her] meanings," a process that "involves . . . so much of the desire that makes choice" (*LP* 169). If the poet has made the right choices, then she has "prepared" her reader to arrive at the same meanings the poet also experiences. The truth of a poem is "an emotional and imaginative truth" the poet and reader share (*LP* 32).

This process of exchange between poet and reader is one of Rukeyser's most intriguing claims about the appreciation of poetry. Acknowledging the implicit liveliness of the aesthetic experience, Rukeyser claims: "The work that a poem does is a transfer of human energy, and I think human energy may be defined as consciousness, the capacity to make change in existing conditions" (*LP* xi). If asked about the sources of this energy, Rukeyser would characterize them as one of two kinds: "I've always thought of two

kinds of poems: the poems of unverifiable facts, based in dreams, in sex, in everything that can be given to other people only through the skill and strength by which it is given; and the other kind being the document, the poem that rests on material evidence."[7] Although it is tempting to classify "Käthe Kollwitz" as the later type of poem,[8] Rukeyser's experimental poem actually amends her own model: there is a third kind of poem, which depends on another person's art making, an expressive activity that itself cannot be categorized as "dream" nor reduced to mere "material evidence."

The poet's aesthetic process of receiving the artist's own initial "transfer of human energy" is not the same as the poet's cognitive process of deliberating over "material evidence." The difference between the basis for the "evidence" type of poem and the third type of poem I am naming here is the same as the difference between a passport photo and a portrait: one is a form of documentation, the other is a form of expression. We can see this distinction clearly when Rukeyser describes her own aesthetic process of appreciating visual art, something she probably experienced with Kollwitz's work, particularly her self-portraits: "But to be given paintings whose images make a sense of arrival in us; whose balance reminds us of the rhythms of our dreams as well as those of waking reality; whose people and whose scenes and whose shapes evoke, through their particulars, that deep recognition and dismay which turns and thanks and changes into love: this is where painting becomes most memorable" (*LP* 134–35). Since Rukeyser refers to several Kollwitz self-portraits and other artworks in her poem, she obviously found them compelling and memorable. As a poem that depends on another person's art making, "Käthe Kollwitz" actually has two primary sources of energy contributed by both the artist's consciousness and the poet's consciousness; this poem enacts a "transfer of human energy" cocreated by both artist and poet. Thus "Käthe Kollwitz" is not primarily about what Rukeyser thinks and feels about Kollwitz's writing and art as material evidence. Instead, this poem is about how Rukeyser aesthetically "listens" to Kollwitz's thoughts and feelings as they are expressed through her writing and art.

In constructing her poem Rukeyser attempts to convey her own aesthetic experience of Kollwitz's creative work, which is both vivid and poignant in the face of Kollwitz's death. Rather than defending Kollwitz and her work by speaking up for her, Rukeyser portrays the truth of Kollwitz's creative life by using Kollwitz's own words and images. In Part II Rukeyser relinquishes most of her authorial control in order to permit Kollwitz to speak in her own words, an unusual feature for an elegy. Out of the 168 lines in the poem, 105 of them—or 63 percent—refer directly to Kollwitz's writings or visual imagery. Rukeyser is not speaking *for* Kollwitz, or *about* Kollwitz, but *with* Kollwitz to cocreate new poetic forms and meanings.

This innovation is one of Rukeyser's most important contributions to our thinking about how a woman writer approaches another woman artist's work: to make the writing "true," Rukeyser conveys something of the creative energy she experiences in Kollwitz's work. By interanimating Kollwitz's words with verbal references to her art images, Rukeyser invents a way to express the deeper energies of Kollwitz's creative life. Although Kollwitz's art cannot be fully represented in Rukeyser's language, its reservoir of visual meaning is nonetheless a resource for this poem. Kollwitz's visual meanings can be included in a class of materials I will call "positive silence," for although these meanings are "wordless" in the poem, they are not technically unknowable or without signification. Rukeyser's references to Kollwitz's visual meanings send readers back to the original artworks themselves. I am also using "positive silence" to include Kollwitz's unquoted written language, for the Kollwitz quotations Rukeyser places in the poem invoke the larger context of Kollwitz's complete diaries and letters.

The correspondence between an artist's images and a writer's words about those images intrigued Rukeyser. When Rukeyser worked for the Office of War Information as a "Visual Information Specialist" between December 1942 and May 1943, she worked with other writers to develop a relationship between artists' images and writers' words, not so that the words would "describe" the images, but rather so that the words could "extend" the images' meanings (*LP* 137).[9] During this time Rukeyser focused on Kollwitz and learned "the impact that a combined form may have when picture and text approach the meaning from different starting-places" (*LP* 137). As readers, we can better appreciate the "whole" of Kollwitz's truth when we can place Kollwitz's visual art within the poem's "agreement of components."

Certainly much of the poem's power comes from its referential reach into Kollwitz's creative work, a body of work that exists extensively "outside" and "beyond" the poem even as some of it is also carried over into the poem. Rukeyser closes Part I with a direct reference to Kollwitz's 1935 sculpture "Rest in the Peace of God's Hands" (figure 1), the piece Kollwitz made to mark her family gravesite. Rukeyser accurately refers to a bronze bas relief with two arms, heavily draped, that hold and enfold an "unknown" face with closed eyes.[10] Rukeyser correctly identifies this person as "you," her addressee, Kollwitz, because Rukeyser recognizes Kollwitz's basic facial features from self-portraits even as she also knows from Kollwitz's diary that the artist could not always afford to pay models and often used her own face in her art. Yet to one not familiar with how these lines in the poem correspond to real images and statements in Kollwitz's lifework, this bronze sculpture could depict anyone.

Even as she apprehends the sculpture in terms of an accurate understanding of Kollwitz's work, Rukeyser also expresses how the sculpture com-

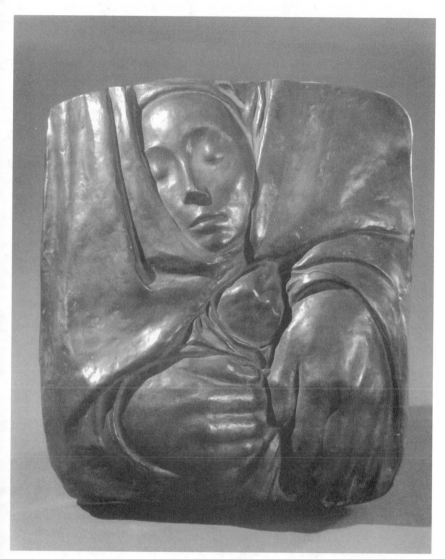

Figure 1: Grave Relief: "Rest in the Peace of God's Hands" by Käthe Kollwitz. Hirshhorn Museum and Sculpture Garden, Smithsonian Institution, Gift of Joseph H. Hirshhorn, 1966. Photographer: Lee Stalsworth.

pletes a transfer of human energy, a "deep recognition" that creates an elision
between Rukeyser and Kollwitz within the poem. Rukeyser's "lifetime" be-
comes superimposed on Kollwitz's in a sequence of overlapping lines that al-
lude to the sculpture:

> and death holding my lifetime between great hands
> the hands of enduring life
> that suffers the gifts and madness of full life, on earth, in our
> time
> and through my life, through my eyes, through my arms and
> hands
> may give the face of this music in portrait waiting for
> the unknown person
> held in the two hands, you. (*RR* 215)

Rukeyser, along with Kollwitz, knows that death is holding her "lifetime be-
tween great hands" even as those hands cannot destroy the enduring "life" of
art made by human hands. Invoking Kollwitz's claim that her creative life
has proceeded like a fugue, Rukeyser asserts that through her poem she will
"give the face of this music in portrait": Rukeyser creates a (double) portrait
of two women artists through her own eyes, arms, and hands, terms all sug-
gested by Kollwitz's own persistent self-portraits.

The apparent catalyst for Rukeyser's poem is located at the close of Part
II. In a restaurant a "tight lipped man" quips to Rukeyser: "Kollwitz? She's
too black and white" (*RR* 217). Readers can imagine Rukeyser's indignant
shock at the man's dismissive retort, for Rukeyser's portrayal of Kollwitz's
truth does not share such a repudiating perspective. Likewise, Rukeyser her-
self often endured people's callous dismissals of her work, judgments that
seemed imperceptive, uninformed, and needlessly restricted by prevailing
preferences. Rukeyser implies that the man's slight is motivated by unexam-
ined preconceptions that prevent him from understanding and valuing Koll-
witz's work. In the American gallery scene at that time, black and white
prints were not valued as "fine art" as compared to oil paintings. For art en-
thusiasts interested in the abstractions of high modernism, Kollwitz's repre-
sentational method and social content, much of it dependent on "the pathos
of maternity," was assessed as inferior.[11] Yet Rukeyser's appreciation of Koll-
witz means that her methods and content do have artistic value. Certainly,
some current art historians would consider Rukeyser insightful, for Alessan-
dra Comini attests that Kollwitz chooses an "appropriately black and white
visual form" for her artistic message (98).

Sympathetic with Kollwitz's aesthetic values, Rukeyser does not condemn
her for being "too black and white." Since Kollwitz was particularly adept at

lithography, which is a subtle treatment of the full range of grays between black and white, the man's accusation is inaccurately reductionistic. In the Kollwitz poem Rukeyser presents the man's statement without the response of her counter-statement, suggesting that in this instance positive silence is the best response.[12] The silence is positive because Rukeyser has implied a residual answer of "Unfair!" in this section of the poem, an answer that is not ultimately mute, although it remains wordless in the poem. Positive silence becomes a potential refuge for the listener, Rukeyser, and the reader, who may retreat from words to protect themselves and their own judgments from flippant misunderstanding or inept engagement. As a transition to the next section of the poem, Rukeyser suggests here that positive silence will constitute part of the complex matrix from which women's truth will emerge.

Part III of Rukeyser's poem presents Kollwitz "held among war," both as a spectator of suffering and as an aggrieved mother and grandmother. The section culminates in a shift from the description of atrocity to an opening of possibility: "What would happen if one woman told the truth about her life? / The world would split open" (*RR* 217). This couplet suggests that one woman's truth has such overwhelming power that it can irrevocably and radically change the known world, a revolutionary thought in a social context that devalues women's claims as unimportant, uninformed, or untrue. On a more general level, the couplet also implies that attaining the conditions for one woman to speak her truth is as impossible—or as cataclysmic—as attaining the conditions that would cause the world to split open. Although Rukeyser's claims might seem hyperbolic, she is exercising poetic license to forcefully assert her protest against the repressive, oppressive, and terrifying conditions that militate against our knowledge of women's truth, both told and drawn.[13]

Since Rukeyser has portrayed Kollwitz as a woman who expresses her truth in both language and image, readers might wonder how this couplet relates to Kollwitz. The question and answer implies that at least one woman, Kollwitz, told the truth about her life; completing the analogy would be to assert that the world split open for Rukeyser. Yet Rukeyser is also profoundly disturbed by the fact that at least one person, the tight-lipped man, does not understand the powerful truth about Kollwitz's creative life. If people could conscientiously understand the truths about women's lives, then this understanding would definitively change the world. Rukeyser's grief and rage over this missed possibility is released in the question and answer, lines that are the culmination of Rukeyser's prolonged study of Kollwitz's art, for they reflect the boldly decisive gestures so indicative of Kollwitz's striking drawings. Truth emerges with all the power of its constructive possibilities, signifying the potential for healing, growth, and fuller life.

The split world consequence of women's truth-telling is not just a disruptive image of breaking silence and taboo, but also a promising image of growth and propagation. A woman with "unforgetting eyes" has the power to prefigure a better future, an idea Rukeyser explores in "Recovering:"

> The force of looking
> returns to my eyes.
>
> Darkness arrives
> splitting the mind open.
>
> Something again
> is beginning to be born. (*CP* 556)

"Splitting open" is ultimately productive, not destructive.[14] The artist, through her creativity, can "[reach] a new relationship with the world" (*Gibbs* 82), one that combines her knowledge of the suffered world with her agency to act within that world.[15] "Knowledge and effective action here become one gesture: the gesture of understanding the world and changing it" (*Gibbs* 82). To imagine the positive consequences of women's truth-telling and to act on that vision is itself an "explosion" that could result in a "split world." According to Rukeyser, "The imaginative act, in all its delicacy, in all its explosiveness, realizes these energies [of understanding, creating, changing], and the continuity behind them—the continuity of force, and of the human spirit alive in many lives" (*Gibbs* 82). Thus Rukeyser's couplet finally confronts readers with a challenge: Can we creatively answer the desire for a balancing, generative truth that a suffered world has awakened in us?

Part V of Rukeyser's poem moves to Kollwitz's self-representations, returning us to the woman as artist. Rukeyser's short lines stream swiftly down the page, carrying with them references to Kollwitz's images. As she brings her poem to completion, Rukeyser suggests the passage of time in Kollwitz's life, a life that must inevitably arrive at death—or, in the case of this poem, it is a life that should arrive ideally at a single, resonant image that recasts our understanding of Kollwitz as a woman and an artist.

Rukeyser lists Kollwitz's self-portraits in the order they appear in the plate section of *The Diary and Letters of Käthe Kollwitz*, edited by Hans Kollwitz in 1955, a fact that confirms this book as a primary source for Rukeyser's poem. Kollwitz produces striking self-portraits across all media during the entire course of her adulthood, and Rukeyser includes those few that were reproduced in Hans Kollwitz's edition. "Self-Portrait en Face, 1892" is the first image, a high-contrast pen-and-ink piece that dramatically renders the youthful Kollwitz with her determined and penetrating gaze. An unfinished

etching from 1910 follows, showing a fatigued Kollwitz who supports her forehead in her strong left hand. The charcoal drawing "Self-Portrait Facing Right, 1916" was used on the cover of the exhibition catalog celebrating Kollwitz's 50th birthday. The etching "Self-Portrait, 1921" shows the aging Kollwitz staring away from the viewer, preoccupied with her own thoughts. The charcoal "Self-Portrait, 1943" depicts Kollwitz as an old woman who seems to have just glanced at the viewer with her weary yet knowing eyes.

Kollwitz's self-portraits are among her most admired pieces, for they are candid and remarkably free from convention. She makes no effort to flatter herself in her images, and, except for one, she is unsmiling, thoughtful, and often directs her resolute gaze at the implied viewer. By ignoring the dictates for socially defined standards of feminine beauty and by eliminating extraneous detail and "pose," Kollwitz repeatedly produces her image as a steady resistance against the confines of objectified womanhood. Kollwitz's commitment to the expressive truth of the image prevented her from needlessly distracting herself with the gendered mannerisms of female portraiture. After analyzing Kollwitz's self-portraits, Marsha Meskimmon concludes,

> Such a sober rendering denies our expectations of woman displayed as the carrier of beauty or sexual difference. We are not allowed voyeuristic access to a woman's body as an object of delectation as we are, for example, in the standard female nudes of the western tradition. Nor are we encouraged to encounter this image as a fashionable society portrait demonstrating the wealth or social status of the sitter. . . . [T]his work is a positive assertion of woman as subject rather than object in representation. (28)

In addition to producing images that assert the expressive truth of women's subjectivity, Kollwitz also produces images of herself working as an artist. Although such images of women are rare in the history of western art prior to our contemporary times, they are significant not only for the contribution they make to our understanding of how women artists see themselves, but also for how women artists value their own work. According to Meskimmon, "In self-representation, it is imperative for women artists to find forms which give voice to their situation as both *woman* and *artist*" (11). In this self-defining task the woman artist demonstrates the primacy of herself as a perceiver rather than as the perceived. Kollwitz's "Self-Portrait in Profile Facing Left, Drawing, 1933" is an excellent example of Kollwitz's assertion of her accomplished talent as a woman artist.[16] Kollwitz's extended right arm is vitalized by a single, deft, continuously leaping line that connects the steady gaze of her artistic intelligence with the piece of charcoal she holds in her working hand. Artists and critics are both deeply pleased by Kollwitz's swift gesture, the mark of spontaneous virtuosity. For example,

Elizabeth Prelinger admires this piece and conjectures, "The zig-zag stroke connecting head and hand over a wide expanse of empty sheet must represent one of the most exciting lines she ever made" (169). Here is a 66-year old woman whose life experiences may have taken their toll on her physically, but they have not diminished her ability to respond artistically. Within her own visual imagery Kollwitz not only defines herself as an artist, but also—through the high quality of her creative strokes—she reveals herself to be a superlative artist confident in her own ability. Although Rukeyser may not have known about this self-portrait, which was not included in *The Diary and Letters of Käthe Kollwitz*, Rukeyser did see several other Kollwitz drawings that also demonstrate the "expressive draftsmanship and utmost economy of means, which together account for the stark and devastating impact of her finest late work" (Prelinger 75). Certainly Rukeyser was repeatedly drawn to Kollwitz's inventive and evocative approach to her own self-representation, to images that all implicitly depict her as a woman artist.

Briefly describing several Kollwitz images, Rukeyser recapitulates for the reader how she arrived at her appreciation for Kollwitz's work and her decision to write this poem about Kollwitz. Rukeyser's short descriptions likewise permit a double-reading of these images, for each description could be referring to Rukeyser as well.[17] For example, Rukeyser does not note any dates that would particularly limit her references to Kollwitz. Instead, we are presented with a "woman, strong, German, young artist" and other terms that could apply equally to Rukeyser. Even Rukeyser's mention of war does not specify either World War I or World War II. Instead, we are presented with a woman "alive, German, in her first War," which could be any war, including the Spanish Civil War, which we would associate with Rukeyser. What might at first seem to be references to Kollwitz's self-portraits are actually references to an implied double-portrait of Kollwitz/Rukeyser. Through this strategy Rukeyser shows that she cannot speak of the other, of Kollwitz, without speaking of herself.[18] After Rukeyser's life has "listened" so attentively to Kollwitz's life, Rukeyser's subjectivity has become an intersubjectivity, a self-awareness shaped in part by Kollwitz's self-awareness.

In addition to her references to Kollwitz's self-portraits, Rukeyser also mentions four more Kollwitz pieces in this section, implying that the significant events documented by these works have shaped Kollwitz's "self" and so belong in her portrait. Kollwitz spent over 17 years planning and working on the granite monument of the bereft mother and father for the military cemetery in Flanders, where her son Peter was buried.[19] Initially she envisions the monument as larger-than-life entrance gates composed of two kneeling figures on either side of a stone-slab floor that would read, "Here lie the finest of Germany's youth" (K 107). The completed life-size statues kneel within the cemetery, without any inscription, but with the crosses

marking the graves "all around them like a flock" (K 121). Kollwitz was aware of her monument's implicit antiwar message and purposefully made the figures from a durable material so they could withstand retaliatory vandalism. One of Kollwitz's most overt antiwar statements is her famous poster *"Nie Wieder Krieg!* 1924" (Never Again War!), which shows an androgynous figure, arm raised in a gesture of halt, shouting out the order to stop aggression. The urgent tone of a reforming demand is also a primary element in "Seedcorn Must Not Be Ground, 1942." This is Kollwitz's last lithograph, finished three years before her death. In a letter to a close friend, Kollwitz reports that she has completed the stone, which depicts a defiant mother sheltering three boys beneath her ample coat. Although the boys want to "break loose" and go to war, Kollwitz imagines the protective mother commanding them, "No! You stay here! . . . [W]hen you are grown up you must get ready for life, not for war again . . ." (K 177). The subject of maternal grief is again depicted in "Pieta, 1937–38," a bronze sculpture of a seated mother who holds her son's limp body between her heavily draped legs.[20] All of the images Rukeyser references in this section particularly consolidate the connection between Kollwitz's life experiences and her art, even as three of the four carry Kollwitz's own face in their image. No wonder they are included within the series of self-portraits Rukeyser chooses to place here.

To support the dramatic energy of Kollwitz's art, Rukeyser uses language that suggests the movement of cinematic images across a screen. Her repetition of the phrase "flows into" provides a kind of musical "sound track" for the images, establishing a continuity between them. For Rukeyser, "The continuity of film . . . is closer to the continuity of poetry than anything else in art" (*LP* 141). By activating the kinesthetic sense of "flow," Rukeyser emphasizes the moving relationships within this poem, relationships that will gain momentum over its entire length. Rukeyser's cursory references to Kollwitz's self-portraits are not "describing" the art images as much as they are extending them as a connected "whole" in the flow of Rukeyser's awareness. Once Rukeyser establishes this swift movement of vital images, their cessation in the finality of the closing image is abrupt and unexpected.

The series of self-portrait images culminates in Rukeyser's description of "Lamentation, 1938" (figure 2), a bronze bas relief sculpture that shows Kollwitz's face partially covered by her hands:

flows into
face almost obliterated
hand over the mouth forever
hand over one eye now
the other great eye
closed (*RR* 219)

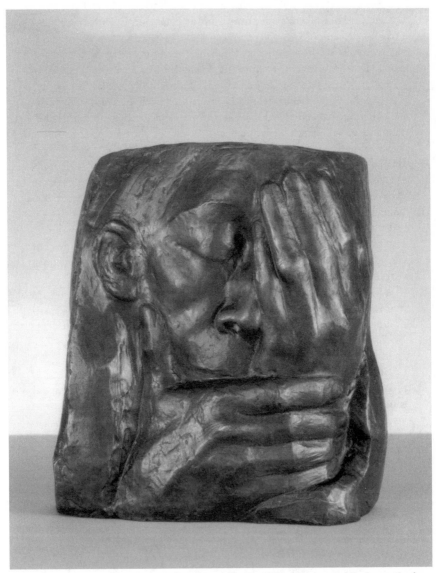

Figure 2: Lamentation: in Memory of Ernst Barlach. Hirshhorn Museum and Sculpture Garden, Smithsonian Institution, Gift of Joseph H. Hirshhorn, 1966. Photographer: Lee Stalsworth.

Obliteration, speechlessness, and occluded vision are stifling images that collide with the expressive power celebrated throughout the course of the poem. Not only does Rukeyser mourn the loss of Kollwitz's productive artistic consciousness in death, but she also fears that Kollwitz's surviving work will be lost through the unwarranted devaluation of Kollwitz.[21] In this closing image readers are given Rukeyser's painful impression of the difficulties and injustices she discovers in Kollwitz's life. However, Rukeyser's entire elegiac poem can be understood as an answering possibility that tries to convey Kollwitz's creative contribution despite the limitations of her life in a suffered world.

If we consider Rukeyser's closing lines alongside a study of Kollwitz's "Lamentation," the stark finality of the terminal image is ameliorated and its extended meanings are revealed. Gone are the enveloping arms of God/War/Death that embrace and confine the woman at the beginning of the poem. Now the woman is on her own; her agency and her embodied thoughts and feelings are the central subjects. The composition is simple and direct, unsupported by any framing elements, an artistic decision that foregrounds the significance of the woman's hands. According to art critic Tom Draper,

> [T]he suffering seen in this face is held within; the sense of tension is emphasized by the almost architectural placement of the hands. These heavily muscled worker's hands, serving an almost shielding function, are characteristic of Kollwitz's sculptural and graphic oeuvre. (10–12)

The woman's hands protect her, indicate the strength of her emotions, and prove her ability to work hard. This is a formidable woman who has withstood painful devastation. Her hands are those of a maker, symbols of her own stay against mortality. Kollwitz believes that the process of making is linked to a kind of immortality. In her diary Kollwitz records her agreement with Goethe's view of death: "My conviction of our continuation after death springs from the concept of activity. For if I go on indefatigably doing my work to the end, nature is obliged to assign me another form of existence when the present form is no longer able to contain my spirit" (K 106).

Although Rukeyser sets up the closing image as one of death, fitting for an elegy, there is an informative correspondence between this image, a passage from a Kollwitz letter, and "Poem," published in the same volume as "Käthe Kollwitz":

> I lived in the first century of world wars.
> Most mornings I would be more or less insane (*RR* 211)

Here Rukeyser wonders how to withstand the harsh truths of her lifetime. She finds a solution in Kollwitz, who writes:

I shrink from such painful impressions. . . . I think [this new timorousness of mine] arises from the instinct for self-preservation. I know and you know too what the war and all it has brought has done to me. If one wishes to live and work, it is only possible by fending it all off. I want to live and work while the daylight lasts. That is why I seek escape from the unbearable pressure. No, perhaps escape is not the right word. I do not want to shut my eyes, but to create a counterpoise to the horror, the pain. (K 156)

Kollwitz "doesn't want to shut her eyes" but to create a counter-balance in her art. In "Lamentation," the sculpture's shut eyes indicate a respite from courageous observation, the woman's move back into the resources of her inner thoughts and feelings, the woman's impulse to seek her own generative truth—not to find an escape. The act of "inward-looking" does not deny life experience but provides the opportunity for renewing reflection. In her diary Kollwitz defines her artistic goal in terms of her creative character: "Strength is: to take life as it is and, unbroken by life—without complaining or over-much weeping—to do one's work powerfully" (K 78).[22]

If Rukeyser admires Kollwitz's remarkable resilience as a woman artist living in difficult times, then her selection of quotations in Part II conveys the emotional shapes that comprise Kollwitz's strength: Kollwitz believes in her work because it has the value of well-composed, though multiple, "voices"; she sees the beauty others miss; she acknowledges her fears; she appreciates the sensual delight her embodiment makes possible; she dares to enjoy love despite its difficulties; she records her sustaining observations in clear language; she defies confinement in "the feminine" and heterosexist expectations; and she stays focused "on the essentials," what she values most.[23] Through Kollwitz's work Rukeyser is reminded that art lives beyond our daily pain and experiences of injustice. So, to return to "Poem," Rukeyser finds a solution for her own situation:

> Slowly I would get to pen and paper,
> Make my poems for others unseen and unborn. (*RR* 211–12)

The act of creative making for others, and for the future, can offset our experience of a suffered world.

When we view "Lamentation," we see the prominence Kollwitz grants to the figure's right ear—a formal feature left unmentioned by Rukeyser—and so positive silence again enters Rukeyser's poem, this time to validate "listening." "Lamentation" is a memorial tribute to Kollwitz's sculptor friend Ernst Barlach, who finished a group of profoundly attentive oak figures called "Frieze of the Listeners" three years before he died.[24] His funeral was held in his studio amidst his figures, and was attended by Kollwitz, who

notes in her diary that her own face, which is the face of his famous Angel, hovered above his coffin (K 126). The Angel is Barlach's tribute to Kollwitz and is now regarded "as a symbol or personification of lamentation over the battlefields of the two world wars."[25] Kollwitz makes her "Lamentation" during the ten years she is forbidden to sell her work and when the opportunities for casting bronze are severely limited (Prelinger 173). Thus both Kollwitz and Barlach listened open-heartedly to the truth of each other's lives, responding artfully in kind. By exploring more deeply the source of Rukeyser's closing image, we find encompassed within it the interrelationships of aesthetic, psychological, and political issues entwined throughout the poem.

Rukeyser's poem reminds us that behind some women's apparent silence is a comprehensive truth awaiting articulation in its best form. When the "tight-lipped man" in Rukeyser's poem dismissively judges Kollwitz as "too black and white," Rukeyser's preliminary reply is positive silence. She senses that the man's unfair assessment could be due to a failure of imagination, an imagination curtailed by unexamined assumptions. Rukeyser's full answer must then register a protest—and yet Rukeyser does not want to protest without making something. Rukeyser's poem honors Kollwitz's creative accomplishment and demonstrates what is so obvious to Rukeyser yet so easily missed by the man: Kollwitz's art manifests her generative truth, her sustained desire to live more fully in a better world. The poem strongly condemns the trivialization of a conscientious woman artist's work by an unconscientious man. Contrary to the man's typification, Kollwitz demonstrates through her art the courage and endurance necessary to face the complex truths of her difficult life. Rukeyser's portrayal of Kollwitz's work demonstrates that a woman's truths can be addressed not only in her writing and her visual imagery, but also in the interanimating relationship between these two discursive forms.

By writing her poem on Kollwitz, Rukeyser has surpassed her own characterization of poems as either based on "unverifiable facts" or "material evidence." For those poems that rely on the quality of the writer's aesthetic receptivity to another artist's work, poetry is not so much the challenge to speak artfully as it is the challenge to listen artfully; only after listening fully can one write well. Rukeyser's initial recognition and admiration for the generative truth in Kollwitz is made more profound by Rukeyser's own experience of trying to portray Kollwitz's creative energy in her poem: ultimately generative truth takes the shape of a creative process of attending to both language and image, a discursive way of striving to discover potentially better ways to understand and value each other. The Kollwitz poem enacts a complicated and emerging understanding of what constitutes women's "truth" in both life and art. For a woman to speak truthfully about her life, and for another person to

fully listen and understand, both people must engage repeatedly with the question of what it means to re-cognize and re-present the truth.

Notes

1. Louise Bernikow collected four centuries of women poets into an anthology entitled *The World Split Open* (New York: Random House, 1974). Some recent examples: Ann Lane cites Rukeyser's lines in the introduction to her biography of Charlotte Perkins Gilman, *To Herland and Beyond* (New York: Pantheon, 1990). Judith Johnson quotes Rukeyser's lines in her introduction to Joyce Sutphen's *Straight Out of View* (Boston: Beacon, 1995), winner of the 1994 Barnard New Women Poets Prize. Judith Stein uses Rukeyser's lines in her essay "Collaboration" in *The Power of Feminist Art*, ed. Norma Broude and Mary Garrad (New York: Harry N. Abrams, 1994).
2. I am using the term "spiritual" in the same way as Steven Smith: "To say that we are spiritual beings is to attain the correct orientation for addressing the question that imposes itself as a condition of all others—How will we live (together)?" Steven G. Smith, *The Concept of the Spiritual* (Philadelphia: Temple University Press, 1988), 5.
3. Rukeyser believes that affinities between people survive significant differences: "For when you dive deep enough into experience, you come to a place where we share our lives." Muriel Rukeyser, "The Music of Translation," *The World of Translation* (New York: P.E.N. American Center, 1971), 188.
4. Jane Cooper, "Forward," *Life of Poetry*, xvi.
5. Käthe Kollwitz, *The Diary and Letters of Käthe Kollwitz*, ed. Hans Kollwitz. Evanston, IL: Northwestern University Press, 1995 (Hereafter K). This is the only English source for Kollwitz's personal writings available before 1968. Kollwitz's complete diaries, *Die Tagebucher*, were published in German by her granddaughter Jutta Bohnke-Kollwitz in 1989.
6. Elizabeth Prelinger, *Käthe Kollwitz* (New Haven, CT: Yale University Press, 1992), 31. Kollwitz also recognized the importance of truth as a "whole." When she reread her diary, which she wrote to work through her perplexities and problems, she observed: "As I read I distinctly felt the half-truth a diary presents. Certainly there was truth behind what I wrote. But I set down only one side of life, its hitches and harassments" (K 111).
7. Muriel Rukeyser, "The Education of a Poet," *The Writer on Her Work*, ed. Janet Sternberg (New York: Norton, 1980), 226. Although Rukeyser does not discuss truth as correspondence—wherein truth is determined by how well one kind of human meaning maps another—her commitment to "material evidence" and to the value of "witness" presupposes that some poems must accurately correspond to real events in order to stand as viable or "true" poems. It is not sufficient for a poem about the unjust exploitation of silica miners to cohere simply as a whole; it must also maintain an accurate referential relationship to the "material evidence" of historical records, medical reports, etc., which exist "outside" it and provide validity for its protest. In her

Kollwitz poem Rukeyser has not resolved all of the tensions between coherence and correspondence, for she alters several of the Kollwitz quotations in Part II to make them cohere with the other components of the poem, even if they do not then correspond accurately to Kollwitz's original writings.

8. "If *Waterlily Fire* is of the first variety, Rukeyser's biographical poems [Kollwitz, Gibbs, Burlak, Ives] are, at least in part, of the second." Florence Howe, "The Poetry of Life," *The Women's Review of Books* (Nov. 1994): 13.

9. Jan Heller Levi, biographer, e-mail to the author, 29 June 1998.

10. Kollwitz titled this sculpture with a Goethe quote. Although most people see the embracing arms as masculine, the Kleins argue that "this image of unutterable and eternal peace" is linked to a drawing made in 1900 showing a "sleeping child secure in the arms of a protective yet unseen mother. For to the artist they were a mother's hands, though Goethe had written *His hands.*" Mina and Arthur Klein, *Käthe Kollwitz: Life in Art* (New York: Hold, Rinehart and Winston, 1972), 163.

11. Dora Apel, "Heros and Whores: The Politics of Gender in Weimar Antiwar Imagery." *Art Bulletin* (September 1997): 380.

12. Kate Daniels claims that Rukeyser attributed much of the "unfair" critical reception of her own work to the fact that critics misunderstood the principles that organized her poems. Although she sometimes articulated her objections, she often responded with silence. When William Pritchard "viciously" reviewed her life's work, *The Collected Poems,* in the *Hudson Review,* "[Rukeyser] responded in a characteristically private way: by mailing a copy of the piece, without comment, to a young critic (Louise Kertesz) who was completing the first book-length study of her work." Kate Daniels, "Muriel Rukeyser and Her Literary Critics," *Gendered Modernisms,* ed. Margaret Dickie and Thomas Travisano (Philadelphia: University of Pennsylvania Press, 1996), 258.

13. As a hypothetical conditional, the question/answer implies a thought-provoking, logical implication: if the world has not yet split open, then not even one woman has told the truth about her life. This reading problematizes the accomplishment of women's truth and changes the claim into an imperative: to change the world, women must tell the truth about their lives. It is this aspect that supports the epiphanic quality of Rukeyser's lines, a quality that leads many authors to quote them apart from their original context in the Kollwitz poem. Of course, many women had told the truth about their lives, and certainly many women writers had told the truth about their lives, prior to this 1968 poem. The real question then becomes whether or not other people are "listening" to women's truth.

14. Rukeyser is not completely consistent about her use of "split open" as productive. In "The Poem as Mask" she uses "split open" to indicate incapacitation; Rukeyser realizes that when she wrote previously of Orpheus as fragmented and exiled from himself, "it was myself, split open, unable to speak, in exile from myself" (*RR* 213). Interestingly, this poem opens *The Speed of Darkness,* which also contains the Kollwitz poem.

15. By "suffered world" I mean "the world the woman has suffered," a world that contains some suffering people, including the woman. I do not mean "a suffering world," which implies that all people are suffering. With my phrase I wish to emphasize the woman's experience of conscientious active endurance more than the world's condition.

16. See Prelinger, *Käthe Kollwitz,* page 168, for an image of this drawing.

17. Suzanne Gardinier also noticed this correlation, but in the opposite direction, when she studied photographs of Rukeyser and suddenly remembered several lines from the "Self-Portrait" section of the Kollwitz poem. Suzanne Gardinier, *"A World That Will Hold All the People:* On Muriel Rukeyser," *Kenyon Review* (Summer 1992): 104.

18. The limitation of this approach is observed by one of the contributors to *Between Women:* "My main difficulty in working on your writings is my fear or wish that the boundaries between us will simply disappear, that I will become a witness to you, who is *no one." Between Women: Biographers, Novelists, Critics, Teachers and Artists Write about Their Work on Women,* eds. Carol Ascher, Louise DeSalvo, Sara Ruddick (Boston: Beacon Press, 1983), xxi.

19. The plural "mothers" in "mothers among the war graves" is probably a typographical or editorial error, since the monument has only one mother. The lines should read "mother among the war graves / bent over death / facing the father / stubborn upon the field" (*RR* 218).

20. This sculpture depicts Mary and Jesus, but the lithograph "Pieta, 1903" does not.

21. Kollwitz's work is well represented in German museum collections primarily because it was favored by several curators in Kollwitz's lifetime. Kollwitz also enjoyed popular success in Germany and she priced her prints to make them accessible to a wide-ranging, appreciative audience. Hildegard Bachert, "Collecting the Art of Käthe Kollwitz" in Prelinger, *Käthe Kollwitz* 117–32.

22. At one point Kollwitz considers the possibility that "joy is really equivalent to strength": "Yesterday I kept thinking about this: How can one cherish joy now when there is really nothing that gives joy? And yet the imperative is surely right. For joy is really equivalent to strength. It is possible to have joy within oneself and yet shoulder all the suffering. Or is it really possible?" (K 87).

23. In order to create a sense of immediacy and to anticipate the path to the poem's closing image of "hand over the mouth forever," Rukeyser treats these quotations as if Kollwitz is "saying" them, when actually all of Kollwitz's language is written text from personal documents. The sources for the Kollwitz quotations are as follows: the fugue (K 141); the dark side (K 43–33); sensuality (K 55–56); Karl (K 57); Carrara (K 47); bisexuality (K 23); lithography (K 94).

24. Carl Dietrich Carls, *Ernst Barlach* (New York: Frederick Praeger, 1968), 199. Images of these sculptures are on pages 177–83; images of the Barlach Angel are on pages 105–6.

25. Mina and Arthur Klein, *Käthe Kollwitz*, 96. Although the Barlach Angel, with its closed eyes, was melted down for scrap metal by the Nazis during World War II, it was later recast and now resides in the fourteenth-century Antoniter Church in Cologne. The Angel was originally commissioned as part of a cathedral memorial for those who died in World War I.

Susan Eisenberg

❖❖❖❖❖❖❖❖❖

"Changing Waters Carry Voices": "Nine Poems for the unborn child"

I was first drawn to Muriel Rukeyser's poetry in the 1970s, when its pull was the content: a woman writing about sex and leftist politics. Two decades later—much of that time spent working as an electrician on large construction projects in Boston—I found myself rereading Rukeyser, this time for form: for her bold play with punctuation, those colons that demand white space on either side; and for the long poems that were massive in both content and structure, which sprawled with an audacity that is more often men's domain. Reviewing *Waterlily Fire,* Rukeyser's first selected poems, May Swenson wrote:

> Characteristic of her poetry . . . is the big canvas, the broad stroke, love of primary color and primary emotion. Her method is the opposite of the designer's, her vision is never small, seldom introverted. Her consciousness of *others* around her, of being but one member of a great writhing body of humanity surging out of the past, filling the present, groping passionately toward the future is a generating force in her work. (164)

Rukeyser's long poems in particular, with their multiple sections often individually titled, are expansive explorations in which she wrestles with major political issues of her day: the Spanish Civil War, the trial of the Scottsboro Nine, the deliberate exposure of tunnel workers in West Virginia to deadly silicosis—all issues in which Rukeyser's involvement, like her writing, was close-range. "Nine Poems for the unborn child," written in 1947 during the pregnancy that resulted in the birth of Rukeyser's only child, her son William L., reflects the same awareness of herself as a player on a larger stage. As she would write

two years later in her review of Charlotte Marletto's book *Jewel of Our Longing* (1949), pregnancy as subject matter was groundbreaking to the arts:

> There is no poetry of birth in the literature that reaches us. In our own time, we can count the poems on our fingers; there is a great blank behind us, in our classic and religious literature. There we might expect to find the clues to human process and common experience. In our religious literature, birth is not faced until the moment after; we are given the scene with the kings and the animals and Joseph, Mary holding the newborn; the Pharoah's daughter discovers the newborn. I cannot think of a scene of birth (and we edit out the little children nowadays) in Greek drama, or all the way up to Gargantua; of any representation in graphic art other than the tribal statues, African, Mexican, Polynesian. I cannot think of anything in films, or in the literature that tries to give us the stream of consciousness; or in music. I cannot think of anything in western poetry, other than formal Nativity odes, until this century. ("A Simple Theme" 236–37)

Her strongest criticism of Marletto's endeavor is that the poems are sentimental and represent an "inadequate attempt to make a form to communicate pregnancy and its emotions" (236). Significantly, it is the form that I find most compelling in Rukeyser's "Nine Poems for the unborn child."

While her other long and sectioned poems are mostly written in open form that at times interweaves documentary or found material, "Nine Poems" stands out as the only one written entirely within a received form. Written as a sonnet cycle, the series of nine poems elasticize but stay within the conventional form, much as a pregnancy elasticizes the female body. While, in a long poem such as "The Book of the Dead," many of the sections can stand on their own as individual poems (only some of them, for example, appear in *Waterlily Fire*), "Nine Poems" works only as a complete cycle, documenting the transition from "childless," the poem's first stressed word, to "child," its final stress. Each titled with a Roman numeral, the sections of the poem correlate with the successive months of pregnancy.

For a poem about pregnancy, a nine-sonnet cycle is a rich and resonant choice for a variety of reasons. Classically the sonnet is associated with the love poem; "Nine Poems" functions as a love poem to Rukeyser's unborn child. Using a received rather than open form adds historical weight to an event that is temporal and outside the traditional realm of poetic focus; in a sense, pregnancy itself is a received form passed generation to generation. Selection of the sonnet for this sequence—the most commonly used and familiar received form in English prosody, its iambic pentameter line correlating with the natural pattern of English speech—emphasizes the normalcy of pregnancy as a human state. A form that is short and contained, the sonnet traditionally presents a problem, heightens it, and then comes to

a resolution within a set number of lines. In "Nine Poems," the persona is presented with the situation of pregnancy, wrestles with various complications personal and political, and arrives, by the end of the ninth poem and ninth month, at a declaration of her hopes for herself and her future child. Rukeyser's nine-sonnet cycle highlights pregnancy as the human species' quintessential act of repetition; it also plays with the notion of closure. Pregnancy moves through a series of stages, transformations that are both physical and psychic, and its closure is, of course, another beginning.

But more than all that, if, as Paul Fussell suggests in *Poetic Meter & Poetic Form,* "The poet who understands the sonnet form is the one who has developed an instinct for exploiting the principle of imbalance" (115), the sonnet is a particularly useful framework against which to examine the one-into-two / into-one / into-simultaneously-one-*and*-two of a progressing pregnancy. During pregnancy, that nine-month preparation for parenting, not only does a woman's physical center of gravity continually shift, but her emotional center does as well; the competition of two lives for the resources of one body unsettles long held habits and assumptions, from eating and sleep/wake cycles to dreams and expectations, as "Nine Poems" documents. Throughout the poem, one month to the next, Rukeyser tinkers with this scaffolding, shifting between one and two stanzas, each 12 to 15 lines, as follows:

I.	1 stanza; 14 lines
II.	2 stanzas; 8 lines, 6 lines
III.	2 stanzas; 8 lines, 7 lines
IV.	2 stanzas; 8 lines, 6 lines
V.	1 stanza; 12 lines
VI.	1 stanza; 14 lines
VII.	2 stanzas; 8 lines, 6 lines
VIII.	2 stanzas; 6 lines, 8 lines
IX.	2 stanzas; 8 lines, 7 lines (*OS* 75–8)

Although Rukeyser varies the number of lines in the sonnets, the length of the entire cycle remains at 9 times 14 (or 126) lines. Some of these stanza lengths are particularly effective choices, with the movement between one and two stanzas always resonant.

Section I, a single 14-line stanza, opens and closes with iambic pentameter lines:

The childless years alone without a home

. .

The fall to life, the cliff and strait of bone. (*OS* 75)

In this first month, although conception has occurred, the pregnancy would not yet be evidenced either by a missed period or (in 1947) by medical testing. Likewise, the octet and sestet of a sonnet exist in the rhyme scheme and "turn," but they are not recognized with a stanza break. The rhyme scheme of the first eight lines, *abcddeba* (home, happiness, loss, cloud, aloud, take, darkness, come) both creates the shadow of an octet and focuses attention on the unrhymed "loss" and "take." The end rhymes in the last six lines, *fghifh* (traces, wind, gone, plane, spaces, bone), similarly suggest a sestet and conclude with a slant rhyme (gone, bone) that mirrors the earlier "home" and "come."

Like a tightly edited film, Section II opens at the doctor's visit that confirms the pregnancy of the poem's persona: "They came to me and said, 'There is a child.'" What had been a single stanza in Section I is now two, reflecting the two entities encased within one body, and now appears as an example of the classic octet/sestet sonnet form. In the third month, the pregnant body expands, the waistline disappears, and the pregnancy begins its psychic settling in: "Miraculously, life, from the old despair." The second stanza of the sonnet of Section III is no longer a sestet; it has plumped into seven lines.

Sections V and VI appear as single stanzas. This fusion into one stanza is anticipated in Section IV by the one instance in "Nine Poems" when an end rhyme threads across a stanza break ("delight" in line six and "light" in line ten). The fifth month of pregnancy is generally when what is called quickening—the first fetal movements felt by the mother—occurs. Not only does Section V have the fewest lines, but the lines are shorter; three have only six syllables, and two have seven. Rukeyser shifts from two stanzas back into one for what is typically a hunkering in, internal time, reflecting that the pregnancy has moved along. The single stanza here serves a different function than it does in Section I, when the poem's persona is unaware of the life it carries; here it suggests an adjustment to the condition of pregnancy by an individual with a strong sense of self. The new life now has taken over and is kicking.

Beginning in the second stanza of Section IV, the narrator's direction becomes overwhelmed by the drives of the fetus growing within her until, by section V, the "I" as actor has almost disappeared:

> The waves are changing, they tremble from waves of waters
> To other essentials — they become waves of light
> And wander through my sleep and through my waking,
> And through my hands and over my lips and over
> Me; brilliant and transformed and clear,
> The pure light. Now I am light and nothing more.

V

Eating sleep, eating sunlight, eating meat,
Lying in the sun to stare
At deliverance, the rapid cloud,
Gull-wing opposing sun-bright wind (*OS* 76–7)

The syntax and end rhymes of Section V dissolve any sense of even a hidden octet/sestet. Lines 2, 5, 7, 10, and 12 share one rhyme in an alternating second and third line pattern that creates almost a nursery quality: "stare," "dare," "flare," "nowhere," "there." The one two-syllable word among them, "nowhere," also marks the syntactic break where the 10-line sentence ends and where the section's turn occurs. The section concludes with a very tender couplet in which the pregnant woman, grown rounder, becomes Earth-like, curious about "who" she carries:

And in my body feel the seasons grow.
Who is it in the dim room? Who is there? (*OS* 77)

Immediately, the external world intrudes against this oneness, which holds firm. As if answering the question posed, Section VI begins, "Death's threat!"—suggesting imagery of the Spanish Civil War, in which Rukeyser's lover was killed fighting—and then moves to the ominous question:

They came to me and said, "If you must choose,
Is it yourself or the child?" Laughter I learned
In that moment, laughter and choice of life. (*OS* 77)

The pronoun "they" has no referent, and it is unclear whether the question is a routine medical formality or due to a specific cause for concern. But it strikes at the vulnerability of being one with another. Again, rhyme and repetition serve as glue holding the stanza together across the expected octet/sestet break: "eyes" ending lines 2 and 14, and "life" ending lines 6 and 11. Rukeyser's use of "choice" and "choose"—words that are related but not identical—to end lines 8 and 9 serves a dual function: to join the stanza, and to anticipate the octet/sestet stanza break that will occur in Section VII.

Rukeyser returns to two stanzas for the poems of the third trimester. At this point in fetal development, a ballooning belly makes the imminence of birth very real. It is with the first word of Section VII that "You"—the child as one to be directly addressed—first appears. The woman and baby are now two—separate, but yoked by the umbilical cord and the sonnet's structure. Each of these final three poems is configured differently. Section VII is the traditional

octet and sestet, highlighting the inversion that follows. Like the pregnant woman's life, like the turning baby in her womb, the sonnet of section VIII is upside down, with the sestet first. The final section, IX, like the one that ends the first trimester, is a 15-line sonnet of two stanzas: eight and seven lines. At this point in pregnancy the baby would have dropped lower in the pelvic cavity. Brought full term, the baby is overfilling its "red room" and is ready for birth. This poem, written in a form structured on imbalance, closes with an almost prayerful wish for balance, from both writer and mother:

> Praise that the homeless may in their bodies be
> A house that time makes, where the future moves
> In his dark lake. Praise that the cities of men,
> The fields of men, may at all moments choose.
> Lose, use, and live. And at this daylight, praise
> To the grace of the world and time that I may hope
> To live, to write, to see my human child. (*OS* 78)

Five decades later, not surprisingly, some aspects of the poem's content seem dated a reminder of the ground broken in literature by Rukeyser in depicting pregnancy bluntly and from inside the experience rather than from an idealized distance. To a reader accustomed to decades of confessional poetry and memoirs—let alone the possibility of reading a total stranger's pregnancy diary on the Internet—aspects of "Nine Poems" seem masked and modest. For example, the child's father's absence, which Rukeyser explains in a much later volume, *The Gates* (1976) as "jailed [. . .] / by his own fantasies—" (*RR* 264), is completely unexplored in this earlier poem. "Nine Poems" enters the physicality of pregnancy, yet it keeps to metaphoric and poetic language, creating its own kind of distance that seems unintended. For one thing, the specific language of pregnancy seems uncharacteristically absent from the poem's diction. There are lots of 'waves' and 'wind' and 'light' to describe quickening, but we're without that wonderful word itself.

> The water-soothed winds move warm above these waves.
> The child changes and moves among these waves. (*OS* 76)

Rukeyser had a documentary filmmaker's relish for technical terms and was a groundbreaker in using scientific terminology in poetry. A decade before "Nine Poems," she wrote in "The Book of the Dead":

> How many feet of whirlpools?
> What is a year in terms of falling water?
> Cylinders; kilowatts; capacities.
> Continuity: Σ Q = 0

Equations for falling water. The streaming motion.
The balance-sheet of energy that flows
passing along its infinite barrier. (*OS* 32)

One might expect someone as highly attuned as Rukeyser to both science
and sound to bring into "Nine Poems for the unborn child" words such
as "amniotic fluid," "placenta," "chloasma" (also known as the mask of preg-
nancy), "linea negra" (the line between navel and pubic bone that darkens
during the second trimester), "fundus" (top of the uterus). That she does not
seems an indicator of the transition point at which the poem was written—
the fulcrum between the romanticized and the confessional. The use of tech-
nical language outside its arena is empowering and democratizing; it claims
territory and also has a normalizing or demythologizing effect. Given that
one of Rukeyser's intentions is that pregnancy, as well as other physical and
emotional concerns particular to women, become an expected focus for the
arts, "Nine Poems" is, not surprisingly, not only a breaker of tradition but
also its product.

"Nine Poems" was written, after all, in 1947, in a conservative post-war
climate that glorified the nuclear family, as many women were expelled from
the labor market and returned to domesticity (or lower-paying jobs). To
write about her pregnancy openly and unapologetically defied many taboos.
Rukeyser was a long-time public political activist now choosing to focus on
her personal life in poetry, and pregnancy was not considered appropriate
subject matter for poetry. Further, not only was Rukeyser unmarried but,
contrary to her expectation, the father of her child chose not to claim him,
a fact that surfaces in the poignant second stanza of Section II,

"There is no father," they came and said to me.
—I have known fatherless children, the searching, walk
The world, look at all faces for their father's life.
Their choice is death or the world. And they do choose.
Earn their brave set of bone, the seeking marvelous look
Of those who lose and use and know their lives. (*OS* 76)

Among all the sections, in this one the iambic pentameter beats
strongest. The first line of this sestet inverts the grammatically parallel first
line of this sonnet's octet, in which the unassigned (and never, in this
poem, friendly) pronoun "they" first appears: "They came to me and said,
'There is a child.'" Because we expect a sonnet to present a situation
("There is a child"), complicate it ("There is no father"), and come to res-
olution in 14 lines, Rukeyser's choice of placement for this information—
the interplay of the sonnet form and its content—encourages the reader to

move on and accept that, yes, not having a father is difficult, but it can be strengthening as well as crippling. This child will make the choice between "death" and "the world."

At the heart of this poem and its feminism that still feels fresh, the theme of choice recurs. Not idealized choices, but choices of will occur within a given social/political/medical reality. The pregnancy and commitment to the child becomes a choice to allow the transformation from "the dark screen of loss / Hardly moving" (Section I) to "screens of leaves" (Section IV). Even in utero the mother-child relationship is complex. Rukeyser at once conveys the mother's acceptance of the experience of pregnancy and of the child, and the mother's control and personal responsibility (Section VIII):

> you hold me in your flesh
> Including me where nothing has included
> Until I said : I will include, will wish
> And in my belly be a birth, will keep
> All delicacy, all delight unclouded. (*OS* 78)

Rukeyser places these choices within the context of larger and ongoing life choices ("Turning each day of living to the living day"). For example, there is the context of her lover killed in Spain who risked death in choosing life: "gladly with a laugh advancing, / His hands full of guns on the enemy of Spain" (*OS* 77).

The child is also identified as one who will enter life as an active player. Not only will he be among those "fatherless children" who choose "death or the world" but, like all children, he will enter the world at a given historical moment of opportunity and limitation. Section VII, almost liturgical in its repetitions, conveys adults' responsibility for creating the human community into which the child is born, but also each new generation's difficult responsibility for creating the ongoing present from the inherited past.

VII

> You will enter the world where death by fear and explosion
> Is waited; longed for by many; by all dreamed.
> You will enter the world where various poverty
> Makes thin the imagination and the bone.
> You will enter the world where birth is walled about,
> Where years are walled journeys, death a walled-in act.
> You will enter the world which eats itself
> Naming faith, reason, naming love, truth, fact. (*OS* 77)

Both as a construction worker and as a woman who entered parenting from an independent adult life, I find Rukeyser's skillful play with form in

"Nine Poems" deeply evocative. To examine the transition from "childless" to welcomer of "my human child" by plying the sonnet's very steel suggests, in a way that content alone cannot, the radical nature of the choices encountered in this process, while at the same time giving structural resonance to the limitations that bind those choices.

Part IV

❖❖❖❖❖❖❖❖❖

Poetry of Witness

John Lowney

Truths of Outrage, Truths of Possibility: Muriel Rukeyser's "The Book of the Dead"

There are roads to take she wrote
when you think of your country

—Adrienne Rich, "An Atlas of the Difficult World"

What three things can never be done?
Forget. Keep silent. Stand alone.

—Muriel Rukeyser, "The Book of the Dead"

As Adrienne Rich's "An Atlas of the Difficult World" (1991) attests, Muriel Rukeyser's work as "poet journalist pioneer mother" (13) has not been entirely forgotten. The long poem that Rich quotes (and footnotes) in her "Atlas," "The Book of the Dead" (1938), maps an early Depression site of industrial disaster that otherwise might have been erased from her "country's" history: the silicosis deaths of hundreds of miners employed in the Union Carbide hydroelectric project in Gauley Bridge, West Virginia. In commemorating a site that corporate and government officials would have preferred to forget, Rukeyser also investigates the dynamic relations of memory, history, and national identity. As the initial poem in Rukeyser's second volume of poems, *U.S. 1*, "The Book of the Dead" represents an important Popular Front intervention into national identity formation during the period of New Deal Democratic ascendancy. However, the interaction of

memory and history remains crucial to Rukeyser's practice as a political poet after the 1930s as well. She asserts in *The Life of Poetry*, "If we are free people, we are also in a sense free to choose our past, at every moment to choose the tradition we will bring to the future" (21). Contrasting the narratives of workers and their families with more "official" versions of the Gauley Bridge catastrophe, "The Book of the Dead" insists on the democratic responsibility of "choosing our past." For Rukeyser, poetry is a form of social action that transforms collective memory. Like "monuments," poems "offer the truths of outrage and the truths of possibility" (*LP* 66). But while the poem offers testimony to its historical moment, it only succeeds if it likewise engages its readers in a creative act of "witnessing."[1] "The Book of the Dead" positions its readers as active "witnesses" through its dialogic process of documenting, interrogating, and revealing the discursive practices by which national history is constructed.

Rukeyser's strategies for representing Gauley Bridge invoke the documentary modes associated with 1930s popular news media (investigative reporting, photojournalism, and documentary film) as well as the narrative strategies for representing place in the Federal Writers' Project (FWP) American Guide Series. The title of *U.S. 1* itself echoes one of the most popular volumes from this series, *U.S. One: Maine to Florida*.[2] However, as recent studies of "The Book of the Dead" have noted, the poem's dialogic structure foregrounds local differences of class, gender, and race to counteract discourses of nationalism that elide such differences.[3] In juxtaposing lyric and narrative poetic modes with documentary forms such as journalistic reporting, transcriptions of Congressional hearings, biography, and personal interviews, "The Book of the Dead" further underscores the dialogic relation of poetry to other discursive forms. As Richard Terdiman concludes about Bakhtin's theory of language in *Present Past: Modernity and the Memory Crisis,* Rukeyser's poetic practice aims to "reassert the mediations linking social objects and signs to the cultural system in which their meanings become meaningful" (45). According to Terdiman, Bakhtin's dialogism is a "memory model" that recalls the social history conveyed through a culture's language; the dialogic structure of "The Book of the Dead" likewise restores cultural memory to a site whose narratives would otherwise be marginalized if not forgotten. As the direct address of Rukeyser's recurring travel motif accentuates—"These are roads to take when you think of your country"—"The Book of the Dead" insists on her readers' engagement in rethinking the cultural significance of Gauley Bridge. And by dynamically relating individual acts of remembering to the formation of collective memory within "The Book of the Dead," Rukeyser transforms a site of geographical and social marginality into a site of memory that contests official interests in forgetting the past.[4] Most significantly, and most often overlooked in commentary on

"The Book of the Dead," Rukeyser foregrounds the racial politics informing the cultural memory—and amnesia—of Gauley Bridge.

The grim facts of Gauley Bridge became widely known in the mid-1930s, but only after the radical press uncovered information that was otherwise either ignored or actively suppressed by Union Carbide officials. First the *New Masses* and the *People's Press,* a radical Detroit labor tabloid, and then, noticeably later, mass-circulation news magazines publicized the facts that are routinely summarized in critical studies of "The Book of the Dead." What remains understated—and even unstated—in readings of Rukeyser's poem, though, is that the majority of those workers exposed to the dust were black migrant laborers. Because they were neither white nor long-term residents of the area in which they died, their deaths were barely noticed in the local media at first, and the cause of their deaths was disputed long after "silicosis" became a familiar term in front-page headlines. The politics of remembering and forgetting that "The Book of the Dead" investigates have as much to do with race as with labor. Rukeyser underscores the racial politics of Gauley Bridge not only through the stories and testimony of black workers and their families, but also through the metaphor of whiteness—the "white glass" of silica. The symbolic associations of this metaphor proliferate with the poem's accumulation of voices defying Union Carbide's systematic silencing of witnesses.

The critical reception of *U.S. 1,* and of Rukeyser's 1930s and 40s writing more generally, suggests how controversial her innovative dialogic practice was.[5] As Walter Kaladjian has argued, the subject, social content, and regional setting of "The Book of the Dead" disrupt the universal stances of both bourgeois humanism and classical Marxism. The criticism of her work in the *Partisan Review* indicates most blatantly that conflicts about Rukeyser's Marxist politics were also thinly veiled attacks on her authority as a woman writer, as indicated by the title of the most notorious condemnation of her work, "Grandeur and Misery of a Poster Girl."[6] If the 1930s marginalization of the "woman question" has until recently been perpetuated in literary histories of the period, the reception of Rukeyser's early writing suggests how class conflict itself was represented in the language of sexual difference. As Paula Rabinowitz documents in *Labor & Desire: Women's Revolutionary Fiction in Depression America,* class struggle within Communist Party rhetoric was "metaphorically engendered through a discourse that re-presented class conflict through the language of sexual difference. The prevailing verbal and visual imagery reveled in an excessively masculine and virile proletariat poised to struggle against the effeminate and decadent bourgeoisie" (8).[7] The class position of bourgeois women, such as Rukeyser, who wanted to become politically active in the Communist Party was especially problematic: "Hopelessly outside of the working class because she was

not hungry, the female intellectual was ideologically inscribed rather than materially determined. Given the hostility of most 1930s American Marxists to ideas (as opposed to action), their valuing of deed over word, the bourgeois woman represented the epitome of false consciousness" (Rabinowitz 54).

The masculinist discourse of class struggle also complicated representations of working-class women during the Depression. As Michael Denning points out, however, such masculinist rhetoric was increasingly contested within the Popular Front of the later 1930s. Representations of working-class women became more prominent, although these representations were often conventional portrayals of mothers and children. Most notable were the representations of migrant mothers in such popular texts as John Steinbeck's novel *The Grapes of Wrath,* and Dorothea Lange's and Paul Taylor's book of photographs, *American Exodus*—representations that appealed to traditional notions of family to portray the agonies of migrant laborers.[8] What differentiates Rukeyser's representation of migrant working-class women from these popular images is that she presents them in public arenas, particularly the courtroom, as well as in their homes. Furthermore, her self-consciousness as a socially privileged narrator—a consciousness that also extends to the role of her colleague, the photographer Nancy Naumberg— makes us continually aware of her class position. This self-consciousness is intensified by the racial dynamic of white investigative reporters gathering information from black migrant workers.

In one of the most lasting Popular Front testimonies to black migration, *Twelve Million Black Voices,* Richard Wright asserts: "We black folk, our history and our present being, are a mirror of all the manifold experiences of America. What we want, what we represent, what we endure is what America *is*. If we black folk perish, America will perish" (144). As confrontational as Wright's stance appears, his statement also reflects the important change in approach to "the Negro question" taken by the Communist Party in the late 1930s. With the Party's affirmation of Communism as "twentieth-century Americanism," Party spokesmen argued increasingly that African Americans were representative of the working class rather than a special case, and that African American experience should be considered integral, rather than peripheral, to transforming American society. In his study of the Communist Party's role in Harlem, Mark Naison explains the impact of this Popular Front strategy: "By defining Black America's struggle for cultural recognition as a source of creative energy for the entire nation, party spokesmen helped give their white constituency a sense that they had a personal stake in black empowerment and that cultural interchange between the races represented a *defining* feature of the American experience, something to be celebrated and dramatized rather than hidden" (216).[9] Affirming that

African Americans are representative of the American working class is one thing; depicting *how* they are representative is another problem altogether for white writers committed to revolutionary change. This challenge is born out in a number of proletarian novels, such as the Gastonia novels of Mary Heaton Vorse, Fielding Burke, and Grace Lumpkin, in which the relative silence of black characters belies the claims made for multiracial unity. More often than not the presence of black characters in proletarian fiction tells us more about the white characters' ability, or lack thereof, to combat racism on behalf of working-class solidarity.[10] It is precisely this challenge of representing black workers without suppressing their voices that explains the dialogic documentary structure of "The Book of the Dead."

The most comprehensive study of the Gauley Bridge tragedy, Martin Cherniack's *The Hawk's Nest Incident: America's Worst Industrial Disaster* (1986), makes very clear how important racial politics were in the initial response to workers' claims.[11] Cherniack, a physician with expertise in occupational disease, underscores how racial politics have informed local memory of this historical incident even generations later. He documents a remarkable tale of official concealment of information, concealment that assumes that black migrant laborers' lives have little value. To his surprise, Cherniack found that not only had Union Carbide officials eliminated from the public record all incriminating information about the deaths of workers, but local residents that he interviewed were reluctant to blame the company as well. When asked why so many people died during and after the project's completion, most of the informants old enough to remember the 1930s reiterated the company's initial explanation: black workers died not from silicosis but from pneumonia resulting from their own self-destructive behavior (such as drinking or gambling outdoors before open fires). The statistics cited by Cherniack explain why such dismissive accounts of so many deaths could persist. Fewer than 20 percent of the workers involved in the New Kanawha Power Project were long-term local residents. The majority of the workers were migrant laborers, who were quick to seek work in this early year of the Depression (1930). Almost two-thirds of these migrant laborers were southern blacks (17). Of the construction workers who spent all or most of their time working within the tunnel, that is, the workers who were most exposed to danger and disease, a disproportionately large number were black (18). The story that Cherniack unravels is certainly one of corporate greed and deceit that cost many workers their lives, but the racial politics dividing the workers and the local region make this tale more complicated. It is also a tale of local distrust of, if not contempt for, the black migrant laborers who occupied the inadequate, overcrowded housing quarters in the racially segregated local towns and the camps built by the Virginia construction company (Rinehart and Dennis) hired by Union Carbide (Cherniack 17–33).

Given Cherniack's detailed assessment of responses to the Gauley Bridge disaster throughout the 1930s—in the radical press, in mass-circulation newspapers and magazines, in Hollywood movie newsreels, and in popular fiction and songs—it is surprising that he says nothing about "The Book of the Dead."[12] The fact that Rukeyser's poem does not exist in this, the most comprehensive account of the medical and social significance of Gauley Bridge, suggests not only how marginalized poetry has remained in American cultural history, but also how radically innovative Rukeyser's documentary method still is: poetry and investigative reporting, poetry and social history, and, for that matter, poetry and science, persist as the mutually exclusive discursive categories that Rukeyser spent a lifetime trying to bridge.[13]

While "The Book of the Dead" reports the same facts that investigative reporters have uncovered, it does so through a montage of narrative, lyric, and didactic modes juxtaposed with a wide range of documentary modes: first-person testimony of a previous independent investigator, the social worker Philippa Allen; portraits, vignettes, interviews with and first-person testimony of local workers and their family members; and quotations from Congressional hearings, medical reports, and Union Carbide stock reports. The juxtaposition of personal testimony with official accounts in "The Book of the Dead" reveals the processes by which the workers' claims were dismissed. Through the personal testimony we are reminded that when faced with so many workers' deaths the local doctors "called it pneumonia at first. / They would pronounce it fever." (*OS* 20), a diagnosis immediately contradicted by the subsequent medical report. This popular misconception is reiterated by the local undertaker, who "tells about Negroes who got wet at work, / shot craps, drank and took cold, pneumonia, died," but whose own credibility is subsequently undercut by the fact that "Rinehart & Dennis paid him $55 / a head for burying these men in plain pine boxes" (*CP* 89). We find out that there were "Negroes driven with pick handles" (*CP* 91) to work in the tunnel, many of whom "went into the tunnel-mouth to stay" (*CP* 76). Underlying such abusive treatment, the first thing we are told about the workers in "Praise of the Committee" is:

> Most of them were not from this valley.
> The freights brought many every day from States
> all up and down the Atlantic seaboard
> and as far inland as Kentucky, Ohio.
> After the work the camps were closed or burned. (*OS* 15)

In stating so directly the wider implications of this local tragedy, the Congressional testimony that Rukeyser quotes refigures the very geography of *U.S. 1* with which the poem begins, a geography of migrant laborers whose

life stories, if not their lives, are rescued from the same oblivion as the camps that were "closed or burned."

Highway U.S. 1 was integral to the formation of the United States. According to the FWP guidebook, it remained "as it was in Colonial and early Federal days the chief line of communication between the centers of the Atlantic Seaboard States" (FWP xi). Most importantly for "The Book of the Dead," this north-south highway was also crucial during the Civil War; south of Fredericksburg, Virginia, "the route . . . traverses an area that has seen more bloodshed than has any other on the North American Continent" (FWP xii). The first section of "The Book of the Dead," entitled "The Road," invokes the relationship between narrative, place, and audience followed by the American Guide Series. Its direct address to "you," traveling by automobile through "your own country," appeals to the reader with the New Deal rhetoric of national purpose that informed the diverse local projects initiated by the Federal Writers Project. Yet underlying this presumed commonality between writer, place, and reader is a subtle interrrogation of what "you" would consider "when you think of your country." As "The Road" moves from its initial invocation of "your country" toward a more specific focus on the local sites surrounding Gauley Bridge, Rukeyser accentuates those texts that authorize national unity:

> These are roads to take when you think of your country
> and interested bring down the maps again,
> phoning the statistician, asking the dear friend,
>
> reading the papers with morning inquiry. (*OS* 10)

From these official means for defining modern nationhood—maps, statistics, newspapers—the narrative goes on to emphasize the social differences that contradict such unity, especially the class differences that divide Gauley Bridge and also distance the narrator from this locality. Whereas the traveler seems at first to be a typical tourist, enjoying the luxury of a "well-traveled six-lane highway planned for safety," Rukeyser disrupts any bourgeois notions of objectivity associated with tour guides by foregrounding the privileged class position and metropolitan vision of the speaker (and her photojournalist companion). Likewise, she insists that her readers consider their own investment in the narrative: "Here is your road, tying / / you to its meanings" (*OS* 11). Neither the speaker nor the reader is exempted from the power relations underlying this plurality of meanings.

The verbal mapping of West Virginia that follows the opening section of "The Book of the Dead" accentuates how the national economy manifests itself locally: on the one hand are impoverished mining towns; on the other are

posh tourist resorts. The road's "meanings" become a social plurality of histori-
cal conflicts embedded within the harsh physical environment. While
Rukeyser's concise but precisely rendered history of West Virginia resembles the
comprehensive introductory overviews of state history found in the Guide
Book Series, it makes no attempt to hide its point of view in selecting what is
most important. It maps the English settling of the western "frontier" and dis-
placement of the local Mohetons, briefly notes the battles of the Revolutionary
War, and describes the crucial position of Gauley Bridge on the North-South
"frontier" of the Civil War. But most notable is the capitalized reference to

> the granite SITE OF THE precursor EXECUTION
> sabres, apostles OF JOHN BROWN LEADER OF THE
> War's brilliant cloudy RAID AT HARPERS FERRY. (*OS* 11)

Given the specific reckoning of corporate culpability that motivates the
poem, such emphasis on local history might seem irrelevant. However, as the
reference to John Brown suggests, Rukeyser insists that a Marxist revolu-
tionary politics in the United States is also a racial politics.[14] In foreground-
ing her role as witness, historian, and investigative reporter speaking for
workers, especially black workers, who inherit a history in which their voices
have not been recorded, Rukeyser affirms her potential to change the pre-
sent through the orchestration of prior historical narratives. At the same
time, she acknowledges the complexity of her inscribed position within this
narrative "scene of power" (*OS* 11).

The narrative journey of "The Book of the Dead"—from "The Road,"
to "West Virginia," to "Gauley Bridge"—documents not only the wasted
lives of the miners but also the documentary poet's process of gathering,
recording, and reporting information. The poet's initially self-conscious
stance becomes more assertive only when additional voices provide collective
support for her point of view. "Gauley Bridge," the fourth poem in this
twenty-poem sequence, underscores how tentatively the narration begins, as
it makes us aware that the presence of the camera is especially intrusive. This
section develops the poem's major trope, the trope of glass, which is at first
the documentary photographer's medium for exposing—and correcting—
the touristic commodification of place: the photographer "follows discovery
/ viewing on groundglass an inverted image" (*OS* 10). Yet glass is also the
very medium through which everyday commerce is conducted: "the public
glass" behind which the owner of "the commercial hotel" keeps his books;
the "postoffice window" with its "hive of private boxes"; the bus station
restaurant with its "plateglass window" and "April-glass-tinted" waitress; the
"beerplace" where this waitress is herself objectified by "one's harsh night
eyes over the beerglass" (*OS* 13–14).

As a medium for reification, glass also exposes how the social relations of Gauley Bridge are racialized. Furthermore, the camera's "groundglass" exposes how representations of Gauley Bridge are necessarily racialized as well. Before reaching the town's "many panes of glass / tin under light," "Gauley Bridge" begins with a bleak, almost blank image of "empty windows" on an "empty street," with a "deserted Negro standing on the corner." This image of the "deserted Negro" takes on further significance only with the testimony of these very people that the camera initially objectifies. Nearby, however, where "nine men are mending road for the government," a boy running with his dog "blurs the camera-glass fixed on the street" (*OS* 13): this blurring suggests that the camera cannot neatly frame the lives it is documenting. This foregrounding of the photographer's interaction with her subject, which indicates how the camera eye can evoke but not contain the lives it documents, is reiterated in the subsequent contrast of visual perspectives, between the "eyes of the tourist house" and the "eyes of the Negro" (*OS* 14).

As the initial tour of Gauley Bridge concludes, the narrative lens is pointed directly at the reader:

> What do you want—a cliff over a city?
> A foreland, sloped to sea and overgrown with roses?
> These people live here. (*OS* 14)

Immediately following this interrogation of the reader's position as consumer of this travel narrative, we are presented with the testimony of the first witness, Vivian Jones. His is not a story of glass as a medium for consumerism but one of glass literally—involuntarily—consumed: "hundreds breathed value, filled their lungs full of glass" (*OS* 15). This "glass" eventually consumes the workers who breathe it. Valuable for corporate investors, deadly for the workers who mine it, this "white glass" (*OS* 14) becomes the medium for revealing the racist social system that underlies the negligent labor practices of Union Carbide. The first mention of the silica's whiteness conspicuously reminds us that the historical remnants of slavery, if barely visible, have hardly disappeared; immediately juxtaposed with the "white glass" showing "precious in the rock" is the image of an "old plantation-house (burned to the mud)," now a "hill-acre of ground" where a "Negro woman throws / gay arches of water out from the front door" (*OS* 14). As "The Book of the Dead" subsequently proceeds through the "eyes of the Negro" rather than "the eyes of the tourist house," the local stories and songs of witness form a composite narrative of countermemory that transforms Gauley Bridge into a "nation's scene" (*OS* 37) that otherwise would have remained obscured.

The most ironic testimony to the lethal power of whiteness is that of George Robinson, a black migrant driller who became the workers' "leader and voice," who "holds all their strength together: / To fight the companies to make somehow a future" (*OS* 16). His insider's description of Gauley Bridge contrasts ironically with the reporter's first impressions: "Gauley Bridge is a good town for Negroes, they let us stand around, they let us stand / around on the sidewalks if we're black or brown" (*OS* 21). His definition of a "good town for Negroes" indicates the degree of official harassment a black man might expect in such a segregated town, but his tone is more ironic than we first suppose, as his account of Union Carbide labor practices goes on to substantiate. Significantly, Robinson's testimony is written in the form of a blues poem. Of the many examples of "our buried poetry" (*LP* 98) that Rukeyser discusses in *The Life of Poetry*, she pays the greatest tribute to the blues.[15] As she writes of Bessie Smith, the pain expressed by so many blues singers corresponds with the treatment they receive by a social system quick to capitalize on their talent—on their labor—but slow to provide necessary support in time of need: "their powers realized, these singers in a moment are surrounded by the doorless walls of an ambivalent society" (*LP* 112). Robinson's blues testimony exposes how systematic such "ambivalence" is. He conveys every absurdly dehumanizing detail in an understated manner that indicts as it seems to so passively accept the pervasiveness of the "white dust." The end rhyming and repetition of key words and phrases reinforces this awful absurdity: "When the blast went off the boss would call out, Come let's go back, / when that heavy loaded blast went white, Come, let's go back . . . the camps and their groves were colored with the dust, / we cleaned our clothes in the groves, but we always had the dust" (*OS* 22). Robinson's blues concludes with an image of whiteness that is brutal in its parody of racial coding:

> As dark as I am, when I came out at morning after the tunnel at night,
> with a white man, nobody could have told which man was white.
> The dust had covered us both, and the dust was white. (*OS* 22)

The cost of such racial equality is of course the lives of both the black miner and the white miner. If, on the surface, both appear white in their shared experience as laborers, the lack of value ascribed to their lives by their employer suggests a commonality more often associated with black lives in the United States. The white appearance of the workers, the virtual erasure of blackness in the deadly silica dust, certainly speaks to the racial coding of the history of Gauley Bridge. Yet the commonality compelled by shared adversity also suggests a potential for interracial alliances to contest the white supremacist thinking that Robinson so bitterly mocks.

The dramatic monologue of Juanita Tinsley that immediately follows Robinson's blues reiterates the importance of song as a form of remembering:

> I know in America there are songs,
> forgetful ballads to be sung,
> but at home I see this wrong. (OS 23)

As "this wrong" is too brutal for "forgetful ballads to be sung," Tinsley refuses to forget: seeing "wrongly," bearing witness to what the corporate powers would prefer she forget, is a subtle act of resistance. Her opposition of "America" and "home," of the national and the local, is furthermore called into question by the chorus of voices the poem orchestrates. These voices coalesce around the figure of "white glass" that signifies the profits of Union Carbide and the deaths of its workers.

The whiteness of the glass becomes most prominent toward the conclusion of "The Book of the Dead," as the narrator journeys toward the sites of corporate and government power most invested in the hydroelectric project's development, from the silica storage and processing site of Alloy, to the power plant, to the dam, and then back to Congress. The view from these official sites contrasts dramatically with the testimony of those subject to the lethal power of "white glass." The angry testimony of a dying engineer who had worked the New Kanawha Power Company, Arthur Peyton, who notes "the white white hills standing upon Alloy," concludes with a crescendo of all consuming glass: "the long glass street . . . my face becoming glass . . . our street our river a deadly glass to hold . . . the stream of glass a stream of living fire." When removed from its site of production, translated into to its "crystalline" commercial form in "Alloy," the silica glass becomes noxiously mystifying in its whiteness: "a blinded field of white / murdering snow" (OS 28). This sublime vision is not only undercut by the reminder of lives lost in the process of production, "forced through this crucible," but also in the farther-reaching impact of the "dust that is blown from off the field of glass" (OS 29). If there is any doubt about the poem's implication of white supremacy with abusive labor practices, the description of the material site of "Power" makes this clear: "The power-house stands skin-white." And immediately after this, the poem returns to its opening statement: "this is the road to take when you think of your country, / between the dam and the furnace, terminal" (OS 29). As impressive an engineering accomplishment as the dam is, its awesome power cannot conceal the devastating social cost of its construction. While the dam harnesses the power of the "white" water of the river in springtime, this whiteness is conveyed as an "excess of white. / White brilliant function of the land's disease" (OS 31). This "scene of power," this "valley's work, the white, the shining" (OS 33), ultimately serves

the interests of Union Carbide stockholders, as the poem's subsequent quotation of the stock report suggests. At the same time, however, its "excess" also galvanizes the revolutionary social forces whose collective interests become visible on the page below the company's bottom line.

In returning to the site of national government—"power on a hill" (*OS* 34)—"The Book of the Dead" infers the sickness of the body politic from its neglect of those suffering from silicosis:

but always now the map and X-ray seem
resemblent pictures of one living breath
one country marked by error
and one air. (*OS* 35)

The Congressional inquiry into the power companies' financial culpability is blocked as the breathing of stricken miners is blocked. The words of the subcommittee investigating the silicosis deaths have little impact: these "Words on a monument. / Capitoline thunder . . . cannot be enough" (*OS* 37). In response to the futile words of this official monument, the poem counterposes its own monumental figure: "dead John Brown's body walking from a tunnel / to break the armored and concluded mind" (*OS* 37). Brown, the heroic figure whose "whole life becomes an image reaching backward and forward in history, illuminating all time" (*LP* 35), returns us to the poem's introductory survey of local West Virginia history, to the "granite SITE" of Brown's execution, but the history of this site has been rewritten. When the conclusion of "The Book of the Dead" reiterates the poem's opening refrain—"These roads will take you into your own country" (*OS* 37)—this refrain is also rewritten, insisting on the reader's active role as "witness" much more forcefully. "These roads" constructed for commerce, including the commerce of tourism, are also the roads traveled by anonymous migrant workers. "The Book of the Dead" assures that "your own country" can neither "forget" nor "keep silent" these workers' defiant narratives of countermemory.

Notes

1. Rukeyser defines the reader's role as that of "witness" in *The Life of Poetry*. She writes that this term "includes the act of seeing or knowing by personal experience, as well as the act of giving evidence" (175). Adapting Charles Sanders Peirce's triadic semiotic model (of sign, object, and interpretant) to the experience of poetry, Rukeyser argues that "witness" is preferable to "reader" or "audience" because its "overtone of responsibility" suggests a more dynamic relationship between poet, poem, and audience (174–75).

2. Like the state guidebooks published in the American Guide Series, the guidebooks to historic transcontinental roadways (*U.S. One, The Ocean Highway* and *The Oregon Trail*), provided mile-by-mile descriptive accounts of local sites, supplemented by quotes from earlier travelers' impressions of these roadways. The state and regional guidebooks were written to promote tourism, especially tourism in places that had been remote until the New Deal construction of highways provided easier access. While the initial impetus for the Guide Book series was as much promotional as documentary, the process of gathering and reporting information raised questions of representation that were inevitably political. The most detailed assessment of the American Guide Series is Penkower, 75–135. See also Mangione 349–66 and Stott 102–118.

3. See especially Kaladjian 160–75 and Davidson 140–49.

4. By "site of memory" I am referring to the concept formulated by historiographer Pierre Nora and applied in the multi-volume study of French history entitled *Les Lieux de Mémoire*. He explains the development of this concept in his introduction to the first volume of the English-language. His earlier definition of *les lieux de mémoire* is also related to a range of African American literary and cultural texts in the collection of essays edited by Geneviève Fabre and Robert O'Meally, *History & Memory in African-American Culture*.

5. For overviews of the critical reception of *U.S. 1,* see Kertesz 98–127 and Kaladjian 160–75.

6. "Grandeur and Misery of a Poster Girl" was the title of an unsigned review in *Partisan Review* 10 (Sept.-Oct. 1943), 471–73. This review became the subject of numerous letters, which the editors published under "The Rukeyser Imbroglio." See Kaladjian 161–62.

7. Rabinowitz cites Mike Gold's polemical writings during the early 1930s as the most prominent examples of such gendered discourse. See Chapter 2 in *Labor & Desire* (17–62) for a cogent overview of the gendered discourse of 1930s leftist literary criticism.

8. See Denning's chapter on migrant narratives in *The Cultural Front* (259–82), especially 263–64.

9. Barbara Foley discusses the Party's Popular Front approach to the "Negro question" in *Radical Representations* 187–93.

10. Foley cites a number of examples in addition to the Gastonia novels: see 193–202.

11. I would like to thank Craig Stormont for making me aware of this book.

12. Cherniack concludes, "[I]t is remarkable that an event so apparently rich in drama, moral significance, and popular attraction should leave no enduring imprint in popular culture" (87). The only fictional text that Cherniack cites is Hubert Skidmore's 1941 novel *Hawk's Nest* (88). The only song he discovered is a 1936 song, "Silicosis Is Killing Me," by the blues musician Josh White, singing under the pseudonym of Pinewood Tom (87).

13. Rukeyser discusses the "meeting-place" of poetry and science in *The Life of Poetry* 159–62.

14. As Denning points out, John Brown was one of the most important figures in American history for the Popular Front: "Whereas the official Americanisms of the Depression usually invoked the figure of Lincoln, the Popular Front was more likely to invoke John Brown" (131). Among the texts honoring Brown that Denning cites are W. E. B. Du Bois's 1935 biography, Mike Gold's *Battle Hymn,* and Jacob Lawrence's series of history paintings. Rukeyser celebrates Brown's example more extensively in "The Soul and Body of John Brown" (*CP* 243–47).

15. Rukeyser writes in *The Life of Poetry:* "On work gangs, prison gangs, in the nightclubs, on the ships and docks, our songs arise. From the Negroes of this country issue a wealth of poetry, buried in that it never touches its full audience; it touches few poets; but it passes, as song, into the common air at once, stirring forever those who hear blues and shouts, the dark poetry" (90). For her discussion of technical aspects of blues poetry, see *The Life of Poetry* 109–13.

Stephanie Hartman

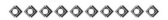

All Systems Go: Muriel Rukeyser's "The Book of the Dead" and the Reinvention of Modernist Poetics

In 1936 Muriel Rukeyser traveled to Gauley Bridge, West Virginia, to investigate an industrial disaster that left hundreds of miners dead and disabled from silicosis. Publications from the leftist *New Masses* to the mainstream *Newsweek* made the Gauley Bridge incident a national scandal (Rossner and Markowitz 96). Rukeyser's contribution was her great long poem, "The Book of the Dead," a formally experimental work that integrates legal, medical, and personal testimony with lyrical language. The poem seeks to go beyond direct reportage to witness the workers' suffering, and to convey, in strikingly inclusive terms, the broad significance of this event. Perhaps surprisingly, Rukeyser responds to this tragedy of the modern era—the Gauley Bridge event was the largest industrial disaster to date—with a fierce assertion of modernization's potential both to empower workers and to inspire a specifically modernist poetry. Rukeyser imagines modernist poetry as a productive, dynamic force capable of forging connections, connections that can rescue the casualties of Gauley Bridge from oblivion and charge the event with meaning.

Rukeyser argues in *The Life of Poetry* (1950) that the defining feature of modernism across disciplines is an emphasis on relationship. Citing Freud, Picasso, and Einstein as examples, she notes, "Joyce we recognize as working in the relationships of language, Marx in social relationship. . . . In our time, we have become used to an idea of history in which process and relationship are stressed." Her core example of relational thinking is scientific and uses the body as a figure for this revisionary understanding of the world:

> And I think of a scene at the Rockefeller Institute I saw: the rabbit, its great thrust and kick of muscular pride, as it was carried under the fluorescent lights, where against the colored unbroken skin glowed the induced cancers, fluorescing violet. A research doctor . . . told how the work he was doing in cancer had changed in its nature, in its meaning. His colleagues and himself were no longer looking at cancer as a fact, an isolated fact.
>
> They were taking another approach: they were dealing with cancer and the body on which it fed as one thing—an equilibrium which had been set up, in which the cancer fed on the host. One could not exist in this state without the other in that state. It was the relationship which was the illness. And he felt that these terms led to the right questions. (*LP* 12)

Rukeyser presents the doctor's systemic view of the body as a radically new approach. Although this is an organic image, it seems mediated as well by what Cecelia Tichi calls "the technology of interconnected component parts" (xi) characteristic of the modern era; the natural world, as well as the mechanical one, is seen to be composed of integrated components. This eerie scene conveys Rukeyser's excitement about the potential for such holistic thinking, as well as her wonder at the violet glow of the tumors visible through the skin of a live rabbit, still powerful and kicking. It also clarifies Rukeyser's effort to make the Gauley Bridge disaster visible (and, at times, even strangely beautiful) and to compel others to recognize it as an indicator of a larger social and economic imbalance.[1]

In Rukeyser's terms, "The Book of the Dead" is modernist because it understands and represents the Gauley Bridge incident as a problem of relationship. The cause of silicosis, after all, is not simply silica dust, but the abuse of modern industrial power: it is the result of the dynamic interactions between the individual worker and his environment, which Rukeyser elaborates with sometimes dizzying complexity. According to David Rossner and Gerald Markowitz, silicosis was inseparable from its roots in modernization, "in the changing production methods—automation, assembly lines, and modern notions of efficiency—that had produced the affluence that twentieth-century Americans had come to believe was their birthright" (7). The poem presents illness not as an "isolated fact," not as merely personal misfortune, but as a symptom of imbalance in America's process of modernization and as a sign of work to be done for the well-being of the nation. To look back to the passage on the rabbit's glowing cancer: examining illness can lead to what Rukeyser considers "the right questions."

The Gauley Bridge disaster was a particularly egregious case of the sacrifice of workers' welfare for corporate profit. The miners, while digging a tunnel to divert water to a hydroelectric power plant, came across large deposits of extraordinarily pure silica, a glasslike substance used to produce steel. The contractors, desiring to extract the valuable silica as quickly and cheaply as

possible, had the workers drill without safety precautions, and the silica dust settled in workers' lungs, causing silicosis. Because silicosis usually takes years or decades to develop, and because most of the miners were poor southern blacks, Union Carbide had assumed that they would not be held accountable for the resulting deaths. The disaster was only part of a widespread problem: as the poem bluntly cites, "Only eleven States have laws. / There are today one million potential victims. / 500,000 Americans have silicosis now. / These are the proportions of a war" (*OS* 34). Her far-ranging and eclectic poem uses elements of reportage similar to journalism and documentary film to establish the factuality and seriousness of the event. One section, "The Bill," intones the facts of the case, as if providing a transcript of the Congressional hearing:

> THAT a tunnel was drilled
> app. dist. 3.75 mis.
> to divert water (from New River)
> to hydroelectric plant (Gauley Junction)
>
> THAT in most of the tunnel, drilled rock contains
> 90—even 99—percent pure silica.
>
> This is a fact that was known.
>
> THAT silica is dangerous to lungs of human beings
> When submitted to contact. Silicosis. (*OS* 35)

The recommendation that the contracting firm be investigated and damages paid, follows; it is even signed by the subcommittee, the poem recreating the indentations of a business letter.

But Rukeyser does not limit herself to a factual, journalistic mode. Witnessing the event requires not only representing suffering—that which documentary fact cannot convey—but converting individual suffering into collective knowledge, and reaching beyond grim facts to imagine a conceivably better future. She adroitly turns from bureaucratic to lyrical language for the section's conclusion, invoking the kinds of energy that the poem seeks to draw from and to sustain:

> The subcommittee subcommits.
> Words on a monument.
> Capitoline thunder. It cannot be enough.
> The origin of storms is not in clouds,
> our lightning strikes when the earth rises,
> spillways free authentic power:

212 ◇ *Stephanie Hartman*

dead John Brown's body walking from a tunnel
to break the armored and concluded mind.[2] (*OS* 37)

Her change of register enables her to move from what is to what could be. Rukeyser locates "authentic power" in the collective action of the workers, whose stirrings she equates with an earthquake, rather than with official forms such as bills; in the terms of the passage, power emanates from "below" rather than from "above," in the stratosphere of the law. Populist power also seems to come from myth. The emergence of John Brown's body from the tunnel not only alludes to a folk chant but presents a body that rebels against the destruction of workers' bodies. This image of resurrection echoes throughout Rukeyser's poem.

"The Book of the Dead" is Rukeyser's attempt to help mobilize and release this suppressed power. At the same time that the poem points a finger at those who abuse power, it celebrates power itself—in effusive, rhapsodic descriptions of the surging river that is the origin of hydroelectric power, of the industrial plant that converts the power, and of the workers who liberate, monitor, and partake of this power. It may appear odd that a poem calling attention to needless deaths can take such a stance. In this poem, however, Rukeyser moves from the specific occasion of the worker's deaths to a broader interrogation of how modernization itself refigures the body and, through it, the self, in ways that may be empowering to workers as well as destructive. In the last century, Karl Marx deemed workers themselves to be created by modernity: "We know that to work well the new-fangled forces of society, they only want to be mastered by new-fangled men—and such are the working men. They are as much the invention of modern times as machinery itself" (qtd. in Klingender 131). Rukeyser similarly inquires into how the workers are "invented" by modernization, without limiting her scope to its destructive effects.

Focusing on relationship enables Rukeyser to examine the interface between the individual and the broader context of modern society—a project that also needs to be recognized as political work, even if (or especially if) it does not fit most conceptions of how modernist poetry can be political. Even as a boldly political modernist writer—a dual identity that has only recently come not to seem oxymoronic, thanks to the work of Cary Nelson, Walter Kalaidjian, Alan Filreis, and others—Rukeyser occupies a singular position. She was not alone in appropriating modernist forms for political ends, as such critics have made clear: Alan Wald, for example, establishes that many of the political poets of the thirties recognized their debt to modernism, noting that "the literary venture from the 1930s with the strongest impact, *Partisan Review*, achieved distinction largely through its willingness to openly ratify modernism as a movement for Marxists to study and from

which to learn new techniques"(15).[3] But while "The Book of the Dead" makes use of Marxist ideology, it hardly toes the party line: Kalaidjian's reading of the poem as a critique of capitalism, for example, insightfully describes how Rukeyser avoids universalizing leftist terms (165–75).[4] The modernist discourses of relativity, energy, and the machine are even more constitutive of her poem than any given political position, particularly because they offer Rukeyser models for rethinking how a poem can be kinetic in form and can participate in the generation and transmission of political and social power.

The first section of "The Book of the Dead," "The Road," claims the national significance of the Gauley Bridge disaster and its centrality to modern American identity. By making the small town, rather than a city such as New York, emblematic of modern America, Rukeyser shifts focus from modernity's towering achievements to its effects upon working-class people; she wants to explore not just its highlights, but the "whole picture." From the first line, "These are the roads you take when you think of your country," Rukeyser forthrightly sets readers within this terrain and implicates them in the events described. The roads transverse America, displacing the city—moving "Past your tall central city's influence" (*OS* 10)—in favor of a decentered, dispersed version of the country, in which the small rural town of Gauley Bridge is able to stand as a locus of modernization.

Rukeyser's exploration of the workers' silicosis makes vivid the impact of work upon the body. In the section "Mearl Blankenship," Rukeyser uses the X-ray to suggest likeness between the worker's body and the land, a likeness created by silicosis:

He stood against the rock
facing the river
grey river grey face
the rock mottled behind him
like X-ray plate enlarged
diffuse and stony
his face against the stone. (*OS* 18)

The passage compares Blankenship's face to both river and stone, and the mottled surface of the rock to an X-ray, to suggest how the worker takes on the characteristics of the earth through work. Most obviously, the worker is disempowered by inhaling the glassy silica: the image suggests that the dying Blankenship is becoming his own X-ray, becoming "grey," inertly "stony" and immobile. The human body in this image is eclipsed by its technological representation. In *Resisting Representation,* Elaine Scarry describes how

the body and work "leave a residue on one another and transfer parts of themselves back and forth" (57); the Gauley Bridge disaster is a particularly grim example of how the work of mining silica leaves a residue on—actually within—the body, for particles of silica became embedded in the lungs.

A later section, "Arthur Peyton," describes another worker's body in the act of assuming the characteristics of his materials, this time employing more explicitly technological imagery. The speaker, also a miner with silicosis, asks the woman he would have married to testify for him—"O love tell the committee that I know"—so that she can project his haunting, ghostly voice into the official avenues of the legal system. He describes himself and his world taken over by glass, in volatile images that suggest the speaker's faltering hold on language and on life:

> my death upon your lips
> my face becoming glass
> strong challenged time making me win immortal
> the love a mirror of our valley
> our street our river a deadly glass to hold.
> Now they are feeding me into a steel mill furnace
> O love the stream of glass a stream of living fire. (*OS* 28)

The section's glassy river and glassy shards of silica are both elements of power linked in the cycle of steel production. Peyton, after imagining himself turning into silica ("my face becoming glass") envisions his entire body fed into the furnace to produce steel. The section's first words—"Consumed. Eaten away" (*OS* 27)—take on new meaning: Peyton's body is used up like a natural resource. The speaker's image presents the laboring body as a consumable resource like the silica rather than as a ceaseless source of power like the flowing river. His illness signifies his reduction from active worker to raw material, from embodied person to sheer body—in a word, his dehumanization. For both Blankenship and Peyton, illness is represented in terms of immobility: Blankenship seems to fade into a mere image or X-ray of himself, and Peyton and his world turn to glass.

These workers' fatal engagement with the industry of steel production throws a cautionary note into the celebration of the machine that was just winding down in the thirties. The image of the machine eating Peyton alive deviates considerably from the general cheer and optimism over the machine prevalent up through the Great Depression, as evident in the 1913 Armory Show; the 1927 Machine Age Exhibit in New York, which "include[d] fantastic drawings of the city of the future, 'modernistic' skyscrapers, constructivists, robot costumes, theatre settings, and factories together with some excellent machines and photographs of machines" (Barr)[5]; and the 1934

Machine Art exhibition. Many artists were eager to claim that the machine revolutionized not only aesthetics, but conceptions of humanity. Vladimir Tatlin, zealous Constructivist originator (along with Alekandr Rodchenko) of the idea of the "artist engineer" or "mechanical hero" who wedded art and technology, saw all art that did not reflect and celebrate the mechanical as drearily humanist and passé: he believed "that a modern factory at work is the culminating manifestation of our times, surpassing the opera and the ballet; that a book by Albert Einstein is certainly more enthralling than any of Dostoevski's novels" (qtd. in Hulten 109). The idea of what might be considered art in the machine age became expanded and newly open to question. Rukeyser's meditations on the power plant, dam, and steel mill furnace need to be recognized within the context of the tremendous excitement about what progress might mean for America as well as the debates about what art's role in this new order would be.

The art critic Meyer Schapiro, reflecting upon the 1913 Armory Show, admits both sympathy and uneasiness with such adulation of the machine: while acknowledging the potential value of a utopian vision—"the art celebrates the beauty of machines and the norms of industry and science as a promise of ultimate harmony and well being"—he adds this warning note: "Yet it does this uncritically, almost childishly, without deep awareness, detaching the technical from the fuller context of subjection and suffering, and surrendering the spontaneity of the person for the sake of an impersonal outward strength that comes to look inhuman" (175). Schapiro suggests that this celebration of machine properties eclipses the human. To aestheticize the machine is to strip it of the larger context of production and ignore the human vulnerability that is obliterated by the steely display of "impersonal outward strength." Rukeyser makes a similar observation when she quotes Paul Rotha's indictment of films that aestheticize "the rhythms of a rotary press or the parade of a milk-bottling machine" without "realiz[ing] that these repetitive rhythms, beautiful to watch in themselves, raised important materialist issues of the men at the machine, of the social and economic problems lying behind modern machinery and transport (qtd. in *LP* 148–49).

Rukeyser sees film as a model for how montage can provide context and suggest relationships through juxtaposition; that is, how it can represent exactly that which is suppressed by aestheticizing and act as a reminder of people's fate during modernization. She also counters the focus on the isolated individual, which Schapiro notes as characteristic of the earlier modernist works displayed at the Armory Show, by using montage to put individual "portraits" such as those of Blankenship and Peyton into a larger context, indeed, into relationship: she presents the workers both as named individuals and as members of their class.[6] A description of a waterfall as a kind of film

screen later in her poem—"printed in silver, images of stone / walk on a screen of falling water / in film-silver" (*OS* 32), superimposes the river, her symbol of free-flowing power, with film, the art form most capable of representing motion and life.

Most poets, while intrigued by the question of what impact the machine might have upon humanity, did not share Rukeyser's interest in the machine's actual material effects; they preferred to idealize it, remaining on the level of fantasy and metaphor. In the popular imagination, the machine seemed to promise freedom from bodily limitations, as if the machine's smooth operation could somehow replace the body's more cantankerous functioning. The introduction to the 1930 collection *Songs of Science,* for example, presents poetry and science as yoked enterprises, progressing together step by step for the good of humanity: "The aim of this anthology has been to link the advance of Science with the rhythmic evolution of Beauty, and the revelation of Knowledge, which is permitting men to lift the veil between the concrete and the ideal, as it is expressed in terms of poetry,"[7] proclaims editor Virginia Shortridge (ix). Echoing this sentiment, one poem imagines that science will effectively remove the impediment of the body, "That the wings of / [One's] soul may / Have freer passage / To the realms of Beauty" (Brown 69). As was typical of the period, the collection tends to conflate technology and science, placing poems about factories and test tubes side by side. A rather tongue-in-cheek poem, "Machines—or Men?" envisions human life streamlined and fine-tuned for modern living, with "Men's souls like shining cars, smooth-running, bright." Technology and science here seem to bypass the body to act directly upon the "soul":

> Electric torches to illume dark moods,
> And radium to kill our secret cares,
> And burn out, slowly, selfishness and greed
> Dread cancers of the spirit . . . killing, too,
> Such vicious germs as loneliness and fear,
> So all men be serene and wise, like gods! (Hepburn 79)

The poem concludes that a self so thoroughly improved would be missing out on human experience, on the stuff of conventional poetry: "Can machinery / Share in the Spring, live through an April day?" (Hepburn 80). It asserts that what makes us human is exactly that which distinguishes us from machines, and implies that "progress" is irrelevant to poetry, which is innately connected to our apparently unchanging humanity. Rukeyser's desire to investigate how modernization might change humanity is fundamentally unlike this kind of opposition between man and machine, as the poem's title—ostensibly flirting with the idea of their proximity—suggests. Yet

Rukeyser also takes account of less benevolent effects, such as the fact that while radium may not kill "secret cares," it can still kill those who work with it. While overall the poems in *Songs of Science* do not address the context of actual relations between people and machines, they testify to the machine's grip on the imagination of the time and express the suspicion that life with machines is unlikely to be the same as before.

A strikingly graphic example of the ready exchange between human and mechanical elements—one more in line with Rukeyser's view—can be found in visual art. Raoul Haussman's 1920 photomontage "Tatlin at Home" uses montage to exchange human and machine characteristics. In this tribute to the Constructivist artist, Haussman shows the interior of Tatlin's head to be composed of pieces of steering wheel, brakes, and other machinery; conversely, he affixes some organic innards to the torso of a nearby dressmaker's dummy. Haussman's image of Taitlin's head literally filled with machine parts—Haussman recalls reasoning at the time, "This man ought to think in terms of large machinery" (qtd. in Hultin 111)—suggests, however jokingly, how work can remake the self (or, perhaps more accurately here, how self and work can create one another), and how permeable the boundaries between machine and man can be. This lack of separation between the natural and artificial leaves behind the pre-industrial suspicion of science and technology traced most famously in Leo Marx's *The Machine in the Garden*.[8] In Haussman's imagination, Tatlin "becomes" machinery much as Peyton turns into the glass he mines, and Blankenship the rock.

Translation into the materials of one's work, then, is not necessarily detrimental. The philosopher Alphonso Lingis, describing the novelist Yukio Mishima's tempering of his flesh by weight lifting, proposes that the phrase "man of steel" is a more than figurative description: "In the coupling of organism with steel . . . there was not competent intentional force shaping inert substance into implements, but a transference of properties. The properties that came to compose the excess musculature came from the steel and were its own properties" (82). He describes the body interiorizing steel's properties, becoming that with which it works. Lingis's example suggests that the body can take on the strengths of its tools as well as be disabled by them, and indeed Rukeyser goes on to imagine workers to be transformed by their labor in empowering as well as destructive ways, potentially benefiting from a "transference of properties," particularly the transference of energy.

Rukeyser is not deaf to the siren song of industrialization, but in praising the machine she avoids either claiming that its impact is entirely beneficial or erasing the human. In "Alloy," Rukeyser acknowledges the aesthetic appeal of the industrial landscape she finds at Gauley Bridge, but—much as

Schapiro cautions against not looking past the machine's beautiful form—
Rukeyser presents this allure as superficial, sinister, deceptive:

> This is the most audacious landscape. The gangster's
> stance with his gun smoking and out is not so
> vicious as this commercial field, its hill of glass.
>
> Sloping as gracefully as thighs, the foothills
> narrow to this, clouds over every town
> finally indicate the stored destruction. (*OS* 28)

The apparently beautiful hill is a mere glittering surface, hiding the lethal silica. Sexualizing the hill's curves converts the common image of the landscape as womanly body (virgin land awaiting the plow of enterprising men) into a "commercial" image; this land has already been opened up. The "hill of glass," sparkling with promise like a crystalline El Dorado, is converted into steel, a substance even more pure and hard, and just as inviting to aestheticize. To this process the workers are subjected—"Forced through this crucible, a million men"—as if they are transported by the overhead conveyor, instead of operating it. The line looks back to the arresting image of Peyton fed into a steel mill furnace. Again, the workers' bodies are consumed in the process of steel production like a raw resource, sharing the fate of the silica, sacrificed to make the invulnerable steel.

Rukeyser's focus on glass helps establish her poem as a comment on modernization as well as a specific response to Gauley Bridge. According to the art critic Robert Hughes, glass was the representative material of the modern city, a symbol of progress and purity: "The supreme Utopian material . . . was sheet glass. . . . It was the face of the Crystal, the Pure Prism. It meant lightness, transparency, structural daring" (175).[9] Glass represented what was most promising and attractive about industrialization. Rukeyser's description of the process of steel making, in which "electric furnaces produce this precious, this clean, / annealing the crystals, fusing at last alloys" (*OS* 28), echoes this fervor for the modern and "perfected." But Rukeyser counterbalances ardor for the beauty of glass and steel (expressed with greater latitude in the next section) with an awareness of how modernization can imperil the body: her glass is deadly.

The lyrical "Power" section begins on an unabashedly aestheticizing note; we soon learn, however, that the plant is built upon—and literally covers over—a darker, more complex version of "power." Rukeyser at first describes the power plant as a harmonious element of a beautiful natural landscape. She anthropomorphizes its graceful, even delicate form: "Steel-bright, light-pointed, the narrow-waisted towers / lift their protective network . . . / gym-

nast, they poise their freight" (*OS* 29). The towers—sleek, taut, "skin-white"—take on perfected human forms, even as the workers are physically broken by their labor. The section follows a vertical movement from the heights of the plant's towers to its depths, again suggesting that this beauty is superficial—or at least that it does not tell the whole story.

The section gains literary resonance as the speaker is taken on a tour deep into the plant by a Virgilian guide, "the engineer Jones, the blueprint man / loving the place he designed" (*OS* 29)—loving it so much that away from the plant he is "Adam unparidiz'd." His words present the plant not as a site of exploitation, but as the product of human vision and labor. As the comparison to Adam, the original name-giver, suggests, Jones is a sort of poet-engineer. In Jones's speech to the last bulb in the shaft—"'Hail, holy light, offspring of Heav'n first-born, / 'Or of th' Eternal Coeternal beam / 'May I express thee unblamed?'" (*OS* 30)—Rukeyser recasts Milton's apostrophe into a speaking situation that makes electricity "coeternal" with divine light, rather than its antithesis.[10] Her reference to *Paradise Lost* also invokes a poetic history of political protest in which Rukeyser claims Milton as a model.

On the way down into the center of the plant, Jones and the speaker encounter working men—"after the tall abstract, the ill, the unmasked men" (*OS* 30)—whose illness is a reminder of how the material can complicate the abstract beauty of the towers, and even Jones's idealism. The section ends at the bottom of the shaft, and on a perhaps surprisingly dire note: "this is the river Death, diversion of power, / the root of the tower and the tunnel's core, / this is the end" (*OS* 31). While the diversion of the river's force powers the plant, the "diversion" or misuse of political and economic power leads to the workers' deaths. If this river of Death is read as Lethe, the reference also suggests that the worker's deaths are due to a kind of forgetting that the poem's act of witnessing, and its drawing of lines of connection, seeks to counteract.

After this descent, the poem invokes a rebirth figured in both mythic and scientific terms: both offer figures of continuation and connection. "The Dam" voices the possibility that witnessing can again divert or transform power. While the "Power" section ends with the line "this is the end," "The Dam" begins, "All power is saved, having no end" (*OS* 31). The second law of thermodynamics, the law of the conservation of energy, is crucial to the poem's movement from charting the destruction of individual bodies to affirming workers' enduring power; Rukeyser's invocation of scientific laws extends to including the formula for the velocity of falling water within her text. Her expansive description of energy in this section envisions Gauley Bridge as a scene of rebirth and sets up an analogy between the conservation of energy and the mythic resurrection of the phoenix:

energy
total and open watercourse
praising the spillway, fiery glaze,
crackle of light, cleanest velocity
flooding, the moulded force.

> *I open out a way over the water*
> *I form a path between the Combatants:*
> *Grant that I sail down like a living bird,*
> *power over the fields and Pool of Fire.*
> *Phoenix, I sail over the phoenix world.* (OS 31)

The conservation of energy is seen as a source of positive transformation. The term "power" for Rukeyser is not synonymous with its abuse: it is a force of constant change that can be reclaimed for the worker's benefit.

Ultimately the river emerges as the main figure for the power of the working class that has been suppressed and usurped. It is opposed to the image of brittle glass, which Rukeyser associates with death and rigidity. In words that evoke class struggle, Rukeyser cajoles the river to rise again, to be reborn:

Effects of friction : to fight and pass again,
learning its power, conquering boundaries,
able to rise blind in revolts of tide,
broken and sacrificed to flow resumed.
Collecting eternally power. Spender of power,
torn, never can be killed, speeded in filaments,
million, its power can rest and rise forever,
wait and be flexible. Be born again. (OS 33)

Rukeyser's images of continuity—of endless flow, inexhaustible power, rebirth—are made to celebrate the durability and strength of the workers. She moves away from her emphasis on the individual ill body to celebrate the collective power of the working class, so that the deaths take their place within the context of a larger struggle, a fight that can be won; through the triumph of the collective, perhaps, the casualties can be reborn. She redeems the deaths of the workers by fitting them into a larger account of the inexhaustibility of power, energy, and motion. In this view, power clearly is not structured as a hierarchy that the unfortunate workers, trapped at the bottom of a class system, struggle to get out from under; rather, it is a continually flowing medium, like water or electricity, as "scarless" and indestructible as the workers' bodies are vulnerable.

Marshall Berman, in *All That Is Solid Melts Into Air* (1982), his celebration of the heady potential offered by the instability and fragmentation of

modern life, emphasizes the reciprocity between people and their world: "These world-historical processes have nourished an amazing variety of visions and ideas that aim to make men and women the subjects as well as the objects of modernization, to give them the power to change the world that is changing them" (16). Rukeyser's vision shares his optimism, ultimately emphasizing not the worker's disempowerment, but their agency. She puts workers on the vanguard of civilization. In the last section her description of the "frontier pushed back like river / controlled and dammed" (*OS* 38) equates the workers with American pioneers, both located on the ever-changing boundary of society, making raw nature useful.[11] She also imagines poetry as a potentially productive force in the world, and envisions witnessing as a method by which power can be channeled and extended outward to others.

In her description of people becoming glass and X-rays, Rukeyser shows that there can be altogether too much relationship between people and the forces of modernity, but this recognition of relationship also makes intervention possible. Her poem has the power to keep those who would be forgotten within public memory, and to suggest the connections that will make readers comprehend this event in the context of American history. The memory of the Gauley Bridge disaster is being recovered along with her work; so is her definition of modern poetry. Rukeyser's understanding of modernism in terms of relationship in *The Life of Poetry* attempted to wrest the definition of modern poetry back from the New Critics, with their emphasis on the poem as a free-standing artifact. In fact, "The Book of the Dead" shares its year of publication, 1938, with a New Critical classic: Cleanth Brooks and Robert Penn Warren's vastly influential *Understanding Poetry*. Perhaps, 60 years later, we are now better able to hear *her* definition of modernist poetry. In *The Life of Poetry,* Rukeyser cites Emerson's definition of language as "fossil poetry" to argue that the New Critics view poetry itself as if it were fossilized, rather than "living"—in effect, killing it. Her sprawling, brilliant "The Book of the Dead" actively resists such a process; it is committed to keeping both people and poetry—to be differentiated from X-rays and fossils—very much alive.

Notes

1. In *The Poetic Vision of Muriel Rukeyser,* Kertesz points out that in *U.S. 1,* the volume in which "The Book of the Dead" first appeared, Rukeyser extensively relies upon the ill body as a metaphor for social ills and characterizes human rigidity as itself a kind of illness, a blockage of life force. Kertesz also emphasizes the importance of relationship in this volume. The model of the body as a fluid, dynamic system is central to Rukeyser's work: she uses the

body as an analog for society, prizing the order not of hierarchy but of harmonious interaction and change.

2. Rukeyser argues in *The Life of Poetry* that poetry can create social change only indirectly, by changing people's minds: "Art is action, but it does not cause action: rather, it prepares us for thought" (24). To break the closures of the "armored and concluded mind" is the work of poetry.

3. Alan Filreis further chips away at the false opposition between high modernist and proletarian poetry: stressing instead shared philosophical struggle, Filreis cites Kenneth Burke's view of the thirties as "a period of stress that forced upon all of us [i.e., both "aesthetes" and communists] the need to decide exactly wherein the worth and efficacy of a literary work reside" (qtd. in Filreis 7).

4. Kalaidjian argues that the poem "embraced a revolutionary model of political identity." Rukeyser adopts a feminist poetics of specific critique, avoiding the universal subject of both bourgeois liberal humanism and of the Left (which imagines an archetypal male worker). Her violation of both models drew fire from both the high art establishment and Left political poets (165).

5. In his introduction, Alfred Barr cites the 1927 exhibition as the height of the romantic attitude toward the machine, an observation borne out by the catalogs of the two exhibitions: while the earlier exhibition is heavy on architecture, including a drawing of a glass skyscraper and photographs of power plants and factories, the latter focuses on dental instruments, petri dishes, drill presses, a vacuum cleaner, ashtrays—objects more quotidian than utopian.

6. To understand how Rukeyser uses montage to invite class analysis, it is useful to compare her method to Sergei Eisenstein's efforts to adapt D. W. Griffith's notion of film montage for political ends. In Deleuze's view, Griffith's elements existed side by side as "independent phenomena. Just like bacon, with its alternation of lean meat and fat, there are rich and poor, good and bad, Whites and Blacks, etc." Eisenstein added "a law of genesis, growth and development" to Griffith's idea of montage as an organic unity of juxtaposed parts. Eisenstein presented a more dynamic conception of the organic, seeing it as "a unity of production, a *cell* which produces its own parts by division, differentiation." His idea of the organic artwork parallels Rukeyser's desire to imagine poetry as a living form, as the title of *The Life of Poetry* suggests (Deleuze 32–33).

7. This is only one of many sources to present poetry and science as closely related projects. See, for example, Harry T. Moore's preface to *Proletarian Writers of the Thirties* (edited by David Madden) or I. A. Richards's *Science and Poetry*.

8. Marx describes the pendulum of pro- and anti-machine sentiment in his long chapter "The Machine" (145–226); the third section, on the machine's ability to fragment and alienate the worker, is particularly relevant to Rukeyser's poem (169–79).

9. Describing this fascination with glass, Hughes writes, "Its transparency associated it with Heaven and cosmic knowledge. . . . Like virtue itself, it was

pure, unyielding, readier to break than to bend. It was associated with the Holy Grail, with ice caves, mountain peaks, glaciers, and the shining ramparts of the New Jerusalem—the whole machinery of Romantic sublimity" (177–78).

10. Rukeyser's conflation of electrical and divine power revises Milton's "opposition of fire (associated with human technology) and sun (associated with the divine creation)," as Leo Marx notes. Marx adds that early nineteenth-century illustrations of *Paradise Lost* portrayed Hell as a factory and that "this tendency to identify Satan with industrialism is to be found in the poem itself" (*Pilot* 122, nt 22).

11. Anson Rabinback states that the first law of thermodynamics (discovered in 1847) framed the cosmos as a kind of ideal system of production: "The laboring body was thus interpreted as the site of convergence, or exchange, between nature and society—the medium through which the forces of nature are transformed into the forces that propel society" (2–3). Rukeyser echoes this view but emphasizes the potential value of workers for themselves, rather than seeing them as a mere "medium."

Stephanie Strickland

Striving All My Life

Maxwell said: There is no more powerful way
to introduce knowledge to the mind than . . . as many different
ways as we can, wrenching the mind

away
from the symbols to the objects and from the objects
back to the symbols.

Maxwell said: I have been striving all my life to be free
of the yoke of Cartesian co-ordinates. I found
such an instrument in

quaternions. Do I need *quaternions*
to talk about light?
Alas,

the square of quaternions
is negative. But Gibbs's vectors, uncouth
seemingly, work

well, in *any* dimension, with a very
great capability for
interpreting space relations.

Rukeyser said: Critical minds
that approach the world with love
have but one possible

defense—to build a system.
Raleigh said, I protest
the compression.

Gibbs: I myself concluded
that the paper was
too long.

Shoshana Wechsler

◇◇◇◇◇◇◇◇◇

A Ma(t)ter of Fact and Vision: The Objectivity Question and Muriel Rukeyser's "The Book of the Dead"

Muriel Rukeyser's pioneering politics and poetics, so clearly articulated even at the inception of her career, have placed her at the embattled center, and not the maverick margins, of American intellectual and literary discourse. This essay resituates her modernist documentary poem within the larger cultural vortex of the 1930s to demonstrate the profundity and continuing significance of her engagement—she who was so compelled by the dance between poetry and science—with the intellectual currents of her time. Rukeyser's unflinching grasp of the immediate manifests itself in a diagnostic largeness of vision that, in retrospect, seems to verge nearly on the prescient. "The Book of the Dead" testifies to a canny preoccupation with precisely those questions that have come to define the present contestation of objectivity, and with it the whole terrain of postmodernity. For if the thirties can be characterized by an objectivist sensibility—a collective infatuation with a whole spectrum of conflicting theories and practices, each claiming the mantle of "objectivity"—then Rukeyser's Depression-era polemic reveals her both as that decade's orthodox product and as its dissenting, holistic prophet, not unlike the remembering goddess Isis she unfurls at the poem's defiant end.

"The Book of the Dead" is a hybrid work—a 1938 *Time* review dismissed it as "part journalism, part lyricism, part Marxian mysticism" ("Rukeyser 2" 63)—that erases the boundaries between art and document, lyric and epic, pen and camera, naming and heroizing the exploited and forgotten in an extended and self-reflexive act of witness. As a documentary

text that cross-examines documentary conventions, it invites close comparison with James Agee's *Let Us Now Praise Famous Men;* like John Dos Passos's *U.S.A.* trilogy, it utilizes modernist technique to compel attention to the world beyond representation. Because it also exhibits many of the earmarks of a long modernist poem "including history," it arguably merits inclusion in the same canon occupied by Ezra Pound's Jefferson and Adams *Cantos* (to which it offers a striking counter-model), and William Carlos Williams's *Paterson* (which it anticipates by just a few years). Written while the the Great Depression deepened in the United States and fascism raged across Europe, the poem signals decisive moments both in American documentary expression and in late modernism, as new and remaining adherents of avant-garde aesthetics revived and revised modernist methods in order to convey the complexities of escalating economic and political crises.

In this latter sense Rukeyser's documentary collage poem can be placed alongside the work of the Objectivist poets who adapted the literary materialism of Pound and Williams to historical-materialist perspectives. To read "The Book of the Dead" as a uniquely inflected instance of modernist objectivism is, of course, to stress affinities (especially with Charles Reznikoff's *Testimony*) over very real differences between them. But the strong correspondences—Louis Zukofsky's manifesto-like formulation of the poem as lens and Rukeyser's minute and probing enactment of it; a common emphasis on the scienticity of poetry, on the concreteness of its materials, and, ultimately, on the status of signs as facts—have much to tell us about the exigencies of post-Imagist poetics, as well as the shared atmosphere of imperatives and restraints in which these poets wrote. Zukofsky's insistence in his 1931 Objectivist program that writing should result from "the detail, not mirage, of seeing, of thinking with the things as they exist," is a deceptively realist rationale for the urgent dismantling of existing representational models. For writers starting out in the thirties, it was impossible to resist the "strong association between the visual and the factual" (Daston and Galison 84) that ran rampant through the culture at large. Rukeyser makes these the central terms of "The Book of the Dead" to enable acts of cognitive will and aesthetic resistance, taking full measure—by way of an allegorized account of the Hawk's Nest disaster—of the catastrophe that was modernity.

A recent visitor to Hawk's Nest notes that the sole commemoration of the tragedy is "a road sign that praises technology without mentioning history." The lethal tunnel whose construction cost 700 lives is now "deep underground and filled with water . . . a hidden artifact that [can] only be imagined" (Cherniack 110). This statement, made by a specialist in occupational medicine, foregrounds the very issues Rukeyser confronted in her earlier narration. For scientific observer as for poet, what is of importance is the overriding fact, and fate, of invisibility: the invisibility of occupational disease and

its ravages, the social invisibility of a mostly black, marginalized labor force that has led to their brutal exploitation and death, as well as their erasure from historical memory. The submerged tunnel neatly lends itself as a perfect objective correlative for Union Carbide's corporate obfuscation. But it can also be profitably linked, in a larger, systemic sense, to reification, the making invisible of human labor (and human experience) in the commodities it produces. To imagine the "hidden artifact"—to render it visible—is in the thirties to aspire to the making of a wholly accurate picture or factual record, which is precisely what Rukeyser attempts in her epic reconstruction, casting her act of *poesis* as a kind of empirically driven de-reification. This "Objectivist" turn, a common direction of left-wing thirties modernists, is always committed, however variably expressed, to a revisionary reformulation of the object as dynamic process or *event:* the submerged artifact as human tragedy, redeemed from historical obscurity to the detailed, scientific clarity of sight.

Media coverage of the Hawk's Nest outrage either tended to be floridly inaccurate, as in the labor tabloids or, as during the brief flurry of mainstream attention to the 1936 congressional inquest, terse and dismissive: *The New York Times,* for one, concluded that the charges against Union Carbide were simply "too harrowing for face value" (Cherniak 84). Rukeyser and a woman photographer friend travelled to West Virginia to examine records and interview the surviving miners and their families. This imperative to eyewitness—to recover "face value"—is enshrined both ethically and epistemologically in the resultant poem. Because the ultimate challenge in any presentation of testimonial evidence is to produce an image of truth, Rukeyser's compositional method places formal emphasis, not surprisingly, on *phanopoeia,* Pound's Imagist term for pictorial representation in words. Her pictured fidelity to surfaces, however, simultaneously authorizes and undermines the quest for an exact, authoritative image that inevitably motivates Pound's or any other objective approach. Rukeyser is equally inspired and restrained by a sense—as Shoshana Felman terms it, glossing Camus— of *"referential debt,* of 'constant obligation' to the 'woes of history,' and to its dead" (115). A deeply felt obligation to history has contributed heavily to obstinate, lifelong literary and political iconoclasm.

As her poem emphasizes, what occurred at Hawk's Nest was inseparable from its representations. The prominence Rukeyser assigns to the struggle for the image, figured as an embattled "field of glass," derives from what she deemed the central paradox of the Union Carbide disaster: that the damage done by the mining of silica ore could not have been exposed without silicon-based photomechanical technology and the representational fields it supports. As her research made clear, the first local lawsuits in 1933–34 brought by dying workers asking for compensation were sites of heated con-

testation of medical evidence. Interpretive disputes over the reading of X-rays, those objective images of lung tissue that could establish the fact of silicosis and hence the validity of legal remedy, lay at the very heart of the forensic debates. In spite of initial hermeneutic conflicts, however, X-ray photographs did eventually emerge as the final arbiters of proof. This was not only a symbolic victory for the working class (for the Hawk's Nest workers it was never anything more than that), but particularly for science and its images, whose transparency of meaning "The Book of the Dead" celebrates: "but always now the map and X-ray seem / resemblent pictures of one living breath / one country marked by error / and one air" (*OS* 35). Scientific, which is also to say Imagist accuracy of representation signified by the "map and X-ray," becomes here a crucial means for social rectification.

In *Willard Gibbs,* Rukeyser's 1942 biography of the physicist who discovered the law of thermodynamics, she explains:

> When one is a woman, when one is writing poems, when one is drawn through a passion to know people today and the web in which they, suffering, find themselves, to learn the people, to dissect the web, one deals with the processes themselves. To know the processes and the machines of process: plane and dynamo, gun and dam. (12)

How nonchalant is her insistence that a woman who writes to "dissect the web" of suffering must "know" the gunmetal and mortar of objective reality. But just as noteworthy as this transgressive rewriting of gender is Rukeyser's identification of the hard products of technology—"plane and dynamo, gun and dam"—with the fluid complexity of process, rather than progress. Hers is a dialectical awareness that couples technology with desire as well as destruction, that stresses the tranformational possibilities inherent in change. In *The Life of Poetry,* the major prose exposition of her poetics, "process" and "relations" circulate (along with the verbs "exchange" and "witness") as virtually synonymous key terms in her critical lexicon. She quotes the nineteenth-century phenomenalist Henri Poincaré as follows:

> External objects . . . are not only groups of sensations, but groups cemented by a constant bond. It is this bond, and this bond alone, which is the object in itself, and this bond is a relation.
>
> Therefore, when we ask what is the objective value of science, that does not mean: Does science teach us the true nature of things? but it means: Does it teach us the true relations of things? (qtd. in *LP* 165)

Rukeyser's scientism very much resembles Pound's in its emphasis on relation, energy, and the new. It is a science not of axioms and demonstration,

but of experimentation and discovery. There is "a constant," she wrote in "Poetry and the Unverifiable Fact," that is "neglected, often despised—which is the unknown, which is a constant in science, as it is in art and the uncertain" (qtd. in Kertesz 300). For Rukeyser, poetry shares with science a heightened quality of vision: the imaginative capacity to recognize knowledge as process, and reciprocity and relationship as fundamental principles of being. They each demonstrate the capability to reinscribe open-endedness over the fatal telos of instrumentality.

The 63-page "Book of the Dead" results from Rukeyser's grand ambition to craft "a summary poem" of the life of a place neither regional nor national, created by the dense convergence of "theories, systems and workmen" (*U.S. 1* 146). At its start she invokes the figure of photography, with "case" and "discovery" giving a decidedly evidentiary cast to an overt emphasis on the instrumentality and technics of seeing: "Now the photographer unpacks camera and case, / surveying the deep country, follows discovery / viewing on groundglass an inverted image" (*OS* 10). The deliberate stress throughout on discovery, mapping, measuring and photography decidedly connects her text to a wider documentary culture committed to the parsing and preservation of observable reality, and to the collection and disclosure of social facts. But Rukeyser's inventive documentary poem sets out to record an intentionally "inverted image" in order to right the wrongs of a world turned upside down. "Poetry," she declares in an afterword to *U.S. 1,* "can extend the document" (146).

The amassing in the 1930s of a huge inventory of data and images was, as one historian has put it, "the most overwhelming effort ever attempted to document in art, reportage, social science, and history the life and values of the American people."[1] The encyclopedic file of poignant rural photographs assembled by the Farm Security Administration and the investigative polls of Gallup's American Institute of Public Opinion, founded in 1935 to gather "empirical" evidence of public attitudes (Susman, "The Thirties" 190), are two particularly telling expressions of a beseiged present struggling to represent, and thus rationalize, itself. "You men of fact," the narrator of "The Book of the Dead" facetiously requests, "measure our times again" (*OS* 39). Alfred Kazin dismissed the mass "retreat into the solid comfort of descriptive facts" as a failure of the collective imagination, a delusory "reserve against bad times" (489). Wallace Stevens, however, was vastly more forgiving. War and the Depression, he wrote in 1936, had inevitably moved everyone "in the direction of fact," and "[i]n the presence of extraordinary actuality, consciousness [necessarily] takes the place of the imagination" (qtd. in Stott 119).

Hunger for credible knowledge of the real coexisted in the thirties with widespread doubt and skepticism. And it was precisely when uncertainty

was epidemic and distrust of received wisdom had reached its peak that the standard of "objectivity" emerged (Schudson 121–59). In the midst of perceived unreality, the appeal of the objectively "real" became so great that even the words "document" and "documentary" took on auratic authority (Stott 138). Few at the time were willing or able to acknowledge, with Kenneth Burke, the unstable mixture of "scientific and fictive qualities" that actually distinguishes—note here Burke's dissenting use of definite article and quotation marks—"the 'document'" (xii).

It is not unusual to find imitations of public documents in the realist novels of the 1930s, especially the proletarian. Those writers who had absorbed the lessons of modernism, however, were committed to utilizing the real thing. Rukeyser's heavy appropriation of actual documentary material in "The Book of the Dead" underscores its "scientific" aspects equally with the "fictive," a double move consistent with objectivist formal strategy. The "facts" that Rukeyser marshals—letters, stock market quotations, interview transcripts, trial transcripts, and congressional reports—provide authenticating detail for her case against economic exploitation, as does this direct quotation of Congressional hearing testimony:

> If the men had worn masks, their use would have involved
> time every hour to wash the sponge at mouth.
> Tunnel, 3⅛ miles long. Much larger than
> the Holland Tunnel, or Pittsburgh's Liberty Tubes.
> Total cost, say, $16,000,000. (*OS* 16)

As "things" or poetic structures, however, these same documents are denaturalized and rematerialized, and they are displayed—as if under glass—as the peculiar or pathetic "excrescences" of public and institutional discourse.[2] Within the space of the poem, documents are proffered as specimens of language meant to be *seen* rather than recognized, to demonstrate that all linguistic *poesis*—a capability signified in the above citation by "mouth," "tubes," and "say"—is of material origin and consequence. As Rukeyser flatly states in a companion poem in *U. S. 1*, "The poem is the fact" (*OS* 46).[3]

Given Rukeyser's radical democratic politics, it is curious how much like Pound's is her approach to documentary materials. "These she uses with something of the skill employed by [him]," Williams commented favorably in his review of *U.S. 1:* "She understands what words are for and how important it is not to twist them in order to make 'poetry' of them" (141). Of course, it was Pound's incorporation of documentary citations in the Malatesta Cantos of the twenties, and the Adams and Dynastic Cantos of the thirties, that set the literary precedent for Rukeyser's own. "I have set down part of / the Evidence" (XLVI: 234) Pound triumphantly

announced in the anti-usury Canto he wrote in the same year Rukeyser's poem made its way into print. Their respective motives, although ideologically divergent, are not entirely dissimilar; both are primarily committed to producing "new effects that resist those of mechanical schemes of production" (Wacker 89). As Richard Sieburth has pointed out, Poundian poetic strategy shifts "the emphasis from language as a means of representation to language as the very object of representation. To quote thus is to adduce words as facts, as exhibits, as documents, to lift them out of context, to isolate them, to make them self-evident" (121). The same shift (toward the materialization of language) occurs in "The Book of the Dead," but without the same derealizing effect produced by the *Cantos.* Pound's kaleidoscopic historical fragments are in marked contrast to the large evidentiary blocks with which Rukeyser builds her far more accessible and plainspoken case against capitalism.

Words spoken to Rukeyser by a mother recalling her dying son take poignant shape as lyrical ballad lines: "'Mother, when I die, / 'I want you to have them open me up and / 'see if that dust killed me" (*OS* 19). Once textualized, however, they are also amplified and restored to public significance. Assuming the factive weight, even the monumentality of public documents, they become both monument and literary remains. The meaning "discovered" by "The Book of the Dead" is as literal and immanent as it is—or so the allegorical title would suggest—transcendent: it lies in the material embodiment of words once spoken by the buried dead at Gauley Bridge. As material text, the poem offers itself both as their discovering and as their living testament.

Rukeyser's frequent presentation of found material without markers to distinguish it from her own language effects a prematurely postmodern conflation of the literary with the non-literary, a tactical move that did not necessarily endear her to literary fellow travelers. A *New Masses* review pronounced the poem "a triumph for the whole left movement" but nonetheless objected to the "assimilation of factual material," whose "internal rhythms conflict with the more rapid and pulse-like beat of poetry" (23). Rukeyser's poem, in fact, is most effective in its conveyance of the sprung rhythms of common speech and courtroom talk. Note the momentum, the preservation of dialogic give and take, the stolid squareness and ironic consolation of medical testimony ("there, there") as a forensic expert points to his X-rays:

And now, this year—short breathing, solid scars
even over the ribs, thick on both sides.
Blood vessels shut. Model conglomeration.

What stage?

Third stage. Each time I place my pencil point:
There and there and there, there, there. (*OS* 21)

Proponents of literary orthodoxy failed to understand that the issues this
raises point precisely to the "unmade boundaries of acts and poems" (*OS* 38)
that extend far beyond the narrow province of formalism. Rukeyser's "as-
similation of factual material into the body of the poem" actively protests the
distinction between poetry and public discourse, and by extension between
poetry and history, the writing of public events. To foreground the textual-
ity of public documents is to reveal the textual nature of history *as* historical
record; it is, moreover, to politicize the struggle for the sign. By construct-
ing a narrative of events as told by its participants, Rukeyser also returns the
documentary project of history to the original Greek meaning of *historia*, or
systematic, personal inquiry. When, in the poem's more allegorical and
imagistic sections, she records her own first-hand observation of the fatal
landscape, she instructs us in the vision of radical subjectivity that enables
the construction of a narrative about objective forces for change.

By unveiling the visual realm as source and proof of all knowledge,
Rukeyser's exploration of documentary poetics marks yet another kind of re-
turn to fundamentals. Enclosing evidence within a narrative that dramatizes
the phenomenology of social optics and acts of observation, the poet restores
it to its originary sense—its derivation from the Latin *videre,* the verb "to
see." Her modernist ocularcentrism, neatly encapsulated in an image of
Hawk's Nest as "a nation's scene and halfway house" (*OS* 37), is offset, how-
ever, by a revisionary linkage of acts of observation with acts of listening:
"Carry abroad the urgent need, the scene, / to photograph and to extend the
voice." And although her poem enthusiastically tropes the camera lens and
the photo-mechanically produced image, both still and moving, as templates
for the poetic image, it also utilizes these "hypericons"[4] to destabilize the
documentary gaze, and by extension, any allegedly socially neutral act of ob-
jective representation. "Defense is sight," the poet proclaims: "widen the lens
and see" (*OS* 40).

The twenty titled sections of the poem are intercut in a sharp unfolding
of dramatically juxtaposed scenes. Subversive historical topography soon
gives way to the spare acoustics of institutional space, carved from the testi-
mony of social worker Philippa Allen before a Congressional committee.
Her pledge to deliver "a general history of / this condition" (*OS* 13) is suc-
ceeded by a visual inventory of Gauley Bridge's main street, heavily littered
with local varieties of glassiness: "camera eye," "night eyes," "plateglass,"
"camera-glass," "beerglass" (*OS* 13–14). Allen's "general history" will take
the form of an instructive lesson on the dual nature of late capitalist eco-
nomics, one that supplements the traditional Marxist view of the use and

exchange values of the commodity—signified here by "glassy" silica ore—with a prescient emphasis on its imagistic, or spectacular, value. This value is directly embodied by a camera, not a mere recording device but an active dramatic agent that literally initiates the new section. Its appearance immediately establishes a framing effect that renders the scene a mise-en-scène. The ocular focus is particularly striking after the speech intimacy of the Congressional hearing:

> Camera at the crossing sees the city
> a street of wooden walls and empty windows
> and the doors shut handless in the empty street,
> and the deserted Negro standing on the corner. (*OS* 13)

Attention is then rapidly directed to a running boy who "blurs the camera-glass fixed on the street"—a "fixed" camera that parallels the road mended by a government crew. We observe next a hotel-owner "keeping his books behind the public glass" (*OS* 13) and a whole series of sad Hopperesque tableaux, all cast in the glare of windows and glass, as the sound of coughing brings the first intimation of silica dust:

> Postoffice window, a hive of private boxes,
> the hand of the man who withdraws, the woman who reaches
> her hand
> and the tall coughing man stamping an envelope. (*OS* 14)

Nearly 20 references to "glass" or to "eyes" coexist in the space of only 40 lines. The condensation of visual effect is so strong that it maintains a charged resonance through the rest of the poem, in which the visual tropes are obsessively revisited, albeit with less frequency. The camera topos in "Gauley Bridge" not only elaborates on Philippa Allen's testimony about the digging of silica ore, but it magnifies the themes of historical tourism, representation, and the camera obscura—the "inverted image" viewed on "groundglass" (*OS* 10)—that were evoked early on in "The Road." The camera obscura is, of course, a classic Marxist figuration of ideology in which material conditions, and their social truth, appear upside down. Subsequent references to the photographic lens will identify it (conversely, but in the same spirit) as a privileged site of true or objective vision that reverses the false consciousness arising from the "phantom objectivity" (to apply Lukacs's term) of capitalist social relations.

What distinguishes "The Book of the Dead" as a quintessentially thirties text is the coexistence within it of an essentially empiricist paradigm of objective vision with a conflicting model that complicates traditional unitary

perspectives. As we have seen, Rukeyser frames the mechanics of observer and observed within an enacted dynamics of polyperspectival vision. Although a camera does the viewing, the reader witnesses its act of observation. Doubling the lines of sight establishes an implicit textual association between writing and photo-graphy; a photograph must be read as well as viewed, just as the reader in this instance must view the camera and "read" its action. The reader is thus made witness to the production of the image, just as the ideal "reader as witness" whom Rukeyser invokes in *The Life of Poetry* necessarily participates in the production of (the meaning of) the poem. Moreover, the hermeneutic role of reader/witness suggests a phenomenalist account of vision by casting "objective" observation as a condition of pure relation, hence disrupting the mechanical, and potentially tyrannical, relationship between the camera lens and what it frames. But Rukeyser has it unambiguously both ways by simultaneously working the camera metaphor in a more strictly empirical sense as well. It is, after all, the assumed mechanical objectivity of the camera, with its impartial revelation of local detail, that ultimately guarantees the accuracy and, more important still, the *universality* of the portrait of Gauley Bridge that would persuade us that "any town looks like this one-street town" (*OS* 14). It is the alleged objectivity of the visual report that authorizes the narrator's insolent challenge to potentially disappointed seekers of the picturesque: "What do you want—a cliff over a city? / A foreland, sloped to sea and overgrown with roses? / These people live here" (*OS* 14). As these lines of verse doubtless demonstrate, the epistemological sight lines, and their ethical consequences, are complicated indeed.

The morally superior apostrophe to sightseer, and reader, reminds us that what is at stake is the actual use made of the camera's objective vision. This stance recalls that of John Dewey, who argued in 1930 in *Human Nature and Conduct* that "morality resides not in perception of fact, but in the use made of its perception" (298; qtd. in Blau 350). What Dewey called his "experimental method of morality" is rooted in empiricism, rather than abstract morality. One always begins from the simple fact that, as Rukeyser would say, "these people live here." Impetus to moral action first arises from accurate observation of particular situations in their full complexity and then leads to experimental verification of any hypotheses that might result. Dewey equates this process with the workings of democracy, which stresses, in his words, "regard for others" (another nod to ethical seeing, and to the centrality of vision to ethics) and the "scientific inquiry into facts" (Blau 350–51). Rukeyser's triadic scene does indeed appear to suggest identical pragmatic necessities.

By positioning a camera in the center of Gauley Bridge's main street and counterpositioning a pair of eyes to stare back at it—"the eyes of the Negro, looking down the track, / hotel-man and hotel, cafeteria, camera" (*OS* 14)—

Rukeyser issues a standard Popular Front endorsement of the social benefits of documentary photography, a genre virtually institutionalized by the New Deal. But she also signals with great economy the difficulty of "the effort," as James Agee puts it, "to perceive *simply* the cruel radiance of what is" (11) (emphasis added). After a decade's accumulation of documentary work, too much of it self-serving or exploitative, poverty and catastrophe had become a spectacle—instead of a visible reality—for the middle- and upper-class documentary audience. This required the invention of far more self-conscious formal structures that would neither objectify nor spectacularize those who were represented. Like Agee, who also fervently believed the camera "incapable of recording anything but absolute, dry truth" (234), Rukeyser self-consciously confronted the challenge to circumvent the potential passivity of any writing done under the sign of the camera.

The reader-witness instructed in the ethics of spectatorship in "Gauley Bridge" is allowed no more comfort than that which the poet herself feels. "The Face of the Dam: Vivian Jones" is a case in point. This is a lyrical recasting of the story from the point of view of a railroad man who transported silica ore from the mines. Once again we encounter incantatory repetitions of "glass"—"hundreds breathed value, filled their lungs full of glass / (O the gay wind the clouds the many men)"—but they are served up this time with a seething poetic diction that blatantly satirizes another recent account of the technological sublime. ("O proud O white O water rolling down" (*OS* 15) effectively conjures Hart Crane, even if it does him serious injustice.) The artificial diction turns democratically on its own maker, as well, by calling attention to the section's literary preciosity. But when Vivian Jones's improbably mannered speech yields at last to the neutral language of federal investigation in "Praise of the Committee," the flat exposition is in turn undercut by an emotional, paranoically charged lyric that conveys an accusatory gaze: "In this man's face / family leans out from two worlds of graves—/ here is a room of eyes, / a single force looks out, reading our life." The relentless seesawing of sound and image, and contradictory linguistic textures and tonalities, keeps our eyes sharply focused on—and pays a referential debt to—the extratextual referents who, "reading our life," demand the payment of an explanation: "Who runs through electric wires? / Who speaks down every road? / Their hands touched mastery; now they / demand an answer" (*OS* 17).

The demand for accountability echoes through the dramatic monologues spoken by Mearl Blankenship, George Robinson, Juanita Tinsley, Arthur Peyton, and others. And answer is given in the deadly, luminous details of the Gauley Bridge environs, categorized simply as "the most audacious landscape. The gangster's / stance with his gun smoking and out is not so / vicious as this commercial field, its hill of glass" (*OS* 28). The exploration of

the "commercial field," which is also nightmarishly glimpsed as a "[c]rys-
talline hill: a blinded field of white / murdering snow, seamed by convergent
tracks" (*OS* 28), now becomes strikingly cinematic. Folk ballad-like
lament—"nobody could have told which man was / white. / The dust had
covered us both, and the dust was white" (*OS* 22)—is juxtaposed against
searing, allegorized pastoral images that fuse into a powerful testamentary
protest against the horrors of misused technology. Under the revelatory light
of day, deadly tunnel dust is "crystallized and beyond the fierce corrosion"
and fallen like a "disintegrated angel on these hills" (*OS* 29). The white dust
as "disintegrated angel" creates much the same effect as Paul Strand's beau-
tifully ravaged shots of drought-fissured earth in Pare Lorenz's pioneering
documentary, *The Plow That Broke the Plains.* These are what Donald Wes-
ling, writing about Wordsworth's *Prelude,* would call "images of exposure" or
examples of "tutorial by landscape" (37). At once beautiful and threateningly
sublime, they strip down complex situations to their dialectical essentials. If
we consider the double sense of "exposure" as a kind of fatal openness to ex-
perience, and as the accumulated effect of the action of light on photosensi-
tive material, we begin to get a sense of why this narrative poem so fully
embraces photographic art, and the film documentary in particular, as its
structural model.

In an epiphanic celebration of photographic technology, Rukeyser en-
dows the watery landscape of "The Dam" with the subliming qualities of a
print in its bath of developing fluid: "Blessing of this innumerable silver, /
printed in silver, images of stone / walk on a screen of falling water / in film-
silver in continual change" (*OS* 32). Her discussion in *The Life of Poetry* on
the parallel problems of continuity in poetry and film, and her astute com-
ments on film and still photography in general, indicate an intense interest
in all aspects of photographic image production (18–19, 137–155). But it is
important to stress that her fascination with the cinematic image is funda-
mentally inseparable from her sympathy with the social agenda of docu-
mentary and other cinema. Moviegoing is a communual rite for
"reconciliation with each other" (148). If Rukeyser adapts film methodology
to the printed page it is to effect a homeopathic cure for the damage done
by technology and modernization.

In *The Life of Poetry* she approvingly quotes documentary filmmaker and
film historian Paul Rotha, in *Documentary Film,* on the fatal blind spot of
modernist filmmaking: "'They shot, these aesthetes, the rhythms of a rotary-
press or the parade of a milk-bottling machine and rested content with the
visual effects of movement. They did not . . . realize that these repetitive
rhythms . . . raised important materialist issues . . .'" (148–49). Hence the
importance of a dialectically driven editing style in which image sequences,
or "constellations" as Rukeyser calls them, "are thrown *into relation* with

each other" (emphasis added), and the "single image, which arrives with its own speed, takes its place in a sequence which reinforces that image" (143). But Rukeyser's law of "reinforcement" is a bit unusual: to be "reinforced" is to be "made to change and grow because of what has gone before" (19). Here we find traces of a whole modernist tradition of image play—Gertrude Stein's "repetition with a difference," Sergei Eisenstein's theory of intellectual film montage, and the ideogrammic method that Pound explicated in his essays of the thirties. The Poundian poem "including history" was to be ideogrammically constructed from those "luminous details" or evidence that, as Pound claimed in his essay "I Gather the Limbs of Osiris," gave "sudden insight into circumjacent conditions, into their causes, their effects, into sequence, and law" (*Selected Prose* 22). Rukeyser, who had internalized the Imagist imperative to show the sudden flare of things in relation, and who had magnified its strategies through the lens of left-wing cinema, was clearly working a parallel vein. In the course of an extended poetic sequence, she learned to keep an image both "kinetic and controlled," as she described water coursing through the Gauley Bridge dam. The ultimate example of this dynamic imagism is the recurrent, overdetermined trope of "glass" that carries the entire conceptual weight of "The Book of the Dead," amassing new semiotic reference with each successive appearance. Herein lies the genius of silica as metaphor (and of Pound's insistence on the natural object as adequate symbol): a steadily branching (some would say totalizing) accumulation of semantic, and socioeconomic, connections.

Rukeyser's glass may enable us to see our way through to postmodern political critique, but it is most definitely molded by classically modernist paradigms of certainty, transparency (because nothing is hidden and everything is exposed), and organic unity so clearly expressed in these messianic comments on film editing: "This gathering-together of elements so that they move together according to a newly visible system . . . may lead to a way to deal with any unity which depends on many elements, all inter-dependent" (*LP* 19). Her vision in "The Book of the Dead" is simultaneously empirical and vatic; she is a seer who opens her lens onto a spiritual landscape, taking up the camera as a mystic instrument of revelation "to waken our eyes." Like the miner's mother in "Absalom" who is determined to wake the dead and "give a mouth to [her] son" (*OS* 20), Rukeyser summons the Egyptian goddess Isis to gather up the pieces of those broken apart in the Hawk's Nest Tunnel. After the perfunctory voices of professional objectivity, and the monotonous restraint of a mother's litany of physical suffering, comes her sudden, exultant outbreak:

> *I open out a way, they have covered my sky with crystal*
> *I come forth by day, I am born a second time,*

I force a way through, and I know the gate
I shall journey over the earth among the living. (*OS* 20)

The Egyptian mythology of the scattered Osiris echoes modernist mythologies of fragmentation and transcendence, but here they take on a specifically feminine and revolutionary register. It is a triumphant goddess Isis who is speaking here, urging the dead to arise and transform themselves.[5] The supernatural aria that forces a way through the world-englobing "crystal" marks the final transformation of the trope of glass, a rendering of glass *as* transformation, like the "radiant gist" in Williams's *Paterson:* a breaking open of the world to utopian and feminine possibility.

To achieve this transformation requires a radical inversion of the image on the "groundglass" so that the seer is no longer the photographer, but rather the subject of the photograph. The undoing of the conventional hierarchy inscribed within the documentary gaze, or of the power dynamics between observer and observed frozen within the patriarchal models of science, is enabled solely by empathic identification with the Other. Writing appreciatively about the photographs of Berenice Abbott, Rukeyser praises them as "pictures of things seen with such concentration that they can be called 'science' pictures," pictures that reflect a "vision of a world in which all things look at us, declaring themselves with a power we recognize" ("Forward," *Berenice Abbot* 10, 11). Rukeyser proposes a vision of science entirely compatible with the feminist critique undertaken in the 1970s, and in particular with Evelyn Fox Keller's theory of "dynamic objectivity." This is "a pursuit of knowledge that makes use of subjective experience," Keller has explained. "The scientist employs a form of attention to the natural world that is like one's ideal attention to the human world: it is a form of love" (117). Rukeyser would no doubt vigorously agree that by allowing things the opportunity to declare themselves to us, we undo the binary between love and power. Hence the final stanza of "The Book of the Dead" that stakes ecstatic claim, in the name of discovery, to "this our region": "[D]esire, field, beginning. Name and road / communication to these many men, / as epilogue, seeds of unending love" (*OS* 40).

The modernist "poem as fact" that aspires to photographic accuracy of representation and sight has arrived, finally, at a space of Emersonian insight. As Rukeyser writes in *The Life of Poetry:* "Behind us overhang the projections of giantism, the inflated powers over all things, according to which nature became some colony of imperial and scientific man, and Fact and Logic his throne and sceptre. He forgot that that sceptre and that throne were signs. Fact is a symbol, Logic is a symbol: they are symbols of the real" (177). To "extend the document" is to imagine a Real unassailable by coercive social or scientific logic, beyond the stretch of the visible, behind the

record of fact. If the goddess sings her crystal-shattering song it is because the signifying glass, however accurate or hyper-real, must at last be broken. She writes poems not to preserve an image of life, but to transform it.

Notes

1. Susman, "The Thirties" 189. See also his "Culture and Commitment"; and Levine.
2. The word belongs to John Wheelwright, who complained in *Partisan Review* that the poem "attacks the excrescences of capitalism, not the system's inner nature" (55).
3. A "factist," according to the *O.E.D.*, is an obsolete term for a poet or dramatist.
4. "Hypericon" is W. J. T. Mitchell's useful term for such double images as Rukeyser's "groundglass," Plato's cave, or Wittgenstein's hieroglyphic. These are "figures of figuration," or "pictures that reflect on the nature of images." See Mitchell 5–6, 158.
5. The ancient instructional manual for the dead that Rukeyser uses as source material includes the following topics: "*of not becoming unseen* . . . of making the body to germinate, and of satisfying it with the water of heaven" (emphasis added). See E. A. Wallis Budge, trans., *The Egyptian Book of the Dead* (New York: Dover, 1967), xliv.

Michele Ware

"An Identity Seemed to Leap Out Before Me": Muriel Rukeyser's The Traces of Thomas Hariot

In the enigmatic and mysterious figure of Thomas Hariot converge many of Muriel Rukeyser's career-long preoccupations: her insistence on the unity at the heart of human experience, her fascination with recovering aspects of history that have been lost or denied, her desire to speak for those who have been silenced, her celebration of the heroic, her yearning for connection to both the past and the future; and her daring use of her art to forge that connection. Thomas Hariot, a sixteenth-century mathematician and astronomer, a tutor and friend of Walter Ralegh, wrote the first account in English of the New World, *A briefe and true report of the new found land of Virginia* (1588). A poet and a scientist, Hariot embodied an ideal that Rukeyser describes in *The Life of Poetry*—"the rare union between poetry and science," a quality that would place Hariot "in a line of heroes of that meeting-place" (160). Yet he remains a shadow, largely unknown, a man who emerges from the political, scientific, and religious turmoil of Elizabethan England in bits and pieces only. Spurred by her curiosity and the mystery of Hariot's relative disappearance from history, Rukeyser began sifting through the clues of his writings, the references to him by others, and the turbulent history of which he was a part. Her biography of Hariot is a record of that digressive and eclectic search, an exploration of what she called the "traces" Hariot left behind, culminating in her vision "of a lost man who was great" (*The Traces of Thomas Hariot* 3).

The Traces of Thomas Hariot is more than an unveiling of a forgotten life, however. In this difficult and unusual book, Rukeyser presents her theory of biography, transforming our notion of what biography should or can be. Here she confirms and completes her experimentation with biography begun in 1942 with *Willard Gibbs*. References to her method are scattered throughout the text, signposts along the way to guide the reader from one point in time to another and to remind the reader of Rukeyser's underlying epistemological assumptions. Early in the text, she articulates a division of human knowledge that her work on Hariot resists: "The idea of history as memory was mapped by Francis Bacon, who divided the country of knowledge into poetry, history, and philosophy, these being ruled by three powers, three faculties which are the imagination, memory, and understanding" (61). Rukeyser's theory of biography fuses these divisions; she calls upon imagination, memory, and understanding to solve the puzzle of Thomas Hariot, recreating a life in a hybrid form that includes poetry, history, and philosophy. Rukeyser insists, however, that her biography is not the last word. She acknowledges that in recreating any life, in writing any biography, the work is never complete, for there is always more to discover and know: "The search for the traces of Thomas Hariot has led to answers, to questions, to a further sight of his life so fine in its structure, in the language of what it says to our time, that I take it as far as I can among the obliterations, and let it go for others to take further" (12). *The Traces of Thomas Hariot* is a starting point and an invitation, the unfinished collage of Rukeyser's search for a way to redefine and reinvigorate biography.

The initial difficulty for readers of Rukeyser's biography of Hariot is her immediate and obvious refusal to do what is expected in writing a biography, that is, to be linear, rational, and authoritative. *The Traces of Thomas Hariot* is a very messy book. And, as Louise Kertesz points out in *The Poetic Vision of Muriel Rukeyser,* much of the disorder of the book is not attributable to Rukeyser's methodology:

> One wonders why there are so many typographical errors in such a beautifully produced book. Why do footnotes not always satisfactorily indicate the source of material used? What is the logic of an index which omits the titles of important books mentioned in the text while listing other books? There are blocks of untranslated Latin. . . . Rukeyser explains that Random House was very careless with the book because they didn't like it. They remaindered it soon after publication. (349–50)

The problems of preparing this unexpected book for publication were compounded by the publisher's loss of the manuscript and the accompanying illustrations, a crisis that Rukeyser mentions only briefly in her account of the

process of bringing *The Traces of Thomas Hariot* to print (*TTH* 315). Once these irritating errors, exclusions, and omissions are set aside, however, the difficulties of Rukeyser's hybrid formal creation generate their own confusion for the reader. "We are given great clusters of vibrant detail" (Kertesz 350), but no instructions about what to do with them. The narrative point of view shifts without warning or explanation from third to first person.[1] Rukeyser provides few, if any, transitional elements between the clusters of detail. She leaps backward and forward through time, decades and even centuries, again without warning or explanation. And she ranges widely in her research, from the barrier islands of North Carolina to the Tower of London, from the poetry of Sir Philip Sidney to the dreams of Descartes.

The text, however, is not formless. Trying to explain her formal considerations in poetry, Rukeyser mused in an interview about "[t]he structure of a life being an art form" (Packard 170). She resists the biographer's presumption in imposing a shape on a life, particularly one such as Hariot's, about which so little was known. Her recurring frustration at the fragmentary nature of her knowledge of Hariot is palpable throughout the book, but so is her excitement in watching his life take shape beneath her pen:

> Indeed, if one searches the past for him, the search will lead to fiery details, a stroke here and then an airy space, another stroke of what is now called fact, and then something obliterated, drowned, burned, lost. And then another stroke, until an entire structure of a life begins to rise, brilliant, with long reaches, venturesome, airy, full of risk, moving in a way that speaks to us in our century. (4)

Because so many facts about Hariot have been lost, Rukeyser trains her focus on the periphery, the "web of lives" (5) in which he moved, scanning a broad horizon—of scientific discovery, political intrigue, exploration, and art—for traces that, taken together, amount to a more complete and satisfying portrait of this enigma. It is a strenuous enterprise for her readers to follow these traces and recognize the significance of the connections Rukeyser draws. We have to run just to keep up. Like her poetry, her prose is subversive in terms of form—and unsettling. Yet in "The Education of a Poet," Rukeyser makes a characteristically blunt case for such formal experimentation: "[T]he idea that form has to be the forms of the past is nonsense" (*RR* 285).

Two distinct structural elements emerge out of the seemingly chaotic mass of information accumulated in Rukeyser's search for Thomas Hariot—a journey of discovery and a collage. The journey and the collage reflect her subject, of course, but also her method. And she invites her readers to participate with her in making both.[2] The controlling metaphors in this text are the "traces" of the title, which she defines at length in an epigraph, and "patterans," which is,

she explains, "that word used by the travelling people for the signs which tell where they have been and in what direction they are moving" (54). Patteran, a variant of the Romany "patrin," according to the *O.E.D.,* refers to handfuls of leaves or grass thrown down by Gypsies to mark their path for others to follow. In the process of Rukeyser's wandering investigation into this "buried life," (87) the vestiges of Thomas Hariot's existence are the patterans that Rukeyser reads and follows. She records her circuitous journey, tracing Hariot back to England from the Outer Banks, tracking down every reference, every suggestion of Hariot's presence. As she moves, she collects the evidence she will use to divine her subject. Increasing and extending the traces of Thomas Hariot, Rukeyser's text becomes a journey for her readers, and those "great clusters of vibrant detail" are the patterans we must use to guide us. Indeed, she labels the two central sections of the biography "The Patteran Part One" and "The Patteran Part Two," directing us first away from Hariot's 1585 expedition to Virginia, back in time to his birth in 1560, and then forward through the swift and steady descent, after 1603, of Hariot's friend and patron, Sir Walter Ralegh. From these littered, meandering, and decaying paths of discovery, the materials that Rukeyser has amassed and that we, too, have gathered become a collage—colorful scraps of a life, of many lives touching, textures of dreams and poems and ideas, overlapping, partly obscured, pasted on the background of an astonishing and dangerous age—creating a portrait of a man who can be, according to Rukeyser, "a real and possible strength to our time" (4).

While there are numerous examples of this digressive technique, one particular path vividly illustrates Rukeyser's methodology. The 1596 edition of George Chapman's translation of Homer, which spurred John Keats to write his sonnet over 200 years later, includes a dedicatory poem to Thomas Hariot. Keats's poetic response to Chapman, Rukeyser argues, "is a celebration of discovery" in which the poet links astronomy ("some watcher of the skies") and exploration ("stout Cortez"), aligning himself with both (145). At this point, Rukeyser makes a characteristic leap, suggesting that the sestet of "On First Looking into Chapman's Homer" refers not to the discoverer Cortez (or Balboa), but to Thomas Hariot:

> [B]ut the curious thing is that in English history it is Hariot, and only Hariot, who combines in his one life the experience of astronomer and American explorer, although it is a necessary stroke of the poet to use the name "Cortez" instead of the other and the discovery of the next ocean instead of any other. The sky, the ocean—they are right. (145)

She has no proof for such an interpretation, which she freely admits: "It is certainly not possible to assert that this conscious opening for Keats is related to the Chapman dedication. . . . It is not even possible to say that Keats

read this poem; nor to find Hariot emerging from a poem on discovery" (146). Having said this, however, Rukeyser then proceeds to draw these very conclusions, not asserting, perhaps, or saying with substantiated authority, but suggesting persuasively that such a connection (a line of communication from Hariot to Chapman to Keats and finally to Rukeyser) may be true. For in his sonnet, Keats (like Hariot) expresses that "rare union" so important to Rukeyser: "Keats binds the kinds of discovery—the inward crisis of finding in poetry, and the explorer's seeing of new sky and new ocean—in the same way that he binds beauty and truth (or poetry and science) in the binding that is his strength" (145–46). In Rukeyser's tracing of Hariot's influence through the centuries, imagination and scholarly inquiry combine in conjecture that is more than invention and as plausible as any unknowable truth. "Let us believe," she urges her readers, and we believe (106). Toward the end of the biography, after many such leaps, Rukeyser records a couplet from Hariot's papers that reflects the intuitive trust she expects her readers to share with her: "The truth when it is seen / is knowne without other evidence" (268). She accumulates as much evidence as possible, but gaps are inevitable in such a scattered historical record. Rukeyser recognizes that many of the connections she envisions cannot be substantiated by fact alone, and she makes such uncertainty a part of the journey.

An important task for Rukeyser in this biography is to reveal Hariot's impressive scientific contributions in astronomy, optics, navigation, natural history, and mathematics.[3] In an age of revolutionary scientific discovery, his is a "threshold life, whose marks and traces hide curiously" (4). To get closer to Hariot, she researches the work of scientists who were his contemporaries—Tycho Brahe, Johannes Kepler, Galileo Galilei—and finds connections. When she discovers notes in Hariot's papers about Kepler, she speculates about the source and quality of Hariot's telescopes. Did he correspond with Kepler? With Galileo? Rukeyser cannot answer these questions with any certainty, and she must rely again on conjecture, the suggestion of a link that rings true.

From the earliest reviews of her first books of poetry, critics have noted Rukeyser's attraction to the world of science. Adrienne Rich points out that the title of *Theory of Flight* "suggests how early she embraced the realm of the technological and scientific imagination" (*RR* xii). Rukeyser's inclusive vision refuses to separate the various facets of human imagination. As David Barber notes in his analysis of *Willard Gibbs,* "central to her poetic aesthetic is the belief that poetry and science are equally valid ways of seeing the world, both needing the other in order to attain their greatest force" (2). Indeed, Rukeyser's poetry and prose reclaim and reinvigorate both the artistic and the scientific imagination. "The union," she claims in *The Life of Poetry,* "is true" (161). Rukeyser's understanding of scientific achievement resembles her theory of biography—each

discovery provides a foundation for future discoveries; the work of the scientific imagination is never complete. Yet Hariot's place in the chain of scientific discovery, Rukeyser fears, will be lost. In order to reestablish his presence, she relates, among other achievements, evidence that Thomas Hariot's methodical close-packing of bullets, experiments he conducted in 1591, contributed to later developments in crystallography and atomic theory (117–21). Rukeyser sets out to demonstrate that although Hariot is not as celebrated or well known as Galileo or Kepler, the significance of his wide-ranging experimentation aligns him with the great scientific minds of his age.

Establishing the relationships between seemingly disparate figures from the world of science—indeed from any discipline—confirms Rukeyser's assertion of historic continuity, her "attempt to sort out the past which lives in the present" (220). When she studies Hariot's extraordinarily precise and accurate drawing of the moon, for example, she turns necessarily to the scientific exploration of her own time. Writing in 1969, the summer of the first manned flight to the moon, contemplating "the white intact" and "untouched" moon of the past (219), Rukeyser ponders the violation:

> These years, men without the qualities of Hariot—who is to us a hero of the counter-culture—have gone to the moon and reported bareness in a time of the clash of dead wars to which are sent our young. But the young are dreaming, this summer, of a moon as fertile and unbegun and to be lived out as Hariot's Virginia. (231)

In this meditation, the powerful possibility in the dreams of the young seems to restore Rukeyser's faith for the future, not only in exploring the unknown, but also in the hope that some few may possess the qualities of Hariot. His drawing of the moon, juxtaposed in the illustrations of the text with a contemporary photograph of the moon's surface, generates a stunning moment of recognition for Rukeyser. Staring at this map of the moon placed alongside "another map with which Hariot is identified, the map of Virginia" (223), she experiences a visionary perception of the man she has been searching for:

> Suddenly something jumps out of the maps, with that startling abrupt movement by which I recognize the authentic, a movement that is no movement at all, like the famous moment in Zen doctrine when the snow is let fall from the branches of trees. An identity seemed to leap out before me from the maps. (224)

The artifacts of the past—scientific or otherwise—speak to us in the present and shape our understanding. Here they create a life.

But history (like scientific discovery, like biography) is always incomplete: "There is also, in any history, the buried, the wasted, and the lost" (*LP* 85). Rukeyser's biography is an act of reclamation, of directing her readers to these buried or forgotten artifacts in an attempt to remedy a loss that threatens to distort the historic record. Such a distortion, what Barber identifies in *Willard Gibbs* as a "willful burial" (12), blinds us in terms of our full knowledge of what has informed and shaped (and continues to inform and shape) American history and culture.[4] "The facts of the past," Rukeyser insists, "are the facts of the present, with the past acknowledged and alive" (62). Rukeyser's life and work represent a persistent challenge to her readers to resist forgetting. One of the most poignant moments in this biography serves as a rationale for her exhaustive search:

> I think of what happens as one stands on Roanoke where Hariot's house was, the fort and the village, where now there is a Hariot Trail, edged with all the New World plants he describes in his Brief and True Report. "Hariot?" they say. "Nobody knows who he is. Well, one or two do." (15)

Geoffrey Wolff writes of *The Traces of Thomas Hariot* as "a book of great learning and loving patience" (103). Rukeyser ensures that those who have the stamina and the courage to explore her massive experimental undertaking will not forget.

The philosophical underpinnings of Rukeyser's multidisciplinary explorations stem from a number of sources, but perhaps the most pervasive are the ideas of Francis Bacon and Giordano Bruno.[5] Bacon's activities in the midst of considerable political maneuvering during the reigns of Elizabeth I and James I and his knowledge and admiration of Hariot would warrant his presence in this biography, but equally important to Rukeyser's subject and method is Bacon's advocacy of empiricism. She draws our attention to the frontispiece of Bacon's *Novum Organum* as an emblem for venturing into the unknown: "[T]he picture of a ship sailing through the Pillars of Hercules into an endless ocean of newness, the bunt of whose sails shows the strength of a following wind, speaks for the opening-out of thought and reach" (7). Bacon's empirical method of inquiry, in which one observes the world, collects facts, and draws conclusions, is Rukeyser's method. And although she doesn't endorse his division of knowledge, she admires the range and scope of his thinking.

Giordano Bruno, before his trial and execution at the hands of the Inquisition in 1600, traveled in London and, like Bacon, moved within the web of lives that touched Thomas Hariot's. He appears as "a hero" in Rukeyser's first book of poems (Kertesz 264), and he serves as a kind of tutelary deity for much of the poet's work. Rukeyser was drawn to Bruno's be-

lief in the unity of all things: "His concern is with the theory of change and transformation, and the function of opposites in making a new unity" (74). In the same way that she reclaims Hariot's scientific place in history, she establishes Bruno as anticipating Hegel's philosophy, and she finds confirmation of her own embrace of the creative energy at the heart of opposition: "He adored the contraries. He acknowledged them fully, he was the contraries" (74). Rukeyser, too, adores the contraries, and her enduring work of synthesis is *The Life of Poetry,* in which she resists classification and erases the boundaries between the worlds of knowledge. It is not surprising, then, that the lives of those who proclaim the unity at the heart of human experience are the lives that fascinate and guide her. The Elizabethan era marks a watershed of achievement in which the disciplinary divisions that Rukeyser abhors seem nonexistent. Exploration and discovery operate equally in all ways of knowing, in the life of the mind and in the life of action, according to Rukeyser, and "Hariot is the pilgrim of the joined life" (268).[6]

Thomas Hariot's achievements represent for Rukeyser the confluence of Bacon's empirical method and Bruno's philosophy of unity. One trace, a diagram and three words, collected in her search through Hariot's scientific papers, reveals Hariot's essential understanding and embrace of the contraries. At the bottom of a page, Hariot has written "non est" and "est," separated by space, over which there is a "line drawn through the points over *to be* and *not to be*" (237). Most significant, however, for Rukeyser, is the point Hariot has drawn in the center of the line, over emptiness, so significant that she has reproduced the diagram at two different places in the text, and its initial presence marks the end of the second patteran, an end point in our journey. She explains: "This age thought in terms of opposites—as did the ancients, as do we. The banner of this thought was 'To be or not to be'" (237). Hariot's drawing reflects his denial of such opposition, a way of thinking, Rukeyser posits, "as we might think of life, in the potential best of our time. To be *and* not to be, with life at the center" (238). The diagram "is so strong a statement that it may be taken as the emblem of his lifework" (237), and it leads Rukeyser down additional paths of inquiry. She links Hariot's est and non est to Descartes' revelatory dream, "the turning-point in Descartes' life" (276). Descartes encounters in his dream a man who gives him a poem by Ausonius, "*beginning with the words* Est et Non" (279). Rukeyser collects the established interpretations of Descartes' dream, but she also follows her own inclinations, searching through the Eclogues of Ausonius and finding the two poems that reverberate in the dream. Her conclusion places Hariot (and Rukeyser herself) in a separate, defiant philosophical tradition:

The choice is within the two poems, and Descartes chose duality, the split of mind and matter, setting his will on the path before him and letting go the

world of *Est* and *Non*, which he saw as *Est* or *Non*, to be *or* not to be, as it has been seen by the entire stream of influential imagining men and women identified with the main and general stream of acceptance. There is, of course, another stream, going through Empedocles, Heraclitus, Bruno, Hariot, the recurring imaging work for the unifying process that sees *Est* and *Non est*, joins them, sees the point around which they turn, and lives, in history and imagination, from that pivotal place. (281)

Hariot's lifework is revolutionary in many ways; he resisted convention, strove for synthesis, and constantly worked in spite of disappointments and setbacks, not for personal glory but simply for the increase of knowledge, the joy of discovery. In assessing Hariot's contribution to the future, Rukeyser turns again to Bacon, who describes the questing spirit of discovery as the source of enlightenment and the individual who acquires and disseminates such new knowledge as "'the benefactor indeed of the human race—the propagator of man's empire over the universe, the champion of liberty, the conqueror and subduer of necessities'" (227). Weaving together the threads of what can be known about Hariot, observing and gathering clues from history, philosophy, science, and poetry for this biography, and presenting her knowledge to the world, Rukeyser also participates in that "unifying process" of enlightenment.

Rukeyser spent much of her career celebrating the heroism of others, those whose actions and ideas have become "emblems of the brave, full life which denies or simplifies no part of the human journey and which, beaten down or blocked, transforms itself into new modes" (Kertesz 349). "Lives," a sequence of poems spread across several volumes of poetry, for example, is a chronicle of courage, of optimism in the face of defeat.[7] Thomas Hariot's is such a life, and his heroic constancy speaks volumes to Rukeyser. For all the triumphant recreation of achievement, a powerful undercurrent of loss flows beneath the surface of this biography. That Hariot published his account of exploration to Virginia at all is something of a miracle. After spending the better part of a year observing, gathering seeds and plant specimens, drawing and writing, Hariot was forced to witness his instruments and books thrown overboard by frightened sailors in a storm that threatened to capsize their small boat. He worked from memory to recover his chronicle of the New World: "Hariot is sailing away from a world—a world of ideas—with the task of summoning up that world in himself and making it coherent" (62). Other losses resonate through the text: Bruno brought before the Inquisition and burned for heresy; Ralegh tried and condemned, imprisoned in the Tower of London, and finally beheaded; Hariot's final, painful cancer of the face and jaw; Northumberland's monument to Hariot destroyed in the Great Fire of London; traces of Hariot disappearing and obliterated. In

spite of what Kertesz calls "a climate of rapacity and violence" (357), Hariot continued his experiments, writing and thinking, observing and measuring the movements of planets. He attended and assisted Ralegh in the Tower as he wrote his *History of the World.* "At the Tower," Rukeyser writes, "they will show you the place on the wall where Hariot built a sun-dial for the long slow time of blood" (13). His fortitude and drive to continue his work impress the diligent, striving artist at work in Rukeyser, the woman who is able to sustain a life's work and vision in the face of her own disappointments and setbacks.

Two potential losses also surface here that have echoes in Rukeyser's poetry. In "The Gates," she writes of a fear she shares with a dissident poet imprisoned in South Korea, "fear that the world will not allow your work" (*RR* 262). And in "Desdichada" she speaks for those who have been forgotten, "the anonymous unacknowledged men and women" (*RR* 248). Rukeyser articulates Hariot's similar possible fate early in her biography: "Not condemned, except to be lost" (5). Hariot defies the first potential loss (public resistance to his work) through his steadfast devotion to science and poetry. And Rukeyser herself defies the second. The beauty and grace of Hariot's imagination survive in the expanded edition of *A briefe and true report,* in the Hariot Trail on the Outer Banks, in his poem "Three Sea Marriages," which Rukeyser transcribes in her text, and in Rukeyser's exhaustive work of recovery. Perceiving the accumulated body of his lifework, she identifies Hariot specifically as Bacon's enlightened and enlightening discoverer, "the hero as subduer of necessity" (227). Because it gave him the power "to change the world and the body of man in its possibilities" (15), Hariot's heroism is a potent example and guide, for Rukeyser and for the future.

At the end of this journey of discovery, the unfinished collage of Hariot's life is all we have to discern the man. Rukeyser includes in the illustrations the only existing portrait of Thomas Hariot, and she describes the painting in some detail, particularly the "penetrating clear gaze out of blue-grey eyes." She is drawn to those eyes: "the observing, noticing quality in them is very strong" (167). But she warns us of the painting's questionable authenticity, the possible Dutch origin and the evidence of later corrections and additions: "The question of the portrait is like many others in this history, mysterious, equivocal, capable of at least two interpretations, and of extreme interest taken together with the other live and mysteriously moving pieces of this evidence. It is possible to swim among many unknowns" (168). Perhaps it is Hariot, perhaps not.

His writing reveals some of his qualities. From *A briefe and true report* we know that he admired and respected the indigenous people he encountered. His thoughtful and precise observations demonstrate his attention to detail and his patience. His participation in the expedition reflects his sense of ad-

venture, in thinking and in action. He was loyal to his patron and friend when such loyalty might have been a dangerous liability. And his papers, full of coded language, ciphers, and anagrams, suggest a love of play and puzzles. By transcribing "Three Sea Marriages," Rukeyser invites the reader to discover the man in his poetry; she even asks the conventional questions: "What does the poem declare of Hariot's emotional thinking? Of his experience, outward lifetime experience or inner concentration?" But an essential part of this work is the lesson it offers in reading, and she quickly steers us away from convention: "One cannot derive the biographical in factual statement from any poem; but one can say what absorbed and evoked the life of these fusions in the poet." She chastens us to avoid the artificial divisions of inner and outer life, "[a]ll the splinters of the kind of thinking that the most whole of the Elizabethans have shown us we never need accept" (258). Rukeyser challenges the arrogant assumption of biographical authority, even her own, and she urges her readers to participate imaginatively and intuitively in the creation of this life. Hariot is less of an enigma than when we began the journey, but we still "swim among many unknowns." "And where is Hariot?" Rukeyser asks near the end of the biography. "He is here, he is everywhere, standing at the ends of all corridors, waiting to be found" (316). He has been recovered by her work, but only in part, for her discoveries are only a beginning.

Rukeyser's biographical experimentation persistently defies the expectations of her readers. Perhaps the most compelling and surprising aspect of her theory of biography is her modest but forthright assertion of the need for collaboration in intellectual exploration. She refers frequently in the text to those whose explorations will add to and extend her own. In *A briefe and true report* Hariot mentions a longer chronicle he plans to write. For Rukeyser, this is an invitation to future scholars: "The chronicle was inexplicably lost, has never been mentioned in writing, and has not yet been found. That is one of the first steps of the hunting still to be done by those who go on where this work leaves off" (105). Her final acknowledgment is "To those unknown to me who will go on with the discoveries" (323). Such a vision of scholarly collaboration and fellowship is rare indeed. Equally rare is her candid revelation of the frustrations she faced in the process of writing Hariot's life: "He fades in and out many times. Often it is a torment to go any further. This is too uncertain. Where are the astronomers, the navigation people, the mathematicians of infinity?" (315). It is hard to imagine biographers Kenneth Silverman or R. W. B. Lewis, for example, making such a naked admission of self-doubt. When Rukeyser's publishers lose the manuscript and illustrations, she faces "[t]he desolation," linking this setback to "Hariot's long story of delay and failure" (315), and finding in his example the courage to continue.

Along with her fears and disappointments, Rukeyser's humor and sense of play surface in her account. When a notice arrives from The Thomas Hariot Seminar in England, she has an instant, funny, and irreverent flash of perception of the gathering of academics: "At Oxford, at that moment, they were meeting. In a panelled room? In their sweaters?" (315). This kind of honesty may be unsettling to those expecting a traditional biography. But Rukeyser's defiance of tradition is refreshing and stimulating, pulling the reader in as a trusted and valuable colleague. She draws the threads of her exploration together, pointing out links and correspondences, not with dogmatic insistence or with a jealous demarcation of her own inviolable critical territory, but with humility and wonder, and with joy at being able to share her awed sense of connection to the past and to the future.

The path Rukeyser has shown us brings us full circle, underscoring her belief in unity and continuity, a belief expressed by the opening and closing of her text. *The Traces of Thomas Hariot* begins with an epigraph, the motto from the title page of *A briefe and true report,* translated from the Latin: "Lost, Perished, and Discovered." The motto appears again, slightly changed, as the title of the final section of her book: "'Lost, Foundered and Found'" (317). As a coda to her biography, however, in homage to her subject, she plays with translation herself, exploring the various possibilities in "PERIIT ET INVENTA EST," closing with an emblem for her hero's life, for his work, and for her own extraordinary act of discovery: "Lost, Employed in discovering. Found" (319).

Notes

1. Kertesz suggests that Rukeyser's shifting narrative perspective "enlivens her presentation" (355). But this technique also demonstrates the intimate connection Rukeyser feels with her subject, the need to experience what he has experienced and to merge imaginatively with Hariot in order to tell his story truly. She inhabits Hariot's history.

2. In the penultimate section of the text, entitled "In the Present: The Search for Thomas Hariot," Rukeyser explains that her explorations began as a collaborative effort, with her students at Sarah Lawrence, focusing not on Hariot, but on Ralegh. Gradually, one led her to the other, and the "two figures joined" (305).

3. Kertesz's discussion of *The Traces of Thomas Hariot* is excellent, especially her analysis of Rukeyser as a historian. We disagree, however, on this point. Following Wilbur Applebaum's review of the biography in *Isis,* Kertesz writes that Rukeyser "is not interested in measuring the particular contributions of Hariot, though she vividly details (with excerpts from his papers) Hariot's pioneering account of Virginia and its inhabitants, his work in optics, alge-

bra, astronomy, and atomic theory" (352). The sheer amount of Rukeyser's meticulous research argues against such a conclusion.

4. She forges one brutal connection between the past and the present, for example, when she discusses Hariot's arraignment with Ralegh in 1594 for suspicion of atheism. Recording the preserved interrogation, she links their questioning specifically with the excesses of McCarthyism: "The questions about God are rather like the questions about communism in our own time in the way they are framed for dogma and to *get* a person as prey; they are hunters' questions, with the same end the hunter has" (135).

5. "Multidisciplinary" and "interdisciplinary" are somewhat inadequate terms to describe Rukeyser's methodology in her biographies, but we do not have a word that defines her absolute refusal to acknowledge any boundaries (other than false divisions wrongfully imposed by man) between disciplines.

6. Rukeyser's philosophy of the unity of knowledge connects her with the work of scientific historian George Sarton and the eminent American biologist Edward O. Wilson. Rukeyser discusses Sarton's *History of Science* at length in *The Life of Poetry*, and Barber devotes much of his analysis of *Willard Gibbs* to the parallels between Rukeyser and Sarton. Wilson's 1998 treatise, *Consilience: The Unity of Knowledge,* is a fascinating study that traces the search for unity from the sixth century B.C.E. to the present day.

7. Some of the heroic lives that she celebrates in this sequence include the Jewish scholar and martyr Akiba, the artist Käthe Kollwitz, the labor organizer Ann Burlak, and the composer Charles Ives.

James Brock

❖❖❖❖❖❖❖❖❖

The Perils of a "Poster Girl": Muriel Rukeyser, Partisan Review, and Wake Island

If there is a twentieth-century American poet who revitalized the receptive and active roles of the poet-witness, she is Muriel Rukeyser. From the thirties, during which she reported on the Scottsboro trial and the Spanish Civil War, through the seventies, during which she visited Hanoi (to meet with American P.O.W.s as well as the civilian victims of the American bombings) and protested in Korea the imprisonment of the radical Catholic poet Kim Chi Ha, her life's work reflected a radical and uncompromising anti-isolationist belief. Rukeyser first successfully joins a feminist aesthetic with her anti-isolationist views in the opening elegies in *A Turning Wind* (1939) and "Letter to the Front" (1944), a mission continued in her other famous works addressing World War II: *Beast in View* (1944), *The Green Wave* (1948), *The Life of Poetry* (1949), and *One Life* (1957). However, these achievements are perhaps best appreciated in light of *Wake Island* (1942), which may be considered an anomaly because it is the only published poem that Rukeyser elided from her *Collected Poems* (1978). This omission is a curiosity, for in the Preface to *The Collected Poems* Rukeyser insists repeatedly that "all the poems are included" (v) in the book. While we do not know why Rukeyser left it out of *The Collected Poems*, *Wake Island* served as a necessary precursor to the later works. Mired in the immediacy of World War II, *Wake Island* articulates Rukeyser's lifelong faith in the public meaning of war and in the public utility of poetry. Although *Wake Island* indeed suffered the most virulent reviews of any of her books, it is significant in the Rukeyser oeuvre because of what it reveals about Rukeyser's development as a political artist.

For Rukeyser, war was not simply a subject for poetry. By opening her poem "Käthe Kollwitz" with the lines, "[h]eld between wars / my lifetime / among wars, the big hands of the world of death," and by declaring that "the False Armistice of 1918" was her first public memory ("War and Poetry" 25),[1] she acknowledged how wars and their destruction framed and defined her life. The Spanish Civil War, World War II, the Vietnam War, and the Israeli/Arab wars punctuated in her mind the incapacity of governments to address the complexities of conflict, as those governments opted to engage in war first and consider the implications later during periods of intermittent peace. "This policy," she notes, "breeds more war, and nothing else" (*WP* 25). Evident in the body of her work, she harbored the most hope for World War II to break that cycle of wars; unfortunately, the failings of governments became most transparent during that war.

Yet Rukeyser did not share the rather fashionable cynicism and disillusionment that afflicted many other leftists due to the betrayal of the Nazi/Soviet pact, the corruption of Stalin, the concessions to Hitler made by Western Europe, and the isolationist stance of the United States. Having once hoped that Communists would take the lead in the battle against fascism in Europe, many American and British leftists grew suspicious of the uncommitted and questioned the purity of Communism among the old guard. Although Rukeyser openly associated with the proletarian writers of the thirties and was a so-called Communist sympathizer in the forties and fifties, she hardly towed the party line. In fact, Marxist journals—especially the *Partisan Review*—often and vehemently ostracized her for her political vacillations and inconsistencies as a leftist intellectual;[2] that Rukeyser was a target for these critics suggests they took her seriously enough to write about her. All the same, Rukeyser was hardly a Communist theorist, as Kate Daniels suggests; Rukeyser's leftist orientation did not mature through studying party doctrine, but through responding to public injustices and to personal crises ("Searching" 76). Rukeyser herself describes her nascent awareness of national and international politics as a personal awakening in the autobiographical section of *The Life of Poetry:* "I learned that I had been brought up as a protected, blindfolded daughter, who . . . knew nothing of people . . . or of herself" (205). Her politics were invested in her need to seek unity and connection with others, to salve the common wounds inflicted by public and private injustices.

Specifically, the politics of World War II acutely affected Rukeyser because of her Jewish heritage and the promise that the "Good War" would oppose fascist ideas, redeem the defeat in Spain, and release the potential of freedom for all peoples. She earnestly dreamed that the American public would someday embrace the liberating precepts of the Ann Burlaks and John Browns of American history (heroic working-class and abolitionist

figures in her poems "Ann Burlak" and "The Soul and Body of John Brown"). Here portended a war against the values of oppression, a war unfettered by twisted nationalistic interests. In that same spirit, Rukeyser accepted a position in the Graphics Workshop of the Office of War Information in 1943, an assignment she hoped would allow her to produce "the images and words which strengthen our lives, for war and for peace" ("Words and Images" 141). Likewise, she wrote *Wake Island*, an enthusiastic, patriotic occasional poem. Her initial response to the United States' involvement in World War II, reflected in this poem, complicates Rukeyser's political commitment as an anti-isolationist, particularly in light of her other accomplishments that bravely and eloquently speak for racial, social, political, and spiritual integration.

A precursor to "Letter to the Front," *Wake Island* is a 94-line poem in three sections, published as a chapbook in the summer of 1942. The poem responds to the December 23, 1941 surrender of a small garrison of U.S. Marines and civilian volunteers who defended Wake Island in the Pacific, having withstood a 15-day air-bombing and finally succumbing a day after the Japanese landed on the island. Of those captured, the Japanese had ruthlessly machine-gunned 98, imprisoning the rest. From its opening stanza, the poem is typical of Rukeyser in its exuberant tone, its high rhetoric, its repetitive noun and verb phrase structures, its images of water and fire, and its affirmation:

> Proof of America! A fire on the sea,
> a tower of flame rising, flame falling out of the sky,
> a wave of flame like a great sea-wave breaking
> over this fighting island in its rain of wounds—
> fighting until the flames grew tall, fighting while waves
> broke and the enemy landed on each wave;
> fighting as if they were the fist of the world
> and they had a world to save. (1)

Critic Louise Kertesz argues that the poem attempts to equate "the fight in Spain and the fight in the Pacific as part of the same struggle" (177); more specifically, the defense of Wake Island becomes a token of proof of the American will to fight as liberators.

It is useful to consider that *Wake Island* anticipates Rukeyser's duties at the Office of War Information—as she perceived those duties. That is, *Wake Island* is first and foremost a public poem meant to encourage Americans to regard Wake Island within the larger context of the war against fascism. Perhaps we have grown too unaccustomed and callous to this kind of public poem—actually, to the idea of a political occasional poem—and choose to

dismiss it as a dated anomaly. For recent examples, we can consider the un-favorable critical reception that greeted the Inaugural Poems of 1992 and 1996 by Maya Angelou and Miller Williams.[3] For Rukeyser, however, such endeavors bring forth the ideas of responsibility, freedom, and possibility for the American people. Indeed, near the end of the poem Rukeyser announces these themes with characteristic directness:

> Impossible courage that finds impossible chance,
> America planted in a sea of war,
> free as our hope is free over all mountains
> flying, and looking down; and our eyes looking
> directly into the eyes of all the brave
> under a night striped with our fire and stars
> until the war's first weapon is liberty,
> and there is no slaveholder and no slave,
> not even in the mind; but only the free. (14)

The obviously public appeal of this poem is accentuated by the familiar ab-stractions and symbols, the overt echoes of the National Anthem: "a night striped with our fire and stars," "eyes of the brave," "liberty," and "only the free." This public language, coupled by Rukeyser's use of perfect end rhymes, results in an accessible, immediate poem for the American people.

Despite being founded on sincere intentions and genuine compassion and reflecting popular sentiment about the war, *Wake Island* was deemed a failure in its own time. No other Rukeyser work received such scathing re-views; worst of all were the petty defamations of the indignant *Partisan Review*. Weldon Kees's review of *Wake Island* contained but one sentence: "There's one thing you can say about Muriel: she's not lazy" (540). More damning, and brutally sexist as well, proved to be the *Partisan Review*'s fol-low-up editorial, "Grandeur and Misery of a Poster Girl," which essentially attacked Rukeyser's politics for being too inconsistent, vapid, and unrigor-ous. The unsigned editorial denigrated her belief that the meanings behind the war could be displayed in public art—such as *Wake Island*—and could influence a nation's conscience: "she . . . bring[s] to mind the dapper ghost of James J. Walker, a famous song-writer, who remarked, when a question of censorship arose, 'I never heard of a girl who was ruined by a book!' . . . As Ring Lardner used to say, there is a limit to games and to fun, and to quote once more, 'Fun is fun, but a girl can't keep laughing all the time'" ("Grandeur" 473). Beyond these slurs that mock a woman who dared to take a public stance, the editors—Philip Rahv, William Phillips, and Del-more Schwartz—selectively interpreted Rukeyser's efforts, preferring to crit-icize them as if they were the recruitment posters produced by the Office of

War Information rather than to seriously consider her goals in the Graphics Workshop.

The unsigned editorial was probably written by Delmore Schwartz, the poetry editor of *Partisan Review,* according to Dwight Macdonald, the editor (Kertesz 180). In a letter to Macdonald, dated December 19, 1942, Schwartz complained of the inadequacy of Kees's review: "Muriel's bad poem and her bandwagon writing from the proletariat to the Marines should have been exposed. . . . Instead of that you print a jealous wisecrack from Kees" (*Letters of Delmore Schwartz* 148). Indeed, Schwartz's own vindictiveness against Rukeyser can be traced earlier in a November 3, 1940 letter, in which he confides to Robert Hivnor: "Muriel Rukeyser I dislike intensely, both as a poet and as a person; she's one of those people for whom energy takes the place of intelligence, she played the Stalinist game for years because it was useful, she is stupid and knows nothing about poetry. Forgive me for being so violent and emphatic but I'm convinced it is so" (104). And during this "Rukeyser Imbroglio" (what the editors themselves named this controversy), Schwartz noted in his journal on July 3, 1943:

> Miss Rukeyser on the Pulpit, N[ew] R[epublic] this week,
> patriotism; Yes, yes, Old Glory around her bandwagon riding.
> Man who destroyed a city for a Helen who was a lesbian. (121)

Written by a poet who views Rukeyser as a lesbian Helen encouraging war, "Grandeur and Misery of a Poster Girl" reveals a private, hateful, homophobic, and obsessive agenda that blinded Schwartz to Rukeyser's value.

Rukeyser clarifies her role as a public artist as she describes the work of the artists whose images were used in the Graphics Workshop: "Welders by Shahn were to be used to remind us of our mixed birth; a head by Shimin, the head of a young Negro boy, for the chance to grow; a landscape by Curry with a line of Whitman's; a raft of three survivors on a copper-hot sea by Peter Blume; a grotesque of syphilis by Dali; the starving children of Käthe Kollwitz" (*LP* 136–37).

Wake Island, also public art, is representative of Rukeyser's own efforts. These artistic projects as a whole should not have been conflated into the propagandistic art of the War Department as the *Partisan Review* editorial suggested; the Workshop's task was not to sell the war for American consumption, but to illuminate anti-fascist truths.

After receiving letters of protest, including those from the poet Babette Deutsch and the critic F. O. Mathiessen, the editors of *Partisan Review* defended their virulent attack on Rukeyser in a rebuttal, excusing it as a satire to shock "the gentility by which American literary life has been ruled" ("The Rukeyser Imbroglio" 127). Setting aside this excuse, which indulgently allows

insult to pass for responsible criticism, the editors finally do "rigorously" state their objections to *Wake Island* in their response. In short, they complain of Rukeyser's naive inability to understand that "there is still a world of difference between the anti-fascist struggle of the Spanish people and war now being waged in the Pacific" (127). However, in this opinion the editors expose their own naivete, for they refuse to accept the possibility of a common root among wars; as Marxists they would find such a linking ahistorical.

Precisely on this point Rukeyser parts company with Marxist intellectuals, as she insists on a moral connection between the two wars. Leftists in America were reeling from the Soviet appeasement of Nazi Germany; the Soviet-German Nonaggression Pact of 1939 was indeed as unsettling as the Munich Conference of 1938, for it revealed that the Communists were no more willing to stop Hitler than were the liberal democracies. In response, many American leftists tended to romanticize and distinguish the Spanish Civil War as an example of a leftist will to fight fascism in the face of American vacillation. Rukeyser, however, does not qualify her indignation against the forces of fascism. Her moral indignation is not selective. Her ardent endorsement of the war against Hitler and Tojo, evident in *Wake Island* and in her work for the Office of War Information, stands as sincerely as her previous support for the defeat of Franco. While the editors made fun of this seemingly easy sincerity, they ignored the difficult consistency and integrity of Rukeyser's perspective.

Wake Island does not fail because its author—a "poster girl" far removed from the actual battle—has no business writing such war poetry, as the editors of *Partisan Review* argued. Indeed, as Susan Schweik has posed in her excellent essay, "Writing War Poetry Like a Woman," such endorsement of direct military experience as a condition for the proper war poem artificially marginalizes other war experiences on other fronts:

> But when experience is privileged or even required as an aesthetic, political, and moral criterion for the proper war poem, the attendant dangers are several. . . . In American forties war poetry, for instance, "experience of war" was generally taken to comprehend the experience of the soldier but not generally, during the war itself, the experience of the Holocaust victim, the Japanese American in an internment camp, or a woman working in a defense plant. Finally reading war poetry as we have been so often taught to read it . . . we may once again be complicit in rendering women . . . silent and invisible and static, suppressing [their] own dynamic and complex relations to systems of war making. (553–54)

And certainly Rukeyser's effort in *Wake Island* does not suffer primarily from her distance from the battle itself. Rather, *Wake Island* fails because Rukeyser

chooses to isolate the fates of the combatants: on one side, the Japanese are described through their inhuman instruments of death, the mechanical gaze of their planes over the human targets, or their singular bestiality, "the one enemy seething at the beach"; on the other side, the Americans meet the planes' "eyes" with their human stares, and they become the ennobled heroes who "fought at this island for the air we breathe" (8). In other words, *Wake Island* violates Rukeyser's own anti-isolationist politics. Caught up in her compassion for the courageous, outnumbered marines and civilian volunteers and in her hopes for the war to be a battle against fascism, she defines the enemy and the saviors along nationalistic and racial lines:

> There are two looks in the world: the plane's gaze down
> on a scene of unrolled sea and open land
> as it becomes a single map of space.
> There is the close look of a fighting face
> when the earth screams and fire falls from the air
> and those fighting together look at each other's lives (5)

At long last, she has rationalized, all of America, not just the Lincoln Brigade, was fighting to keep the world free.

The projects of the Graphics Workshop never reached fruition. Rukeyser blamed this failure on the government's yielding to the "[a]dvertising men [who] came in, telling the administration that ideas were their field, that the government needed their techniques. . . . The advertising men won, with those who decided that this war was not a war against fascism, that it was a war to be won. . . ." (*LP* 137). Before the Graphics Workshop dissolved, Rukeyser, "sick at heart," had resigned from her position on May Day, 1943, according to her friend Rebecca Pitts, "because the war was increasingly 'unconscious' and because our business and political leaders were more concerned with *stifling* the meanings and values involved than they were with educating the American people to the real issues of the struggle" ("The Rukeyser Imbroglio" 126). Rather than subscribe to the detached cynicism so popular at the time among leftist intellectuals, Rukeyser took her writing into battle on the home front, knowing that beyond World War II was a greater, more urgent war. As she later explained, "now the fact that [World War II] might be a war against fascist ideas has slipped away. So that the war for those concerned with life, the truth which is open to all, is still ahead" (*WP* 25). Her wish that the battle against fascism might stir a sweeping, liberating consciousness was lost in the compromises of England's and France's concessions and the United States' isolationism in the war's beginnings. She had recognized that political expediencies overwhelmed the moral issues of this war. For as she feared in "War and Poetry," these liberal governments, in

masking the causes of this war from their citizens and themselves, were doomed to follow the political cycles that perpetuate conflict.

Rukeyser's experiences with the Office of War Information taught her how governments, even those ostensibly defending democracy, inflict suffering on their own people; how political states encourage and educate their citizens toward conformity, toward being chattel of the state, so that "[w]e think in terms of property, weapons, secrets" (*LP* 43); how nations at war—divorced from the causes that beget wars—must "win the war first, and work out meanings afterward" (*WP* 25). She discovered that American isolationism, the kind by which the United States distances itself from friend and foe, impoverishes our individual imaginations and engenders patriotic chauvinism. Rukeyser, quoting from the sociologist Trigant Burrow who defines conflict "not as a condition of mind common to both parties, but as the 'wrongness' of the other fellow, the other group or the other nation" (*LP* 42), laments this fallacy of conformity. Such thinking dominated the war years: being good Americans, we could righteously admit our slight imperfections, but we had only to mention the atrocities committed by the enemy to confirm our moral superiority.

Major presses, for one example, published such treatises as Ralph Barton Perry's *Our Side Is Right* (1942), in which the difference between the Allies and the Nazis is said to rest in the Allies' belief that "freedom is right" and the Nazis' belief that "slavery is right" (11). Francis J. Spellman's *The Road to Victory* (1942) was typical in its effort to claim that America's was a divine duty, one imposed from without: "America's morale draws . . . from a just cause and a just God. We know the facts. We face a situation forced on us" (122–23). To the contrary, Rukeyser ultimately advocates a creative alternative to how we actually perceive power. As she argues in a passage dated June 1940 in *One Life,* her biography of Wendell Willkie, we need not settle for a choice between evils:

> Choose between evils,
> You live in the world, you must learn to choose between evils.
> Two gray colors of smoke waiting to be chosen.
> Will nobody tell them? They do not seem to know.
> I will. My brothers of smoke, my brothers,
> You do not have to choose between evils. (*CP* 345)

Here, through the voice of Willkie, the poet-biographer seeks reconciliation with her brothers, wishing not to foster separation by limiting choices only between fascism and isolationism. Having recognized first-hand the compromised principles of the U.S. involvement in World War II, she is conscious of the dangers of isolationism. With this refusal "to choose between

evils," then, her political stance has not evolved into that of the pacifist in 1943, but into that of the radical anti-isolationist: engagement in the war alone is not enough to ensure peace. This political position takes its cue from Wendell Willkie, the Republican presidential candidate of 1940 who, like Rukeyser, embraced an unconventional set of political beliefs.

Willkie announces his anti-isolationist program in his 1943 work *One World,* which he wrote after traveling through Europe, Africa, and Asia in 1942. Essentially, the book makes the point that American isolationism after World War I, represented by the government's failure to join the League of Nations, was a contributing factor to World War II. More specifically, Willkie chides Winston Churchill, Franklin Roosevelt, and Josef Stalin for wavering from the clear purpose of the war with their political maneuverings behind the scenes, and thus he argues that the people must wrestle the war's meanings from their political leaders: "It is plain that to win this war we must make it our war, the war of all of us" (168). Indeed, Willkie reminds his readers that World War II is more than the simple and expedient liberation of some countries from the Nazi or Japanese armies: "[O]ur common job of liberation includes giving to all peoples freedom to govern themselves" (180). And like Rukeyser, Willkie recognizes that the roots of oppression do not extend exclusively from the side of the Axis powers: "Today it is becoming increasingly apparent to thoughtful Americans that we cannot fight the forces and ideas of imperialism abroad and maintain any form of imperialism at home" (190). On this issue of a global liberation, Rukeyser is very much a Willkiean looking for a means to transcend these oppressive forces. Obviously, Rukeyser perceived the moral necessity of defeating Germany and Japan, but she also abhorred the moral whitewashing of the war and its promotion of a morality predicated on jingoism. Whereas *Wake Island* does not entirely escape those fallacies, Rukeyser—relieved from the conflicting demands of the Office of War Information—got to the heart of the moral issues of World War II in *Beast in View,* "Letter to the Front," *The Green Wave, The Life of Poetry,* and *One Life.*

In writing those works, Rukeyser examines the difficulty a United States citizen faces in coming to terms with a radical anti-isolationism. For Rukeyser—being an unwed mother, a Jew, a leftist, a lesbian, a poet—such negotiation was complicated by her desire to endorse the liberating promises of American democracy while rejecting the underlying oppression wedded to Americanism. Certainly Rukeyser's artistic and personal struggles attest to the difficulty of striving to be free from the trappings of nationalism. She was not always successful or consistent, as her detractors and reviewers quickly pointed out. Yet what Rukeyser has made available are all the political and human dimensions inherent in such a struggle.

Notes

1. Hereafter, all parenthetical citations to "War and Poetry" will be noted as *WP.*

2. I detail Rukeyser's final break with the *Partisan Review* in this essay, which will reveal what became the standard critique against her politics among the New York intellectuals. *Partisan Review* until 1944 had faithfully and regularly reviewed her books of poetry and had frequently published her poetry. However, after the "Rukeyser Imbroglio," *Partisan Review* never again published any of her poetry and did not review any of her books until 1982—a posthumous review of *The Collected Poems* by Grace Schulman that proved to be one of the strongest endorsements of Rukeyser's contribution to American poetry.

3. See Calvin Trillin, "Poetic Justice," *Time* January 20, 1997: 18; Morris Freedman, "How Poetry is Dead," *The Virginia Quarterly Review* 71 (Spring 1995): 315–20; and John Meroney, "The Real Maya Angelou," *The American Spectator* 26.3 (March 1993): 68. These responses range from Trillin's playfully feint praise of Miller as "one of the better Arkansas poets," to Freedman's dismissal of Angelou as a serious poet, to Meroney's vindictive attack on Angelou's literary skills and liberal politics.

Leslie Ann Minot

"Kodak As You Go": The Photographic Metaphor in the Work of Muriel Rukeyser

What we see, we see
and seeing is changing

—Adrienne Rich, "Planetarium"

there is no place, nay,
which does not see you. You must change your life.

—Rainer Maria Rilke, "Archaic Torso of Apollo"[1]

Literature has, in one form or another, a long and complex history of engaging with questions of visual representation and the visual arts. No one is surprised that Rilke, in the epigraph above, would write a poem that both describes and extends our understanding of another work of art—in this case a shattered piece of classical sculpture. Photography, however, is a form of visual representation that has tended to be seen as inimical to literature. Its historically uncertain status—falling somewhere between art, hobby, and technological fluke—can be linked to the "anxiety" it is said to produce in the field of representation. In his essay "Reproduction and the 'Real Thing': The Anxiety of Realism in the Age of Photography," Miles Orvell suggests that the reaction of American realist writers to photography until fairly recently has been one of shifting anxieties, beginning in the nineteenth century with their fear of being too literal—not literary enough—and transforming in the twentieth century into a fear that they were not able to equal the accuracy of the camera, a fear that lasted at least until the 1970s.

Hostility to, or regret about, photography's role in contemporary culture persists in discussions of poetry into the 1980s. In the Prolog to *Praises & Dispraises: Poetry and Politics, the 20th Century,* Terrence Des Pres argues that "the press of the real," "the surfeit of images provided by photojournalists," threatens to drown poetry in the despair of a "spectacle" of power that is "immediate, encompassing, supercharged with shame and disgust, and also, of course, with dread . . ." (xv). He cites Andre Brink of South Africa, who argues in *Writing Under Siege* (1983), "Mass communications have propagated these events around the world; and 'no man can claim that he has not personally SEEN the intolerable condition of the world'" (Des Pres xiv–xv).

Des Pres also cites Charles Simic, in a passage from "Notes on Poetry and History" (1984), which I want to quote in its entirety because it illustrates certain emotional assumptions that differ in revealing ways from those of Rukeyser.

> If not for the invention of photography and motion pictures, one could per-haps still think of history in the manner of nineteenth-century painting and Soviet Revolutionary posters. There you meet the idealized masses and their heroic leaders leading them with chests bared and sleeves rolled up. They are marching with radiant faces and flags unfurled through the carnage of the bat-tlefield. The dying young man in the arms of his steadfast comrades has the half-veiled gaze of the visionary. We know that he has glimpsed the future of humanity, and that it looks good. Unfortunately for all concerned, people started taking pictures. I remember, for example, a black-and-white photo-graph of a small child running toward the camera on a street of collapsing buildings in a city being fire-bombed. . . . She's wearing a party dress, perhaps a birthday party dress. One is also told that it is not known where and when the picture had been taken. (qtd. in Des Pres xv–xvi)

For Simic in this passage, photography produces emotional deflation. The photograph that serves as his example is "political" insofar as it shows us ter-rible realities to which we might respond, yet what it in fact produces is a sense of ignorance and paralysis.

Des Pres draws on this passage to suggest that changes in the means of representation, changes in mass communication including photography and cinema, lead to a vision of the world in which "politics is everywhere and hopeless" (xvi). The solution Des Pres pursues in his study is what he calls "bardic practice," in which the poet responds to politics by building up a community and voicing that community's values in praises and dis-praises, in blessings and curses, a solution that does not respond directly to the problems raised by photography, but offers alternate values and an al-ternate approach.

In the midst of movements between anxiety and blame in the face of photography, the work of Muriel Rukeyser offers a different approach to the question. Photography is crucially linked to various forms of bearing witness in Rukeyser's early poetry, and Rukeyser is not afraid to see the terrible truths it may show us. The photograph of horror or injustice does not produce paralysis for her—it makes action and change possible. In *The Life of Poetry*, Rukeyser mentions briefly her experience working in the graphics division of the War Information Office in 1943. She notes,

> . . . among the things we learned was the impact that a combined form may have when pictures and text approach the meaning from different starting-places. In this combination of an image and a few words, there are separables: the meaning of the image, the meaning of the words, and a third, the meaning of the two in combination. The words are not used to describe the picture, but to extend its meaning. (137)

While she is aware that photography is different from earlier forms of representation—"its immediacy answers the need that our newspaper readers have for the eye-witness, a need that runs through all our culture" (138)—she suggests that in many cases it is the writing that accompanies photographs that is "reactionary," that denies the possibilities of the photographs. "The most powerful picture magazine . . . prints better and better photographs, while its writing lags a generation behind, and the captions for the photographs repeat the images and are printed in blocks beneath, for all the world like the labels on cans of soup" (139). Rukeyser's willingness to imagine writing that can collaborate with the best possibilities of photography makes her a relatively rare figure, as does the importance of photography as a metaphor and a theme in her early work.

From the beginning, Rukeyser struggles with complex issues of poetic representation, realism, and the role of the image. The camera and the photographer appear at crucial moments in her work to illustrate and sometimes to resolve the complex relationship between subjective or internal reality and the testimony of documentary realism, between the personal and the social or historical. Rukeyser's engagement with the idea of photography offers a reflection on the possibilities of both poetry and technology as positive forces for social change. This engagement also appears to be connected with formal innovations in Rukeyser's work, particularly the use of *deixis* to produce the effect of immediacy in *U.S. 1.*[2] In the pages that follow, I will explore the complexity and importance of the metaphor or example of photography to Rukeyser's work. In thinking about the personal and social uses of photography, I have found myself drawn to the work of the French structuralist, Marxist thinker Roland

Barthes, whose discussion of photography seems to pursue many of the same issues that concern Rukeyser.

In *Camera Lucida: Reflections on Photography* (1980; trans. 1981), Barthes argues, "The Photograph does not call up the past (nothing Proustian in a photograph). The effect it produces upon me is not to restore what has been abolished (by time, by distance) but to attest that what I see has indeed existed. Now, this is a strictly scandalous effect" (82). This "scandal" of photographic testimony does not replace but supplements memory in a particular way. A similar, complex relationship between photography and memory can be seen in Rukeyser's work, literally from the beginning, in "Poem out of Childhood," the first poem in her first volume of poetry, *Theory of Flight* (1935).

"Poem out of Childhood" is concerned with the origins of both the poetic and the political impulse. "Breathe-in experience, breathe-out poetry," instructs the first line, drawing attention to the ways in which the self and the body are traversed by and contribute to what is external to the self. A series of images that represent a disturbing recognition of illness and death are recounted in the face of the "the magnificent past" that "shot deep illuminations into high school." These provide the occasion for the speaker to reflect on the function of images: "These bandages of image wrap my head, / when I put my hand up I hardly feel the wounds" (*RR* 5). Rukeyser makes a point of separating the images of pain or of painful experiences from the painful wounds. The images do not contribute to the wounds—they are the bandages that make it possible for the speaker to go on. These "bandages of image," like the photographs of the poem's second section, are part of an effort toward recovery, in both senses. They help the speaker to recover the experience of childhood; at the same time, they participate in a type of emotional recovery from the traumas described, a possibility of moving beyond pain into action.

The visual dominates through the second part of the poem, and the camera itself appears in the last stanza of this section:

Ratat a drum upon the armistice,

Kodak As You Go : photo : they danced late,
and we were a generation of grim children
leaning over the bedroom sills, watching
the music and the shoulders and how the war was over. (*RR* 7)

Armistice and advertising arrive in quick succession as the camera records the celebration after the ending of World War I. The auditory and visual blend into each other, the "ratat" on the drum slides into an advertising slo-

gan, then an unspecified "photo." "Watching" is the verb used to mark the children's relationship to the music, the shoulders of the dancers, and the overall experience of "how the war was over," suggesting ways in which the visual, the image, may be linked to passivity, to the inability to understand or to intervene in the adult world. In the next section of the poem, however, these images of the past will be "organized" into a "potent catalyst," actualizing the potential of this witnessing.

The word "photo" itself is curiously flat in this passage, conjuring up no image. There is no such thing as a photograph in general, a photograph without a specific content, except when created in language such as this. The word functions between the colons like the clicking of a shutter or the blink of an eye, extending the long "o" from both ends of "Kodak As You Go" and echoing them in quick succession around the sharpness of the "t" at its center. The word "photo" stands in the middle of the line, between the reference to the culture of the camera and the image the camera records.

The end of the stanza calls up more links to photography:

> The child's curls blow in a forgotten wind,
> immortal ivy trembles on the wall:
> the sun has crystallized these scenes, and tall
> shadows remember time cannot rescind. (*RR* 7)

The child's curls blowing in a "forgotten wind" and the "immortal ivy" are part of what the sun has "crystallized." It is worth remarking, with Barthes, that photography "was possible only on the day when a scientific circumstance (the discovery that silver halogens were sensitive to light) made it possible to recover and print directly the luminous rays emitted by a variously lighted object" (80). Rukeyser, with her interest in chemical and technological processes, may well be thinking along these lines. Frequently her work praises the sun and its light, often linking light with life and with action for good.[3] If "the sun has crystallized these scenes" as photographs, capturing the trace of the "forgotten wind," these images supplement the memory of the "tall shadows," the children who have grown amid the unhappiness and the ambivalence of the war years.

"Time cannot rescind"—the scandal of the photograph is that it attests directly to the existence of its referent in a way that memory alone cannot. Yet the photograph of the child and the tall shadow of child grown to woman reach the reader at an even further remove. What is the reader to do with these photographs and remembered images of the past? On the one hand, the poem is deeply personal, both in its recollections and its declaration of politics and sympathies. On the other hand, the poem carefully works to construct a recognizable collective history and to establish a voice

that can speak not only for "I" but for "we." It is in this oscillation between the personal and the collective that photography has a role to play. The appeal to photography has a particular rhetorical effect on the reader, establishing a crucial space between image and interpretation, encouraging us to accept at least some of the images presented as simply factual, not metaphorical or symbolic. Rather than naturalizing the relationship of specific images and incidents to developmental narratives of politics and aesthetics, Rukeyser offers us gaps and discontinuities between the testimony of unelaborated images, such as the child's curls, and the various philosophical attempts to "[o]rganize the full results of that rich past" (*RR* 7). Rukeyser produces a tension of interpretation in the poem not only by juxtaposing such images as the "rush of triumphant violins" and the "mouldered face" of a "syphilitic woman," but also by juxtaposing the figure of the young girl whose father and brother had just died with the banality of everyday life: "and / I went into the corridor for a drink of water" (*RR* 5). These juxtapositions force the reader to question the relationship between each "snapshot" image and the ones before and after.

The images do not simply accumulate, building on one another, leading the reader in one direction. They interrupt, argue with each other, reroute the reader's search and speaker's story at critical moments. For example, the memory of the murder committed by Leopold and Loeb is followed by and seems to evoke the speaker's anger at "[t]hey who manipulated and misused our youth . . . trapping us in a welter of dead names . . . ," an outcry countered by a passage that evokes youthful enthusiasm for the classics, beginning, "We were ready to go the long descent with Virgil . . ." (*RR* 5). This passage, which goes on to describe the drowned Sappho, is countered by, "Not Sappho, Sacco" (*RR* 6), returning the speaker and the reader to a different type of "murder" by evoking the execution of Sacco and Vanzetti.

Certainly some of the images put forward recall a collective memory: Loeb and Leopold, the war, Sacco and Vanzetti. Others, such as Brahms and Sappho, point to a collective cultural and aesthetic history. In the midst of these more broadly accessible references, there are those, such as the girl dealing with the deaths of her father and brother, that point toward a particularity from which we are excluded. The "we"—the collective consciousness of a whole generation that Rukeyser evokes in phrases like "Prinzip's year bore us" (*RR* 6)—remains balanced by the specific, the individual, the particular. In contrast to a war that she describes in the final part of the poem as "shapeless" (*RR* 7), the incidents she recounts have a sharpness, a specificity to them. Through the analogy of photography, the reader is asked to accept the poem's collection of images not as a series of metaphors, but as real, incontrovertible moments from a specific past, moments that are nevertheless marked by the events of collective history. This tension between the particular and general is

crucial to creating a viable "we"—a collective identity that recognizes indi-
vidual differences: " . . . our youth assumes a thousand differing flesh" (*RR* 7),
which seems to indicate the differences both within and among individuals
as they grow and assume their bodies in the material and historical world.

Barthes notes that the "photographic referent" is not "the *optionally* real
thing to which an image or a sign refers but the *necessarily* real thing which
has been placed before the lens . . ." (76). The metaphor of photography
lends a sense of authentication—reference to this material and historical
world—that is not traditionally associated with language. The appeal to
photography as authentication supplements lyric poetry's traditional appeal
to individual or personal memory. Rukeyser has not simply produced a
poem "of" childhood, but a poem "out of" childhood, a poem made of
pieces of information, of evidence collected from childhood, things that re-
main if you "Kodak As You Go."

This striving toward authentication becomes even more pronounced
in "The Book of the Dead" series in *U.S. 1.* In 1938, Rukeyser studied
the situation of miners dying of silicosis due to corporate decisions not to
take precautions to protect them in what came to be called the Gauley
Bridge tragedy of West Virginia. She personally investigated the site,
spoke with survivors, and studied the reports of Congressional commit-
tees to produce a sequence of poems that can only be described as a doc-
umentary in verse. "The Book of the Dead" mingles what Barthes would
call the fictional and the unfictional poles of language. He writes, "It is
the misfortune (but also perhaps the voluptuous pleasure) of language not
to be able to authenticate itself . . . language is, by nature, fictional; the
attempt to render language unfictional requires an enormous apparatus of
measurements: we convoke logic, or, lacking that, sworn oath; but the
Photograph is indifferent to all intermediaries . . . it is authentication it-
self" (85–87). In addition to making use of the metaphor of photogra-
phy, Rukeyser draws on the "enormous apparatus of measurements" and
the "sworn oath" to bear witness to what she has seen in West Virginia,
incorporating Union Carbide stock tables, chemical formulae, courtroom
testimony, and fierce cross-examination into what nevertheless remains a
strongly lyrical poem sequence.

The camera is an essential motif of this documentary project. Photogra-
phy is invoked as a way of making witness portable, of bridging space, pri-
marily, and not time, as in "Poem out of Childhood." Near the conclusion
of "The Book of the Dead," she offers an imperative that describes the work
of the poem:

> Carry abroad the urgent need, the scene,
> to photograph and to extend the voice,

to speak this meaning.

Voices to speak to us directly. As we move. (*OS* 40)

The poem will give a directness, an immediacy to the events, will supplement, extend the voice, to speak to a collective "us," a collective that is in motion.

If the photograph serves as a site of specificity, particularity, the photographer is nevertheless a strangely generalized figure in the poem:

Now the photographer unpacks camera and case,
surveying the deep country, follows discovery
viewing on groundglass an inverted image. (*OS* 10)

The photographer is presented to validate the accuracy of the poem's images. The name of the photographer is not given; the photographer's role is not explained; we cannot even picture the photographer on the basis of the information we are given because we do not know facts that are crucial to our ability to produce an image, facts that are important in our understanding of the majority of other people who appear in the poem—race, sex, and age, to name a few of these characteristics.

The act of recording is more important in this poem than the one who records. Unlike "Poem out of Childhood," "The Book of the Dead" is not centered around one "I" who attempts to piece together personal and collective memory. Instead, as we shall see, this burden falls on "you," the addressee, the reader of the poem. The act of recording, the fact of the camera's gaze, is particularly important in the section titled "Gauley Bridge." This poem is made up of a series of views, of images, beginning as follows:

Camera at the crossing sees the city
a street of wooden walls and empty windows,
the doors shut handless in the empty street,
and the deserted Negro standing on the corner. (*OS* 13)

The lone view of camera—it, not the photographer, "sees the city"—is soon joined by other eyes, the "man on the street and the camera eye," described as equals. This begins the slippage of point of view, the movement among a series of eyes whose gaze ultimately leads to other eyes in a technique that shifts the subject vision in a way that resembles the cinematic construction of shot/reverse shot used to insert the viewer in the place of one of the characters in a film by showing what that character sees.

Rukeyser's involvement with documentary film and her interest in strategies for combining writing with photographs in series, both of which she

discusses in *The Life of Poetry,* may have taught her how to construct this sequence of images. She notes, "In writing for sequences of stills, the motion of the sequence is a primary consideration. The editing and arranging of the photographs will determine the flow of the text" (139–40).

The motion of the sequence is what moves "Gauley Bridge" forward, through shifting points of view, refusing to validate any particular point of view over the others:

Glass, wood, and naked eye: the movie-house
. .

Whistling, the train comes from a long way away,
slow, and the Negro watches it grow in the grey air,
. .
Eyes of the tourist house, red-and-white filling station,
the eyes of the Negro, looking down the track,
hotel-man and hotel, cafeteria, camera.

. .
always one's harsh night eyes over the beerglass
follow the waitress and the yellow apron. (*OS* 14)

Even the camera is not the ultimate point of view, the source of all seeing, since it too is seen. These images are repeatedly structured like a cinema cut—we see eyes, then see what those eyes see. The reader is given the task of drawing these varying points of view together, of synthesizing them and also of recognizing the differences these different lines of vision represent, of which race and gender are only the most obvious. The act of looking, in itself, does not necessarily overcome separation—the people in the poem watch one another, without necessarily interacting. The poem, however, may be the "bridge" of its title, the place where these different viewpoints, these different ways of seeing, can be brought together, although it does not automatically follow that they will be. The camera, similarly, can be said to be located at a metaphorical "crossing" of points of view, as it is located at a physical "crossing" in the town. The reader, too, is called upon to occupy the place of that bridge and that crossing, since the reader's consciousness is crossed by these different lines of vision.

I noted above that the addressee of the poem, the reader, is a crucial central figure in this sequence of poems. In "Poem out of Childhood," Rukeyser appealed to "we" and "us" to construct a collective subject. In "The Book of the Dead," Rukeyser tries a different approach, asking "you" to take on the responsibilities of this collective consciousness. Rukeyser marks the importance of the reader by beginning the first poem in the se-

quence, "The Road," with a gesture designed to reach out to a specifically American audience:

> These are roads to take when you think of your country
> and interested bring down the maps again (*OS* 10)

The direct address is designed to engage the reader, to draw the reader into the poem's exploration, into the poem's witnessing. The "you" does not exist separately from the collective represented by "your country."

The appeal to the possessive, "your country," draws the reader in, but into what? Into "these"—particular roads that actually exist. "These"—like "this," "those," "here," and "now," which hold such critical, often opening positions in so many of Rukeyser's poems of this period, and like the "you" of the poem's address—is a *deictic,* a word that refers outside the text to some given referent. In the same way, the photographic image, according to Barthes, directs the viewer to a "necessarily real" referent beyond the image.

Like the referent of a photograph, the referent of a deictic has an immediacy and directness while remaining at the same time untouchable, deferred. Although deictics point to immediacy of perception, this immediacy is deferred, because, as Emile Benveniste has shown, "their very meaning (the method used to find their referent) . . . can only be defined by allusion to their use" (qtd. in Ducrot). Deixis (the use of deictics) becomes in Rukeyser's hands a way to ensure that poems and the world outside them interpenetrate, depend on each other, so that the reader must include the world beyond the poem in trying to understand the poem's meaning.

A detour through the "allusion to their use" must be taken before arriving at the reference of "these" roads. This detour is the linear unfolding of the image in the form of text:

> Past your tall central city's influence,
> outside its body: traffic, penumbral crowds,
> are centers removed and strong, fighting for good reason.
>
> These roads will take you into your own country.
> Select the mountains, follow rivers back,
> travel the passes. Touch West Virginia where
>
> the Midland Trail leaves the Virginia furnace,
> iron Clifton Forge, Covington iron, goes down
> into the wealthy valley, resorts, the chalk hotel

. .

> The simple mountains, sheer, dark-graded with pine
> in the sudden weather, wet outbreak of spring,
> crosscut by snow, wind at the hill's shoulder. (*OS* 10)

This flowing description continually reaches out of itself, involving the reader, insisting on the reader's participation, action, decision: "your tall central city's influence," "these roads," the imperatives "touch" and "select."

In looking at these poems, I have focused on Rukeyser's use of photography as an appeal to "authentication" and to "reference," but I have said little so far about meaning or interpretation. Rukeyser's use of techniques such as deixis and direct appeal to the reader as participant contribute substantially to how we can understand questions of "meaning" in her poetry. Like deictics—whose "meaning" can be found only by looking at the context beyond the words—Rukeyser's poems and images frequently point outward to material circumstances. We see this aspect of "meaning" in Rukeyser's imperative, "Carry abroad the urgent need, the scene, / to photograph and to extend the voice, / to speak this meaning" (*OS* 40). Photography is linked to "extending" the voice, extending the senses, "carrying" a content that is both an "urgent need" and a visual record. The scene, the need, and the meaning are inseparable, ensuring that testimony can lead to action.

We can also gain some insight into Rukeyser's sense of how an image or object "carries" a meaning by looking at the concluding passage of "The Road," where she writes:

> Here is your road, tying
>
> you to its meanings: gorge, boulder, precipice.
> Telescoped down, the hard and stone-green river
> cutting fast and direct into the town. (*OS* 11)

Again, the road is offered to the reader as something that belongs to her or him. The road is possessed by the reader, but it also possesses the reader, compels her or him, "ties" her or him to its "meanings." These meanings are not abstract, philosophical statements, ideas, or values—they are listed simply as "gorge, boulder, precipice." As symbols, they may be inscrutable, but you ignore them on a real road only at your peril. They make demands on you by their actuality.

Barthes has described the essence of photography as "'That-has-been,' or again: the Intractable" (77). This quality might apply equally to the poetry of "The Book of the Dead," which tests what happens when the reader is confronted with a demanding actuality. "What do you want—" Rukeyser asks at the conclusion of "Gauley Bridge"—"a cliff over a city? / A foreland,

sloped to sea and overgrown with roses?" Her answer offers only more in-tractable *deixis:* "*These* people live *here*" (emphasis added) (*OS* 14).

"These people"—George Robinson, Juanita Tinsley, Mearl Blankenship, and others—are allowed to speak, to tell their stories, through the poems in the sequence. They live "here"—a place we come to know through the un-folding of the poem, a place we could actually visit if we chose to follow "these roads." Louise Kertesz has suggested that in these lines Rukeyser was needling Archibald MacLeish and others who looked to the beauties of Eu-rope for "truth" or "art" (Kertesz 101). Certainly, Rukeyser does not offer beautiful images as a form of consolation in the midst of social turmoil. Nei-ther consolation nor nostalgia is the motivating force of the majority of her work. Rather, her compelling optimism rests on the idea that the reader is capable of embracing the actual and imagining the possible.

Des Pres fears that the "press of the real," heightened by the immediacy and insistence of photojournalism, flattens imagination in our culture, di-minishes the possibility of creative response to the violence of our world. Deploring the rise of certain forms of mass communication, however, will not make them disappear. Rukeyser's work offers an alternative, the possi-bility that the poet and the reader have the power to imagine in the face of "the real" and to integrate photography and documentary evidence into the imaginative and the creative. Rukeyser's faith in the documentary impulse has a direct influence on her ability to find poetic techniques to build the kind of community that Des Pres calls for in his appeal to "bardic practice." "Defense is sight," Rukeyser explains near the end of "The Book of the Dead," "widen the lens and see" (*OS* 40).

Notes

1. Translated by Vernon Watkins. This translation can be found in Barnstone et al., eds., *Modern European Poetry* (New York: Bantam, 1966), a volume that is now, sadly, out of print.

2. "Deixis" is a linguistic term that refers to the use of "deictics"—words whose referent can only be determined in relation to the speakers or the sit-uation in which they are spoken. For example, the referent of the pronoun "I" changes with each speaker. Similarly, our understanding of what is meant by words such as "here," "this," and "yesterday" is dependent on the spatial and temporal location of the speaker. Deictics are also called "shifters" and "embrayeurs" by some linguists. See Ducrot, Oswald, and Tzvetan Todorov, *Encyclopedic Dictionary of the Sciences of Language,* trans. Catherine Porter (Baltimore: Johns Hopkins University Press, 1979) and Crystal, David, *A Dictionary of Linguistics and Phonetics,* 2nd edition (Lon-don: Basil Blackwell in association with Andre Deutsch, 1985) for further information and references.

3. See, for example, "Palos Verdes Cliffs" from *A Turning Wind* (1939), "The Children's Orchard" from *The Green Wave* (1948), "Waterlily Fire" from *Waterlily Fire* (1962), "Looking" from *Breaking Open* (1973), "Song : Lying in Daylight," "The Sun-Artist," and "Poem White Page / White Page Poem" from *The Gates* (1976). Rukeyser also makes ironic use of "light" in her poem "Movie" from *Theory of Flight* (1935).

Daniel Gabriel

Metapoem (1)

the memory of the act
is not the act,
but this thinking
this pathos
drives us to a
re-creation,
a correspondence
with the act:
as if the moment
of the blood
comes into us
and the many
moments posthumous
to the blood.
they are bodies,
Sacco,
they are bodies,
Vanzetti;
they have eyes
that send
a kind of laser
through time,
this searing light
that scorches
the mind,
that charges
the blood

from the first
blood—
that moves
the words
that tell us:
the memory of the act
is not the act,
but which sing
their lives
into our very nerves.

Part V

◇◇◇◇◇◇◇◇◇

Remembering Muriel Rukeyser

Judith Hemschemeyer

To Muriel Rukeyser

I saw you only twice,
once leaning on a friend and a cane,
head high, your wide-open face,
your splayed, caped body moving
like a great ship in the rain

unashamed of anything
that body ever did or could do,

then at that reading,
your last poems larger than life,
huge on the page
because that's the way you had to write them
so you could see.

Yet you watched over your city
to the end.

Now let us watch with you
and take you by the hand
and walk with you
past all those tender, cardboard poems
propped in shop windows:

"Any Kind Sandwich"
"Every Monday Closed, Rose."

Jan Heller Levi

◇◇◇◇◇◇◇◇◇

"Too Much Life to Kill": Some Thoughts on Muriel Rukeyser

Note: This essay is based on the transcript from a talk delivered at The Modern Language Association's Annual Meeting of 1994 as part of a panel on Muriel Rukeyser entitled "How Shall We Tell Each Other of the Poet?: The Life and Writing of Muriel Rukeyser," organized by Anne Herzog and Janet Kaufman.

Muriel Rukeyser was our great epistemologist of feeling. In her life and work, she wanted to draw on two ways of knowing (she would say "reaching") that have been deemed in our culture mutually exclusive: verifiable and unverifiable fact. Verifiable facts come from documentary evidence, interviews, transcripts, Congressional hearings, laboratory and medical reports, and newspapers, for example. Information gleaned from such sources is the most honored, most respected, and most accepted in Western culture. Unverifiable facts come to us, according to Rukeyser, through dreams, or memory, or myth. She determinedly, doggedly refused to make a poetry that privileged one of these forms of knowledge over the other. This may seem very obvious and very easy; it may seem simply the poet's job to bring together what we might call, for other purposes, the objective and the subjective.

But, first, it isn't so obvious. Here's a North American, white woman poet of the mid-twentieth century who wants to write, needs to write, about both the Spanish Civil War and breastfeeding, for example. I think we can well imagine how the camps split over that one. There were the "Hey, steer clear of politics and write poems appropriate for a woman, poems about love and love gone wrong" camps. There were the "Hey, who cares about your love

affairs, your feelings, your life, there's a war going on, a revolution going on, there's a lynching going on, there's a strike here, there are miners dying there" camps. There were those who believed women poets should write about women's things, and there were those who said, "write about women's things and you're dead in the water as far as being a poet." And nobody believed, not the children lovers or the children deniers, that anybody should be writing about breast-feeding.

Second, it isn't so simple. To say that Rukeyser showed us that we were incomplete without embracing both ways of knowing is not to say that she brought these two ways of knowing together. That would be to imagine her as a weaver or a welder, and that's not how she saw what she was doing; in fact, that's *not* what she was doing. "Fusion" might be a word we could explore, but it's not quite right either. For what we might see as a putting-together, Rukeyser saw as already fused. As she wrote in *The Traces of Thomas Hariot* (1971), "the poem is not 'emotional thinking' nor any other putting together of the split terms of our usage." It is, she said, an expression of the life buried beneath these terms, which we can "bring . . . through in ourselves." King David, she said, knew it and named it in the prayer for his son Solomon: "' . . . the thoughts of the imagination of the heart'" (258).

The following year, in an interview in *The New York Quarterly,* she puts it another way. "It isn't that one brings life together, " she said, "it's that one will not allow it to be torn apart" (Packard 132). Whatever the subject(s) of any given poem, this refusal to succumb to conventional divisions of any kind is either present, illustrated, echoed, affirmed, or embodied. In "Islands," from her last collection, *The Gates* (1976), the subject is explicitly the unity (or at least relationship) among all things, and in three haiku-like stanzas, with wickedly Western enjambment, she manages—decisively, yet so gently one almost might not notice—to chide us for our most fundamental misapprehensions of the world, and therefore, ourselves:

O for God's sake
they are connected
underneath

They look at each other
across the glittering sea
some keep a low profile

Some are cliffs
The bathers think
islands are separate like them (*RR* 256)

"Islands" is characteristic of Rukeyser's later work—spare, clean, seemingly lit from within. One of the particular delights of following her writing career is to watch as she releases her crafty sense of humor, more and more, into the poems—that's part of the appeal of the later books. The "joke" in "Islands" is, of course, an ironic one: woe to the isolated empiricists, bathing themselves in the sea of appearances. At the same time, "Islands" is a lament—for as Rukeyser is well aware, it is those who see the islands, and themselves, as separate, who rule the world. Finally, "Islands" is a marvelous piece of social philosophy, and the most profound rejoinder to John Donne's "No man is an island" that I can think of. (Rukeyser had already begun her critique of Donne's island metaphor when she makes herself an island in "Waterlily Fire" [*RR* 201–6]). Who else but Rukeyser could turn John Donne on his head, at the same time honoring the ethical impulse of his poem?

Rukeyser was frequently accused of sloppiness, or deliberate obscurity. Even her early mentor, Horace Gregory, warned her to beware of "those little swamps" that pooled in her work, places where the poems seemed to lose focus, and things "shift and blur." Hard to believe Gregory was referring to the same poet who would one day write "Islands." But many people (myself included) have drawn a somewhat causal thread between Rukeyser's stroke of 1964—which struck at her powers of speech—her struggle to regain language, and the distinct change in her style thereafter, beginning with her 1968 collection, *The Speed of Darkness*. This book has come to be acknowledged as a classic of feminist literature. It is also (or certainly should be) an essential text for anybody in the twentieth century who has given even a moment's thought to any of the following topics: love, war, sex, death, the relationship between the sexes and the relationship between same-sex partners, being a parent, being a child, being a man, a woman, a human being. In *The Speed of Darkness,* it's as if Rukeyser is systematically flinging open one sealed door after another in the human psyche and community. All excess baggage is to be jettisoned in this journey ("No more masks!"—she cries in "The Poem as Mask" [*RR* 213]) in order for her to earn the book's closing question, which asserts the fiercest claim for poetry's eternal value precisely by embracing its historical specificity. Awake at night, she is wondering who will be the "poet / yet unborn . . . / who will be the throat of these hours." Then she corrects herself. "No. Of *those* hours. / Who will speak *these* days, / if not I / if not you?" (*RR* 232, emphasis mine).

Often there's a greater honoring of Rukeyser's later books of poetry—*The Speed of Darkness* (1968), *Breaking Open* (1973), and *The Gates* (1976)—for their accessibility. Such accessibility is one of her gifts, but so is the troubling, troubled difficulty of many important poems that come before. For every one of her late, great poems, there is precedent in her earlier books.

But "precedent"—with its fixed and judicial connotation—is not quite the right word; nor, for example is "foreshadowing," which would be, in this case, just a literary device. The leaving of clues is another matter entirely, implying, as it does, that Rukeyser, as well as her readers, would share in the process of discovering these clues, and exploring their meanings. More than any poet I can think of, Rukeyser lived on paper (that she was willing to do so was clear from the start—"Breathe-in experience, breathe-out poetry" [*RR* 5]), continually exploring and elaborating her key themes of connection and growth. The ways in which these themes reveal and re-reveal themselves is, for me, one of the greatest pleasures of reading her. When she quotes Käthe Kollwitz in the poem of the same title, in a passage describing Kollwitz's working process, she is also describing her own:

> "The process is after all like music,
> like the development of a piece of music.
> The fugues come back and
> again and again
> interweave.
> A theme may seem to have been put aside,
> but it keeps returning—
> the same thing modulated,
> somewhat changed in form.
> Usually richer.
> And it is very good that this is so." (*RR* 215)

In closing, I would like to say that Muriel Rukeyser—as feminist, Jew, lover of women and men, single mother, political activist, scientific biographer, teacher, poet—has come to mean many different things to different people. As I delve deeper into her life and work, I often find my own reflection looking back at me. I frequently sense, in the passionate responses to her work by others, that I am not alone in this. But, as we each cherish our "own" Muriel, it becomes even more essential that we don't, by clinging to one part of her, let other parts be "torn away." Let's not allow this deeply psychological writer to be torn away from the political one. Let's not allow the Jew to be torn away from the American, or the experimental poet be torn away from the highly gifted formal one, or the lover of women be torn away from the lover of men. Everything she stood for in her life asks us not to do this. Here's just one of her "clues," the last stanza of her "Suicide Blues":

> Too much life, my darling, embraces and strong veins,
> Every sense speaking in my real voice,
> Too many flowers, a too-knowing sun,
> Too much life to kill. (*RR* 108)

I have used the earlier and later poems as an example of this. Beautifully resolved poems, a gem such as "Islands," for example, cannot and should not be torn away from the grand though sometimes faltering explorations of her earlier works such as "Theory of Flight," "Ann Burlak," "Suite for Lord Timothy Dexter," or "The Outer Banks." When William Carlos Williams, excited by Rukeyser's second book of poems, *U.S. 1* (1938), reviewed it for *The New Republic,* he conceded there were passages "that are pretty dull but that is bound to be the character of all good things if they are serious enough. When a devoted and determined person sets off to do a thing, he wants to get there even if he has to crawl on his face. When he is able to, whenever he is able to, he gets up and runs" (142).

It continues to astonish me to read and re-read Muriel Rukeyser as she travels through the twentieth century, sometimes crawling, more often getting up and running, and, time and time again, actually flying.

Anne Marx

For Muriel Rukeyser

On the way to join in the last tribute
to you, Muriel, as I take a late train
from my suburb to your cherished New York,
I think of you, sister poet, born in
my birth-year, recalling our final encounter:

 Privileged to introduce you, I waited
 along with a large audience. The last
 possible moment you materialized
 arriving in our town hall on your own,
 a capricious cape around your shoulders
 poorly concealing recent frailty.
 We wondered why no one brought you.

 Taking a firm stance, thin legs in flat shoes,
 you swept us into the reading, filling the air
 with passion and compassion, strong, for one hour.
 You were hitting us where we lived too complacently.
 Inscribing your last book for me later,
 you spelled my name correctly without prompting.
 (Not many do!) I took you to the train.
 Why didn't I drive you all the way home?

Back in the present, again on the train, I return
along the same route you traveled that day.
After hearing close friends revive you in fragments,
after the shock of seeing you alive on film,

I bury myself in a paperback of Emily Dickinson's poems
that manage to console me more. She died in '86.
A hundred years from now, Muriel, the unborn
will read your poems on trains of the future
for consolation. You will rouse the complacent ones.

Denise Levertov

On Muriel Rukeyser

Muriel Rukeyser, more than any other poet I know of (including Pablo Neruda), consistently fused lyricism and overt social and political concern. Her *Collected Poems,* which came out just over a year before her death, clearly reveals this seamlessness, this wholeness: virtually every page contains questions or affirmations relating to her sense of the human creature as a social species with the responsibilities, culpabilities, and possibilities attendant upon that condition. And virtually every page is infused with the sonic and figurative qualities of lyric poetry.

Her life presented a parallel fusion. From her presence as a protester at the Scottsboro trial in 1931, when she was eighteen, to the lone journey to Seoul which she undertook in 1975 in the (alas unsuccessful) attempt—using her prestige as president of PEN—to obtain the release from jail of Kim Chi Ha, the Korean poet and activist, Muriel *acted* on her beliefs, rather than assuming that the ability to verbalize them somehow exempted her from further responsibility. The range of her concern expressed the fact that she went beyond humanitarian sympathy to a recognition of interconnections and parallels: she had a strong, independent, personal grasp of politics, and just as she blended the engaged and the lyrical, the life of writing and the life of action, so too did she blend her warm compassion and her extraordinary intelligence. To list some of the subjects of her poems is also to allude to events of her biography, and vice versa: Spain during the civil war; the working conditions of West Virginia miners in the 1930s; the unhating, profoundly civilized spirit of Hanoi, 1972; war-resistance and jail in D.C.— these are a few instances that come to mind. Whether working with schoolchildren in Harlem or learning to fly a plane; whether experiencing single-parenthood or researching the life of the sixteenth/seventeenth-century mathematician, explorer and alchemist Thomas Hariot, Muriel

never placed the objects of her attention in the sealed compartments of sterile expertise, but informed all that she touched with that unifying imagination that made her truly great.

Something that especially moves me about Muriel Rukeyser is the way in which her work moved towards greater economy and clarity in her later books. There are marvelous early poems, but sometimes her very generosity of spirit seemed to bring about a rush of words that had not the condensed power she eventually attained. Clarity of communication was not easy for her because her mind was so complex, causing her conversation often to be hard to follow as she leapt across gulfs most of us had to trudge down into and up the other side; but she did attain it—a luminous precision—time after time.

I had known Muriel for many years before she and I and Jane Hart went to Vietnam together in the fall of 1972. That journey bound us in a deeper friendship. Among my recollections are two small incidents from that trip that seem expressive: one is her painful embarrassment at having to receive medical attention in a Hanoi hospital—she felt that, among so many war-injured Vietnamese civilians, an American with an injured toe was grossly out of place. (In fact, the matter was serious because of her diabetes.) The other is the look of distress I suddenly noticed on her face when I, in answer to a question from one of the Vietnamese writers we met, described New York City in extremely negative terms. She was a New Yorker born and bred and though she knew all about its terrors and tragedies, she loved the city and saw its possibilities, looking upon it with a passionate hope, as upon a troubled but beloved person.

It would be inappropriate to memorialize her, however briefly, without mentioning her humor. (She included in her last book the two-line squib,

I'd rather be Muriel
than be dead and be Ariel,

under the title *Not to be Printed, Not to be Said, Not to be Thought.*) Equally inappropriate would be omission of a reference to her lifelong interest in science and to the fact that she wrote not only poetry (including translations) but notable biographies, children's books, and two other uncategorizable prose works, *The Life of Poetry* and *The Orgy.* Then, too, there was her life as a teacher, for many years, at Sarah Lawrence, where the tutorial system demands of faculty an unusual degree of dedication.

The loss of this person, this poet, and for some of us this wonderful friend, is a great one. Her work and her example remain to sustain us—an ongoing source of life-affirmative energy. In the preface to her *Collected Poems* she wrote of "the parts of life in which we dive deep and sometimes—

with strength of expression and skill and luck—reach that place where things are shared, and we all recognize the secrets." Muriel Rukeyser had that strength, that skill, that luck—and she did reach that place.

II: About Muriel, August 1980

I first met Muriel at a dinner preceding a reading in New York City. We were both to read. I was very late because I got lost on the Columbia campus and didn't have with me the exact location of the event. It was a wild, windy night and I wandered about confused and anxious. When I finally got to the right building and right room my impression was of a crowd of dark-suited irritable middle-aged men holding sherry glasses and looking at their watches. From the midst of them broke the tall and massive woman who was Muriel—she came welcomingly towards me on thin legs, like a large water-bird, and exclaimed in a deep voice (not really so much deep as rich) "Ah, you've come at last! I've been terribly bored, waiting to meet you!" I'm sure that in fact there were nice and interesting people there, but Muriel so out-shone them all that the effect for me resembled the cinematic technique which puts all but one character out of focus and concentrates the specta-tor's awareness wholly on that central personage. I was nine or ten years younger and much less known than she, but Muriel at once treated me as an equal and assumed that we would be friends.

A few years later (1965) I wrote of something which occurred during the reading on that same night:

Two or three years ago Muriel Rukeyser was answering questions from the au-dience after a poetry reading at Columbia University. A man in, I judge, his late twenties—perhaps older—spoke up. "Maybe this question I'm going to ask will strike you as foolish . . . I'm not a writer myself, not an English major . . . in fact I'm an engineering student" (idiot laughter from unidenti-fied sources) "but I *am* eager to read poetry. . . . And the question I want to ask is, to get the most out of one's reading, what should one bring to a poem?" Muriel Rukeyser is a tall, leonine woman, a genuinely sibylline presence. She rose and stood silent while she brooded over what had been asked; her arms hung by her sides, she was quite obviously unaware at that moment of the other people sitting on each side of her, or of the large audience awaiting her reply. Then she lifted her head and spoke directly to the questioner: "It's *not* a foolish question. It's a question everyone has to ask, all of us. And I think what must be brought to a poem is what must be brought to anything you care about, to anything in life that really matters: ALL of yourself."

When the deep voice, sure of what it felt, ceased to speak there was a long quietness. Then people rose to their feet to clap. It is not often that the an-swer to a question is thus applauded.

My son must have been about twelve when I began to know Muriel, and her son was two or three years older. We arranged for the two boys to meet, but children rarely take to one another when they are supposed to, and they did not develop a friendship as we had hoped. But Muriel always took a special interest in Nikolai, writing him recommendations for Putney and The Rhode Island School of Design which helped his acceptance at both places, and from time to time exchanging letters with him. This feeling for Nik was personal and particular, but it was also an instance of her great love for children and indeed for all kinds of beginnings, seeds, images of growth. Over the years our friendship, though we saw one another rarely, continued to grow. I dedicated a poem called "The Unknown" to her because it seemed to be about a kind of revelation Muriel's imagination exemplified: the way the unconscious works at a different pace from our willful intentions, and surfaces—bringing us clues, keys, rewards—only after strenuous efforts have been put aside and replaced by a surrender that is receptive. Muriel's conversation often dipped beneath the waters of consciousness and reemerged at unexpected points as a diving bird does; to understand her one had to swoop after her, like some following, smaller bird alert to her subaqueous movement.

Going to Vietnam together (with Jane Hart) in 1972 of course consolidated our friendship. One of my residual impressions of that trip is of how firm and strong a presence she was, how unflappable. She saw and felt everything so deeply, but while Jane, I think, relied (at first) on a certain scepticism to protect herself from some of the impact of what we experienced, and while I tended to seesaw between euphoria and despair, Muriel stood rocklike in the midst of what we all knew to be American shame and Vietnamese courage, never losing either her compassion or her humor. Her sensibility was so well tuned that she could derive from it sound and balanced intellectual conclusions without going through a laborious reasoning process. Of course, she was at the same time highly intellectual and passionately interested in ideas and in science, but her intellect was fed to an unusual degree from intuitive sources. Another poem of mine, "Joy" (which also quotes from a letter of my mother's about the rediscovery of joy after its long absence), refers to an experience of Muriel's when she was hospitalized in the mid-sixties and the accidental breaking of old scar tissue released in her a new flow of psychic energy.

With all her intelligence, energy, and humor, she was nevertheless terribly vulnerable to feelings of shame and embarrassment. She was also, like everyone else, not free of feelings of jealousy and hurt pride in certain situations, but what was so marvelous and lovable in her was the way in which she could admit them. No one I've ever known was more generous.

After my mother died in 1977, when I told Muriel forlornly that I felt myself to be a middle-aged orphan, she said, "Oh, I'll adopt you. You'll be

my Adopted Something." She meant that and I felt it, felt warmed and strengthened. She was the same age as my late sister, but I don't think we felt like sisters—a truly sisterly relationship must be based on a closely parallel childhood and youth. Muriel and I were colleagues who became friends—fellow votaries of Poetry who were also mothers and political allies. Her "adoption" of me gave a further depth to that relationship, and she was a source of strength to me although she herself was declining in physical strength.

Muriel's last word to me was a phone call she made to Arkansas to tell me I'd been elected to the American Academy of Arts and Letters. I was much more impressed at her kindness in doing so than by the honor itself, which I didn't fully understand. But a few weeks afterwards, when Grace Paley called to tell me Muriel had died that day, I realized that my election and Grace's, both of which Muriel had evidently worked for, unknown to us, constituted a kind of bequest from her. She lives in her work and in our memories; but life has less resonance without her.

Gerald Stern

A Short Oration For Muriel

Muriel Rukeyser was a poet of light. *The* poet of light, as the Persians understood light and as the Europeans and Americans tried to. That is, she believed in the radiant place, though she did not seem to be obsessed by opposites in the classic manner. She was unencumbered by Pascalian doubt, though she had a little Descartian and a little Kierkegaardian. She predated and anticipated and prepared the way for three generations of feminists. She spoke constantly, and fiercely, for the despised and the unacknowledged. She was Jungian more than Freudian and Reichian more than Jungian. She was consistent. Her radicalism became only more lucid and human and personal the longer she lived. She had the long view. She was influenced in dozens of ways by writers as diverse as Eliot, Browning, Shelley, Pound, Rimbaud, Rilke, Crane, cummings, Auden, Macleish, Whitman, Dos Passos, Stein, Jeffers. But she had a distinct and amazing voice from the very beginning. She became a better and better poet the older she got. In her poetry, she was, among other things, a speaker, an orator—not in the self-conscious sense of Auden, say, good as that was, but in the serious sense of the Amerindian, the Greek, the Biblical. She was a master of the lyric and the long poem. She was the most generous poet of the twentieth century. She was a dramatic poet and I think she had the radio play in mind, particularly in her early poems. Much of what she did, including the last great poem "The Gates," could have been and probably will be dramatized as the American theater comes to know her. And her magnificent novel, *The Orgy*, could be made into a powerful play or film. It almost begs for that.

Just as she came to terms in her lifetime with the nature of poetic utterance, so she came to terms and agonized over and sought to understand the significance of her Jewishness and her femaleness. She was treated abominably by the men of her generation, I suspect because she was an outspo-

ken woman and because her poetics were not their poetics, just as her politics, in the main, were not theirs. She spoke the unspoken and the unspeakable. She made poems out of new material. She continued and reinvigorated modernism, yet she directly challenged it. She was a great teacher and a great friend. She taught us in a trice how the political poem was to be written. She was talking personally, and we invoke her poetry when we invoke her, just as we do with, say, Baudelaire or Pound or Browning.

Her soul was in New York City and she was there at a lucky time. Her body betrayed her a little, like everyone's. She was an absolute master of situations. She had ears and eyes everywhere. She shared her *shame* with us. She was patient; she allowed herself to be weak. She was a poet of ecstasy but not religious ecstasy in the English and Spanish tradition, for example. She was a follower of Orpheus, but Orpheus the singer, the singing head, rather than he of the backward stare. She was tremendously aware of her own body as a poetic source, and though it was common in her day as in our own, she never was a toady—when we think of her we'll just have to throw that word away. Whatever else poetry was for her, it was a means of explanation and it was a reminder that we must change.

She loved Icarus, she loved Houdini, she loved the Blues. She told secrets, since she was a prophet. She believed in extraordinary moments. She loved John Quincy Adams, Congressman and president. She fought against fear. Her vocation was bard. She almost remembered the nineteenth century. She grew up when the skyscrapers were being erected in New York. She was privileged economically and socially, but she put it to use rather than indulge it. She was alone, deeply alone, particularly in her early years. She did not believe in a fallen world or a depraved world. She was one of the first to speak about process, relationship, possibility, as it affects poetry. She was happy the world was pear-shaped. She understood darkness.

One time I came to visit Muriel shortly after my book *Lucky Life* was accepted for publication. She had recently had a stroke and was in bed in her apartment in New York. I wanted to subtly release her from her promise to write a blurb for my book and was working my charm, which of course she saw through immediately. "Help me out of bed, Mr. Poet," she said. I was always half delighted, half chagrined, that she called me "Mr. Poet" when she was either pleased or vexed with me. When we got to the kitchen and I had made her tea she told me from memory what it was she was planning on saying on my book jacket. She seemed surprised that I didn't know by heart what the one or two other supporters were going to say, so strong was her belief in the oral.

One time we were reading together at the Walnut Street Theater in Philadelphia. It was 1976, I believe. It was a huge crowd, come to see her, for I was still fairly unknown. First we answered questions. I was being

taunted by a member of the audience on my poem "Behaving Like a Jew," which contained a decent attack on Charles Lindbergh, the Jew-hater and blue-eyed soloist. I was gearing up for an attack, but tried to restrain myself; it was such a pleasant evening. "I don't want to be mean," I said. "Be mean, be mean," she whispered to me in a loud enough voice. She gave a gorgeous reading that evening, full of free association, impromptu thought, and spontaneous vision. I was deeply moved, and I was going to love her forever. I was very, very mean to my tormentor.

Daniel Halpern

Muriel

By the time we first met
you were the big-hearted poet,
big in every way,
breast and head, wrist and calves,
but largest in the heart.
And deep in the eye, grey
like your hair, unlike those areas
through which you moved
as if on glass, unyielding
in your big, gentle way, no longer
that dark beauty of the oval picture
set at the back of Oscar Williams' anthology
where I first found your poems.
I still have that black
enameled painting you brought back
from Vietnam—was I to pass it along
to your friend Denise?
I've let you down.
I've kept it as your gift to me—
the oldest of four, the only male,
I've always kept what I imagined I needed
to possess.
 When things seemed
to be going the right way,
you would look up, place your hands
in front of you, squaring
your shoulders, and say,

Oh good. Good.
And it was like an authority
from the high Renaissance
giving that part of life the okay.
We last met over burgers
on Fifth at 38th Street.
You were tired and your body
was beginning to let you down,
along with the ongoing shabbiness
of our country's politics. Your eyes reflected
the opacity of the national vote.
But there was never a meeting
in which you didn't find the chance
to bless one thing or another. *Good.*
The delicate figures of that enameled painting
hover near me in their black backdrop,
large with the suffering you shared with them,
as you shared the sadness of being here,
in mourning, in joy—Muriel, we are pedestrians
in the body's ghetto, and the ghetto
our bodies inherit and rise from.
Good. As you would want it.

William L. Rukeyser

Inventing a Life

My mother's views of poetry and people were not always consistent. But the contradictions in her character made my mother much more interesting than if she had been 100 percent consistent.

Muriel Rukeyser really believed that poetry is for everyone, that we could all do it. While she said that poetry was egalitarian, she insisted on and valued a high degree of excellence; she could be scathing of students and others she felt were lazy or untalented writers. However, she told my high school class that the Beatles were poets and cried when she listened to "Eleanor Rigby." She also loved to make up bilingual doggerel that made little sense in either English or French.

My mother invented her own career and she invented her life. She broke a lot of rules and she paid the price. In the thirties she didn't fear to embrace the Communists—for what they believed, or at least what they said they believed. But she wasn't timid about rejecting Communist dogma or thought control. For her pains she was vilified by both sides in many battles because she wouldn't follow anybody's party line except her own. When others talked or wrote about "The People," she kept her eyes on the stories of one person at a time. She believed in the nobility of labor, but she recognized the absurdity of a lot of it. I remember her closely observing, from her bedroom window, a Con Ed (New York City electricity company) crew at the corner of York and 88th. That crew dug holes in the pavement, covered them with steel plates, and then paved them over. All to restart the process immediately, before the tar was cool.

In her professional life she refused to play the office politics that are often necessary to get ahead in the literary and academic worlds.

On a personal level she rejected the life of a suburban, married matron her parents had designed for her. She decided to become a single mother at a time when such a decision was much more difficult than it is today.

However, my mother often talked the way some people felt she wrote: indirectly, tossing out seemingly contradictory clues rather than simple declarative sentences. That is why it is difficult, even this much later, to say for sure whether she made the decision to have a child before she became pregnant or only after. It is also impossible to say whether there was affection between her and her mate. Some indications are that she went searching for a father for her child the way people go to The Gap: she was shopping for genes.

Regardless, several friends pointed out the challenges of single motherhood and offered her a variety of alternatives during her pregnancy and my infancy. If she had her early doubts, her resolve was strengthened during that time.

But she did not resolve how to present her decision to have a child (either within her own family or to the rest of the world). While she hints at the situation and the challenges in her writing, she made up and stuck to a variety of contradictory stories that involved a marriage and widowhood prior to my birth. She also insisted on using a "Mrs." in front of her maiden name, and on my birth certificate used a false name for the father, which was an anagram of his real name. As far as I could tell, she never truly resolved how to present her decision to become a single mother.

She was not always the absolutely certain and self-confident person she often appeared to be. In fact she respected and often sought the advice of people whose world views were far more conservative than hers.

The decisions she made during my childhood tell us something about her methods of coping in the fifties. She stayed firmly rooted in the liberal milieu of New York City. As improbable as it sounds, she found a school for me in the city with demographics such that the average class was mostly Jewish, had several blacks and Puerto Ricans and other Catholics, and one token WASP. On top of that, most of the kids had one parent at home—although usually because of divorce. It wasn't until I was sent away to a more conservative high school that I realized the rest of America didn't look that way.

Muriel Rukeyser was proud of what she was: Jewish, fat (in her view that equated to strong), independent—a free woman, long before society was ready for free women.

But she was also fascinated by what she wasn't. "When I'm thin, blonde and rich" was a favorite way for her to start conversations. She also flirted with the Episcopalian church.

If she had felt the complete freedom to invent herself, there would have been another Muriel beside the consummate New Yorker that she was. This

Muriel would have been seen paddling around New England in a canoe. She even visualized the color and brand it would have been . . . a red Old Town. She never got it. But she did follow the advice of *The Wind in the Willows,* and she liked to "mess about in boats." One of her favorite places was New York's City Island, where she would go to rent outboard motor boats. I remember one afternoon driving there and stopping at a little city park that had granite busts of old Greek gods and Homeric figures. I was about ten at the time. Most of the busts had their noses broken off, but instead of launching into a tirade about vandalism, she took this opportunity to give me an impromptu lesson in Greek mythology.

One of the American myths that fascinated my mother was that of Erich Weiss, better known as Harry Houdini. She certainly wasn't the only one; many people have focused on Houdini's ability to escape from anything and his debunking of the paranormal, but Muriel Rukeyser's fascination was probably as much with his invention of his identity as anything else. It was no accident that she wrote a play, a musical, about Houdini, and that it dealt prominently with Houdini's invented identity.

One song in the musical, "I Make My Magic," contains these lines:

and I am clear of all the chains
and the magic now that rains
down around me is
a sunlight magic,
I come to a sunlight magic,
yours.

Muriel Rukeyser spent her life getting clear of other people's chains. Even if she constructed a few of her own, she was largely successful in inventing her life.

Contributors

SUSAN AYRES is visiting Assistant Professor of Law at Roger Williams University School of Law. She has published articles including: "'The Straight Mind' in Russ's *The Female Man,*" "'Piper, Pipe That Song Again': The Pied Piper Motif in the Poems of W. S. Merwin," "Women in the Later Poems of William Carlos Williams," and "Coming Out: Decision-Making in State and Federal Sodomy Decisions."

JOHN BRADLEY's *Love-In-Idleness: The Poetry of Roberto Zingarello,* a manuscript of persona poetry, won the Washington Prize. He is the editor of *Atomic Ghost: Poets Respond to the Nuclear Age,* an international poetry anthology published by Coffee House Press. Bradley teaches writing at Northern Illinois University.

JAMES BROCK is a teacher and a poet. He has been awarded an NEA Fellowship, the Alex Haley Fellowship from the Tennessee Arts Commission, and the Artist Fellowship for Poetry from the Idaho Commission for the Arts. His first book, *The Sunshine Mine Disaster* (1996), takes its cue from Rukeyser's *U.S. 1.*

CHRISTOPHER COKINOS has been the recipient of awards from the Kansas Arts Commission (1996 Poetry Mini-Fellowship) and the American Antiquarian Society (1998 Lila Wallace/Reader's Digest Fund Visiting Artist Fellow). His book of literary nonfiction, *Hope Is the Thing with Feathers: A Personal Chronicle of Extinct American Birds,* is forthcoming from Tarcher Books, an imprint of Penguin-Putnam.

JANE COOPER taught for many years at Sarah Lawrence College, where she was a colleague of Muriel Rukeyser. She is the author of four books of poems, most recently *Green Notebook, Winter Road* (Tilbury House, 1994). In 1995 she was named New York State Poet. She has received, among other honors, the Lamont Award of the Academy of American Poets, a 1995 Award in Literature from the American Academy of Arts and Letters, and fellowships from the National Endowment for the Arts, and the Guggenheim and Ingram Merrill foundations.

ALMITRA MARINO DAVID was born in Pittsburgh in 1941. She currently teaches Spanish at Friends Select School in Philadelphia. Her poems and translations have been published in various journals; her chapbook, *Building the Cathedral,* was published in 1986 by Slash & Burn Press. Her first book, *Between the Sea and Home,* won the Eighth Mountain Press Poetry Prize, selected by Linda Hogan, in 1992.

JAN JOHNSON DRANTELL is the author of *Healing Hearts* (Bantam, 1994) and co-author of *A Music I No Longer Heard: The Early Death of a Parent* (Simon & Schuster, 1998). Her poetry and short fiction have been published in various small journals including the story "Blood Dirt Red" in *Fourteen Hills* (San Francisco, Spring 1997). She is a book editor and lives in Boston.

ELAINE EDELMAN's published works include *Boom-De-Boom* (1980) and *Noeva: Three Women Poets* (1975). Her essays and articles have appeared in *Esquire, The New York Times Book Review,* and *Vanity Fair,* among others. She has published poems in *American Poetry Review, Prairie Schooner,* and *Hanging Loose.* Edelman currently teaches creative writing in New York City for The Writer's Voice of The West Side Y.

SUSAN EISENBERG is the author of *We'll Call You If We Need You: Experiences of Women Working Construction* (Cornell, 1998) and *Pioneering: Poems from the Construction Site* (Cornell, 1998). A union electrician for 15 years, she received her MFA from the Program for Writers at Warren Wilson College. She teaches at the College of Public and Community Service of the University of Massachusetts, Boston.

DANIEL GABRIEL has published two books, *Columbus* (Gnosis Press, 1993) and *Sacco and Vanzetti* (Gull Books, 1983), both book-length poems. His poetry has appeared in *American Poetry Review, Poetry New York,* and *Gnosis Anthology,* among others. He teaches at Rutgers University.

LORRIE GOLDENSOHN is the author of two books of poetry, *The Tether* and *Dreamwork.* Her work *Elizabeth Bishop: The Biography of Poetry* (1993) was published by Columbia University Press. She teaches at Vassar College.

REGINALD GIBBONS has published six volumes of poetry, most recently *Sparrow: New and Selected Poems* (LSU Press, 1997) and *Homage to Longshot O'Leary* (Holy Cow! Press, 1999), as well as the novel *Sweetbitter* (Penguin, 1996) and other books. From 1981 to 1997 he was the editor of *TriQuarterly* magazine at Northwestern University, where he is a Professor of English.

DANIEL HALPERN is editor-in-chief of Ecco Press. Winner of the Jessie Rehder Poetry Award, the YMHA Discovery Award, an NEA Fellowship, and a Robert Frost Fellowship, Halpern has taught creative writing at the

New School, Princeton University, and Columbia University. His most recent publications are *Selected Poems* (1994), *Foreign Neon: Poems* (1991), and *Tango: Poems* (1988).

STEPHANIE HARTMAN has a Ph.D. in Literature in English from Rutgers University, where she has taught modern poetry, women's studies, and literature survey courses. Her dissertation examines how twentieth-century poets have used the occasion of illness to redefine identity.

JUDITH HEMSCHEMEYER is the author of four books of poetry: *I Remember the Room Was Filled with Light* (Wesleyan, 1973), *Very Close and Very Slow* (Wesleyan, 1975), *The Ride Home* (Texas Tech, 1987), and *Certain Animals* (Snake Nation Press, 1998). Her translation of *The Complete Poems of Anna Akhmatova* was published by Zephyr Press in 1990, and her book of stories, *The Harvest,* by Pig Iron Press in 1998.

ANNE HERZOG is Associate Professor of English at West Chester University. She has published on both Adrienne Rich and Muriel Rukeyser and has recently contributed articles to *Calyx, Contemporary Women Writers* (St. James Press), and *Modern Women Writers* (Continuum). Her current scholarship continues to focus on the politics and poetry of American women writers.

RICHARD HOWARD's most recent book of poems is *Like Most Revelations* (1994); in 1996 he was awarded a MacArthur Fellowship. In 1970 he was awarded a Pulitzer Prize for his third book of poems, *Untitled Subjects,* and received the National Institute of Arts and Letters Literary Award for his poetry. He is currently a University Professor of English at the University of Houston.

JANET KAUFMAN is Assistant Professor at the University of Utah, focusing on English Education. She has written about adolescent literature and teaching in *English Journal, Helping Adolescents at Risk Through Literature* and *By the Flash of Fireflies: Perspectives on Teaching Short Fiction.* Together with Salt Lake City teachers, students, pre-service teachers, and university colleagues, she is developing a family literacy center.

AARON KRAMER's poetry collections include *On the Way to Palermo, Carousel Parkway,* and *The Burning Bush.* His scholarly works include *The Prophetic Tradition in American Poetry* and *Melville's Poetry: Toward the Enlarged Heart.* Dr. Kramer received his Ph.D. at New York University and was Professor of English at Dowling College, Long Island, from 1961 until his death in 1997.

DENISE LEVERTOV has published over 17 books of poetry and prose including *Poems 1960–1967, Oblique Prayers, Breathing the Water,* and *A Door in*

the Hive. She received the Elmer Holmes Bobst Award in poetry, the Lannan Prize, and the 1996 Governor's Writing Award from the Washington State Commission for the Humanities. She died of lymphoma on December 20, 1997, in Seattle, Washington.

JAN HELLER LEVI was awarded the 1998 Walt Whitman Award by the Academy of American Poets for her collection of poetry *Once I Gazed at You in Wonder*. Her poems have appeared in such publications as *The Antioch Review, The Beloit Poetry Journal, The Iowa Review,* and *Ploughshares*. She was Muriel Rukeyser's personal assistant from 1978 to 1980 and is the editor of *A Muriel Rukeyser Reader* (Norton, 1994), named one of the Best Books of 1994 by *Choice* magazine. She is currently under contract by Knopf to write a biography of Muriel Rukeyser.

LYN LIFSHIN has written more than 100 books and edited 4 anthologies of women writers, including *Tangled Vines: Mother and Daughter Poems* and *Ariadne's Thread: Women's Diaries and Journals*. Her latest book of poems, *Cold Comfort,* is available from Black Sparrow Press.

CHRIS LLEWELLYN has published two books of poetry: *Fragments from the Fire: The Triangle Shirtwaist Company Fire of March 25, 1911* (1987), which won the Walt Whitman Award, and *Steam Dummy* (1993). She has been the recipient of grants from the NEA and the Washington, D.C. Commission on the Arts and Humanities. She currently teaches poetry at the Writer's Center, a community workshop in Bethesda, Maryland.

JOHN LOWNEY is Assistant Professor of English at St. John's University, New York. He is the author of *The American Avant-Garde Tradition: William Carlos Williams, Postmodern Poetry, and the Politics of Cultural Memory* (Bucknell University Press, 1997). His articles have appeared in *American Literature, Contemporary Literature, Sagetrieb,* and *MELUS*.

ANNE MARX's most recent books of poetry are *Love in Late Season: New Poems* (1993) and *A Further Semester: New Poems* (1985).

LESLIE ANN MINOT has recently completed a Ph.D. in Comparative Literature at the University of California at Berkeley, where she was active in anti-oppression work and the graduate-student labor struggle. She currently works as a grant writer in the nonprofit sector of the San Francisco Bay Area.

SHARON OLDS's most recent book of poems is *The Wellspring* (1995). Her book *The Dead and the Living* (1984) was both the Lamont Poetry Selection for 1983 and winner of the National Book Critics Circle Award. Olds teaches poetry workshops in the Graduate Creative Writing Program at New

York University and helps run the NYU workshop program at Goldwater Hospital on Roosevelt Island in New York.

ALICIA SUSKIN OSTRIKER is a poet and critic and author of nine books of poetry—most recently *The Little Space: Poems Selected and New, 1968–1998,* which was nominated for a National Book Award. As a critic she is the author of *Stealing the Language: The Emergence of Women's Poetry in America,* and *Feminist Revision and the Bible.* Ostriker is Professor of English at Rutgers University.

RUTH PORRITT's work has appeared in *Women's Studies: An Interdisciplinary Journal, The Bedford Introduction to Literature, Writing Poems,* and *The Virginia Quarterly Review.* She is Associate Professor of Philosophy and Women's Studies at West Chester University, where she specializes in Aesthetics.

ADRIENNE RICH has published more than 15 volumes of poetry, including her most recent: *Dark Fields of the Republic: Poems 1991–1995* and *Midnight Salvage: Poems 1995–1998.* Her prose works include *Of Woman Born* and *What is Found There: Notebooks on Poetry and Politics.* She received a Mac-Arthur Fellowship in 1994.

WILLIAM RUKEYSER has spent his career in broadcast news and political communications. He was educated at the University of California, Berkeley and has lived in Europe, Canada (during the Indochina War), and California. He has four children and currently coordinates an educational nonprofit organization in California's Central Valley.

MEG SCHOERKE is Assistant Professor of English at San Francisco State University and has recently contributed articles to *The Oxford Companion to Women's Writing in the U.S.* (Oxford University Press) and *The Gay and Lesbian Literary Heritage* (Henry Holt). Her poems have appeared in journals such as *The American Scholar, TriQuarterly,* and *River Styx.*

GERALD STERN is the author of nine collections of poetry—most recently *This Time,* which was awarded the 1998 National Book Award for Poetry. He is a recipient of a Guggenheim Fellowship and grants from the National Endowment for the Arts, as well as the winner of a Lamont Poetry Prize, the Bess Hoskin Award for Poetry, and the Paterson Poetry Prize, among others. He recently retired from the faculty of the Iowa Writers' Workshop.

STEPHANIE STRICKLAND is the author of *Give the Body Back* (University of Missouri Press, 1991), *The Red Virgin: A Poem of Simone Weil* (University of Wisconsin Press, 1993), and *True North* (University of Notre Dame, 1997). *True North* has been awarded the Poetry Society of America's Di Castagnola prize, selected by Barbara Guest, as well as the Notre Dame Sandeen Prize.

MICHAEL TRUE, author of *An Energy Field More Intense Than War: The Nonviolent Tradition and American Literature* (1995), was a Fullbright Lecturer in India, 1997–98. He has taught at colleges and universities in the U.S. and China, including Assumption College in Massachusetts, Colorado College, University of Hawaii, and Nanjing University.

MICHELE S. WARE teaches in the University Writing Program at Duke University. She is currently working on a manuscript about aesthetics and artists in Edith Wharton's short fiction. Her scholarly interests include the American short story and American women's political poetry.

SHOSHANA WECHSLER lives in San Francisco where she is completing a Ph.D. in English at Stanford. She is currently working on a book-length study entitled "Modernist Objectivity."

Works Cited

Agee, James and Walker Evans. *Let Us Now Praise Famous Men: Three Tenant Families.* 1939. Boston: Houghton Mifflin, 1960.

Apel, Dora. "Heroes and Whores: The Politics of Gender in Weimer Antiwar Imagery." *Art Bulletin* (September 1997): 380.

Applebaum, Wilbur. Rev. of *The Traces of Thomas Hariot. Isis* 63 (June 1972): 278–80.

Auden, W. H. "Spain." *Selected Poems.* Ed. Edward Mendelson. New York: Random House, 1979.

Baker, Houston A., Jr. "Lowground and Inaudible Valleys: Reflection on Afro-American Spirit Work." In *Afro-American Poetics: Revisions of Harlem & The Black Aesthetic.* Madison: U of Wisconsin P, 1988.

Barber, David S. "'The Poet of Unity': Muriel Rukeyser's *Willard Gibbs.*" *CLIO* 12.1 (Fall 1982): 1–15.

Barnstone et al., eds. *Modern European Poetry.* New York: Bantam, 1966.

Barr, Alfred H. Introduction. *Machine Art: March 6 to April 30, 1934.* By the Museum of Modern Art. New York: MoMA, 1934.

Barthes, Roland. *Camera Lucida: Reflections on Photography.* Trans. Richard Howard. New York: Hill and Wang, 1981.

Berg, Stephen and Robert Mezey, eds. *The New Naked Poetry.* New York: Bobbs-Merrill, 1976.

Berman, Marshall. *All That Is Solid Melts Into Air.* New York: Penguin, 1982.

Bishop, John Peale. "Spirit and Sense." Rev. of *A Turning Wind,* by Muriel Rukeyser. *The Nation* (20 July 1940): 55–56.

Blackmur, R. P. "Notes on Eleven Poets." Rev. of *Beast in View,* by Muriel Rukeyser. *Kenyon Review* 7 (1945): 339–52.

Blau, Joseph L. *Men and Movements in American Philosophy.* 1952. Westport, CT: Greenwood P, 1977.

Bogan, Louise. Rev. of *Selected Poems,* by Muriel Rukeyser. *New Yorker* (Nov. 3, 1951): 150–51.

Brecht, Bertolt. "Writing the Truth: Five Difficulties." In *Galileo,* Ed. Eric Bentley. New York: Grove Press, 1966.

Brinnin, John Malcolm. "Muriel Rukeyser: The Social Poet and the Problem of Communication." *Poetry* 61 (January 1943): 554–75.

Brodsky, Joseph. *Less Than One: Selected Essays.* New York: Farrar Straus Giroux, 1986.

Brooks, Cleanth and Robert Penn Warren, eds. *Understanding Poetry.* New York: Holt, Rinehart & Winston, 1938.

Brown, Jane. "The Girl in the Lab Thinks of Her Grandmother." *Songs of Science.* Ed. Virginia Shortridge. Boston: Marshall-Jones, 1930. 69.

Buber, Martin. *Between Man and Man.* Trans. Ronald Gregor Smith. New York: Collier Books, 1965.

———. *I and Thou.* Trans. Ronald Gregor Smith. New York: Collier, 1958.

Burke, Kenneth. Introduction. *Testimony.* By Charles Reznikoff. New York: Objectivist P, 1934.

Burnett, Whit, ed. *This Is My Best.* New York: Dial, 1942.

Burnshaw, Stanley. "Response to Edwin Rolfe." *Partisan Review* 2 (April-May 1935): 47–49.

Butler, Judith. *Bodies That Matter: On the Discursive Limits of "Sex."* New York: Routledge, 1993.

———. *Gender Trouble: Feminism and the Subversion of Identity.* New York: Routledge, 1990.

Caldwell, James R. "Invigoration and a Brilliant Hope." Rev. of *The Life of Poetry,* by Muriel Rukeyser. *The Saturday Review* (11 March 1950): 26.

Cherniack, Martin. *The Hawk's Nest Incident: America's Worst Industrial Disaster.* New Haven: Yale UP, 1986.

Cixous, Hélène. "The Laugh of the Medusa." Trans. Keith Cohen and Paula Cohen. *New French Feminisms: An Anthology.* Ed. Elaine Marks and Isabelle de Courtivron. New York: Schocken, 1980. 245–64.

———. "Sorties." Trans. Betsy Wing. *The Newly Born Woman,* by Hélène Cixous and Catherine Clément. Minneapolis: U of Minnesota P, 1986. 63–132.

Coleridge, Samuel Taylor. *Biographia Literaria or Biographical Sketches of My Literary Life and Opinions.* Ed. James Engell and W. Jackson Bate. Vol. 7 of *The Collected Works of Samuel Taylor Coleridge.* 16 vols. Princeton: Princeton UP, 1971.

———. Letter to William Sotheby. 10 September 1802. *Selected Letters.* Ed. H.J. Jackson. Oxford: Oxford UP, 1987. 112–17.

Comini, Allesandra. "Kollwitz in Context." In *Käthe Kollwitz,* Ed. Elizabeth Prelinger. New Haven: Yale UP, 1992.

Crystal, David. *A Dictionary of Linguistics and Phonetics.* 2nd ed. London: Basil Blackwell in association with Andre Deutsch, 1985.

Daniels, Kate. Introduction to *Out of Silence,* by Muriel Rukeyser. Evanston: TriQuarterly Books, 1992.

———. "Muriel Rukeyser and Her Literary Critics." *Gendered Modernisms.* Ed. Margaret Dickie and Thomas Travisano. Philadelphia: U of Pennsylvania P, 1996. 247–63.

———. "Searching/Not Searching: Writing the Biography of Muriel Rukeyser." *Poetry East* 16/17 (1985): 70–93.

Daston, Lorraine and Peter Galison. "The Image of Objectivity." *Representations* 40 (1992): 81–128.

Davidson, Michael. *Ghostlier Demarcations: Modern Poetry and the Material World.* Berkeley: U of California P, 1997.

Deleuze, Gilles. *Cinema 1: The Movement-Image.* U of Minnesota P, 1986.

Denning, Michael. *The Cultural Front: The Laboring of American Culture in the Twentieth Century.* New York: Verso, 1996.

Derrida, Jacques. "Before the Law." Trans. Arital Ronell. *Acts of Literature.* Ed. Derek Attridge. New York: Routledge, 1992. 181–220.

———. "The Law of Genre." Trans. Arital Ronell. *Acts of Literature.* Ed. Derek Attridge. New York: Routledge, 1992. 221–52.

———. "Women in the Beehive." *Men in Feminism.* Ed. Alice Jardine and Paul Smith. New York: Methuen, 1987. 189–203.

Des Pres, Terrence. *Praises & Dispraises: Poetry and Politics, the 20th Century.* New York: Penguin, 1988.

Deutscher, Isaac. *The Non-Jewish Jew and Other Essays.* London: Oxford UP, 1968.

Draper, Tom. "Käthe Kollwitz Revealed in Sculpture." *Sculpture Review* 41.4 (1992): 10–12.

Ducrot, Oswald and Tzvetan Todorov. *Encyclopedic Dictionary of the Sciences of Language.* Trans. Catherine Porter. Baltimore: John Hopkins UP, 1979.

DuPlessis, Rachel Blau. "The Critique of Consciousness and Myth in Levertov, Rich, and Rukeyser." *Shakespeare's Sisters.* Ed. Sandra M. Gilbert and Susan Gubar. Bloomington: Indiana UP, 1979. 280–300.

Fabre, Geneviève and Robert O'Meally, eds. *History & Memory in African-American Culture.* New York: Oxford UP, 1994.

Federal Writers' Project (FWP). *U.S. One: Maine to Florida.* American Guide Series. New York: Modern Age, 1938.

Felman, Shoshana and Dori Laub, M. D. *Testimony: Crises of Witnessing in Literature, Psychoanalysis, and History.* New York: Routledge, 1992.

Filreis, Alan. *Modernism from Right to Left: Wallace Stevens, the Thirties, and Literary Radicalism.* New York: Cambridge UP, 1994.

Finch, Annie. *The Ghost of Meter: Culture and Prosody in American Free Verse.* Ann Arbor: U of Michigan P, 1993.

Foley, Barbara. *Radical Representations: Politics and Form in U.S. Proletarian Fiction, 1929–1941.* Durham: Duke UP, 1993.

Fuss, Diana. *Essentially Speaking.* New York: Routledge, 1989.

Fussell, Paul. *Poetic Meter & Poetic Form.* Rev. ed. New York: McGraw, 1979.

Gardinier, Suzanne. "A World That Will Hold All the People (Muriel Rukeyser)." *A World That Will Hold All the People.* Ann Arbor: U of Michigan P, 1996. 25–46.

Gibbons, Reginald and Terrence Des Pres, eds. *Thomas McGrath: Life and the Poem.* U of Illinois P, 1992.

Grahn, Judy. *The Work of a Common Woman.* Trumansburg, NY: Crossing Press, 1978.

"Grandeur and Misery of a Poster Girl." *Partisan Review* 10 (1943): 471–73.

Gregory, Horace. Undated letter to Muriel Rukeyser. Muriel Rukeyser Papers. Library of Congress, Washington, DC.

Grosz, Elizabeth. *Sexual Subversions: Three French Feminists.* Sydney: Allen & Unwin, 1989.

Hepburn, Elizabeth Newport. "Machines—Or Men?" *Songs of Science.* Ed. Virginia Shortridge. Boston: Marshall-Jones, 1930. 79–80.

Hicks, Granville. "Those Who Quibble, Bicker, Nag, and Deny." Rev. of *New Letters in America,* by Horace Gregory. *New Masses* 25.1 (28 September 1937): 22–23. Reprinted in *Granville Hicks in the New Masses,* Ed. Jack Alan Robbins, 382–87. Port Washington, NY: Kennikat Press, 1974.

Howe, Florence and Ellen Bass, eds. *No More Masks!* New York: Anchor/Doubleday, 1973.

Hughes, Robert. *The Shock of the New.* New York: Knopf, 1981.

Hulten, Karl Gunnar Pontus. *The Machine as Seen at the End of the Mechanical Age.* New York: MoMA, 1968.

Humphries, Rolfe. Letter. *New Masses* 25.6 (2 November 1937): 22. *Granville Hicks in the New Masses.* Ed. Jack Alan Robbins. Port Washington, NY: Kennikat Press, 1974. 405.

Irigaray, Luce. *An Ethics of Sexual Difference.* Trans. Carolyn Burke and Gillian C. Gill. Ithaca: Cornell UP, 1993.

Jones, Richard. *Poetry and Politics: An Anthology of Essays.* New York: Quill, 1985.

Jones, Richard and Kate Daniels, eds. *Poetry East: A Special Issue on Muriel Rukeyser* 16 & 17 (Spring/Summer 1985).

Jordan, June. "For the Sake of People's Poetry: Walt Whitman and the Rest of Us." In *On Call: Political Essays.* Boston: South End Press, 1985.

Kaladjian, Walter. *American Culture Between the Wars: Revisionary Modernism & Postmodern Critique.* New York: Columbia UP, 1993.

Kazin, Alfred. *On Native Grounds: An Interpretation of Modern American Prose Literature.* New York: Reynal, 1942.

Kearns, Martha. *Käthe Kollwitz: Woman and Artist.* New York: Midmarch Associations, 1976.

———. "Martha Kearns on Muriel Rukeyser on Käthe Kollwitz." In *Voices of Women: Three Critics on Three Poets on Three Heroines.* Ed. Cynthia Navaretta. New York: Midmarch Associations, 1980.

Kees, Weldon. "Miss Rukeyser's Marine Poem." *Partisan Review* 9 (1942): 540.

Keller, Evelyn Fox. *Reflections on Gender and Science.* New Haven: Yale UP, 1985.

Kertesz, Louise, *The Poetic Vision of Muriel Rukeyser.* Baton Rouge: Louisiana State UP, 1980.

Klingender, Francis D. *Art and the Industrial Revolution.* London: N. Carrington, 1947.

LeSueur, Meridel. "The Fetish of Being Outside." In *Writing Red: An Anthology of Women Writers, 1930–1940,* Ed. Charlotte Nekola and Paula Rabinowitz. New York: The Feminist Press at the City U of New York, 1987. 299–303.

Levertov, Denise. "On Muriel Rukeyser." *Light Up the Cave.* NY: New Directions, 1981. (189–195).

———. *Poems 1960–67.* New York: New Directions, 1983.

Levi, Jan Heller, ed. *A Muriel Rukeyser Reader.* New York: Norton, 1994.

Levine, Lawrence W. "American Culture and the Great Depression." *The Yale Review* 74.2 (1985): 196–223.

Lingus, Alphonso. *Foreign Bodies.* New York: Routledge, 1994.

McCorkle, James. "Contemporary Poetics and History: Pinsky, Klepfisz, and Rothenberg." *The Kenyon Review* 14.1 (1992): 171–88.

Mangione, Jerre. *The Dream and the Deal: The Federal Writer's Project 1935–1943.* 1972. Philadelphia: U of Pennsylvania P, 1983.

Marx, Leo. *The Machine in the Garden: Technology and the Pastoral Ideal in America.* New York: Oxford UP, 1964.

———. *The Pilot and the Passenger: Essays on Literature, Technology, and Culture in the United States.* New York: Oxford UP, 1988.

Meredith, William. *Effort at Speech.* Evanston: Northwestern UP, 1997.

Meskimmon, Marsha. *The Art of Reflection: Women Artists' Self-Portraiture in the Twentieth Century.* New York: Columbia UP, 1996.

Miller, John, ed. *Voices Against Tyranny: Writing of the Spanish Civil War.* New York: Scribner's, 1986.

Millspaugh, C. A. "Among the New Books of Verse." Rev. of *A Turning Wind. Kenyon Review* 2 (1940): 359–63.

Mitchell, W. J. T. *Iconology: Image, Text, Ideology.* Chicago: U of Chicago P, 1986.

Moore, Harry T. Preface to *Proletarian Writers of the Thirties.* Ed. David Madden. Carbondale: Southern Illinois UP, 1968.

Mulvey, Laura. "Fears, Fantasies and the Male Unconscious or 'You Don't Know What is Happening, Do You Mr. Jones?'" *Visual and Other Pleasures.* Bloomington: Indiana UP, 1989. 6–13.

———. "Visual Pleasure and Narrative Cinema." *Visual and Other Pleasures.* Bloomington: Indiana UP, 1989. 14–26.

Naison, Mark. *Communists in Harlem during the Depression.* New York: Grove Press, 1983.

Neruda, Pablo. *Selected Poems.* Ed. Nathaniel Tarn. New York: Delta, 1970.

Nora, Pierre. "General Introduction: Between History and Memory." Trans. Arthur Goldhammer. *Realms of Memory: Rethinking the French Past.* Vol. I: *Conflicts and Divisions.* Ed. Lawrence D. Kritzman. New York: Columbia UP, 1996.

Orvell, Miles. "Reproduction and the 'Real Thing': The Anxiety of Realism in the Age of Photography." *The Technological Imagination.* Ed. Teresa De Lauretis, Andreas Huyssen, and Kathleen Woodward. Madison: Coda, 1980.

Ostriker, Alicia Suskin. "Dancing at the Devil's Party: Some Notes on Politics and Poetry." *Politics and Poetic Value.* Ed. Robert von Hallberg. Chicago: U of Chicago P, 1987. 207–24.

———. "The Thieves of Language: Women Poets and Revisionist Mythmaking." *The New Feminist Criticism: Essays on Women, Literature and Theory.* Ed. Elaine Showalter. New York: Pantheon, 1985. 314–38.

———. *Writing Like a Woman.* U of Michigan P, 1983.

Packard, William, ed. *The Craft of Poetry: Interviews from the New York Quarterly.* New York: Doubleday & Company, 1974.

Paley, Grace, "Six Days: Some Remembering." *Alaska Quarterly Review.* Rpt. in *The Pushcart Prize, XX: Best of the Small Presses.* Ed. Bill Henderson. Wainscott, NY: Pushcart, 1995. 446–51.

Penkower, Monty Noam. *The Federal Writer's Project: A Study in Government Patronage of the Arts.* Urbana: U of Illinois P, 1977.

Perry, Ralph Barton. *Our Side Is Right.* Cambridge: Harvard UP, 1942.

Plaskow, Judith. *Standing Again at Sinai.* New York: HarperCollins, 1991.

Pound, Ezra. *Selected Prose 1909–1965.* Ed. William Cookson. New York: New Directions, 1973.

———. *The Cantos of Ezra Pound.* 1970. New York: New Directions, 1986.

Prelinger, Elizabeth, ed. *Käthe Kollwitz.* New Haven: Yale UP, 1992.

Rabinbach, Anson. *The Human Motor: Energy, Fatigue, and the Origins of Modernity.* New York: Basic Books, 1990.

Rabinowitz, Paula. *Labor & Desire: Women's Revolutionary Fiction in Depression America.* Chapel Hill: U of North Carolina P, 1991.

Rich, Adrienne. "An Atlas of the Difficult World." *An Atlas of the Difficult World: Poems 1988–1991.* New York: Norton, 1991. 3–26.

———. "Blood, Bread, and Poetry: The Location of the Poet." *Blood, Bread and Poetry: Selected Prose 1979–1985.* New York: Norton, 1986. 167–87.

———. *Dark Fields of the Republic: Poems 1991–1995.* New York: Norton, 1995.

———. *The Fact of a Doorframe.* New York: Norton, 1984.

———. Introduction to *A Muriel Rukeyser Reader.* xi-xv.

———. *Of Woman Born: Motherhood as Experience and Institution.* 1976. New York: Norton, 1975.

———. *What Is Found There: Notebooks on Poetry and Politics.* New York: Norton, 1993.

———. "When We Dead Awaken: Writing as Re-Vision." *On Lies, Secrets, and Silence: Selected Prose 1966–1978.* New York: Norton, 1995. 33–49.

Richards, I. A. *Poetries and Sciences.* Rpt. of *Science and Poetry.* 1926. London: Routledge and Kegan Paul, 1970.

Rolfe, Edwin. "Poetry." *Partisan Review* 2 (April-May 1935): 32–42.

Rolo, Charles. Rev. of *The Life of Poetry,* by Muriel Rukeyser. *The Atlantic Monthly* 185.3 (March 1950): 81–82.

Rosenthal, M. L. "On the 'Dissidents' of the Thirties.'" *University of Kansas City Review* (Summer 1951): 294–300.

Rossner, David and Gerald Markowitz. *Deadly Dust: Silicosis and the Politics of Occupational Disease in Twentieth-Century America.* Princeton, NJ: Princeton U P, 1991.

Rubin, Barry. *Assimilation and Its Discontents.* New York: Random House, 1995.

Rukeyser, Muriel. *Beast in View.* Garden City, NY: Doubleday, 1944.

———. "The Book of the Dead." 1938. *Out of Silence: Selected Poems.* Ed. Kate Daniels. TriQuarterly Books, Northwestern UP, 1992. 10–40.

———. *Breaking Open.* New York: Random House, 1973.

———. *The Collected Poems of Muriel Rukeyser.* New York: McGraw-Hill, 1978.

———. "A Conversation with Muriel Rukeyser." By Judith McDaniel. *New Women's Times Feminist Review* (April 25–May 8, 1980): 16–19.

———. "Craft Interview with Muriel Rukeyser. In *The Craft of Poetry.* Ed. William Packard, 153–76. Garden City, NY: Doubleday, 1974.

———. "The Education of a Poet." In *A Muriel Rukeyser Reader.* Ed. Jan Heller Levi. New York: Norton, 1994. 217–85.

———. Foreword to *Berenice Abbott Photographs.* New York: Horizon, 1970.

———. Foreword. *Invented a Person: The Personal Record of a Life.* By Lenore Marshall. Ed. Janice Thaddeus. New York: Horizon, 1979. 7–9.

———. Interview. 10 April 1964. *Talks with Authors.* Ed. Charles F. Madden, Carbondale, IL: Southern Illinois UP, 1968. 125–50.

———. *The Life of Poetry.* 1949. Ashfield, MA.: Paris P, 1996.

———. *A Muriel Rukeyser Reader.* Ed. Jan Heller Levi. New York: Norton, 1994.

———. *One Life.* New York: Simon and Schuster, 1970.

———. *The Orgy.* New York: Coward McCann, 1965.

———. *Out of Silence.* Ed. Kate Daniels. Evanston, IL: TriQuarterly Books/Northwestern UP, 1992.

———. Rev. of *Land of the Free,* by Archibald MacLeish. *New Masses* (26 April 1938): 26–28.

———. *Selected Poems of Octavio Paz.* Trans. Muriel Rukeyser. Bloomington: Indiana UP, 1963.

———. "A Simple Theme." Rev. of *Jewel of Our Longing,* by Charlotte Marletto. *Poetry* 74 (1949): 236–39.

———. *The Speed of Darkness.* New York: Random House, 1968.

———. *The Traces of Thomas Hariot.* New York: Random House, 1971.

———. "Under Forty: A Symposium of American Literature and the Younger Generation of American Jews." *Contemporary Jewish Record* 7.1 (February 1944): 3–36. Rpt. in *Bridges* 1.1 (Spring 1990/5750) 26–29.

———. *U.S. 1.* New York: Covici Friede, 1938.

———. *Wake Island.* Garden City, NY: Doubleday, 1942.

———. "War and Poetry." *The War Poets.* Ed. Oscar Williams. New York: John Day, 1945. 25–26.

———. "We Came for the Games." *Esquire* 82 (Oct. 1974): 192–94, 368–70.

———. *Willard Gibbs.* 1942. NY: Dutton. 1964.

———. "Words and Images." *New Republic* (2 August 1943): 140–42.

"The Rukeyser Imbroglio." *Partisan Review* 11 (1944): 125–29.

"The Rukeyser Imbroglio (cont'd)." *Partisan Review* 11 (1944): 217–18.

"Rukeyser 2." Rev. of *U.S. 1,* by Muriel Rukeyser. *Time* (28 March 1938): 63.

Salomon, I. L. "From Union Square to Parnassus." Rev. of *Selected Poems,* by Muriel Rukeyser. *Poetry* 80 (April 1952): 52–57.

Scarry, Elaine. *Resisting Representation.* New York: Oxford UP, 1994.

Schapiro, Meyer. *Modern Art: Nineteenth and Twentieth Centuries.* New York: George Braziller, 1978.

Schor, Naomi. "This Essentialism Which Is Not One: Coming to Grips with Irigaray." *Engaging with Irigaray: Feminist Philosophy and Modern European Thought.* Ed. Carolyn Burke, Naomi Schor, and Margaret Whitford. New York: Columbia UP, 1994. 57–78.

Schwartz, Delmore. *Letters of Delmore Schwartz.* Ed. Robert Phillips. Princeton: Ontario Review Press, 1984.

———. *Portrait of Delmore: Journal and Notes of Delmore Schwartz, 1939–1959.* Ed. Elizabeth Pollet. New York: Farrar, Straus & Giroux, 1986.

Schudson, Michael. *Discovering the News: A Social History of American Newspapers.* New York: Basic Books, 1978.

Schultz, Bud and Ruth Schultz. *It Did Happen Here*. Berkeley: U of California P, 1989.

Schweik, Susan. "The Letter and the Body: Muriel Rukeyser's 'Letter to the Front.'" *A Gulf So Deeply Cut: American Women Poets and the Second World War*. Madison, WI: U of Wisconsin P, 1991. 140–170.

———. "Writing War Poetry Like a Woman." *Critical Inquiry* 13.3 (1987): 532–56.

Shortridge, Virginia, ed. *Songs of Science*. Boston: Marshall-Jones, 1930.

Showalter, Elaine. "Toward a Feminist Poetics." *The New Feminist Criticism: Essays on Women, Literature and Theory*. Ed. Elaine Showalter. New York: Pantheon, 1985. 125–43.

Sieburth, Richard. *Instigations: Ezra Pound and Remy De Gourmont*. Cambridge, MA: Harvard UP, 1978.

Silberman, Charles E. *A Certain People: American Jews and Their Lives Today*. New York: Summit Books, 1985.

Spellman, Francis J. *The Road to Victory*. New York: Scribners, 1942.

Sternberg, Janet, ed. *The Writer on Her Work*. New York: Norton, 1980.

Stott, William. *Documentary Expression and Thirties America*. 1973. Chicago: U of Chicago P, 1986.

Susman, Warren I. "The Thirties." *The Development of an American Culture*. Ed. Stanley Coben and Lorman Ratner. Englewood Cliffs, NJ: Prentice-Hall, 1970. 179–218.

———. "Culture and Commitment." *Culture as History: The Transformation of American Society in the Twentieth Century*. New York: Pantheon, 1984. 184–210.

Swenson, May. "Poetry of Three Women." *The Nation* (23 Feb. 1963): 164–66.

Terdiman, Richard. *Present Past: Modernity and the Memory Crisis*. Ithaca, NY: Cornell UP, 1993.

Thompson, D'Arcy Wentworth. *On Growth and Form*. Cambridge: Cambridge UP, 1942.

Tichi, Cecelia. *Shifting Gears: Technology, Literature, Culture in Modernist America*. Chapel Hill: U of North Carolina P, 1987.

Toronto Arts Group for Human Rights, eds. *The Writer & Human Rights*. New York: Anchor/Doubleday, 1983.

Wacker, Norman. "Ezra Pound and the Visual: Notations for New Subjects in *The Cantos*." *Images and Ideology in Modern/Post Modern Discourse*. Ed. David B. Downing and Susan Bazargan. Albany: State U of New York P, 1991. 85–104.

Wald, Alan. *The Revolutionary Imagination: The Poetry and Politics of John Wheelwright and Sherry Mangan*. Chapel Hill: U of North Carolina P, 1983.

Wesling, Donald. *Wordsworth and the Adequacy of Landscape*. London: Routledge, 1970.

Wheelwright, John. "*U.S. 1*." Rev. of *U.S. 1*, by Muriel Rukeyser. *Partisan Review* (March 1938): 54–56.

Whitford, Margaret. *Luce Irigaray: Philosophy in the Feminine*. London: Routledge, 1991.

Williams, William Carlos. "Muriel Rukeyser's 'US1.'" Rev. of *U.S. 1*, by Muriel Rukeyser. *New Republic* 9 (March 1938): 141–42.

————. *Selected Poems.* Ed. Charles Tomlinson. New York: New Directions, 1985.

Willkie, Wendell. *One World.* New York: Simon and Schuster, 1943.

Wilson, Edward O. *Consilience: The Unity of Knowledge.* New York: Knopf, 1998.

Wittig, Monique. *The Straight Mind and Other Essays.* Boston: Beacon, 1992.

Wolff, David. "Document and Poetry." Rev. of *U.S. 1,* by Muriel Rukeyser. *New Masses* 22 (Feb. 1938): 23–24.

Wolff, Geoffrey. Rev. of *The Traces of Thomas Hariot,* by Muriel Rukeyser. *Newsweek* (29 March 1971): 101–3.

Wright, Richard. *Twelve Million Black Voices.* 1941. New York: Arno and the New York Times, 1969.

Permissions

Index